A Life of Collecting: VICTOR AND SALLY GANZ

EDITED BY MICHAEL FITZGERALD

CHRISTIE'S

Introduction

Michael FitzGerald 6

Picasso

John Richardson PAINTINGS, DRAWINGS, AND SCULPTURE 26

Leo Steinberg In the Algerian Room 64

Maya Picasso A True Passion for Art 68

Brigitte Baer PRINTS 74

Interview with Leo Castelli 84

Johns

Roberta Bernstein PAINTINGS AND DRAWINGS 88

David Sylvester Picasso, Johns, and Grisaille 112

Robert Monk Victor and *Corpse and Mirror* 116

Susan Lorence PRINTS 118

Rauschenberg

Roni Feinstein PAINTINGS, DRAWINGS, SCULPTURE, AND PRINTS 136

Stella

Judith Goldman PAINTINGS 158

Hesse

Linda Shearer SCULPTURE AND DRAWINGS 172

Bill Barrette Eva Hesse and the Ganzes 192

Contemporaries

Carter Ratcliff 202

Remembrances of Victor and Sally

THE WHITNEY MUSEUM OF AMERICAN ART

Brendan Gill 218

Flora Biddle 219

Thomas Armstrong 219

BATTERY PARK CITY

Calvin Tomkins 221

Mary Miss 223

Agnes Gund 223

THE MUSEUM OF MODERN ART

William Rubin 225

Kirk Varnedoe 225

Mel Bochner 227

Gabriella De Ferrari 227

Chronology of the Collection 230

CONTRIBUTOR BIOGRAPHIES 239

ACKNOWLEDGMENTS 241

CREDITS 242

INTRO

DUCTION

MICHAEL FITZGERALD

"**A**ll in all, he was the best collector that we had. . . . For anyone who wants to know this period, they must only look at Victor and apply his lessons." That is how Leo Castelli describes Victor Ganz, who shared with his wife, Sally, a life filled with some of the finest art of this century. They were among the early collectors to support Jasper Johns, Robert Rauschenberg, and Frank Stella by building important groups of each artist's work in the 1960s. And by the end of that decade, they had extended their attention to Mel Bochner, Eva Hesse, Dorothea Rockburne, Richard Tuttle, Robert Smithson, and artists of following generations. Moreover, as the Ganzes' commitment to young artists grew, their engagement expanded beyond the private interaction of buying for their own satisfaction to the public stewardship that guides our leading museums and civic projects. At his death in 1987, Victor was both the vice president of the Whitney Museum of American Art and chairman of the Fine Arts Committee for Battery Park City. During the ten years before her death in 1997, Sally stepped into this public role, placing works in museums, lending pictures to exhibitions, and welcoming a constant stream of visitors into her home.

Yet these diverse activities constituted only the second and third acts of their lifelong commitment to art, and the model they exemplified was far from typical of collectors in the 1960s, 1970s, and 1980s. In the last year of his life, Victor spoke against many practices that had become common by the late 1980s. Like others, he dismissed

Nancy, Victor, Sally, Tony, and Kate Ganz with Jasper Johns, 1962

the goals of financial investment or social advancement that had come to drive the art market. But primarily, he lamented how frequently these extraneous concerns deflected people from a personal relationship with works of art—not the diverting company of artists—but the intensely private face-off between one individual and a complex creation made by another person and passed out into the world. For Victor and Sally, the competition to buy first, and the resulting reliance on an adviser to scout the scene, were unthinkable, a barrier to the deeply considered understanding that must precede any purchase. The purpose of this book is not merely to commemorate two widely admired individuals but also to convey the highly disciplined and courageous approach they brought to the history of collecting and the art of our time.

The pictures assembled by the Ganzes (they never spoke of a collection) each entered their life through this confrontation and won a place in their home only after filling their imaginations. All lived together in this family way. In an apartment with no track lights and no gilt frames, the pictures hung behind table lamps and tiers of personal photographs—primarily showing children and grandchildren—as if none had precedence. If snapshots of artists were buried in a hallway bathroom, most of the men and women who made the pictures on the walls were such welcome guests that Rauschenberg, for one, said he felt like a member of the family. Nor was every moment devoted to high-minded disquisition. At one gathering, Sally spied the eminent art historians Leo Steinberg and Alfred Barr locked in discussion and crossed the

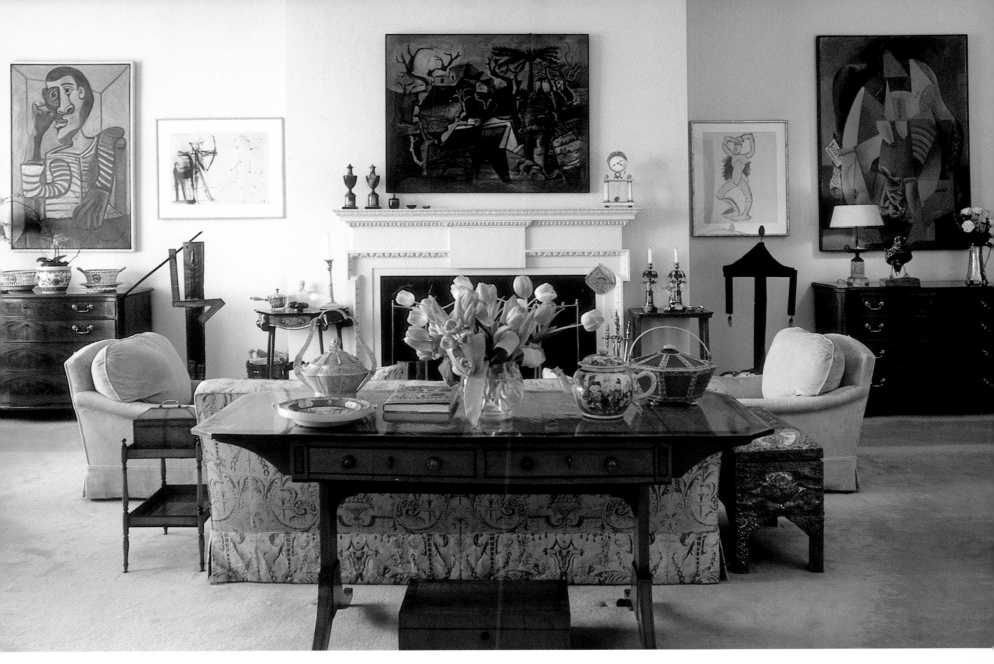

In the Ganzes' living room, from left to right: Pablo Picasso, *Sailor* (1943); Picasso, *Battle of the Centaurs* (1946); Picasso, *Winter Landscape* (1950); Picasso, study for *Les Demoiselles d'Avignon* (1907); Picasso, *Woman in an Armchair* (1913)

room to report, with great pleasure, that the subject was TV dinners. Not only did scholars and artists frequent the Ganzes' apartment at 1175 Park Avenue, and later at 10 Gracie Square (where they moved in 1969), generations freely intermingled. Having been struck by Eva Hesse's first show and having talked with her at the gallery, Victor invited the little-known artist to his home so that she could meet one of her "heroes," Jasper Johns.

Victor and Sally defined an era; yet their choices were not representative. They were not democratic collectors, selecting a signature piece by each of the leading artists or seeking to include works from the primary phases of a favored artist's career. They avoided entire movements of the 1960s and 1970s such as Color Field painting and Minimalism. More surprisingly, given their respect for Castelli, they owned few works by the Pop artists—one early painting by Roy Lichtenstein, an important sculpture by Claes Oldenburg, but nothing by Andy Warhol except a portfolio of silkscreens. The Ganzes extended their intense confrontation with individual works of art into exclusive dialogues with a handful of young artists, primarily Johns, Rauschenberg, Stella, and Hesse.

Their greatest commitment, however, was to Picasso. Over the course of fifty-six years, Victor and Sally owned

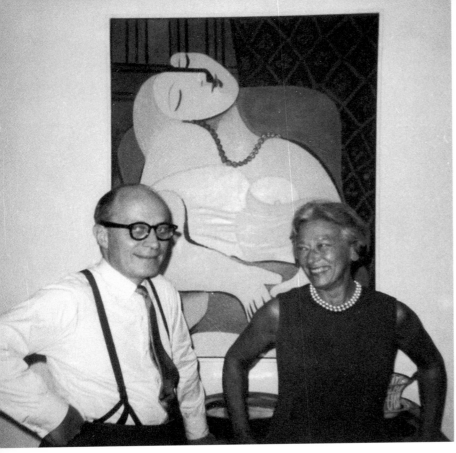

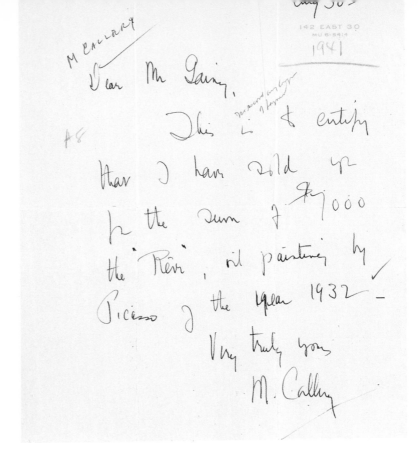

Victor and Sally in front of *The Dream* (1932) in 1968; **receipt from Meric Callery for the Ganzes' 1941 purchase of *The Dream***

twenty-four paintings, ten drawings, five sculptures, and several hundred prints by Picasso. For twenty years—until 1961, when they bought their first work by Johns—they collected only Picassos. Even later, they measured every work they chose against their conception of his achievement and the real things that hung on their walls.

Born in New York City in 1913, Victor began buying art before he joined the family's costume jewelry business, D. Lisner & Co., in 1934. Apparently without encouragement from his parents or a mentor, he managed to obtain three original works while still a teenager: a watercolor by Louis Eilshemius, another by Jules Pascin, and an oil by Raphael Soyer. Victor's brother, Paul, also became addicted to the visual arts. Yet whereas Paul came to focus on old masters, Victor immediately responded to living artists. His taste soon leaped beyond the modest talents who had first attracted him, but he kept the Eilshemius and Pascin and referred to them often, as both a mark of affection and a measure of how much his taste had changed.

In collecting, as in most other aspects of life, Victor was intensely independent and generally led the team. As an adolescent, he had skipped three grades in school and entered City College at the age of fifteen, only to drop out a few years later. He was largely self-taught; like many who have little formal education, he never stopped learning. Although an easy sense of humor enabled him to charm others, his path to understanding was private contemplation, rather than public discussion. By the late 1930s, he established a regimen for art: Saturdays were devoted to seeing as many exhibitions as possible, and this pursuit expanded to absorb more and more of the weekdays as the years passed. Conversations with dealers, artists, curators, and other collectors were welcome, but his chief source of knowledge was the work itself, a personal dialogue that many witnessed but few seem to have ever shared. Sally, as she called herself, had been born Carolyn Wile in Louisville, Kentucky, in 1912. She attended the University of Wisconsin and then came to New York, where she worked at Macy's and met Victor in 1935. She soon grew to share his avocation; they married in January 1942.

For the few New Yorkers who were seriously concerned about contemporary art, the months before the United

States entered World War II were dominated by a single cultural event. The Museum of Modern Art celebrated its tenth anniversary by presenting an exhibition of the artist whom Alfred Barr, the museum's founding director, called the greatest of the century: Picasso. There is no doubt that this first full retrospective of Picasso's work in this country provided the opportunity for Victor and Sally to immerse themselves in a body of work that was still not well-known. Nor is there any doubt they took advantage of it.

By the next year, Victor was ready to make a major purchase, when, quite unexpectedly, the opportunity

Top: Jules Pascin, *Untitled (Atlantic City)* (date unknown)
Bottom: Louis Eilshemius, *Shelter Island, Maine* (c. 1908)

suddenly arose. With the European war already joined, refugees were streaming across the Atlantic, and one was the sculptor Meric Callery, whose wealth and friendship with other artists had enabled her to gather a fine group of paintings by leaders of the School of Paris, as it was then called. With German troops approaching Paris, Callery rolled up these canvases and fled to the United States, where another friend, the dealer Paul Rosenberg, helped her settle. Rosenberg had been Picasso's dealer for the two decades between the world wars and had himself escaped in early 1940 to reopen his gallery in New York. In the summer of 1941, Rosenberg presented an exhibition of Callery's Picassos, several of which she had purchased from him. Knowing Rosenberg's reputation, Sally and Victor visited the exhibition one Saturday in August. This was the moment they encountered *The Dream* (1932) and made the leap from passionate admirers of Picasso's art to hopeful possessors of one of his masterpieces. Upon leaving the exhibition, Victor acted boldly. He looked up Callery's telephone number, called, and made an appointment.

Except for the war, it is unlikely the Ganzes could ever have owned the painting. They had no standing in the establishment and their wealth was not great, so they would not have been solicited as buyers. Callery would not have sold if the war had not forced her hand, and the passage of years would have driven the price beyond their means. Yet in those very uncertain times, the chance arose and they were willing to make the commitment. The price was $7,000. Today it seems minuscule, but three years earlier, in 1938, The Modern had had difficulty convincing Mrs. Solomon Guggenheim to give Rosenberg $10,000 for *The Girl Before a Mirror*, another painting from this great series of 1932. With Sally's strict encouragement, Victor demonstrated both his aesthetic discernment and business acumen by acquiring a remarkable picture at a bargain

price, a combination of skills he would apply many times over the following decades.

If they had chosen to publicize it, this purchase would immediately have made Victor and Sally figures of respect in the tiny art community of New York. Because of their discretion, more than a decade passed before word of their continuing acquisitions began to circulate. Moreover, they nearly decided on another picture, one that in certain ways more strongly reflects the choices they made in future years. *The Dream* is one of the lushest of this series of vividly colored, sensual images. It represents a high point, an abundance of visual pleasure that the Ganzes sought

only rarely—most clearly in the *Women of Algiers* (1955), which they frequently compared with *The Dream*, or Rauschenberg's exuberant Combines, such as *Rebus* (1955). The alternative in 1941 was Picasso's *Bather* (1908–09), a painting made at the dawn of Cubism that manifests a hard-bitten austerity and manipulation of the human figure. It is the counterpart of *The Dream*: both are great achievements of aesthetic concentration, but they stand at opposite extremes, one of opulence, the other of deprivation. Perhaps at that moment, *The Dream* seemed better suited to their budding life together; yet when they saw *Bather* more than thirty years later in the home of

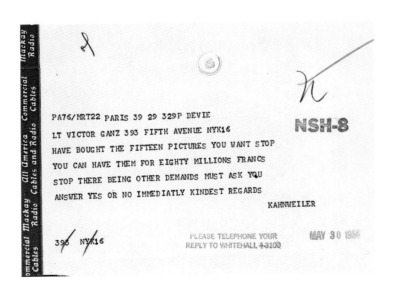

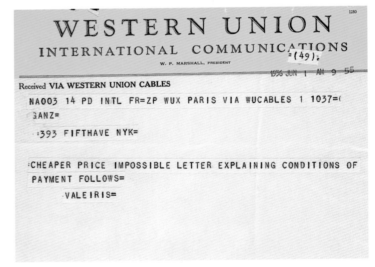

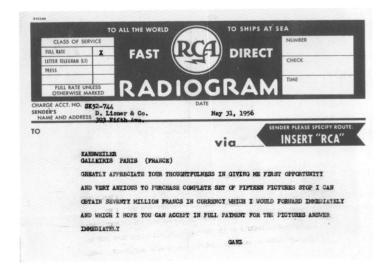

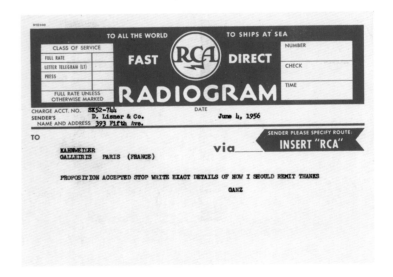

Negotiations for the purchase of Picasso's *Women of Algiers*, May 30–June 4, 1956

Louise Smith (who bequeathed it to The Modern), they still regretted not having believed they could afford both (Sally had always preferred *Bather*). As it turned out, the Ganzes would not have a great Cubist picture until 1967, when they made their last purchase of a Picasso painting, *Woman in an Armchair* (1913).

Like the absence of *Bather*, the timing of this acquisition was a matter of chance. Sally and Victor had tracked the *Woman in an Armchair* for years, plotted with the Cubist collector Douglas Cooper to obtain it for their collection, and when the opportunity finally arose, bargained furiously to possess it. Yet it is a masterpiece that only the most sophisticated can stomach. This monumental image of a woman stripped, flayed, and nailed back together by the intensity of Picasso's analysis is the acid test of any collector's devotion to Cubism. It is exactly right for the Ganzes.

Throughout the later 1940s and the 1950s, they consistently bought some of the most brutally challenging pictures Picasso ever painted—not the highly popular (and equally great) pictures of the Blue, Rose, and neoclassical periods. The violence of the pictures they bought registers the deprivations of civilian life in wartime Paris—*Still Life with Sausage* (1941)—and allegorizes the battles themselves—*Cat and Bird* (1939) and *Cock and Knife* (1947). They do not correspond to the life that Sally and Victor were leading in New York. They match the dark, intensely introspective mentality that dominated the Ganzes' relationship with art, most prominently in the muddy decay of *Winter Landscape* (1950)—which Picasso painted on the obdurate surface of a wooden panel and loaned to Henri Matisse, who surrounded it with the brilliant hues of his Vence chasubles in order to exorcise its unrelenting morbidity.

The Ganzes bought many of these pictures from Samuel Kootz, the maverick dealer who brought a fat wallet and a carnival manner to the New York art trade after he convinced Picasso to sell him paintings while the artist held off his longtime dealers, Paul Rosenberg and Daniel Henry Kahnweiler. In 1953, the Ganzes did buy the ornate, late Cubist *Bird Cage* (1923) from Rosenberg for $30,000, their most expensive purchase up until then. And three years later, they made a remarkable arrangement with Kahnweiler. Responding to the dealer's statement that Picasso's most recent series, *Women of Algiers* (1954–55), must be sold as a set (supposedly Picasso's demand, which the artist later flatly denied), Victor went out on a limb and agreed to purchase all fifteen paintings for the price of $212,953, far more than he could afford to spend. (He recounted hearing himself dictate the acceptance as if his voice came from someone else.) Working with Rosenberg and Eleanore and Daniel Saidenberg, he soon whittled them down to the core group he wanted to keep and sold the other ten to collectors and museums around the country. Unlike most of those he declined, these five pictures are governed by a strict, linear clarity of design; yet they range from near monochromatic washes and open expanses to intensely worked, polycolored textures—spanning the aesthetic opposition that characterizes the Ganzes' pictures.

In later years, Victor would occasionally buy a painting by Picasso, but the *Women* remained the centerpiece. They were installed in a specially designed room—their own harem—quite unlike the other pictures, which rotated from bedrooms to dining room to living room to foyer. In part, Picasso was simply becoming too expensive for Victor, but there were also aesthetic reasons for this detachment. In the early 1960s, probably 1962, Kahnweiler showed Victor and Sally the newly finished *Luncheon on the Grass* (1960–61), after Edouard Manet. No doubt Kahnweiler

Overleaf: In the "Algerian room": Picasso, *Women of Algiers* (1955) from left to right: "H"; "O, final version"; "K"; "M"

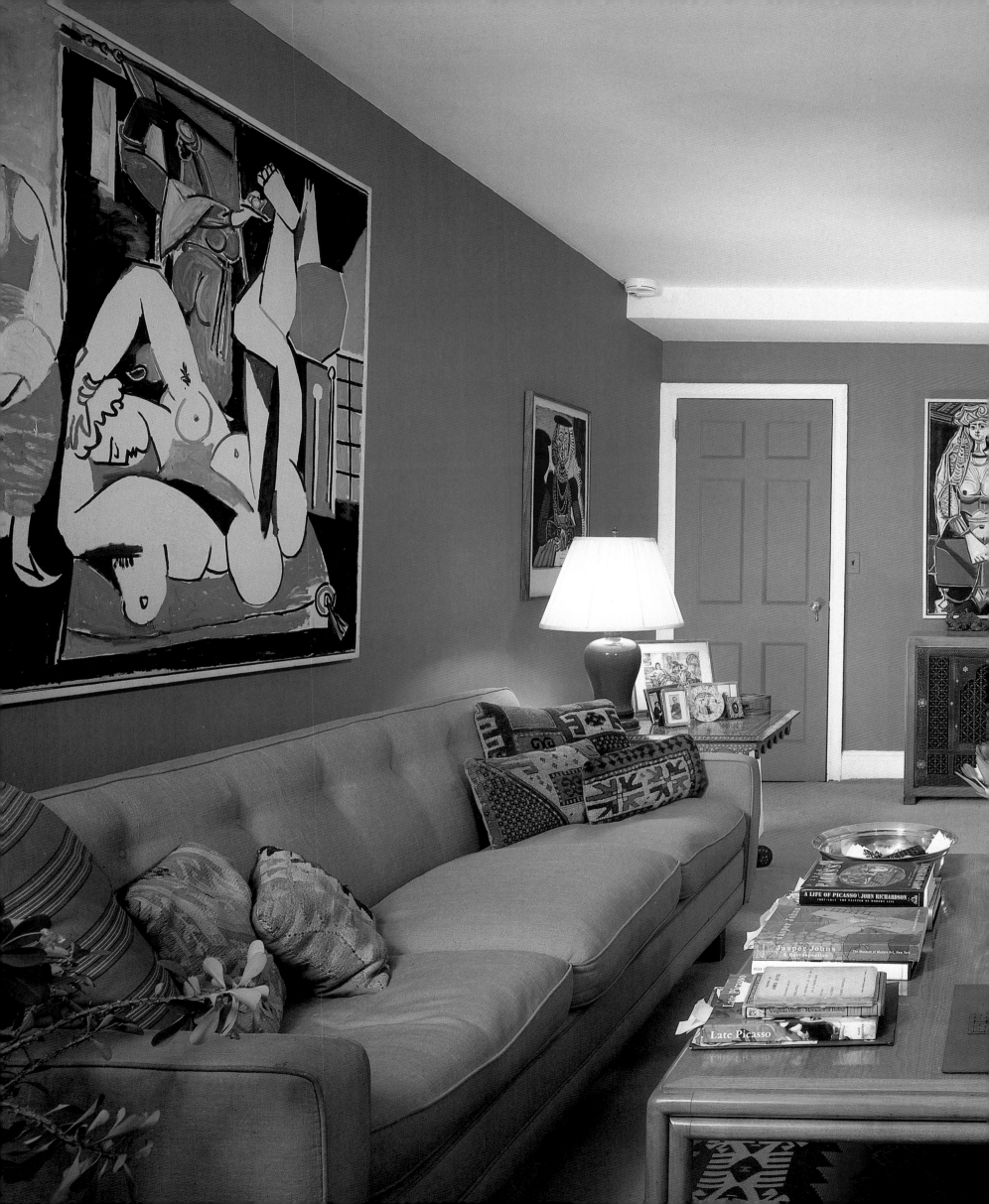

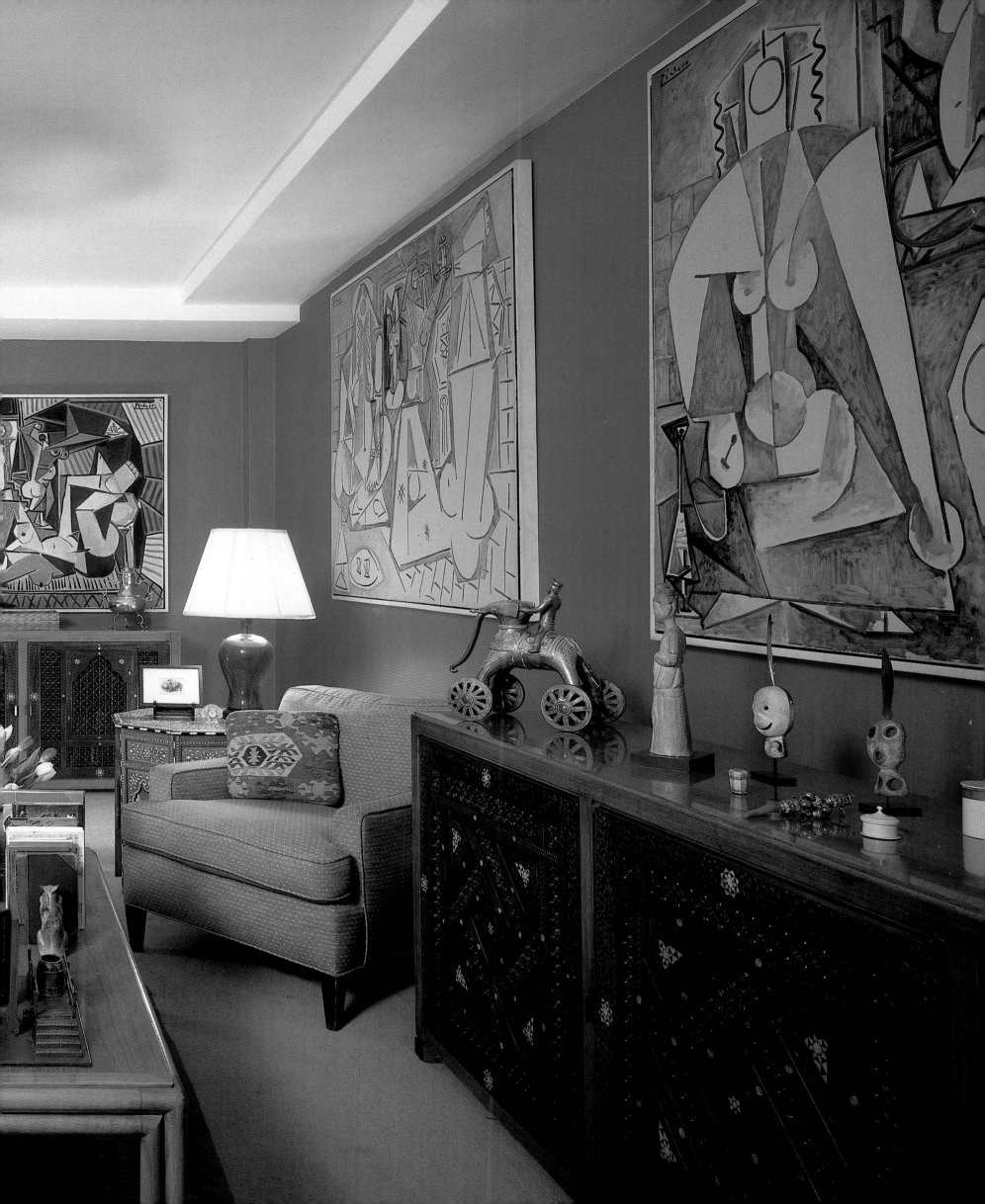

hoped that they would buy a group to match the *Women of Algiers*. After a night of anguish over whether to follow his own judgment that the paintings were flaccid failures or to put aside his opinion out of respect for the artist he still revered, Victor refused to buy a single one. He never acquired another contemporary painting by Picasso, although he did come to advocate his late work and strongly recommend it to some collectors while it was still generally dismissed.

The Ganzes frequently traveled to France after World War II and could have become members of Picasso's entourage, yet they saw him only twice. The first time, April 8, 1948, they sought him out, driving to Le Golfe-Juan, where he lived, and entreating a local bookseller to make the introduction. The visit is memorable primarily because of the Ganzes' restraint—waiting until the end to mention that they owned *The Dream* and seeking no more than the autograph Picasso drew in a book. Their second and last meeting, a brief encounter on May 8, 1970, occurred at the urging of Marga Barr and resulted in two sketches they gladly brought home. Despite Victor and Sally's tremendous enjoyment of their time with Picasso, his prominence made him too intimidating to imagine as a friend. With younger artists, life and art would be richly interwoven.

The decisiveness and seasoned experience that led Victor to reject Picasso's variations after Manet also gave him the self-confidence to shift his support to contemporary artists in New York. In turning to American art, the Ganzes did not follow conventional wisdom, which portrayed Abstract Expressionism as the point of origin for an American avant-garde equal to its European predecessors. Although Victor admired Jackson Pollock in particular and had regularly visited the 1950s exhibitions at Betty Parsons and other galleries, none of the achievements of the Abstract Expressionists tempted him to switch his

Carnet de Dessins de Picasso inscribed to Victor
by Picasso, April 8, 1948

allegiance. Perhaps the artists' struggle to escape Picasso's influence seemed to him somewhat misguided or not sufficiently resolved. Instead, he was won over by the following generation of artists, who—thanks to the achievements of Pollock, Willem de Kooning, and Barnett Newman—could comfortably distance themselves from Picasso, accept him as a largely historical figure, and

engage his work without fear of absorption.

The first of these acquisitions was Jasper Johns's *Flag* (1957), a drawing they bought from Leo Castelli on February 28, 1961. The choice and timing are entirely characteristic. In deciding to break the exceptional, single-minded focus of their collecting, Victor acted with great premeditation. After all, Johns had been lionized by the New York art world since his first exhibition at Castelli's gallery in 1958, when Victor's friend Alfred Barr had acquired three paintings for The Modern. Considering

Barr's past devotion to Picasso, this vote of confidence must have caused Victor to give Johns immediate and serious attention. Nonetheless, he waited three years, and when he finally bought, he selected a drawing ($1,545) rather than a more expensive painting. In the meantime, Victor had spent long hours reading, discussing, and looking. This modest first act would grow into the Ganzes' most extensive commitment after Picasso.

Besides coming to share the judgment of others, perhaps Victor foresaw that Johns would become the artist of his generation who is the most deeply enthralled with Picasso. This prediction, however, would have been self-fulfilling, since Johns's concern with Picasso was fueled by his frequent visits to the Ganzes' apartment and his intimate examination of their pictures. (Would he have painted the hatched compositions of the 1970s and early 1980s without the opportunity to study the densely packed, regular strokes that knit together figures and ground in the final version of the *Women of Algiers*?) It is certainly appropriate that the last purchase of a Johns was *Untitled* (1990), a variation on Picasso's *Woman in a Straw Hat* (1936).

As Victor began to shift his concentration from Picasso to contemporary American art, two exhibitions became his classrooms: the Jewish Museum retrospectives of Rauschenberg (March 31–May 12, 1963) and Johns (February 16–April 12, 1964). They offered Victor the opportunity to surround himself with the artists' work, evaluate their achievements, and make commitments he would follow for the rest of his life. Ten days after the Rauschenberg retrospective closed, Victor bought *Winter Pool* (1959), one of the most complex Combines in the show. His choice of a large work as his first purchase evinces none of the hesitation apparent in his selection of the Johns drawing two years before. Victor had educated himself and decided. Over the next five years, he bought

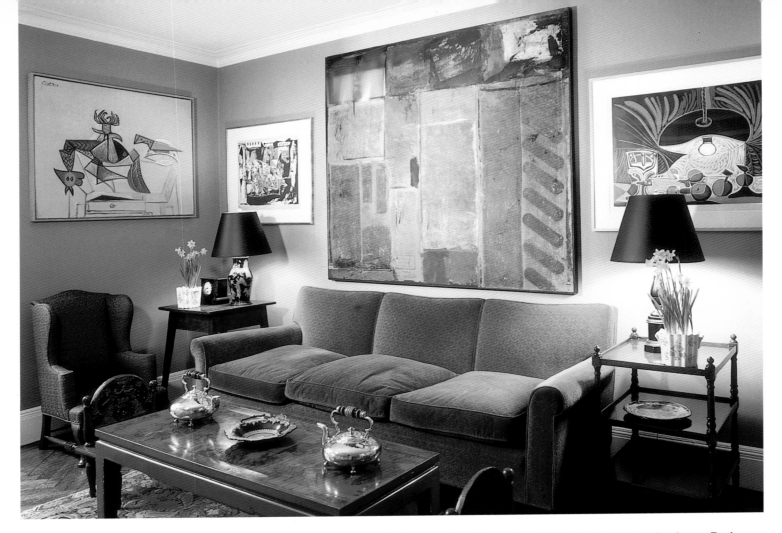

On the landing, from left to right: Picasso, *Cock and Knife* (1947); Picasso, *The Departure* (1951); Robert Rauschenberg, *Red Interior* (1954); Picasso, *Still Life with Hanging Lamp* (1962)

eight more major works by Rauschenberg, and six of these—22 *The Lily White* (1949); *Red Interior* (1954); *Rebus* (1955); *Odalisk* (1955); *Allegory* (1959–60); and *Rigger* (1961)—had appeared in the exhibition.

The Ganzes lent their *Flag* and another 1961 purchase, *Liar* (1961), to the Johns retrospective, but they also bought from the show. Three days after the opening, they acquired *Diver*, a huge drawing of 1963, as well as two other works on paper; less than a month after the closing, they purchased the first painting, *Gray Rectangles* (1957). For the following eleven years, they bought a major Johns almost every year, and most of these were new works. Unlike Rauschenberg, whose art of the 1950s fascinated Victor the most, Johns became a continuing obsession.

Despite the fame both artists enjoyed by the time of these exhibitions, their careers were still shaky. Victor bought several of the best Rauschenbergs directly from the

artist, whose largest and most free-form work was viewed with skepticism by many. At the Jewish Museum show, Barr had declined Johns's recommendation that The Modern purchase *Rebus*. Rauschenberg still had it three years later, when Victor made an offer. Besides the support of these steady purchases, inclusion in the Ganzes' collection was a great boost to these artists' reputations and their self-esteem. As Castelli recalls, "To be in the Victor Ganz collection was really an honor for them, a distinction that the artist could stand up to the competition."

Of course, here, the competition was Picasso. Where else could Rauschenberg's *Odalisk* be seen next to the *Women of Algiers*? Its pinup photos, strutting cock, and pierced pillow both parody the tradition of exotic female nudes and bring it up to date—a reversal of the transformation Picasso had wrought by portraying his lover Jacqueline Roque as if she belonged in a Delacroix.

Moreover, both works were made in the same year, 1955, a conjunction that shatters the pigeonholes of conventional art history. Or where else could the deep, heavily worked skin of Johns's *Diver* hang beside Picasso's twisted grisaille, *Still Life with Sausage*?

Despite moments of efflorescence, the Ganzes' choices were remarkably tough—art that is dark to the point of obscurity and so complexly layered as to border on the illegible. There is a link to Picasso's wartime pictures, but the Ganzes were also mining a vein of highly controlled austerity running through the Pop era. The bleached, scratched surfaces of Rauschenberg's *22 The Lily White*, or the almost impenetrable rusts of his *Red Interior* (a picture the Ganzes hung in one of the darkest recesses of their apartment) overturn the artist's undeserved reputation for lighthearted acceptance of things as they are. In Johns, Victor and Sally found an artist who consistently shared their skepticism of everything easy, immediately understandable, or conventionally pleasing. From their purchase of *Liar* in 1961 (a work whose title, stamped on the paper, confirms the unreliability of the shadowy field below) to *Corpse and Mirror* (1974), Victor and Sally tracked Johns through the most resistant and deeply pessimistic phases of his career. Tragedy is an essential theme of the Ganz pictures.

At first glance, it is surprising that they did not buy one of Frank Stella's black paintings until 1980. Yet, like the late purchase of Picasso's *Woman in an Armchair* (1913), the timing was largely a matter of availability. Victor had not thought of buying one of Stella's paintings when they were

Victor and his daughter Vicky, 1985

shown in The Modern's exhibition "Sixteen Americans," in 1959, and at Castelli's gallery the following year, just as he had passed on Johns and Rauschenberg in those last years of his fixation on Picasso. As he voraciously turned his attention to young artists, he and Sally soon chose Stella as the third of their contemporary triumvirate. In 1966, the Ganzes took two new paintings, *Tuftonboro I* and *Cinema di Pepsi*, and for the next decade were steady buyers of works from most of Stella's new series. They kept returning to the Polish Village works (1971–72), acquiring four of these giant reliefs. Since they were too large to be displayed in the apartment, Victor hung some of them in his office and rented a space in the basement of their apartment building, which was quickly dubbed "The Museum" because of its relative severity. Throughout the late 1960s and the 1970s, he searched for a black painting and finally found *Turkish Mambo* (1959).

Many collectors would have stopped at this point. Many would have never gone beyond Picasso. But for Victor and Sally, it was not enough to own masterpieces by the greatest European artist of their time and the acknowledged leaders of contemporary American art.

Having opened their imaginations to new work, they kept searching. They began collecting the projects of Mel Bochner, an artist whose cerebral approach might seem unsympathetic to a couple devoted to painting. Yet Bochner's use of complex numerical relationships matched Victor's lifelong fascination with numbers and his remarkable mathematical skills. The Ganzes had already acquired two paintings of numerals,

Rauschenberg's *22 The Lily White* and Johns's *White Numbers* (1959). Moreover, geometric patterns, the visual equivalent of equations, span the collection from *The Dream* through Stella's formal permutations, Richard Tuttle's *Blue Pole* (1965) and Dorothea Rockburne's *Golden Section Painting* (1974). In this collection, structure is the necessary counterpoint to shadow and chaos. Tautly articulated composition subverts the tragic overtones of many of the works by affirming the artists' ability to order and control the desolation depicted in them.

In 1968 Victor found Eva Hesse. Unlike the other artists he came to collect in-depth, Hesse was not recognized when he first encountered her work. She was his discovery. And she became his cause, as cancer ended her life and the public slowly came to recognize her art. Hesse's work is also based on geometry but is rendered in pliable materials that transform abstraction by welcoming gravity and the decay of natural processes. In 1975 the Ganzes bought a group of sixteen drawings by Robert Smithson, an artist whose obsession with entropy highlights issues implicit in Hesse's sculpture.

Victor had already begun to apply his energy and enthusiasm to new challenges. He and Sally still bought a painting now and then, usually a Stella, and kept up their dedication to Johns and Rauschenberg by subscribing to the prints (the publisher ULAE reserved number two of every edition for them). Yet the art boom of the later 1970s and the 1980s drove the prices of most

In the Ganzes' basement gallery:
Bill Barrette, Victor, and Sally, 1981.
Back wall left to right: Eva Hesse, *Vertiginous Detour* (1966); Frank Stella, *Chodorow II* (1971); Hesse, *Connection* (1969)

major works beyond what they could afford and created a climate of speculation they found repellent. Besides, without ever intending to form a "collection," Victor and Sally had done just that. In their dining room, Hesse's *Ennead* (1966) looped across a corner to join Rauschenberg's *Rebus* with Picasso's *Bird Cage* in a compelling exchange, one that art historians were coming to realize mapped much of the twentieth century. The house was full. In the late 1960s and early 1970s, Victor had sold *Odalisk* and *Allegory* to Peter Ludwig for his new museum and disposed of a few Picassos—*Bullfight*, *Baboon and Young*, and an impression of *Minotauromachy*—rare deaccessions that enabled him to buy the apartment on Gracie Square and retire some of the mountainous debt he had long carried to finance his collecting. These sales had "ripped [his] guts out." In order for the collection to grow substantially, more art would have to be sold. Except for a few works they placed with museums, no more important ones left his possession during his lifetime.

Over the decades, the Ganzes' collecting had naturally drawn them into close relationships with museums in Europe and America. In 1955 they were substantial lenders to the Picasso retrospective organized by the Musée des Arts Décoratifs (the first exhibition of his work presented by a French museum), yet during their "Picasso Period" the strongest link was to The Museum of Modern Art in New York. Barr's pioneering 1939–40 exhibition had introduced Victor

and Sally to the artist; by the mid-1950s they joined the director's circle as they accumulated the largest private collection of Picasso's work in this country. Although neither Victor nor Sally ever served as a trustee of the museum or sat on one of its primary committees, they did become close friends of Alfred and Marga. On June 5, 1956—the day after accepting Kahnweiler's ultimatum—Victor called to report that he had bought the fifteen *Women of Algiers* and to offer "any or all of them for loan to the museum." Characteristically, Victor had made the purchase without consulting Barr, but once it was concluded, he wanted the museum to benefit immediately.

One year later, the Ganzes nearly emptied their house to supply eight pictures, including the five versions of the *Women*, and one sculpture to Barr's celebration of Picasso's seventy-fifth birthday. When William Rubin organized the great 1980 retrospective, they once again lent generously. Moreover, they agreed to part with one of these paintings, *Bather with Beach Ball* (1932), as a partial gift to the museum—a rare act for collectors who frankly stated that too much of their wealth was tied up in pictures for them to be able to donate masterpieces. Perhaps the most telling testament of their respect, a mixture of devotion and reticence, came in April 1958, when a fire threatened to consume the museum building and forced staff members to evacuate paintings across the rooftops. In a note to Alfred the next morning, Sally wrote, "It's hard to explain, but last night we both wanted to come and work— it was a hard impulse to resist and we did so because, of course, we should only have been a nuisance."

The Ganzes' relationship with The Modern continued until Sally's death, yet their greatest contribution was to the Whitney Museum of American Art. In 1976 Victor became a founding member of the museum's Drawing Committee, and over the next twelve years he served on every one of

In the sitting room

the museum's acquisitions committees, as well as on the budget committee. By all reports, he was one of those exceptional outsiders who understood and gave cogent advice on the tangled nexus of business and artistic matters at the heart of cultural organizations. He became a trustee in 1981 and served as vice president during the last years of his life. When Victor finally joined the board he joked, "I've lost my virginity," and his extensive affiliation with the Whitney does mark a break with his long-standing preference for independence.

Under the directors John Baur and Thomas Armstrong, and the founder's granddaughter, Flora Biddle, the Whitney was transforming itself from a sedate supporter of relatively provincial realism into a dynamic

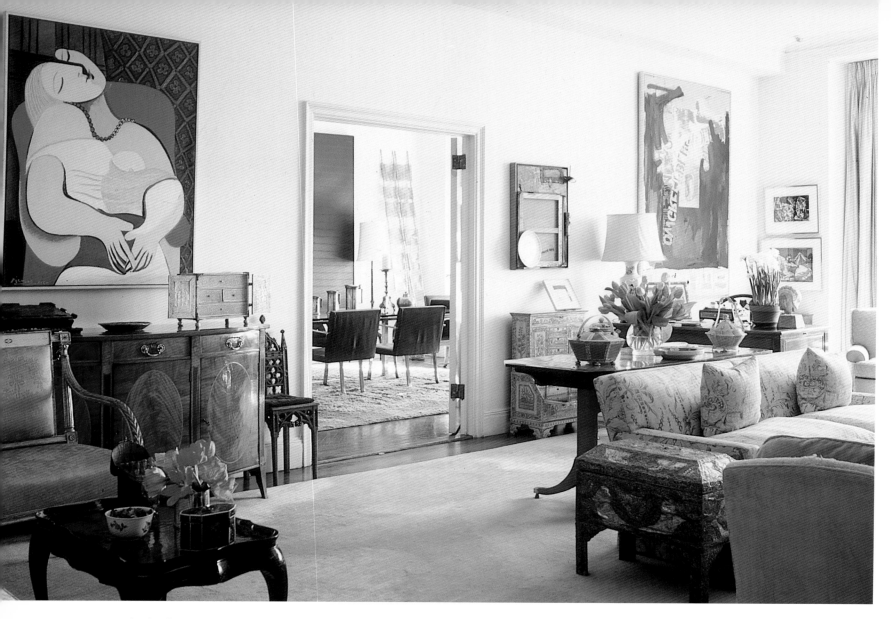

In the living room, left to right: Picasso, *The Dream* (1932); Jasper Johns, *Souvenir 2* (1964); Johns, *Decoy* (1971); Picasso, *Blind Minotaur Guided by a Little Girl in the Night* (1934), Picasso, *Faun Unveiling a Woman* (1936). In the dining room behind, left to right: Stella, *Turkish Mambo* (1959); Hesse, *Vinculum I* (1969)

advocate of innovation in contemporary art. Victor welcomed this change and played a large role in making the Whitney the leading museum of contemporary American art. In a 1984 report to the board, he laid out the situation. "When I was invited to join the newly created Drawing Committee almost ten years ago, I was initially very doubtful. . . . My perception of the Whitney, and that of my friends and acquaintances in the art world, was not very bright—it seemed like a quiet, comfortable little village set in a valley between twin peaks, the Metropolitan and The Modern." He did not mince words: "In the decades from 1940 to 1970 it had come close to missing the greatest moment in the history of American art."

Victor pushed for riskier acquisitions and exhibitions of young artists' work that would prevent the Whitney from repeating this error. In 1979, he and Sally celebrated the museum's fiftieth anniversary by donating Oldenburg's *Soft Toilet* (1966) and four years later they gave Bochner's *Triangle and Square: First Diagonal* (1974). Three years after Victor's death, the family gave Stella's *Dove of Tanna* (1977). In 1977, when the museum organized the first retrospective of Johns's work since the Jewish Museum show, the Ganzes were major contributors. As Sally wrote, "We have stripped ourselves for it, everything we own except for the small flag and white numbers, AND [all the pictures] will be gone for almost two years—but since the

show is a really crucial one for Jasper and since he is a devoted friend we simply could not refuse." Besides major retrospectives, Sally and Victor took particular interest in the Biennials, the museum's showcase of new talent.

In committee meetings Victor acknowledged that collecting the work of unproven artists would lead to some mistakes, but he nonetheless spurred the staff and trustees by admonishing them that their predecessors had overlooked Johns and his contemporaries until their work was nearly unaffordable. Even at one of the last meetings he attended, in February 1987, he fought self-satisfaction by branding parts of the program "retardataire."

By the late 1970s, the Whitney's desire for additional space had immersed Victor in architecture. He helped select Michael Graves as architect for the expansion and became deeply involved in clearing the many hurdles that confront anyone seeking to alter the physical fabric of New York City. These tasks revealed Victor's long-standing fascination with buildings and urban design, which he had pursued over the course of many summers in Italy and France, spending days racing from church to piazza to villa after most of the family had retired in exhaustion. These experiences prepared him for an even more difficult challenge—Battery Park City, a vast development near the southern tip of Manhattan that was supposed to integrate apartment towers, office buildings, parks, and art. Despite the advisory role of his committee, Victor convinced both government officials and architects that sculpture could not be "plunked down," as he called it, but must be created for a particular setting in collaboration with the

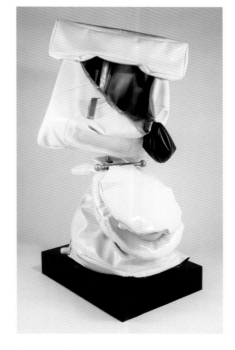

Claes Oldenburg, *Soft Toilet* (1966)

artist. They commissioned works from Siah Armanjani and Scott Burton, Mary Miss, Ned Smyth, Richard Artschwager, R. M. Fischer, and Jennifer Bartlett.

By sharing their devotion to art with people both inside and outside the art world, Sally and Victor left a remarkable legacy. Among the individuals who credit the Ganzes' guidance, Michael Eisner, the chairman of the Walt Disney Company, grew up as a friend of the family and enjoyed the privilege of borrowing one of their Picassos, *Bullfight*, to hang in his bedroom. Over the years, they took him to galleries and museums, and in 1960 they led him on a two-day forced march through the architecture of Rome. When his plans for Disney's Orlando facilities promised to become one of the larger architectural projects in recent decades, Eisner turned to Victor as a behind-the-scenes advisor to structure and guide the competitions which resulted in commissions to Robert Venturi, Michael Graves, Arata Isozaki, and many others. Eisner credits Victor with convincing him to overturn decisions that the company had made on economic grounds, particularly urging him to restore the pyramid of Graves's Dolphin Hotel. "Victor was the person I used to get us started, and the basic designer responsible for whatever influence we have had on the improvement of corporate architecture."

Within the art community, the Ganzes most important contribution may well turn out to have been their championing of Eva Hesse. When they bought a large group of her work in 1972, Sally recorded that they would try to increase the artist's visibility (and solve storage problems) by loaning the sculptures to museums. Seven years

later, they placed one permanently, selling *Addendum* (1967) to the Tate Gallery in London. In 1986, they sold *Seven Poles* (1970) to the Centre Pompidou in Paris. But Victor's death in October 1987 led to the largest dispersal. The following year, Sally honored Victor's "stronger and stronger feeling of [Hesse's] importance," by selling four of the artist's greatest works to American museums: *Hang-Up* (1965–66) to the Art Institute of Chicago; *Vertiginous Detour* (1966) to the Hirshhorn; *Untitled (Wall Piece)* (1970) to the Des Moines Art Center; and the huge *Untitled (Rope Piece)* (1969–70) to the Whitney. In a matter of months, Hesse's presence in our museums soared from minimal to major.

That same year Sally gave Johns's *Studio II* (1966) to the Whitney and *Watchman* (1966) to The Modern, and also sold twelve works by Picasso, Johns, Rauschenberg, and Stella at Sotheby's. Sally had long pursued her own activities in the arts, organizing the nine-gallery "American Tribute" to Picasso in 1962, a Braque exhibition in 1964, and several others in following years. All were to benefit the Public Education Association, an organization to support literacy in New York City, that she helped found.

After the initial sales and gifts to settle the estate and provide for her financial security, Sally eagerly shared the remaining pictures, lending them widely and making her home available to the growing number of people who asked to visit. She also added one work to the collection, Johns's *Untitled* (1990).

Above: Jasper Johns and Sally at the opening of "The Drawings of Jasper Johns" at the National Gallery of Art, 1990
Right: In the Ganzes' master bedroom, Johns, *Corpse and Mirror* (1974)

Buying the Johns reinvigorated Sally. The acts of choosing this specific picture as the best of the series and paying the price (several times more than their most expensive Picasso) gave her a tremendous sense of independence that crackled through her final years. It is a perfect capstone to this collection and to her life—a work by the contemporary artist she and Victor most admired, and one that builds on Picasso's achievement, where their shared passion for art had begun. No one who knew Sally was surprised that she died a few hours after the many Johnses she had loaned to The Modern's retrospective had been safely returned and rehung.

I remember a visit in October 1996, when I called in the hope of convincing her to participate in a panel discussion of the Picasso market, which took place at the Metropolitan Museum a few weeks later. While she firmly denied having any particular knowledge of the subject, she tossed off stories about dealers, collectors, and artists. Sitting in her bedroom, sipping a gin and tonic and drawing on cigarette after cigarette, a breathing machine at her side, she told about the purchase of *The Dream*, the meetings with Picasso, and many other fascinating events in their lives as collectors that only friends had heard. But, no, "I really don't have anything substantial to say." (She was in the front row when the panel convened, and we all looked to her as referee.) As her energy flagged that evening in October, she told me to go and look at the pictures. "Take as many hours as you like and let yourself out when you have had enough."

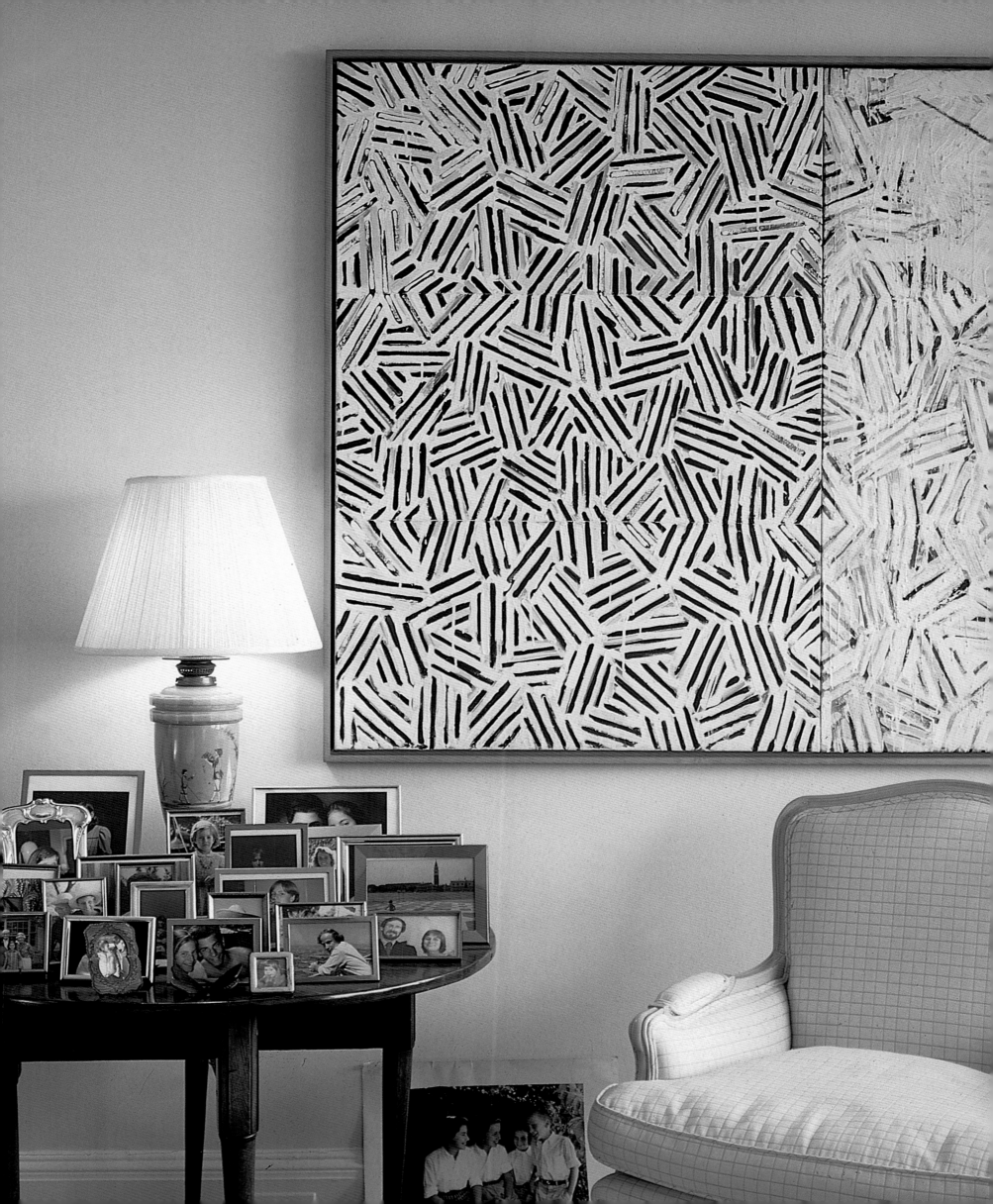

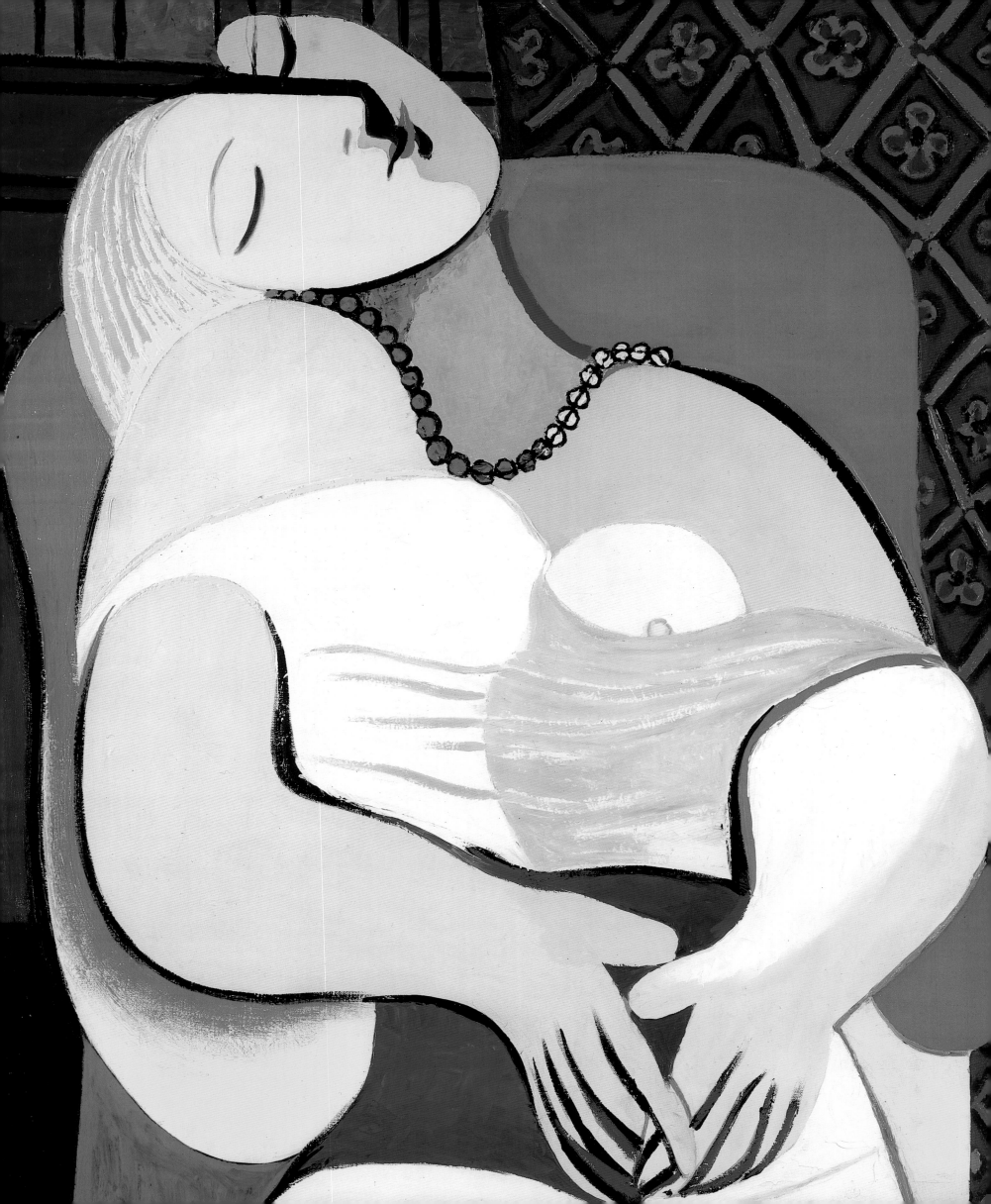

PICASSO

JOHN RICHARDSON

Victor and Sally Ganz never considered themselves collectors: they thought the word pretentious, and pretentiousness was anathema to them. Nevertheless, at one time they had the largest private collection of Picassos in the world. More impressive than the sheer quantity of their holdings were the historical importance and quality of so many of the paintings. Theirs was a collection of masterpieces—many of them difficult ones. Victor and Sally agreed with André Breton's definition of a good painting—that it should have "an exceptional ability to shock." They preferred paintings that challenged them and—in the early years of their marriage, at least—horrified their friends. ("Please don't seat me opposite

that painting," guests used to say about *The Dream*.)

Fortunately the Ganzes had the courage and discrimination to live up to their ideals and, time and again, to go after the huge, provocative, barely affordable painting. The strength of the collection is all the more amazing, given that the Ganzes' resources were modest in comparison with those of most other collectors in their field. Major acquisitions meant they had to sacrifice appurtenances—a weekend house, for instance—that their friends took for granted. "There goes my winter coat," Sally said to me with rueful pride after one particularly extravagant purchase, "I'll just have to tighten the belt on the old one."

The Ganzes' involvement with Picasso started in

Pablo Picasso, *The Dream* (1932), detail

27

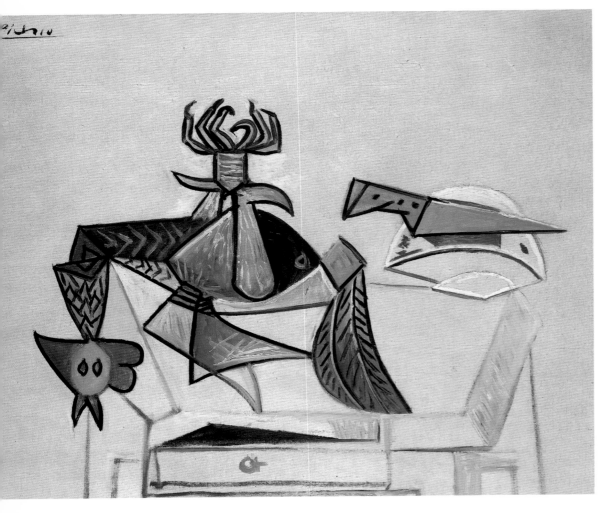

One Saturday, when they were doing the rounds of the New York galleries, they went into Paul Rosenberg's and saw a painting that "just absolutely magnetized you. . . . Very, very beautiful." It was *The Dream*. They asked Rosenberg if it was for sale. "Unfortunately, I don't own it," he said. "It belongs to a woman named Meric Callery. Have you ever heard of her?" They hadn't.

Meric Callery was a sculptor (remembered today for her gilded abstraction crowning the proscenium arch at the Metropolitan Opera). After divorcing Frederick Coudert, a Republican congressman, Callery had married Carlo Frua di Angeli, an enlightened Italian industrialist, renowned for forming a vast Picasso collection and for financing Christian Zervos, publisher of Picasso's catalogue raisonné and *Cahiers d'Art*, the leading avant-garde art magazine. Hence Callery's friendship with Picasso, who did a drawing of the back of her long neck and well-groomed head. After the outbreak of World War II, she had rolled up a number of Braques and Picassos, among them *The Dream*, and returned, alone, to New York.

Victor wasted no time tracking Callery down and telephoning her. Sally has described how she received them in her carriage house. Sally admired the same feature that had attracted Picasso: the way her hair was pulled back above the nape of her beautiful, long neck. Callery showed them her Picassos—all major works. Besides *The Dream*, they admired the great Cubist *Bather* of 1908–09. Sally preferred the more "difficult" *Bather*, but Victor prevailed and they bought *The Dream* for $7,000—"an

August 1941, when Victor and Sally, who had not yet married, were overwhelmed by their first sight of *The Dream* (1932). The purchase of this masterpiece, Victor told me, was the second of three interrelated events that occurred in the course of his twenty-eighth year and that would change his life. Shortly before acquiring *The Dream*, he had embarked on analysis; shortly after acquiring it, he married Sally Wile, whom he had been courting for the previous seven years. They were a perfect match, both extremely intelligent, cultivated, and public spirited. Sally's outgoing warmth, inner strength, and spontaneity were the right foil for Victor's cerebral coolness and intimate complexity, which his charm and diffidence usually concealed.

In taped interviews with Dodie Kazanjian, Sally has described how she and Victor came to buy *The Dream*.

Picasso, *Cock and Knife* (1947)

Picasso, *Still Life with Sausage* (1941), detail

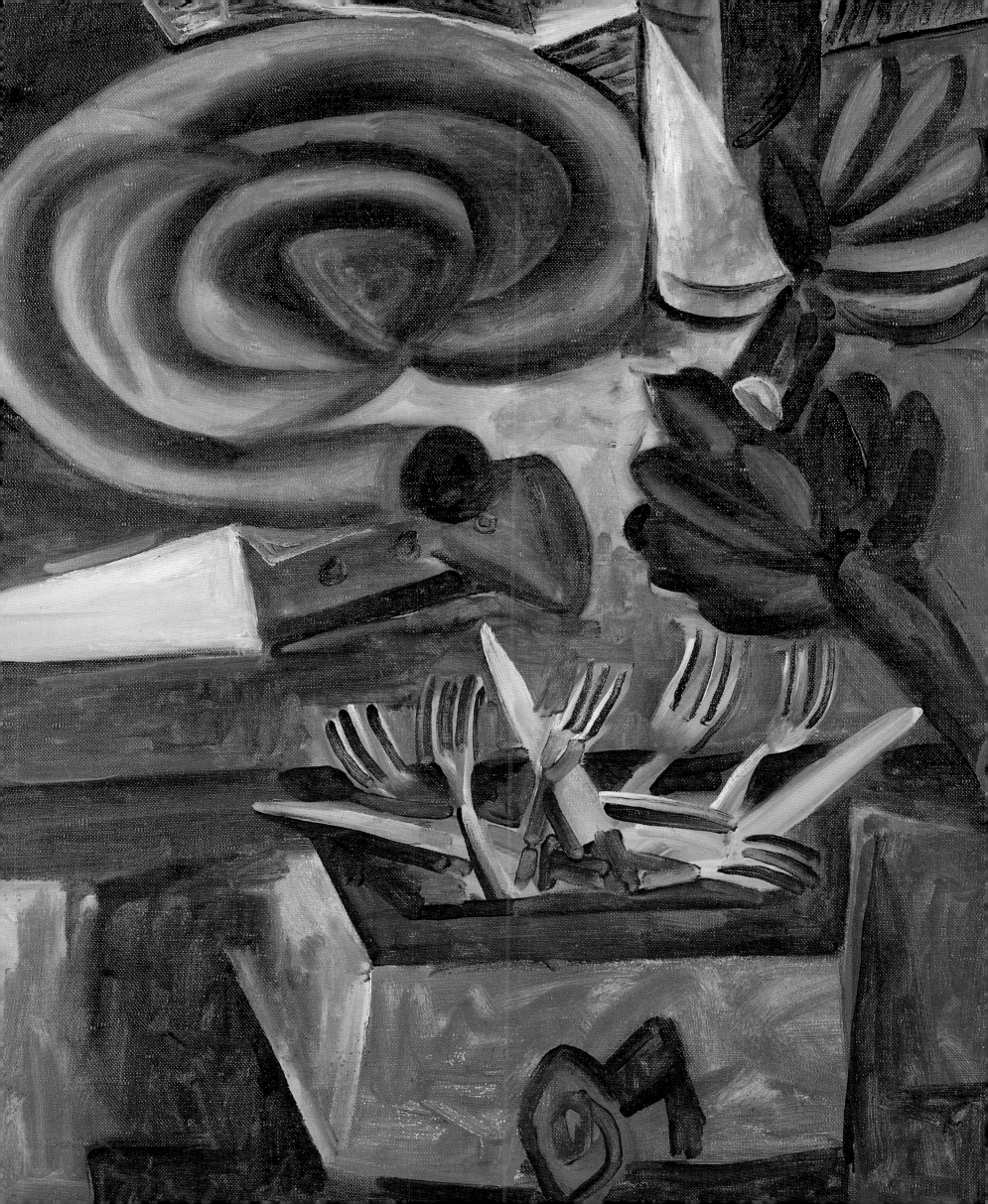

enormous amount of money in those days. . . . Victor's salary wasn't all that great." Victor and Sally were married some months later. Subsequently the Ganzes became friends with Callery and, after the war, dined with her on their visits to Paris. Besides Picasso, she had known Matisse and had once lent him her studio. Which of the two artists do you think is the greater? Victor once asked her. Callery thought for a minute and then said, "But Victor, *Victor*, Matisse never went to the dance."

Picasso had painted *The Dream* on Sunday, January 24, 1932, in Paris. It is perhaps the most lyrical and also the most covertly erotic image of the voluptuous Marie-Thérèse Walter, whom he had picked up outside the Galeries Lafayette in 1925, when she was sixteen. (The artist always maintained that this had happened in 1927, when she would have been eighteen.) As Marie-Thérèse was underage she had to be kept hidden from the authorities as well as from his jealous wife, Olga Khokhlova; hence references to her are almost all in code. Marie-Thérèse figures as a monogram, a musical instrument, a piece of sculpture, a bowl of fruit. But after she turned twenty-one in 1930, Picasso set her up in an apartment next to his and used her as the model for virtually all the women in his work of the early 1930s.

Marie-Thérèse was a passive, easygoing girl who liked to sleep, read, swim, play on the beach, and make love. Picasso would characterize her as *la dormeuse* ("the sleeper"), just as he would characterize her successor Dora Maar as *la pleureuse* ("the weeper"). He came to see this part-French, part-German, part-Swedish girl as a kind of Nordic fertility goddess. This concept inspired a series of monumental sculptures, each with a protruding nose like a penis and protruding cheeks like a backside. In *The Dream,* Picasso uses the same visual puns: he portrays Marie-Thérèse in double profile, her face cleft suggestively

in two. The upper profile is discreetly phallic: sex is literally on the dreamer's mind. This is what gives this seemingly lyrical image its erotic charge.

The Dream was the apple of Victor's eye as well as Sally's, and if they had acceded to all the requests for it, the painting would have been constantly off their walls, so they made it available only to major retrospectives. And yet somehow its fame spread. What neither the Ganzes, nor the artist, nor the artist's heirs had any power to control was the spate of unauthorized reproductions that ensued. Someone gave Sally a handkerchief from Japan embossed with *The Dream.* It has also been used in TV commercials to promote all manner of unworthy products. And so, for better or worse, this great painting has become one of Picasso's most celebrated icons. Amazingly, the surfeit of

Picasso, Study for *Les Desmoiselles d'Avignon* (1907)

great man passed the shop en route to his Vallauris studio. Next morning, they drove over and waited at a neighboring café. Sure enough, Picasso appeared; the bookseller asked him into his shop; the Ganzes followed suit and were introduced. Picasso was extraordinarily intuitive in his reactions to people. Without knowing that they owned a painting by him, he told them to get into their car and follow him to Vallauris so that he could show them his pottery. Eventually they told him that they were the proud possessors of *The Dream*. The fact that they had not used their ownership of the painting as an open sesame delighted him.

As was his way, Picasso flirted with Sally, who was "in a sort of rosy glow." "When he fixed his head lamps on you," she said, "you felt it." Victor likewise fell under the artist's spell. His own father had been weak—at least in comparison with his strong, "peppy" mother—and as a result of this epiphany of a meeting, he would henceforth admit to adopting Picasso as a father figure. Sally's crush on the artist was less filial. For his part, Picasso came to have the highest regard for the Ganzes; he was amazed by their

exposure has not affected its power to enchant or excite or seduce us into a trance of Picassian voyeurism.

Two years after buying *The Dream*, Victor acquired a couple of fine Picasso drawings, *The Family* and *Three Women*, both of 1938, which had also belonged to Callery. This time, however, he did not buy them directly from her but through an intermediary, the Valentine Gallery.

After the war was over, the Ganzes decided to go and meet "the genius who had painted *The Dream*." Trust them to do this on their own without recourse to intermediaries. While staying at Monte Carlo in April 1948, they drove over to Golfe-Juan to reconnoiter. In the Kazanjian tapes Sally describes how they made friends with a bookseller who lived next door to Picasso. The bookseller told them that every morning around nine the

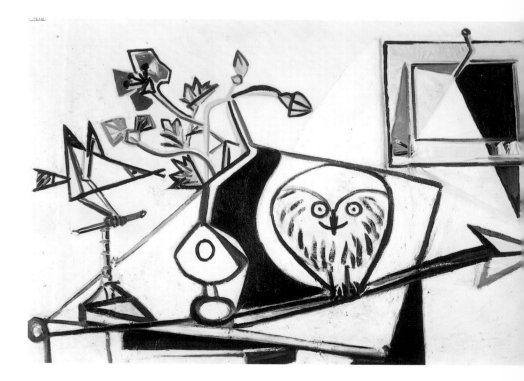

Picasso, *Concierge's Daughter with Doll* (1947)

Picasso, *Owl and Arrow* (1945–46)

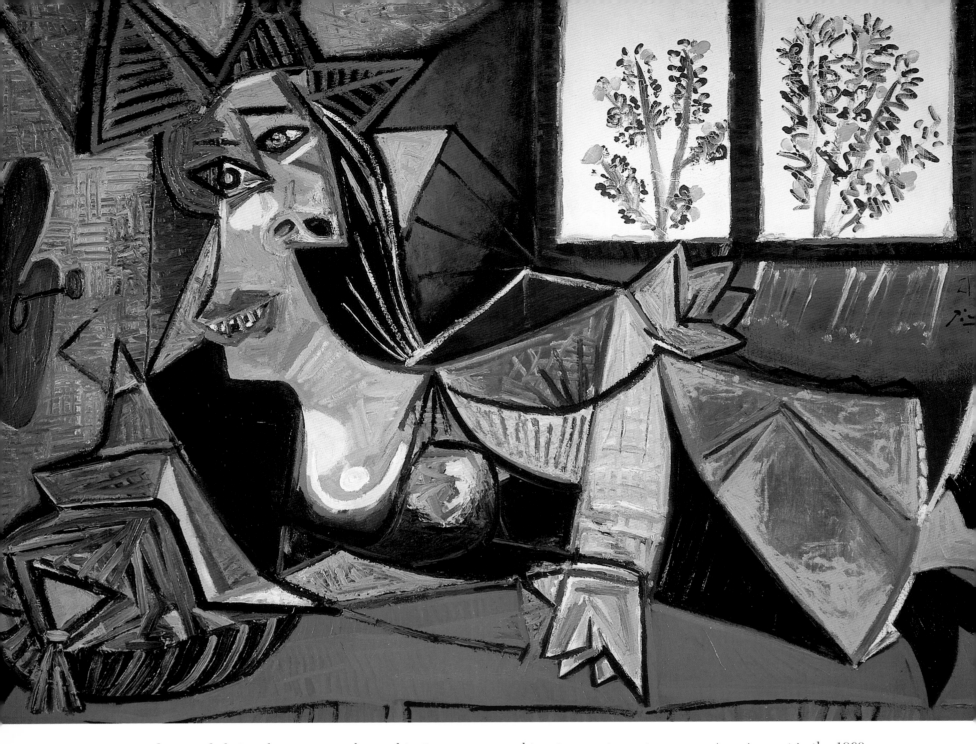

modesty and their reluctance to take up his time, even when he begged them to return. On taking leave of them, he said something that their driver had to translate: "I like you very much because there are very few people who come here and don't want anything from me. And you didn't ask for anything. You never asked." Although the Ganzes did not visit him again for another twenty-two years, Picasso always enquired about them. "*Et les Ganz! What have they bought now?*" He was always amazed at their courage, their taste for large, tough paintings—and so many of them. "Aren't they running out of wall space?" he once asked. I never dared let on when Victor switched

his patronage to contemporary American art in the 1960s.

After *The Dream*, Victor did not buy a second Picasso painting for another seven years. "I had no intention of becoming a collector," he said. In the meantime he had developed a taste for the more challenging imagery advocated by Breton and the Surrealists. *Still Life with Sausage*, which he bought for $5,000 in February 1948 from Picasso's New York representative, Curt Valentin (Bucholz Gallery), was painted on May 10, 1941—one of the darkest periods of World War II. Hence the grisaille and the somber Spanish overtones. Picasso said he wanted to evoke the penitential gloom and austerity of Philip II's

Picasso, *Woman on a Red Couch* (1939)

life in the Escorial. He compared the twisted knives and forks in the open drawer to souls in purgatory crying out for mercy. Wartime shortages are reflected in the meager, unappetizing look of the food: the dried-up segment of Camembert, the sinister, rubbery coil of blood sausage. If the artichokes look menacing, it is because Picasso lifted them from Giorgio de Chirico: specifically from two "Metaphysical" still lifes with artichokes in the collection of the Vicomte and Vicomtesse de Noailles, friends of his so-called Duchess period, whom he continued to see during the war. Echoes of de Chirico give this painting an eerie Surrealist resonance.

A year after buying *Still Life with Sausage*, Victor acquired yet another highly charged still life, *Cock and Knife*, dated March 21, 1947. This came from Samuel Kootz, the New York dealer to whom Picasso sold the occasional painting in the hope—ultimately fulfilled—of squeezing higher prices out of his principal dealer, Daniel Henry Kahnweiler. Kootz got the present painting out of Picasso by giving him a white Oldsmobile convertible. The dealer had paid around $1,750 for the motorcar. Victor paid $5,000 for the painting. *Cock and Knife* appealed to Victor's preference for daunting subjects. On one level it is about the chopping, cutting, and killing that cookery entails; on another it is about ritual sacrifice; on yet another it refers to the famous mystical axiom— "Whatsoever is below is like that which is above as all things are made from one" (attributed to the legendary Hermes Trismegistos)—which Picasso had drawn on many years earlier. This axiom is embodied in the contrast between the almost severed, downward-drooping head and the upward-thrusting claws; also in the way Picasso has painted these trussed claws as if they are the roots of a leek reaching paradoxically heavenward. I am not being fanciful. Picasso himself admitted that the leeks in his wartime still lifes were a pun on crossbones.

In February 1950, Victor bought a fine watercolor study for *Les Demoiselles d'Avignon* (1907) at auction for just under $500—the earliest Picasso he would ever own. In May he returned to Kootz and bought yet another $5,000 painting, *Owl and Arrow* (dated June 7, 1945 and November 23, 1946). In this at first sight puzzling composition a quizzical owl is perched on a huge arrow and played off against a vase of arrow-shaped flowers and a small stuffed, similarly arrowlike bird. According to Lydia Gasman, the leading authority on Picasso's use of symbols, owls refer either to Picasso or mortality. Arrows symbolize fascism (a large red arrow was the symbol of the Spanish Falange). Picasso, who had become a Communist in October 1944, seems to be saying that the defeat of Nazism had not brought about the defeat of Spanish fascism. Later in the year, Victor went back again to Kootz and spent $4,000 on a painting, described in Françoise Gilot's memoirs as "a small, very graphic portrait of the daughter of the concierge" at Picasso's rue des Grands-Augustins studio.

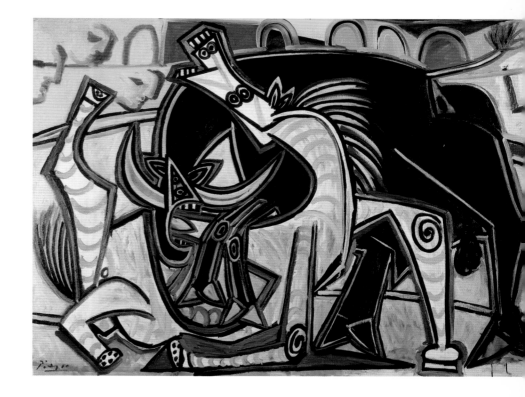

Picasso, *Bullfight* (1934)

(In fact, at 36½" x 28½", *Concierge's Daughter with Doll* is not all that small.) In 1963 Victor would deaccession these two paintings. In exchange, Klaus Perls would let him have the magnificent *Cat and Bird* (1939).

Victor always denied being a collector, but it was difficult for him to go on doing so after acquiring three superb Picassos in 1952: *Sailor* (1943), *Woman on a Red Couch* (1939), and *Bullfight* (1934). *Sailor*, which he bought from the publisher Harry Abrams for $11,000, was the only male image by Picasso in the Ganz collection. Victor believed it to be a self-portrait. This is true to the extent that the artist usually wore a striped vest as an undershirt and that he once said that all the men in his work are to some degree self-portraits (he also said that all the men in his work are to some degree his father). In fact, this *Sailor* and some related sketches done a few days earlier hark back to drawings and paintings of a young man in a striped shirt done at Mougins in 1938 and at Royan in 1939. If Picasso reverted to this Mediterranean subject in the middle of the war, it would have been out of a desperate yearning to be back on the shores of his native sea. Picasso told me that when he felt something was missing from his life—on a Sunday it might be a bullfight; in the winter the sun of the *Midi*—he would console himself by summoning it up on paper or canvas. Penned up in the prison of occupied Paris in a cold, wet October, six weeks after being ordered to report to the Nazis for deportation to Germany (as Gertje Utley has recently published)—an order that was in the end not enforced— Picasso would desperately have needed to raise his spirits. And who better to invoke the sunlight and serenity of the Mediterranean than this man of the south—like himself? *Sailor* is surely an attempt to exorcise the hateful Germans.

The next Picasso that Victor bought is one of the most powerful images of the artist's beautiful, tortured mistress, Dora Maar. She is portrayed reclining on a red, cushioned sofa wearing one of the *outré* hats she favored. This painting is of considerable iconographic importance in that, on the very same day (January 21, 1939), Picasso painted a pendant, identical in size, format, and composition, of Marie-Thérèse Walter, his mistress of the previous ten years, whom Dora had to some extent supplanted. For all their similarities, the paintings are utterly different in morphology. The sharp, jagged forms and zigzag facial dislocations Picasso devised for the dramatic Dora are in marked contrast to the soft, curvilinear ones he devised for the voluptuous Marie-Thérèse.

To understand why Picasso should have wanted to make pictorial distinctions between these very different women—the dazzling Surrealist photographer whom he loved but found "frightening," and the uneducated blonde beauty whose warmth and sexuality inspired his most ecstatically libidinous images, but whose lack of intellect and style sometimes irritated him—we should realize that he was under enormous pressure. The winter of 1938–39 had been a traumatic one. An agonizing attack of sciatica had kept him in bed, and then on January 13, his ever supportive mother had died in Barcelona. Because of the Spanish Civil War, her dutiful but somewhat distant son was unable to go to her deathbed or funeral. Only slightly less upsetting, that city which Picasso had come to regard as his hometown was about to fall to Franco's fascist forces. In the past, Picasso had always taken the woman in his life to Barcelona to meet his mother. He had not been able to do this with Marie-Thérèse or Dora Maar. Out of Spanish convention and superstition he may well have felt impelled to introduce these two women to his mother, as it were, in death. Both canvases are dated January 21, 1939, but that does not necessarily mean that they were done the same day;

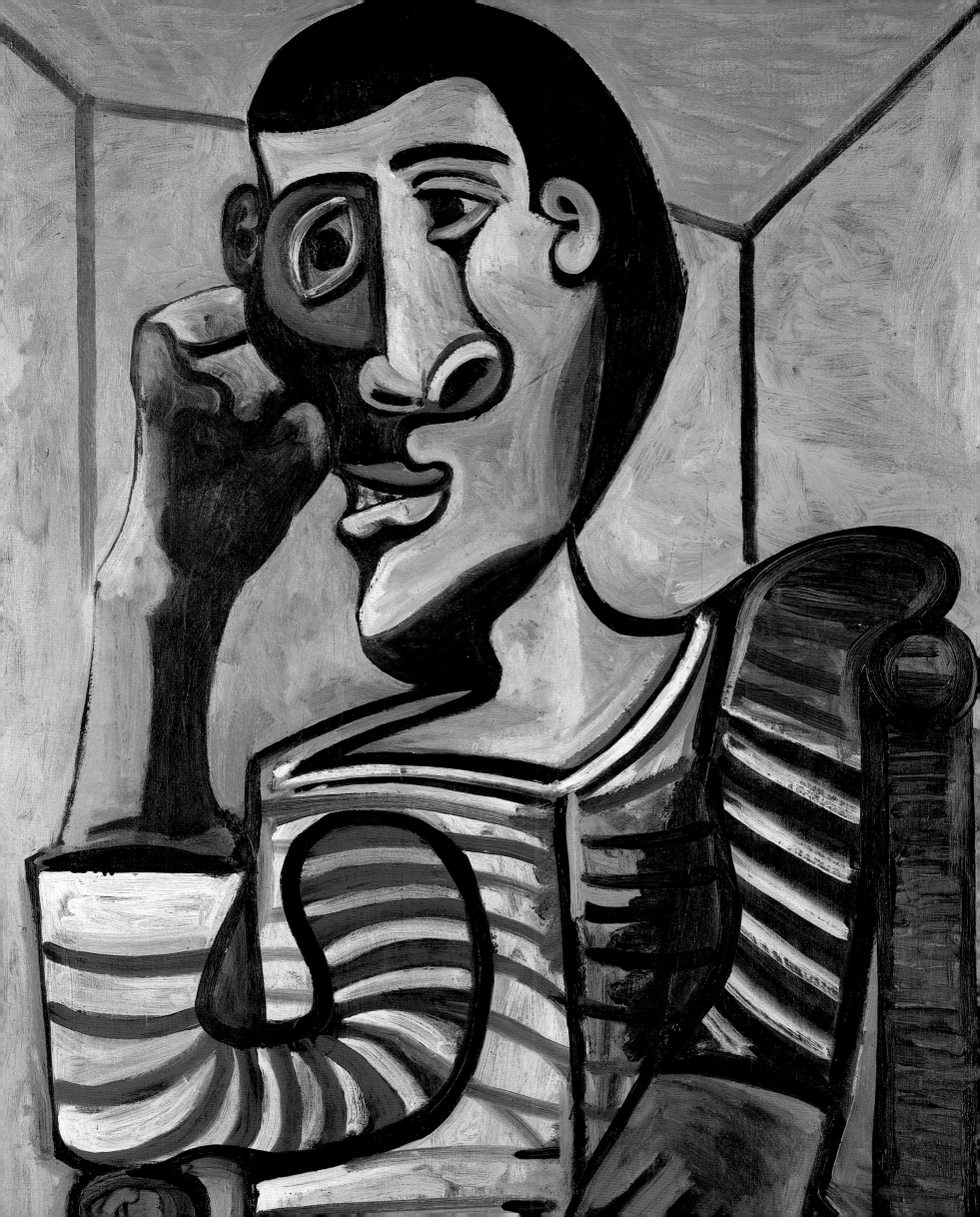

Picasso, *Winter Landscape* (1950)

the Dora Maar in particular is much too heavily worked.

These portraits were executed at Ambroise Vollard's country house at Tremblay-sur-Mauldre, where Picasso would spend weekends with Marie-Thérèse and their two-year-old daughter, Maya. Dora would not have been aware of these revelatory paintings. Marie-Thérèse, on the other hand, would have seen them and been able to conclude from the contrast between the images that her lover felt more tenderness and desire for his *dormeuse* than he did for her rival, the high-strung, high-style Dora. However, tenderness does not necessarily bring out Picasso's greatest strengths. His sadistic love for Dora—his obsessive exploitation of her tears—has made for much the more powerful image. As Victor once pointed out, a Picasso collector cannot avoid getting caught up in the toils of the artist's personal life.

Like the Dora Maar painting, *Bullfight* had belonged to Meric Callery's husband, Carlo Frua di Angeli. There is very little documentation in the Ganz files about either of these works, but Victor appears to have acquired both of them through Klaus Perls, who was acting on behalf of Angeli's representative, the Lucerne dealer Maurice d'Arquian. *Bullfight* is yet another example of the Ganzes' preference for challenging subjects. The bull has not just gored the horse; it has disemboweled it, under the eyes of Marie-Thérèse look-alikes painted red and yellow—the colors of Spain.

This *Bullfight* is one of the larger and more powerful works in a self-referential sequence of gory paintings and even gorier drawings of tauromachic subjects, which Picasso worked on between June and September 1934. In the earlier images the artist identifies with a Minotaur, who ravishes a submissive and abandoned Marie-Thérèse. Later, as in this painting, he identifies with the pain-maddened bull who rips into a picador's horse—a surrogate, he suggested, for his

malevolently jealous wife. As a rule Picasso's bullfight scenes postdate a visit to the bullring or turn out to have been done on a Sunday, when there was no corrida to go to. These 1934 images are unusual in that they predate the real thing. In the course of doing them, the artist developed such nostalgia for the bullring that in late August he embarked on a tauromachic pilgrimage to San Sebastian, Burgos, Toledo, Madrid, and Barcelona. If he took his wife and son Paulo along, it was because he wanted to share his *afición* with his son, just as his father had done with him. This would be the last trip the family took together.

Hitherto, Victor had bought only one painting from Kahnweiler's New York representative, Curt Valentin; however, he had made a point of cultivating him in order to know whenever Picasso released a fresh consignment of work. The relationship paid off. In March 1953 Valentin came up with photographs of Kahnweiler's latest acquisitions. Victor immediately (March 21) made an offer through Valentin for two of the best of them: the powerful panel painting *Winter Landscape* (December 22, 1950)—to my mind the finest of all Picasso's later landscapes—and the no less powerful *Portrait of a Painter after El Greco*, also of 1950 and on panel. Knowing Victor to be a hard bargainer, Valentin assured Kahnweiler that his client would not pay a penny more than $21,000 for the two paintings. "If necessary [Valentin wrote] I will take a little less than my usual discount." Kahnweiler, who had been trained as a banker, almost never lowered his prices, but he seems to have realized the importance of establishing a good relationship with this voracious young Picasso collector. And, sure enough, Victor got the *Winter Landscape* at his price of $12,000—over a million francs less than the five-and-a-half-million that Kahnweiler had asked. But Kahnweiler was not prepared to let *Portrait of a Painter after El Greco* go so cheaply, and Victor lost it to

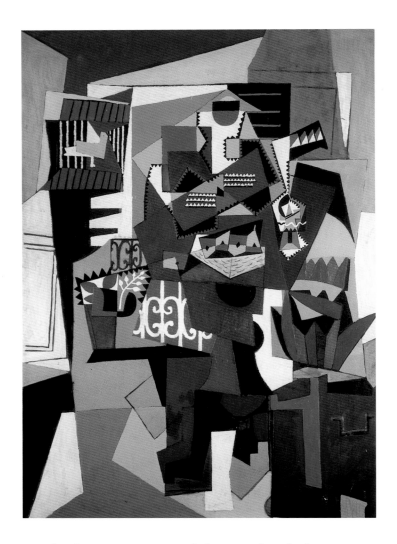

Siegfried Rosengart, one of the very few dealers Picasso respected. He kept it for his private collection.

That Kahnweiler accepted Victor's low offer for *Winter Landscape* is only slightly less surprising than Picasso's decision to sell this painting, which he cherished to the extent of refusing to relinquish it to Matisse. In her memoirs Françoise Gilot describes how this had come about: Picasso had taken some of his recent paintings to show Matisse, who was sick and confined to his room; he had placed *Winter Landscape* on the mantelpiece "so that Matisse could see it well from his bed;" whereupon "Matisse was struck, as if by lightning." Since his revered rival was so smitten with the work, Picasso decided to leave it with him for a few weeks—a decision he instantly regretted. Two months later, Picasso went back to see

Matisse and was even more dismayed when Matisse proposed keeping the landscape in exchange for one of his own paintings. How could Picasso, who set great store by this particular work, extricate himself from this embarrassing situation without giving offense? On a subsequent visit, Matisse solved the problem for him by hanging the four most brilliant cut-paper chasubles he had done for his chapel around Picasso's somber, Grecoesque landscape. "[The effect] took your breath away," Gilot says. "There was a moment of silence in the room." After this confrontation, talk of an exchange died down. ". . . Matisse never proposed a specific painting of his as a match for it. Matisse and Picasso had jousted, and no one had been found wanting." When the painting had to be photographed for an art journal, Matisse sent it back.

Why then did Picasso turn round and sell *Winter Landscape* to Kahnweiler? I suspect it was out of superstition. According to Gilot, this wintry rendering of the meridional scene, painted three days before Christmas but conspicuously lacking in any traditional Christmas spirit, is an allegory of mortality. Usually the artist divested himself of anything to do with death. Putting this ominous painting on the market could well have been exorcistic—like throwing a highly charged fetish into a stream.

In 1953 Victor continued to splurge. In September he paid Paul Rosenberg $30,000—more money than he had ever spent before—for *Bird Cage* of 1923. Larger, earlier, and more worked over than any of Victor's previous Picassos, *Bird Cage* is one of the last and most ornate and colorful in a series of monumental still lifes set on a gueridon (a pedestal table) in front of an open window. This series, which enabled the artist to play indoor space off against outdoor space in a variety of ingenious ways, harks back six or seven years to the last phase of Synthetic Cubism. So numerous were the variations that Picasso's

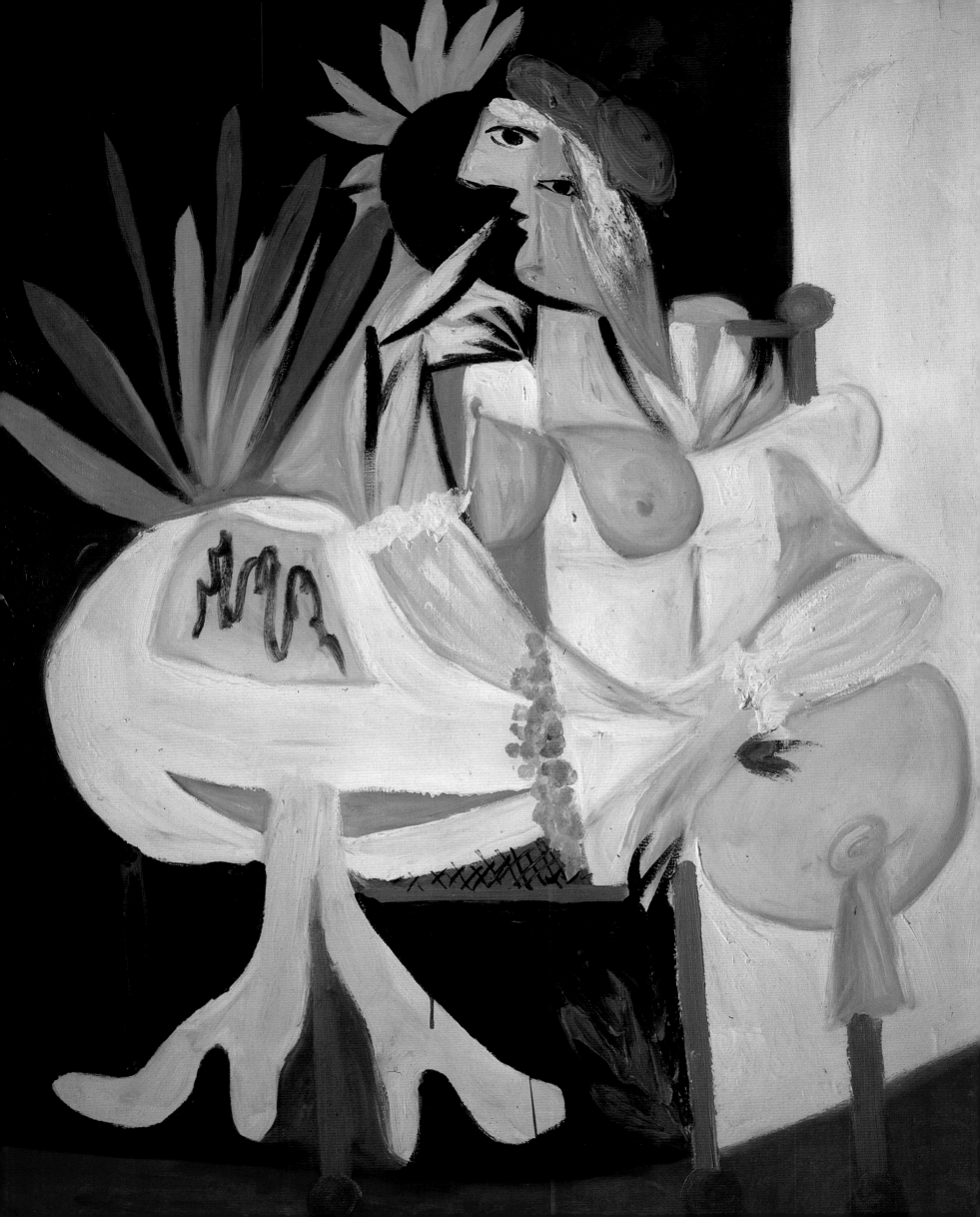

Besides the eponymous birdcage (top left of the 1923 painting) and the ubiquitous fruit dish, glass, and guitar, Picasso has included a mahogany jardinière with a handle on the side, a spiky-leaved plant emerging from it (bottom right), and a glimpse of shutters and ornate balcony railings. *Bird Cage* was a prestigious addition to Victor's collection; it also turned out to have been a brilliant investment, as it sold for $15.4 million in 1988. However, of all Victor's major Picassos, it is the only one to lack the stamp of the artist's quirkish flair and daring.

After the major purchases he made in 1952 and 1953, Victor slowed down. At the very end of 1953, he bought his first Picasso sculpture from Curt Valentin: one of two painted bronze casts of an owl, which the artist had pieced together, earlier in the year, out of odds and ends lying around the studio.

In 1954, Victor limited himself to a single large painting, *Woman in a Red Hat* (dated September 18, 1934), which he bought from Paul Rosenberg. Unlike *The Dream* of two years earlier, this image of Marie-Thérèse has a somewhat parodic look, thanks to the beret—a badge of girlishness that often identifies her in Picasso's work—as well as the winsome finger up to her mouth and the bizarre articulation of her body. Might Picasso have been poking fun at Matisse's orientalism? This would explain the luscious color and Marie-Thérèse's stilted odalisquelike pose, clutching a bouquet of mauve flowers as she reclines against a tasseled bolster on a chaise longue. The way her

then dealer, Paul Rosenberg, devoted a large exhibition to them in April 1924. Smaller versions of the subject usually turn out to have been painted during the summers that Picasso spent in hotel bedrooms looking out over the Mediterranean. Larger versions like *Bird Cage* were done back in Paris and include elements that we know from photographs of the salon in his rue La Boétie apartment.

Picasso, *Seated Woman* (1946)

white-stockinged legs and high-heeled white shoes mimic the legs of a table is a pictorial pun that dates back to Cubist figure studies of 1913–14. As for the sheet of paper on her knee with black squiggles on it, Marie-Thérèse is either writing a letter or doing a drawing, as most of the artist's mistresses tried at one time or another to do. These squiggles might also have related to the willfully childlike formulation of her meringue-shaped skirt. What appear to be studies for the painting were in fact done ten or eleven days later and confirm the artist's continuing preoccupation with the Cubist problem of portraying a figure as both vertical and horizontal. Trust Victor's sharp, subversive eye to detect the exceptional qualities of this mocking jeu d'esprit.

There were no additions to the Ganz collection in 1955, but in 1956 Victor started buying again. On May 2, he bought a hieratic *Seated Woman* (May 28, 1946)—a likeness of Françoise Gilot—for $19,500 from Kootz, who had managed to wheedle a further group of pictures out of Picasso. Shortly before this work was painted, Françoise had finally given in to the artist and moved into his rue des Grands-Augustins studio, whereupon he had begun his most famous portrait of her: the full-length, whittled-down image known as *Woman-Flower*, which he finished on May 5. Three weeks later, he embarked on this painting, using some of the same devices that Gilot describes him using in *Woman-Flower*. "Even though you have a fairly long oval face," Picasso had told her, "what I need, in order to show its light and its expression, is to make it a wide oval. . . . It will be like a little blue moon." The only posing she did for Picasso, Gilot writes, took place before he had even started to paint her. He had made her strip and stand very erect, arms at her side, for over an hour. "His eyes didn't leave me for a second. He didn't touch his drawing pad; he wasn't even holding a pencil. It seemed like a very long time. Finally he said, 'I

see what I need to do. You can dress now. You won't have to pose again.' " And she never did.

This painting envisions Françoise as a crouching sphinx with huge hooves for hands. Large, leafy flanges of hair are the only references to her former flowerdom. She is much more formidable as a sphinx than as a plant. Picasso seems already to have realized that this was not a woman he could manipulate as he had manipulated Olga, Marie-Thérèse, and Dora. After finishing this painting, he did a succession of eleven lithographs in which he transforms Françoise's disc of a face from a moon into a sun. The sun did not shine for long. After she left him in September 1953, he put several likenesses of her on the market.

Nineteen-fifty-six was Victor's annus mirabilis. In June he brought off his greatest coup as a collector. He purchased the entire set of fifteen variations on the theme of Delacroix's *Women of Algiers* (after the version in the Louvre as well as the later one in the Musée Fabre at Montpellier). Picasso had completed them six months earlier. Victor had set his heart on buying a painting or two from this series, after seeing it (minus one canvas, which the artist had kept) at the great retrospective at the Musée des Arts Décoratifs in Paris in June 1955. Ironically, this belated tribute to Picasso on the part of France's Musées Nationaux had been organized by a dealer, Kahnweiler's associate Maurice Jardot, rather than by a museum curator.

The *Women of Algiers* variations constituted the principal revelation as well as the grand finale of this retrospective. The series announced a new stylistic departure, also the arrival of a new woman in Picasso's life, Jacqueline Roque, who would become his second wife. On the strength of her resemblance to the squatting woman in white on the right of the Louvre's Delacroix, Jacqueline had inspired these variations. Picasso was tickled by the fact that Jacqueline had formerly been married to an

engineer in the colonial service in the Upper Volta (now called Burkina Faso). "Ougadougou may not be Algiers," he remarked, "but Jacqueline has an African provenance." Picasso may also have known about the man who had granted Delacroix the rare privilege, for an infidel, of entry into his harem to sketch his three wives: he was an engineer, albeit a Muslim one, like Jacqueline's husband.

Besides being a tribute to the new mistress, the *Women of Algiers* series was also a tribute to his old friend and rival, Matisse, who had died on November 3, 1954 (six weeks before Picasso started work on his versions). "I am going to carry on his work," he announced. "When Matisse died," Picasso told Roland Penrose, "he left me his odalisques as a legacy, and this series is my idea of the Orient although I have never been there." And to Douglas Cooper he observed that Matisse was the only artist since Delacroix to have exorcised the "picturesque sentimental-

ity that is the curse of most orientalism." Variation "E," for instance, includes a bright blue nude: a tribute to Matisse's famous *Blue Nude, Memory of Biskra*, which had left its mark on *Les Demoiselles d'Avignon*. Furthermore, as Susan Grace Galassi has pointed out, this same odalisque with her legs in the air is based on a Matisse lithograph: *Upside-down Nude with Stove* of 1929.

The Paris retrospective was important for the Ganzes in that it enabled them to see how the five major paintings they had lent to it measured up to the best of the artist's oeuvre. They measured up exceedingly well. The Ganzes also realized that by virtue of being the biggest private collectors of Picasso to have emerged on the postwar scene, they were now in a position to ask Kahnweiler to earmark specific pictures for them — one or two of the *Women of Algiers*, for instance. The dealer promised to do what he could.

After the show had closed in Paris and reopened in Munich, Victor followed up his initial inquiry with a request for information (November 7, 1955). Kahnweiler replied that nothing could be done until the exhibition had run its course (further stints at Cologne and Hamburg), at which time the pictures would be returned to the artist. On April 16, Victor wrote again to reconfirm his interest and to ask what other paintings might be available. Kahnweiler sent him three photographs—none of which were of interest—and once again counseled patience. And then on May 9, the dealer wrote that he was just back from seeing Picasso in Cannes and had bought all fifteen *Women of Algiers*. Picasso, he said, was adamant that they be sold en bloc. The price to Victor for all fifteen would be 80 million francs ($212,953). Kahnweiler ends his letter, "There is somebody else who wants to buy the whole set too; you asked me first so I tell you first, but I must know if you buy or not."

Picasso, *Two Ballet Dancers* (1919)

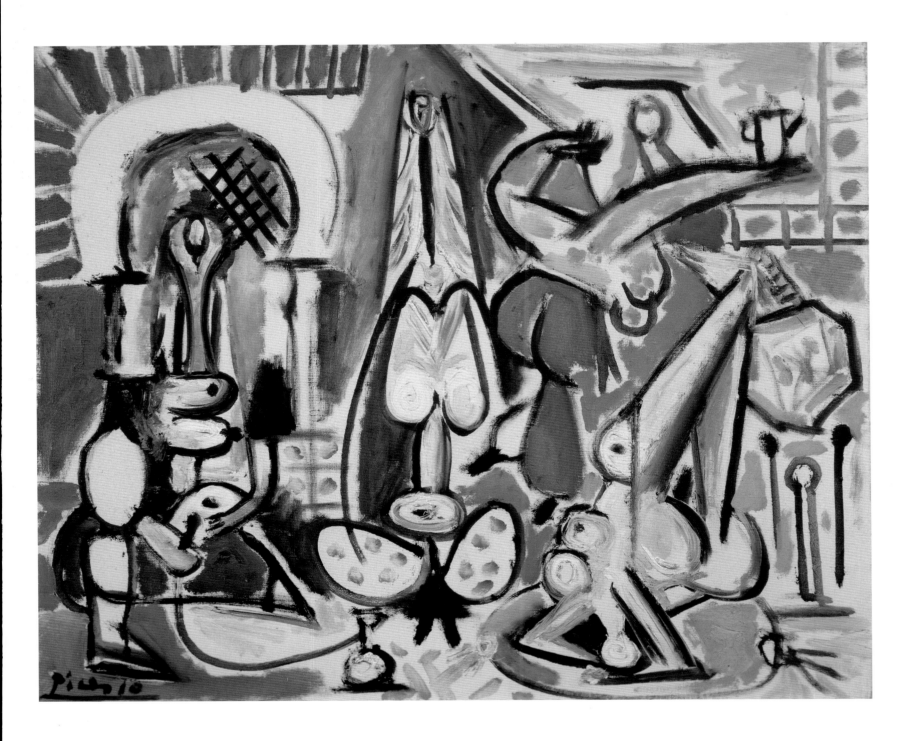

Picasso, *Women of Algiers "C"* (1954)

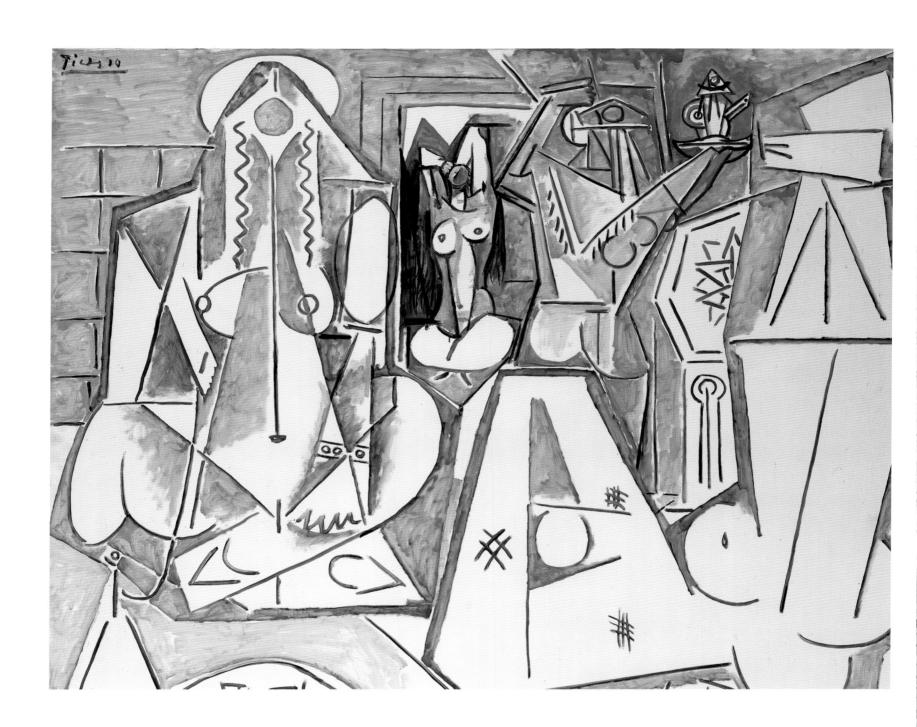

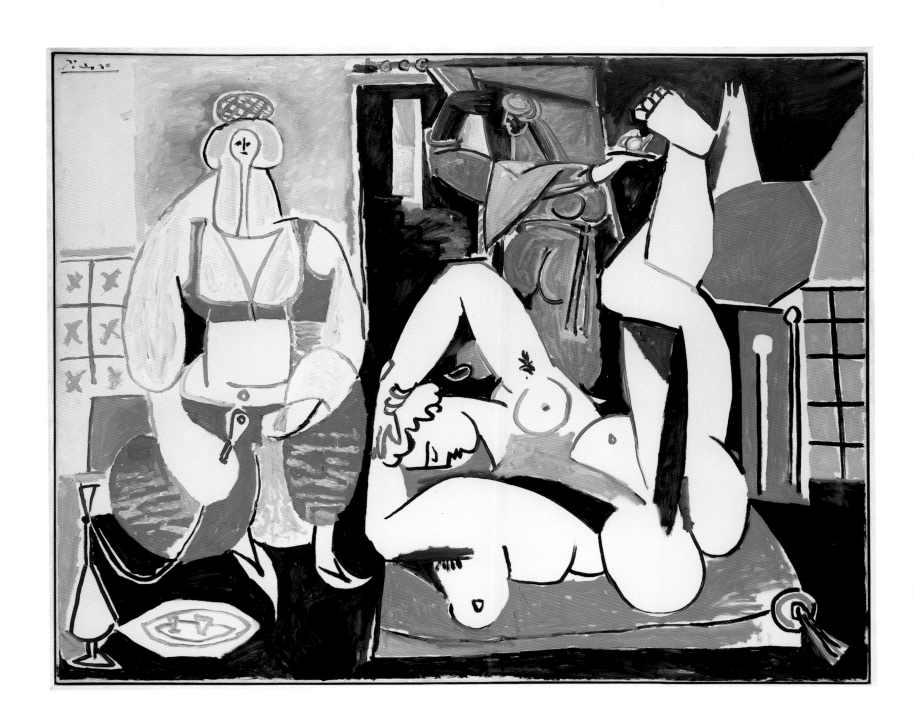

Preceding page: **Picasso,** *Women of Algiers* "C" (1954), detail

Left to right: **Picasso,** *Women of Algiers* "H" (1955); "K" (1955); "M" (1955); "O, final version" (1955)

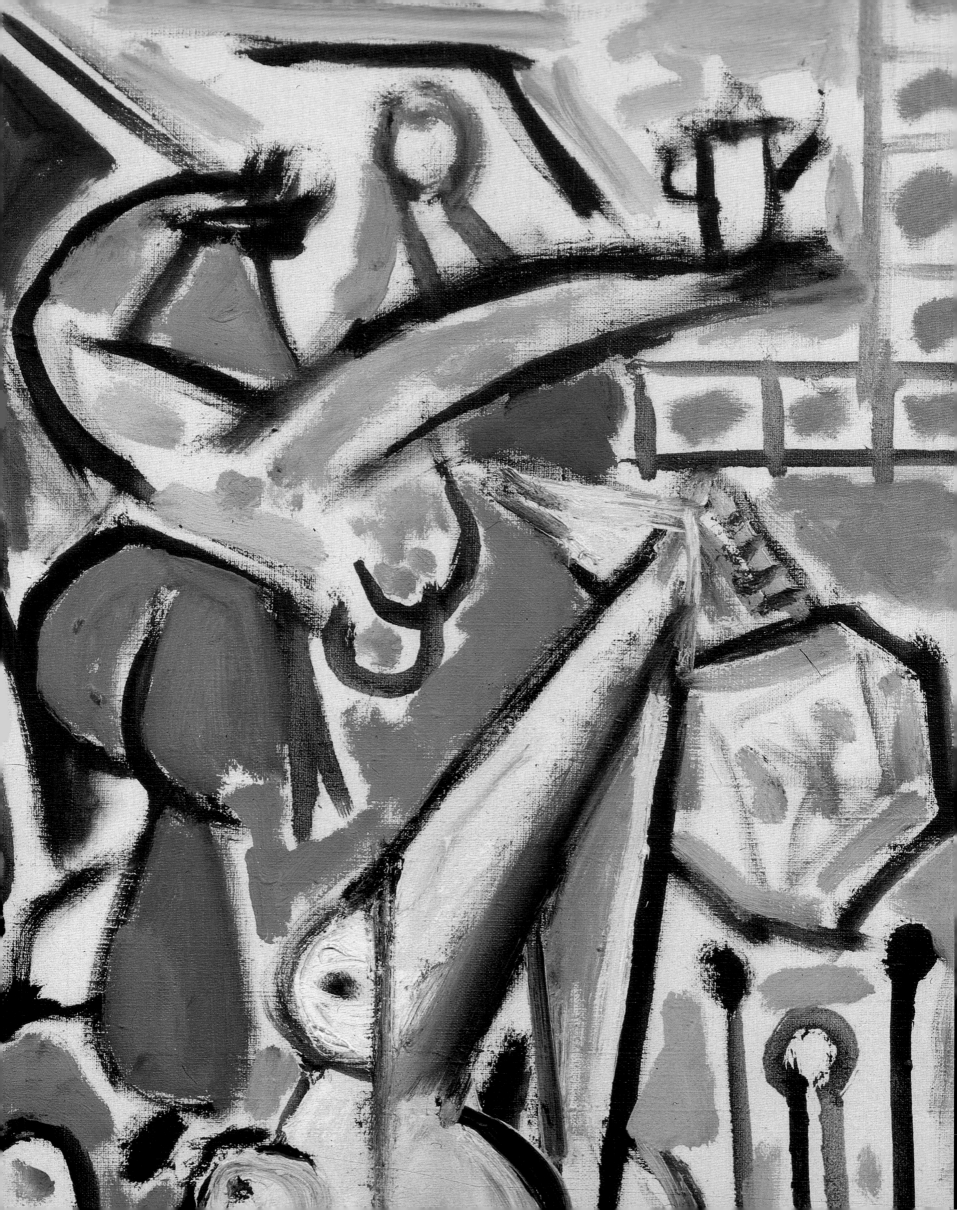

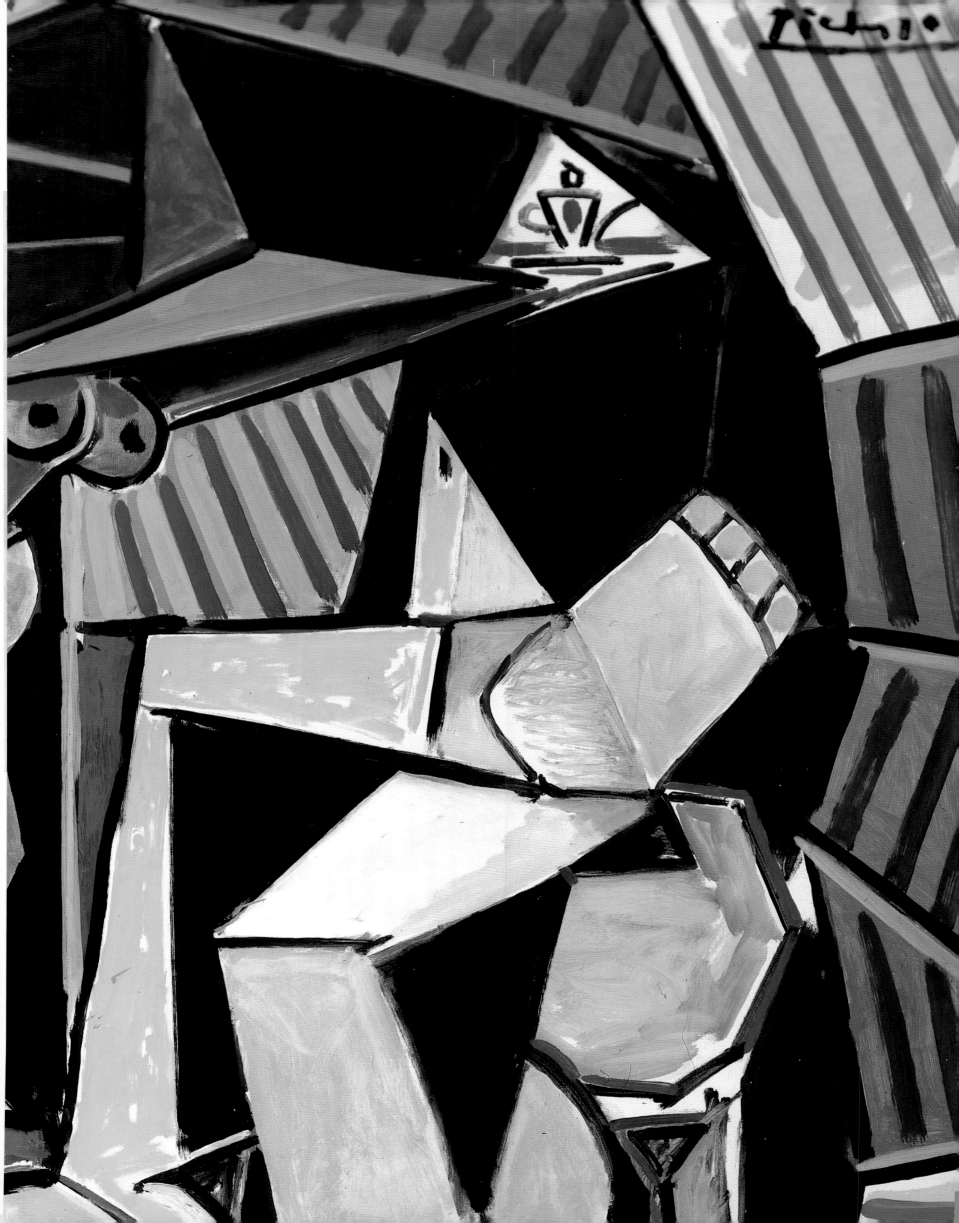

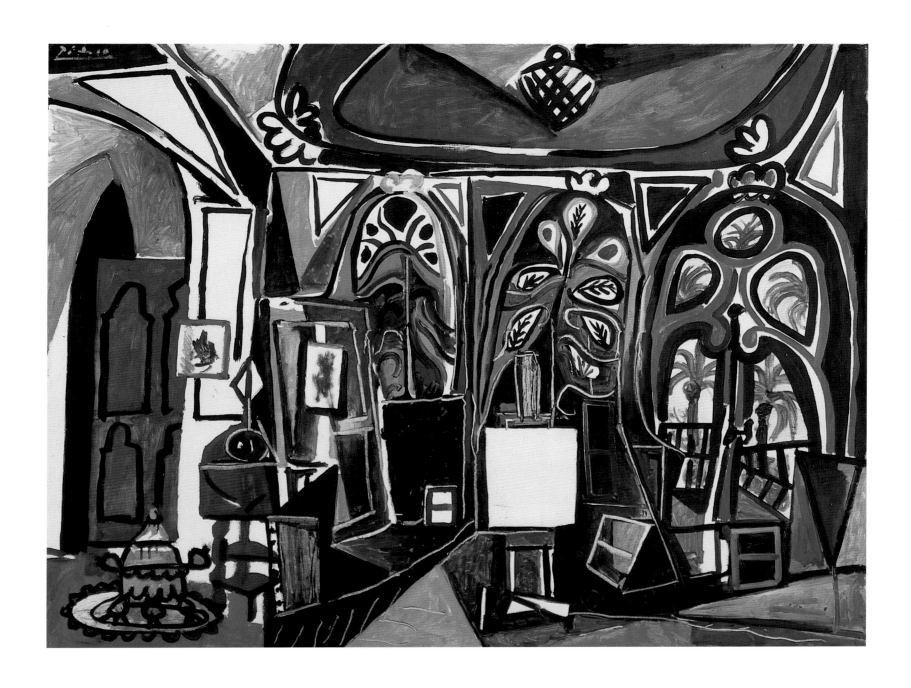

Picasso, *Studio* (1956)

The only trouble was that the Ganzes did not want all fifteen paintings. After serious thought, they decided that there was no way they could raise the money so they had better renege on the deal. Victor rehearsed what he was going to tell Kahnweiler the following day, but when he dictated his reply to his secretary, words failed him, and he found to his horror that he had said yes instead of no. He offered 70 million francs—to no avail. "Cheap price impossible," Kahnweiler cabled back and mailed his sales instructions: $100,000 to be paid at the official French rate of 350 francs to the dollar, and a separate check for $112,500 to be paid unofficially into the Swiss account of his old friend from Bern, Hermann Rupf.

Once the deal was settled, Kahnweiler wrote Victor ("Now, dear Mr. Ganz, let me ask you very simply something. . . .") that his New York representative, Eleanore Saidenberg (Curt Valentin had died the year before), had been next in line to buy the paintings and was very disappointed at losing them. Would Victor be so good as to lend her the paintings for an exhibition in the fall? He was happy to do so. That way he could take advantage of Kahnweiler's insistence that he buy the series en bloc. By putting the surplus paintings back on the market, Victor could recover a lot of his costs. This turned out to be a welcome bonus. The sheer scale of their purchases—as well as the installation of his *Women of Algiers* in a contemporary version of an orientalist room designed by Robsjohn Gibbings—was putting a considerable strain on the Ganzes resources. Years later, Victor asked Picasso why he had insisted on keeping the *Women of Algiers* together. "Nothing to do with me," he said. That had purely been Kahnweiler's sales ploy.

Victor proceeded to negotiate an agreement with Eleanore Saidenberg whereby she could exhibit the series at her gallery during December 1956 and January 1957,

and for a commission of 10 percent have the right to sell the ten paintings he was not keeping. Saidenberg purchased four of the smaller paintings (B, E, F, G) for a total of $37,000; Paul Rosenberg's gallery bought a more important group (A, D, I, J, L, N) for a total of $120,500. This meant that Victor's five paintings (C, H, K, M, O) cost him approximately $55,000. No question about it, Victor obtained the pick of the crop, including all three of the magnificent monochrome variations and the culminating canvas, "O." Rightly or wrongly, he later regretted having sold the penultimate variation, "N" (which now belongs to Washington University, St. Louis). Apropos of this painting, Picasso told me some years later that he usually preferred the first in a series, however sketchy, and then the one before the last. The only trouble with the final one in a series, he said, is that there are no more problems left to solve.

Just how incorrigible a collector Victor had become emerges in his correspondence with Kahnweiler. The same day (June 12, 1956) that he mailed a check for the *Women of Algiers*, he wrote asking the dealer to send photographs of some of the other eighteen works he had been able to extract from Picasso. One of the artist's most powerful paintings of World War II turned out to be available: the great *Reclining Nude* (September 30, 1942). Victor tried and failed to get a 20 percent discount, but wisely went ahead and bought this exceedingly important work. The price was $31,500, and as before he was obliged to make an unofficial as well as an official payment.

Asked in 1945 whether he had painted the war, Picasso replied that he had not set out to do so but that the war permeated everything that he had done during the Occupation. And to another interviewer around the same time, he observed that "painting is not done to decorate apartments. It is an instrument of war for attack and

Overleaf: **Picasso,** *Reclining Nude* (1942)

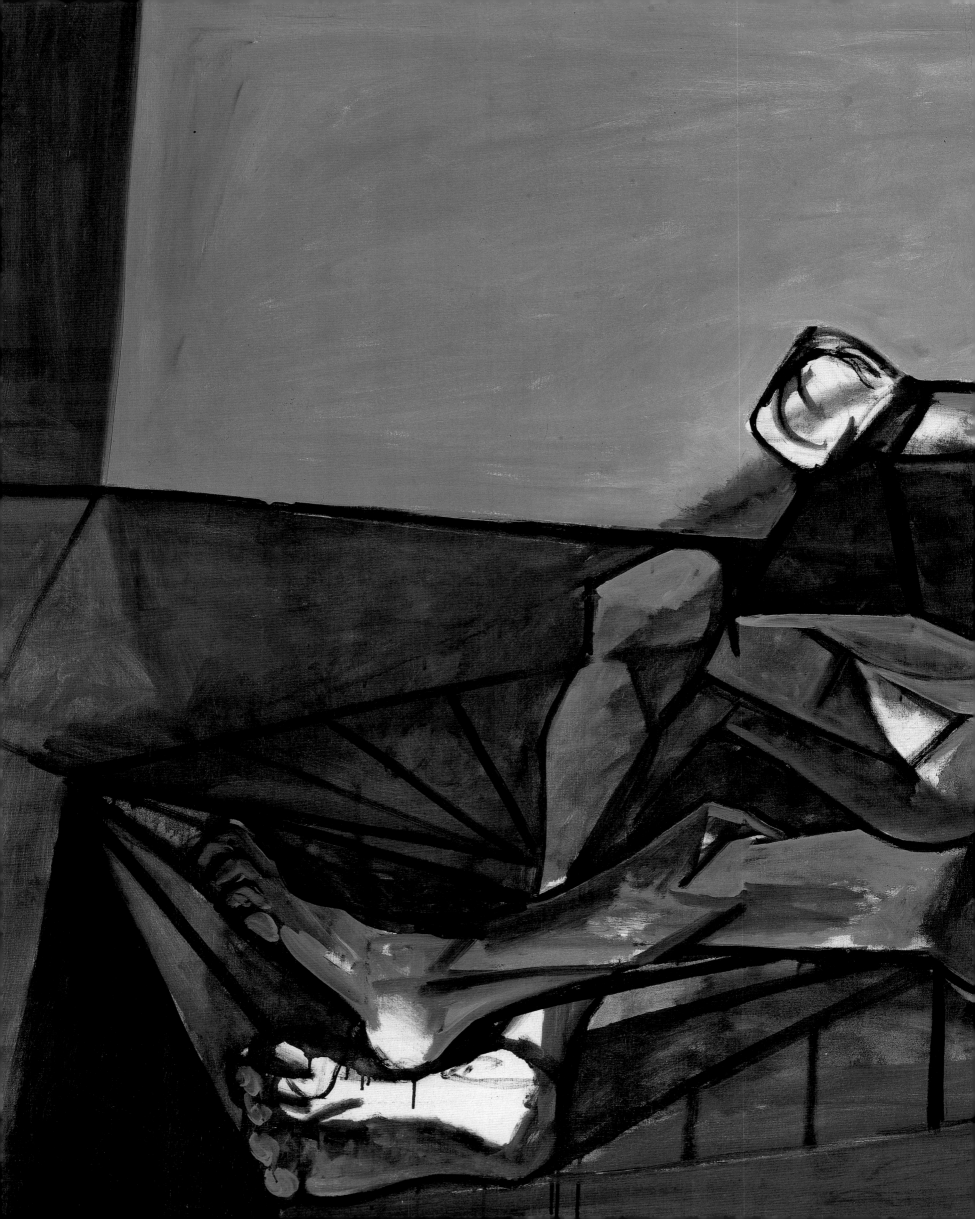

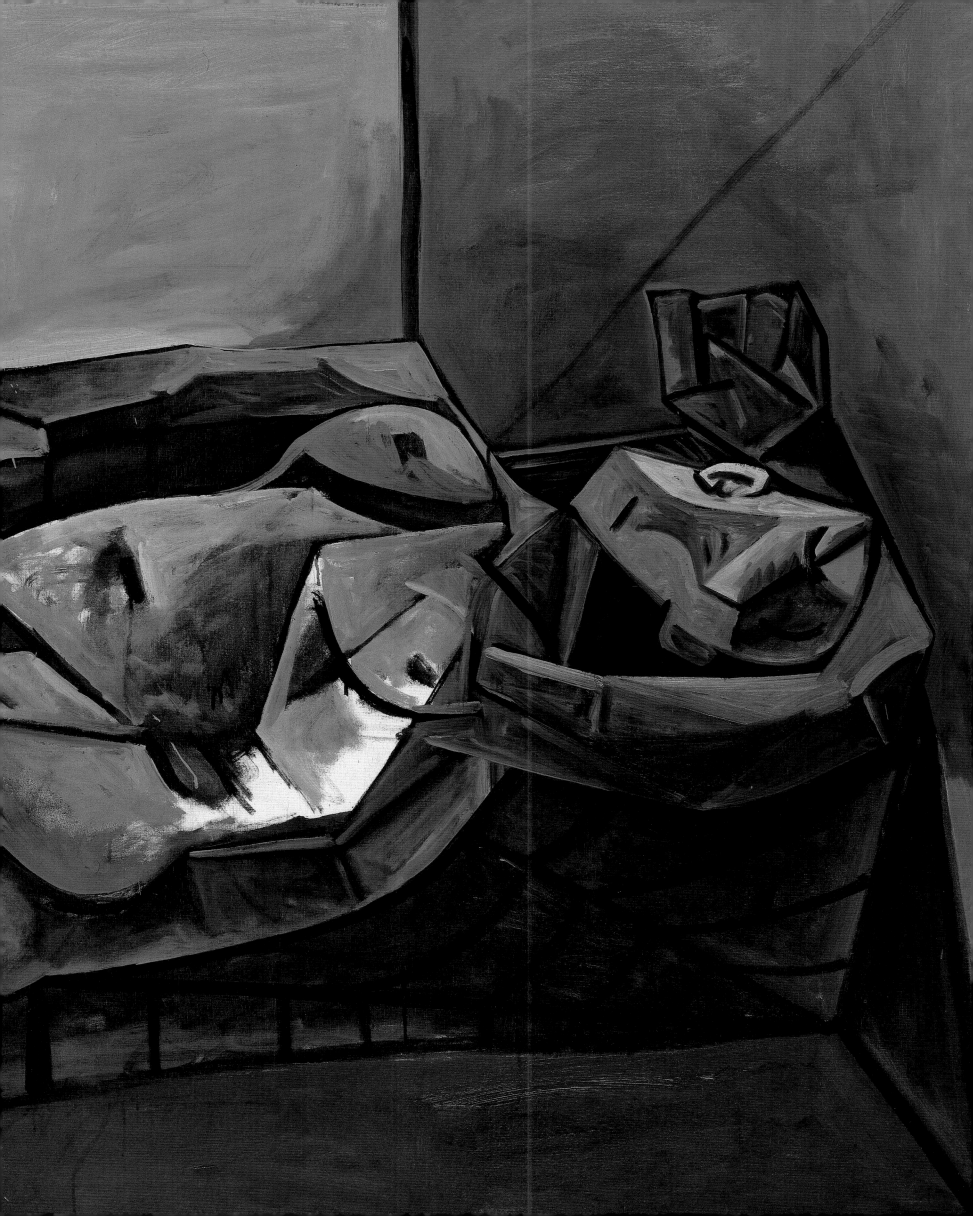

defense against the enemy." The war certainly makes itself felt in this image of a naked, flayed-looking Dora Maar stretched out on a mattress in a room as cramped and bleak and bare as a prison cell. The painting is about the agony of confinement—not just Picasso's and Dora's but the world's. Although the artist and his mistress officially lived under separate roofs, the wartime curfew condemned them to spend much of their time cooped up together. This and the epidemic of fear that the Occupation unleashed took a tremendous toll on them both. And as the war dragged on, the images of Dora become ever more anguished. Picasso uses her tears to stand for mankind's. Here, for instance, her face is set in a rictus of grief; her hands are clenched into fists that are as tight and spiky as that staple of wartime diet, the artichoke; and her legs are articulated to resemble crossbones, such as we find in code in other paintings done during the Occupation.

For this somber nude Picasso has reverted to Cubism, not the later Synthetic kind, but the earlier Dionysiac style of 1907–08, as well as to a more recent precedent. In 1938, he had gone to stay with Christian Zervos at his country house at Vézelay. Back in Paris, he had done a painting and a large, black chalk drawing on canvas of a naked Dora sprawled across the countryside. Zervos has catalogued this

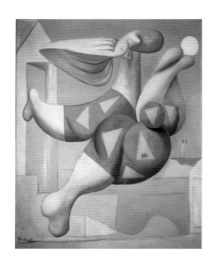

painting as a transposition of the Vézelay landscape: the two feet represent the roads to Clamecy and Avallon; the stomach the Place de la Foire; and the two arms the roads that lead to the great Romanesque basilica.

Picasso, *Bather with Beach Ball* (1932); detail shown right

It is surely no coincidence that Picasso drew on this earthy, outdoor nude for his claustrophobic, indoor one.

Picasso had started doing studies for a large recumbent nude as early as May 1941. These would culminate a year later in that great set piece, *Aubade*, the artist's largest painting of the war years. The subject could hardly be more traditional: a recumbent nude, evidently Dora Maar, being serenaded by a woman holding a mandoline. Marie-Thérèse? Unlikely. To judge by the mirror on the floor, she is more likely to be Dora in a more tranquil mode than usual. Four months after finishing *Aubade*, Picasso embarked on this more powerful and disturbing image of his mistress in much the same pose. Work on the painting coincided with a covert commitment on Picasso's part to the struggle against the Germans. His best friend, Paul Eluard, who had recently joined the resistance and rejoined the Communist party, had persuaded Picasso to help with the backing of *Les Lettres Françaises*. It is surely no coincidence that the *Reclining Nude* was executed ten days after the first issue of this celebrated underground newspaper. To my mind, this painting conveys the actual horror of war with far more immediacy than the celebrated *Charnel House* of 1944–45, that overcontrived and insufficiently moving denunciation of atrocity.

After *Reclining Nude*, Victor bought nothing until 1958 (he seems to have been a hostage to his overdraft) when he made another purchase from Kahnweiler, *Jardinière* (dated June 5, 1956). Victor told me he liked this painting for the sardonic absurdity of its subject: the tawdry remains of an elaborate floral set piece, which Picasso had left in the studio to disintegrate until nothing remained but the silvered basketwork stand with its monumentally dainty mauve bow, whimsical fir cone, twigs, and sprays of dead fern. When I showed a photograph of it to Picasso, he told me that the painting had fallen off the

easel when he was working on it and had almost killed him (in fact it had struck him lightly on the head). He also said that he had wanted "to do a Manet"—that is to say a mocking version of one of Manet's sumptuous flower pieces, with only useless accoutrements—and that Manet had struck back at him.

What *Jardinière* is really about is Picasso's use of objets trouvés in his sculpture. If we see it in terms of the artist's assemblages, particularly the skeletal, welded constructions with cut-out metal leaves that he had done with Julio Gonzaléz in the early 1930s, it is less baffling. We should also bear in mind that Picasso had anything but a soft spot for flowers. "Don't bother to put them in water," he would say when flowers were delivered, "they're going to die anyway." And far from deriving inspiration from their beauty of shape and color, as did Matisse and Braque, he did what he could to make them look ugly or, as here, ridiculous by memorializing them in this ironical way. Victor paid Kahnweiler $35,890 for this painting—once again in two checks—and sold it to the Saidenberg Gallery for $175,000 in January 1973.

Between 1956 and 1959 the Ganzes bought relatively little—for them. On a trip to Paris in September 1958, they acquired a unique bronze cast of *Little Bull* (1957) from Kahnweiler for just under $1,190. A few days later, they went on to Switzerland and bought one of the finest of the Studio paintings (dated April 1, 1956), in which Picasso paid tribute to the ornate splendors of his newly acquired turn-of-the-century Villa la Californie, in back of Cannes. Victor paid Siegfried Rosengart, the Lucerne dealer, $31,000. Rosengart also sold them a drawing from the *Antipolis* series.

And then Sally and Victor fell in love with yet another of Picasso's great images of Marie-Thérèse Walter, *Bather with Beach Ball*, which had been painted at Boisgeloup on

August 9, 1932—six months after *The Dream*. *Bather with Beach Ball* has its origins in a series of paintings and drawings of Marie-Thérèse playing on the beach, done at Dinard, Brittany, in 1928. At his wife's insistence, Picasso had taken a villa for the summer in this resort which he found stiflingly bourgeois. As he had no intention of being separated from Marie-Thérèse, he arranged for her to spend July and August at a local *colonie de vacances*. What perverse pleasure he must have derived from having his nineteen-year-old mistress concealed from his wife and the rest of his friends in a children's holiday camp. Every day Picasso would take her to the beach, watch her romp with other girls, and make wild love to her in a beach cabana. Later, he would record these erotic rituals in numerous small paintings and sketchbook drawings, in which he reduces Marie-Thérèse and her ball-playing friends in

Picasso, *Cat and Bird* (1939), detail

Picasso, *Baboon and Young* (1951)

their striped bathing suits to two-dimensional cutouts. These turn out to have been inspired by the ambivalently flat deck chairs on which the exhausted girls finally flop. Picasso turns the beach into a sexual arena, in which he appears in allegory as a phallic cabana.

The difference between the ball-playing girls of 1928 and this one of 1932 is mainly one of volume. Since executing a series of monumental plaster heads in his new sculpture studio at Boisgeloup, Picasso had come to envision Marie-Thérèse as "a fertility goddess"—hence the overwhelming physicality of this image, its promise of what T. S. Eliot called "pneumatic bliss." Robert Rosenblum has described *Bather with Beach Ball* as "a humanoid kind of a rubbery, gray squid. . . . Her bulbous head, with its two round staring, lidless eyes and its vertical air vent, both mouth and vagina, mindlessly hunting its prey, the hair streaking behind like waterborne tentacles. The prey, of course, is . . . nothing but a beach ball, but it will never be caught." *Bather with Beach Ball* is without doubt one of Picasso's most erotic, entertaining, and disturbing images, and to that extent a wonderfully appropriate addition to the Ganzes' collection.

In the early 1960s Victor switched to buying contemporary American art, but he continued to acquire Picassos: a Cubist drawing, *Still Life with Bullfight Poster* of 1912, which he bought for $4,000 from Albert Loeb. As prices for Picasso paintings soared, Victor switched to sculpture, which was more affordable. In November 1960, he bought one of six bronze casts of the celebrated *Baboon and Young* (1951) for $41,000 from the Otto Gerson Gallery. This is the piece that Picasso had assembled out of bits of junk and objets trouvés, including one of his son's toy motorcars. Many years later, Victor sold this piece to E. V. Thaw. It ended up in the collection of the Shah of Iran.

In April 1961, Victor returned to Gerson and bought two bronze casts, *Figure with a Spoon* and *Figure with Javelin Thrower*, from a set of six figures that Picasso had originally knocked together out of planks of wood, bits of bamboo, broomsticks, and the like that he had foraged by the wayside. There were eight of these frontal stick figures, six of which Kahnweiler exhibited in his gallery as *Bathers*. (The originals are now in the Staatsgalerie, Stuttgart.) Although they were not conceived as such, Picasso came to see them as bathers, and three months later proceeded to draw and paint them as if they were real people on a beach or in the sea. These sketches culminate a year later (December 1957) in a series of projects for the vast panel he had been commissioned to do for the UNESCO building in Paris.

Only one other person played a role in Victor's decision making, and that was Sally. Far from advocating caution or thrift, as so many wives would have done, she encouraged him to take risks, even when this involved taking out further bank loans. I did not realize the extent of Sally's commitment to Picasso until I helped her organize and catalogue the "American Tribute to Picasso" exhibition (April–May 1962). Besides honoring the artist on his eightieth birthday, Sally wanted to raise funds for a cause with which she was deeply involved: the Public Education Association. None of New York's commercial galleries was large enough for a full-scale retrospective, so she had the genial idea of dividing it up between nine different galleries (Knoedler, Saidenberg, Rosenberg, Duveen, Perls, Staempfli, Cordier-Warren, The New Gallery, and Gerson). Many of these dealers had never worked together before; getting them to do so required all of Sally's diplomacy and firmness. Thanks largely to her tireless efforts, the project was such a success that the galleries banded together under the aegis of Ralph Colin into the Art Dealers' Association.

Sally also proved extremely effective at persuading collectors to lend their treasures, of which there were well over three hundred. None of the collectors lent as much as she and Victor did—over twenty works: hence the impact of the later sections. A byproduct of this nine-gallery extravaganza was my own career in the New York art world. Without Sally's choice of me as her co-worker, Christie's might never have appointed me to be their U.S. representative. Sally launched me into orbit.

In 1963, Klaus Perls showed Victor a painting that he and Sally could not possibly resist: the more powerful of Picasso's two fearsome images of a cat killing a bird. Picasso had painted both versions in April 1939, while he was staying in the house at Tremblay-sur-Mauldre, which belonged to the cat-loving Vollard. (When I stayed in this house twenty years later, I found that cats still abounded.) When he embarked on these paintings, Picasso had just heard that Franco had finally entered Madrid and declared himself the winner in the Spanish Civil War. Earlier in March, Hitler had made a no less triumphant entry into Prague. Coming on top of his mother's death in January and the surrender of Barcelona, these disasters plunged Picasso into darkest gloom; at the same time they spurred him on to a peak of creative rage. Like the menacing bulls in his recent work, this predatory cat stands for the three things Picasso most hated and feared: fascism, war, and death. However, much as he did in *Guernica*, he has included a faint suggestion of himself—

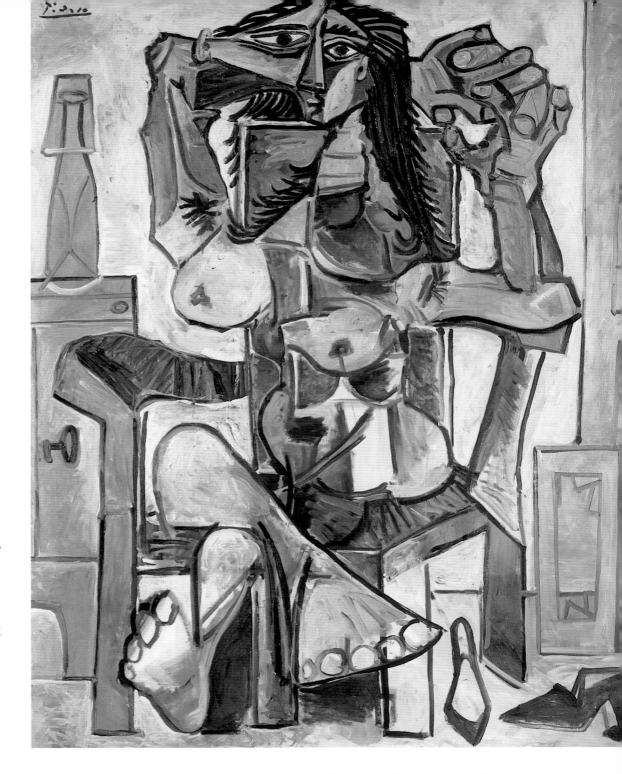

the eyes—in his fascist beast, as if to admit that he, too, had an aggressive streak. This paradox accounts for much of this animal's power. Since *Cat and Bird* was more than Victor could afford, he was obliged to give Perls two of his Picasso paintings for it—*Concierge's Daughter with Doll* and *Owl and Arrow*, which was also triggered by fear of fascism. The deal went through on New Year's Day of 1963.

The Ganzes' next, and next to last, Picasso was yet another *Seated Woman*, and they acquired it from Kootz in October 1963 for $66,000. It is an image of Jacqueline, but a very different one from the Matissian odalisque of the

Picasso, *Seated Woman* (1959)

Jacqueline's arms look as if they have been hacked out of wood. She holds them behind her head to expose her shaggy armpits and clenches her hands in stress. She has kicked off her shoes, but her huge feet look all the uglier for her having done so. This harsh, hieratic image prepares us for the fact that Jacqueline would eventually take her own life.

Although the Ganzes focused principally on Picasso's work of the 1930s, 1940s, and 1950s, they took a great interest in Cubism and often talked about acquiring a major Cubist painting, but the right one never came their way. However, there was one work that they had particularly admired at the Tate Gallery retrospective in 1960: the famous 1913 *Woman in an Armchair* (the portrait of the artist's mistress Eva Gouel, which was known to the Surrealists who venerated it as *The Woman with the Golden Breasts*). It was the most powerful painting in the show, Victor told Penrose, who had organized it.

For some thirty-five years this *Woman in an Armchair* had belonged to a Czech art historian, Ingeborg Eichmann, and been on loan with the rest of her collection to the Kunstmuseum in Zurich. Who was this mysterious collector? Eichmann had been born into a prosperous family that had the good luck to manufacture Czech banknotes but the bad luck to live in the Sudetenland, hence abrupt changes of passport. At an early age, Eichmann had become the mistress of Dr. G. F. Reber, a German speculator living in Switzerland, celebrated for having briefly owned the world's largest and finest collection of works by Picasso, Braque, Léger, and Gris. After losses on the Paris Bourse in 1929 and 1930 had

Women of Algiers. This time Picasso has harked back to his own work, specifically to the *Reclining Nude* of 1942, which Victor and Sally had bought in 1956. If Jacqueline looks anguished in this life-size portrayal, it is not because of war or oppression but because she was sick and in need of an operation. Picasso's misogynistic statements that women's illnesses were all their own fault had induced her to postpone hospitalization; as a result she was often in considerable pain. Hence the lack of compassion in this painting of the woman whom Picasso would marry in 1961.

Picasso, *Still Life with Bullfight Poster* (1912)

wiped out his fortune, Reber became a private dealer. Two of his principal clients were his mistress and the young English art historian Douglas Cooper, who was in the process of forming a collection along the lines of Reber's. Cooper would become a good friend of the Ganzes.

How this great painting came into Eichmann's possession is not entirely clear. Given her closeness to Reber and the fact that he was the source for most of her collection, he either gave it to her or, since it is not listed in Dorothy Kozinski's checklist of his paintings, bought it on her behalf. When Hitler's annexation of the Sudetenland left Eichmann stateless, Reber tried to persuade Cooper to marry her so that she could become a British citizen and also amalgamate her collection with his. Instead, she married Georg Pudelko, another art historian, whose first wife had been Reber's daughter. They spent most of the war in Florence. Eichmann remained in close touch with Cooper; and it was to him that she turned when she decided to sell *Woman in an Armchair*. Since Cooper regarded ownership of this painting as something of a sacred trust, he was determined that it should end up in the best possible hands and, since he could not afford to buy it himself, whose better than Victor's?

On March 26, 1964, Cooper, who had installed his vast Cubist collection in a château near Avignon, sent Victor a letter saying that Eichmann had decided to sell *Woman in an Armchair*, but had not yet settled on a price. Victor had difficulty getting through to Cooper in Provence, so he sent a night letter confirming that he was indeed interested. However, he assumed that the price would be more than he could afford. Cooper replied that Eichmann was asking $300,000, but her real price was in the region of $275,000. "I have been with Picasso for the last four days," Cooper's letter ends, "and he says he envies whoever gets the painting."

"The very best I can afford," Victor replied on April 4, "would be $200,000"—and in installments over the next year. Cooper wrote on the 15th that he could not persuade Eichmann to accept this offer. "I don't see any hope of getting it at less than $250,000—and even then I may be under the price. I wish you could get it—your collection deserves it even at the cost of sacrificing something—and the chance will not recur." Victor replied on the 20th that he was very disappointed: "I would do almost anything but hold up the Bank of England in order to buy it." No further letters between them survive in the Ganz archives.

Negotiations may have petered out, but Victor did not give up hope of acquiring the painting. Whenever I saw the Ganzes in the mid-1960s the conversation would sooner or later come round to *Woman in an Armchair*. How could Victor possibly pay for it? Liquidate part of his great collection of Picasso prints? This is what he eventually did when, three years later, Heinz Berggruen, the international dealer based in Paris, took Cooper's place in the negotiations. He agreed to broker a deal for Victor: offer Eichmann a demoralizingly low $180,000, with a view to getting the painting for $200,000: then buy enough prints from Victor at prices to be arranged between them to raise a quarter or a third of the purchase price. After holding out for $210,000, which Berggruen failed to get Victor to accept, Eichmann caved in and took $200,000. There was a slight problem when Victor discovered that the "current values" that Berggruen proposed for the prints were based on a three-year-old price list and therefore too low. Once this was rectified, everything went according to plan.

"Frankly, Victor," Berggruen wrote on April 7, "I don't think I ever worked so hard on a major deal and made so little." This was high praise from a famously tough negotiator. Few collectors would have had the nerve or the pertinacity to hang on for three years, as Victor did, and

finally get a great masterpiece at his price and on his terms.

The 1913 *Woman in an Armchair* was probably the possession of which Victor and Sally were proudest. Besides being a Cubist milestone, it is one of the most radical images of a woman in Western art. Guillaume Apollinnaire had been fascinated by it. He told Picasso that he had "always wanted to pull up her chemise. You can really see that she's all woman." Picasso replied, "She's even got what she conceals"—a reference to the vaginal nature of the image. Many years later, the artist told Pierre Daix that this was the work that had prompted his famous question to Braque, "Is this a woman or a painting? Do her armpits smell?" André Breton likewise venerated this painting—so much so that Picasso gave him one of the best of the many studies for it—and declared it a Surrealist icon.

Both Breton and Eluard wrote ecstatically about this painting, but, so far as I know, none of the Surrealists or anyone else for that matter realized why it seems so charged with erotic mystery. As I pointed out in the second volume of my Picasso biography, it is because the artist has portrayed Eva "proudly and tenderly but also monstrously, in terms of her own genitals." Some years after Victor's death, I discussed the painting with Sally. Had she been shocked by my analysis? I asked. "Let me take another look when I get home," Sally said with that purposeful grin of hers. The following morning she called me: "How come nobody ever pointed this out before?"

The 1913 *Woman in an Armchair* was the last major Picasso that the Ganzes acquired. And what more appropriate conclusion for a collection that had started off with *The Dream*? These two paintings are not so dissimilar as they might appear. Both are works of utmost originality and what the Surrealists called convulsive beauty; and both are imbued with so much of the artist's sexual passion that blood seems to course through the paint as if it were erectile tissue. As Picasso said to Roland Penrose, "People don't realize what they have when they own a picture by me. Each picture is a vial filled with my blood. That is what has gone into it." Victor's choice of paintings confirms his awareness of this phenomenon.

Because they had had such a memorable time with Picasso in 1948, the Ganzes were wary of repeating the experience. Sally was emphatic about not wanting to join the throng of petitioners and time wasters who besieged the artist's house at Mougins. However, unknown to them, their great friend Marga Barr (widow of the pioneer Picasso scholar Alfred Barr) told Jacqueline Picasso that Victor and Sally were going to spend a few days at Antibes in May 1970—and would Picasso like to see them? Of course he would: Jacqueline asked them to Notre-Dame-de-Vie for drinks. "So he was very old and I was very old," Sally reported, "but he was still flirting." And so was she. When she took off her sunglasses; he put them on his nose "and made himself look funny." She suddenly understood why women had not been able to resist him and why he had not been able to resist destroying them. Before they left, their hero did two drawings of a bearded man for them; and Sally threw her arms round him and "gave him a big kiss."

After Picasso's death, the Ganzes kept up with his family: his widow, Jacqueline, would call on them whenever she visited New York, always making straight for the final version of *Women of Algiers*, in which she felt enshrined; his daughter Maya would come and sit proudly in front of *The Dream*; and his son Claude, then a photographer, would take the portrait of the Ganzes' daughter Kate when she got married. In later years they bought only one more Picasso—a 1941 drawing of a recumbent Dora Maar—from the Galerie Kohler in Zurich. That was in 1980, thirty-nine years after the Ganzes had started off their amazing collection with *The Dream*.

Picasso, *Woman in an Armchair* (1913)

IN THE ALGERIAN ROOM

LEO STEINBERG

Dining out with my new friends Victor and Sally Ganz sometime in 1957, I asked a question so loaded that Victor wondered whether to trust me with a straight answer. I had just seen their apartment at 1175 Park Avenue—four Ganz children in it and an abundance of Ganz Picassos, Picassos on every wall and no other art—not so much as a Braque to blunt the effect (though I would later discover two Matisse lithographs in a bathroom). Most of the vintage years were represented—1907, 1923, 1932; but the parade included unabashed 1940s material as well as a batch from the mid-1950s, when, according to that decade's critical judgment, Picasso had long been coasting downhill. Victor thought otherwise. A businessman with as yet no personal friends in the art world, he persisted against skepticism under both kinds—the naïve and the informed. His business friends regarded him (and his holdings in what one of them called "your Picassios") as slightly cuckoo. Readers of Clement Greenberg (described in those days as "a critic who's just never wrong") would have thought Victor misguided.

Misguided or no, Victor fed ever more paintings and sculptures, drawings and prints into his home until, as far as the eye could see, no upright surface lacked its Picasso, while temporary excess (anticipating a move to larger quarters) choked the maid's room. For virulent Picassophilia I knew of no case more severe; hence, at our first meal together, my impertinent query: "What's this with you and Picasso?"

Victor consulted his wife: "Shall I tell him?"

Sally shrugged. "Go ahead."

Victor, grinning: "I think I am Picasso." Then, composing his mouth (Daisy Barr, Alfred Barr's acute wife, declared that mouth to be the finest chiseled ever seen on a man), Victor confided: "You and I," he said, "belong to a generation that has always taken Picasso's genius for granted. But people complained that one couldn't live with his pictures, whereas all I wanted was exactly that—live with them."

This he did. Intimately. In 1941, he acquired his first Picasso, the 1932 *Dream*, for $7,000; and went on to accommodate even the harshest, the most abrasive disturbers of peace. Above Sally and Victor's bed hung a huge, jagged, somber-toned *Reclining Nude* of 1942 (purchased in 1956), a female sleeper so remote from conventional loveliness that Picasso himself was impressed—impressed, I suspect, by the love that would admit such a sleeping companion.

When Victor and Sally met with Picasso in 1970 and mentioned the wild thing over their bed, old Pablo, then going on ninety, sprang from his chair to impart a dark secret: "And do you know what I do when the two of you sleep?" He doubled over and, arming his temples with forefinger horns, stalked the Ganz couple around the table, a goblin rehearsing his nightly haunt and promoting that Manhattan bedroom to a *ménage à trois*.

As Victor was telling me this, Sally recalled the male gaze of those Andalusian eyes: "Try to imagine what it means to a woman my age to be looked at like that." But this was spoken a generation ago, before the monster misogynist in Picasso was advertised.

Or the manipulator. Just how engaged was the artist in managing his financial affairs and his market?

From their visit with the old prankster, the Ganzes brought back one other small revelation. It concerns *Les Femmes d'Alger* of 1954–55, which Victor had bought from Picasso's dealer, Daniel Kahnweiler, after its first showing in Paris, 1956. The purchase had not been easy, since the buyer, as Kahnweiler explained with regret, had to take all or nothing, all fifteen canvases. The price for this bumper was unaffordably steep, but Kahnweiler swore that he was following orders; it was Picasso who insisted that the crop be sold as one lot. Fourteen years after the sale, artist and buyer now face to face, it turned out that Picasso was innocent. The one-lot stipulation—one more Picasso misattribution—was Kahnweiler's way of ensuring that he would not be stuck with unwanted duds after selling off the prize items. Getting the story from Victor Ganz, Picasso, according to Victor, seemed mildly peeved and amused. (That Picasso's protestation of innocence might have been less than honest did not occur to me at the time. It becomes thinkable as film buffs learn to perceive Picasso in the persona of Anthony Hopkins.)

Victor and Sally had kept the five *Femmes d'Alger* pictures which they loved best—one small study and four of the big ones, all hanging together in the "Algerian Room." This is where I came to know them and where, years later, I experienced a minor epiphany. I'd like to share this personal recollection, even though it's rather long in the telling and perhaps too technical for the present occasion;[1] worse still, the protagonist doesn't enter until the last act. But that late entry puts Victor Ganz where I want to remember him.

A dinner party in the Ganz home, now relocated in a duplex at 10 Gracie Square. Our hosts and most of the company were still at table, while I and an American

became suddenly clear that Picasso was all along wrestling an impossibility. His chosen problem was to pose the sleeper simultaneously on her back and on her stomach, sunnyside up and turned over—not successively, but both views at once and as one compact body. Put another way: the sleeper's torso in canvas "M" shows two left sides and no right—one left side recto, and the same again verso. Belly and upper breast represent her supine—arms overhead, a blank face above folded hands. The underside of the image shows the girl prone, seen from her left, head resting on folded hands.

Most amazing to me was her long, rigid base—a black rod and no more; yet one end of it, overlapping a breast, defines the heart side, while its other end, before tucking under, contours her lower back viewed once again from the right. How on earth were these shifts engineered? Could this straight edge be a rotating shaft, turning while I wasn't looking?

The coincidence of opposite aspects—to be seen not in succession, but in solid simultaneity—seems a crazy idea: it is so plainly impossible. As every beach bunny knows, even the sun can't flatter front and back in one beam. Does Picasso's eye presume to do better?

No doubt, Picasso's intention here is more easily recognized now than it was thirty years ago. Pictures gradually educate, and one learns to read what had been unapparent or unsuspected. I therefore ask for indulgence if the sleeper's duplicity now looks self-evident; time was when the "decoding" seemed an exhilarating discovery. It made a new man of me, one who finally understood the design of that sleeper, its bid to compress divergent aspects in convergent form. What I had taken for arbitrary mayhem, for carelessness or provocation, was rather the effort to

sculptor of reputation made for Algiers. We sat down facing "H," no. 8 of *Les Femmes d'Alger*, the first of the large canvases in the series. The sculptor said it was a very good picture. I disagreed; the sleeping nude at the right had always struck me as an offense. I disliked the way her trunk falls apart, like a butchered carcass. And the drawing was sloppy, perhaps deliberately perverse, especially at the bottom, where the deformations seemed impatient, senseless, grotesque.

But even as I was talking, a nagging compunction made me turn around to look at the corresponding passage in the canvas behind us, "M," the antepenultimate in the series. And then I saw—for the first time after such long acquaintance—what Picasso was actually doing.

Comparing the sleeper in these two canvases, it

Picasso, *Women of Algiers* "H" (1955), detail

incorporate simultaneity at any cost. What had looked like disruption now appeared as an impulse to reconcile, to bring disparate aspects together.

I learned something, too, about resistance, the need to dispute visual evidence when it upsets. The sculptor with me promptly denied that anything like front-back simultaneity was involved; he thought the figure merely reordered on Cubist lines. Not until he was asked to identify first the upper breast, then the lower, did he concede that both featured the body's left side, diversely viewed. He then said no more—just kept looking.

As other guests filed in one by one, each answering the same question, each at first read the sleeper as on her back, hoisted legs propped on a taboret. Then, asked to consider each breast in turn, they admitted the composite reading—with feelings ranging from initial embarrassment to delight. One famous art expert produced a characteristic reaction. Having first read the posture simplistically and realizing at last how complex it was, he maneuvered: "Nothing new here; simultaneity had been around ever since Cubism, 1911." He had vaulted from denying its presence to declaring it commonplace. Wrong on both counts.

Then hostess Sally walked in, underwent the same inquisition and the same passage from errancy to enlightenment, but in her case followed by a rueful reflection: "I'm not sure I deserve to live with these pictures if I don't see what goes on in them."

Enter at last Victor Ganz; whom we asked with feigned nonchalance how he read the pose of the sleeper in "M"—all of us holding our breath. The answer came calmly delivered: "She lies supine on her back and prone on her belly at the same time."

So he'd known all along, without telling a soul,

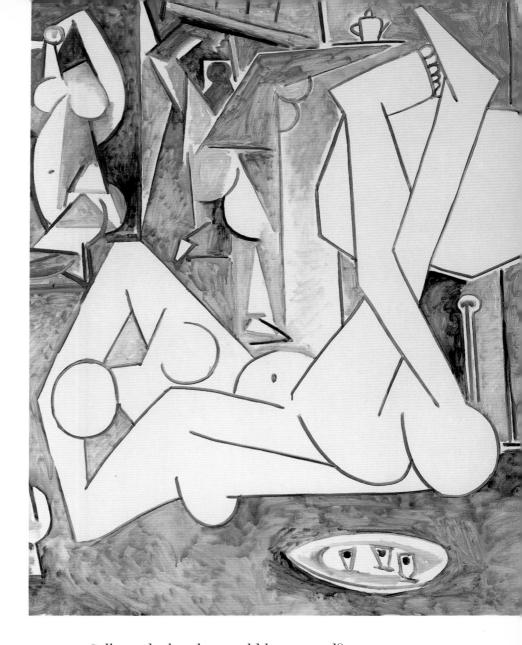

not even Sally, and who else would have cared?

Everybody fell silent and stared at the canvas over the couch. During the first fifteen years of the life of this picture, the sleeper in it had been understood by only two men: by him who had painted it, and by him who desired to live with it. In his attention to what was actually there, neglecting even to label the picture "Cubist," Victor had been rethinking Picasso's thought. Perhaps that's what he meant when he parried my first pertinent question with a quip.

I learned a lot in those twenty post-prandial minutes; not least, that a collector, a rare collector, deserves the great art he owns.

1. The subject is treated at length in L. Steinberg, "The Algerian Women and Picasso at Large," in *Other Criteria: Confrontations with Twentieth-Century Art*, New York, 1972, pp. 124–234.

Picasso, *Women of Algiers* "M" (1955), detail

A TRUE PASSION FOR ART

MAYA PICASSO

Writing about Victor and Sally Ganz and their startling, splendid collection would seem a very natural thing. At present I feel rather forlorn at the impossibility of asking them questions—how they discovered this or that work, how they negotiated for it, and with whom—in short, of having a way to learn and understand more about these offspring of my father's that are scattered throughout the world.

I was fortunate to have close, almost family relations with the Ganzes, with Victor Ganz in particular—that sort of late-day friendship that one no longer dares hope for and that one savors all the more when it involves such exceptional persons as the two of them.

Our friendship came about because of my father. Victor, ever on the hunt for the strongest possible pictorial emotions, fell in love with a painting that belonged to me—*The Fisherman's Family*—and that I had loaned to The Museum of Modern Art for a fabulous exhibition, the kind that only American museums can afford on an artist as famous and prolific as my father.

The anonymous status of my loan—"Private collection"—further fanned Victor's desire; he was so determined to find out who the owner was that he managed to convince Dominique Bozo, the first director of the Musée Picasso, to contact that mysterious owner and tell him or her how enchanted he was by this marvelous painting—so much that he later told me, "That was the painting I kept finding myself in front of!"

That was Victor Ganz—enthusiasm, passion.

He wrote me in August 1982 how happy he'd been to spend two months in Italy and Sicily admiring the marvelous eighteenth-century Baroque architecture, and

that, I think, is what makes the best collectors—their verve, their directness, their openness to the art of all times.

I don't know whether the fact that I never sold *The Fisherman's Family* to him or to anyone else convinced him I was not merely an inheritor. I can affirm that, far from angering him, my refusal seems to have brought us closer. It is thanks to that circumstance that I joyfully preserve the correspondence we carried on over many years.

Sally certainly seconded the delight they took throughout their lives in collecting works of art, but I do think that Victor was the more fanatical of the two.

What was exceptional in their house was that the paintings, drawings, and sculptures lived with them; I was reminded of my father's studios. All those works were there not for decoration: each somehow had its place on the walls the way the tables, the benches, the chests, or the beds had their places on the floor.

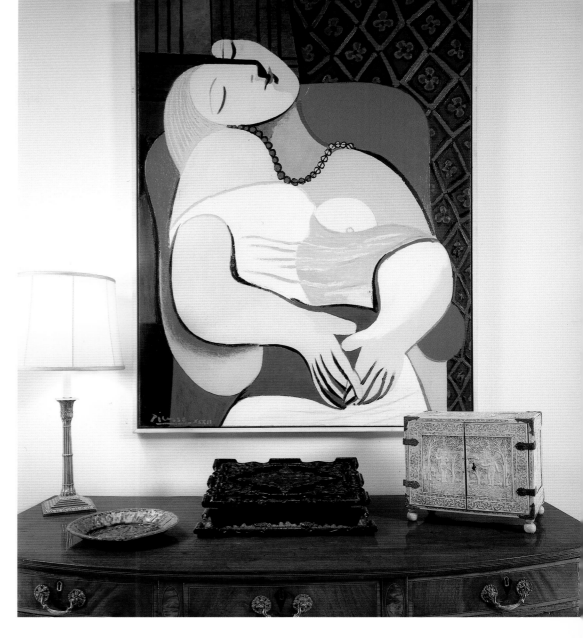

In the Ganzes' living room, Picasso, *The Dream* (1932)

The Dream (1932), Victor told me, seemed to him an absolutely wonderful representation of my mother—of the woman—but also he was very deeply attached to that painting because it was the first one by my father he had acquired and it therefore marked the beginning of his collection of Picassos and the passion he felt about them.

There are those who watch television in bed; the Ganzes watched *The Dream* before falling asleep. That set me giggling, because, as I told them, I generally see collectors' best pieces reigning triumphant on the walls of their living rooms. The Ganzes kept this one for themselves, across from their bed, savoring at the same time the fleshly curves of my mother translated by all the

love of the man who adored her, and what is doubtless the twentieth century's masterwork by Pablo Picasso.

But where *The Dream* radiated all the tenderness of the Satisfied Man, the Ganzes' second acquisition is a very different thing: *Still Life with Sausage* (1941). I'm crazy about that painting! It is *The Dream* from the time of war shortages.

Because the Germans were requisitioning it, my parents had to take abrupt leave of Tremblay-sur-Mauldre, the great country mansion lent them by the art dealer Ambroise Vollard; they had to buy ragtag tableware and a butcher's knives (I still have them, incidentally). The aggressive knife at the middle of the

69

painting, which cuts the picture in half, is one of those.

The shortages became dreams: the chunk of Camembert, the sausage whose size is impressive, the wine, all glow a little within that grisaille of the war like a mirage. Down below, the plates are in a turmoil, they seem to want to escape the drawer and shout, "Don't forget us! Don't forget us!," giddy to join in again as they did in the days of long-ago feasts. My father always, without exception, transmitted the truth; even the lampshade bears the black screen required by the civil defense.

I know that Victor Ganz was not one of those people who buy on a whim. He cared about having his emotions moved, and about understanding his own emotion just as much as those the artist must have been feeling. We were deep in the war when my father put onto canvas what the overburdened French were feeling—the lack of those very simple foods, Camembert, blood sausage, wine, even artichokes; everything was lacking, and the lacks became dreams; even light was denied us. In short, it's another painting where the stomach cries famine but dreams of the past.

This painting hung near a splendid Jasper Johns, at once austere and eloquent, with splendid equilibrium.

How surprised I was to see that in the Ganzes' salon was a portrait of a sailor dated October 28, 1943. This pensive sailor I knew very well because on the twenty-fourth of that same month my father did several drawings of that person. He was a nearly anonymous sailor to begin with, then little by little took on character, especially in his gaze. At the time my father was caught between two loves—Marie-Thérèse and Dora—uncomfortable in the situation because he could not choose . . . because he did not want to choose. They were so very different in body, in coloring especially, and in temperament! He had need of the calm that Marie-Thérèse had always afforded him,

but he also needed Dora Maar's storms, which shook him out of the familial routine that he himself had established. Behind the sailor, the depths of the room recede, which makes his concern more intense and his gaze more anxious. This portrait was another target choice on the interrogation over man's "present-future," from which there emanates a deep feeling to which the Ganzes cannot fail to have responded.

Also honored in their salon was the *Reclining Nude* of September 30, 1942. This nude must intrigue us. Time was inexorably passing, and my father's love problems, bound up with the problems the war imposed, burst out in that canvas. Food was scarcer and scarcer, and so was light. The two women in his life, exactly the same age, brought him complications. The painting reflects the atmosphere of the moment.

Another obsession of the Ganzes, in their red salon: discovering an artist's process of approaching Delacroix's masterpiece, *Women of Algiers*!

Jacqueline certainly figures here. He seems to have dared with her—because of her—this personal interpretation of that masterwork of the last century. She appears in the foreground, in all the splendor of her youth. The blazing red translates the Love fires sweeping over the whole being of this painter, aging certainly, but still responsive—so very responsive!—to the volumes of a woman's body.

Jacqueline's sphinx face personalized that woman reclining in the foreground, but gradually only her young, firm body became the main subject. For the first time he was introducing us to his heart's choice.

Was it again that version of *The Dream* that attracted Victor Ganz?—I can't say, but undoubtedly that privileged moment of abandon seduced him to the point of buying the whole series of the Algerian women. That was the only way to understand the evolution of the final painting, and

to see how the lover-painter reveals himself in full daylight. Victor Ganz thus entered into the life, the emotions, the searching of the painter, and proved to all how thoroughly he and his wife were collectors—real collectors, in my view, not people looking to invest their capital.

On the three walls of their red salon, visitors like us could share in that approach to the painter's search for the finality of a masterpiece. The crowning work of his life bursts forth: the woman's body trembles with past and future joy, but my father presents her at last: sane and stoical as Jacqueline could be, her heavy breasts held up by the bodice but notably, in that pose with the crossed legs she was so fond of. Her great dark eyes are filled with submissiveness before her lord and master. Might that be a premonitory painting for my father's life? Who knows? It is true that Jacqueline would play that role of the Submissive in the years to come.

The Ganzes, always unusual in their choices, were to turn their attention for a moment to the difficult subject of death, choosing two of my father's paintings that illustrate the savagery that is animal but, we well know, could be human.

In *Cock and Knife* (1947), the cock seems to have had its throat slit by the knife alone. Man is absent; the butcher's blood-streaked knife seems to be the sole enemy. In that painting springs forth the whole hypocrisy of the world: the "I didn't do it, the other person did." It is a marvel of interpretation that was my father's secret.

The other painting, *Cat and Bird*, has an uncanny power and stirs us to thinking. We are in 1939: war is an underlying concern, but it is on everyone's mind. Blood is already flowing, the bird is dying, the cat is already poised to attack other powerless victims, its body is tense, its

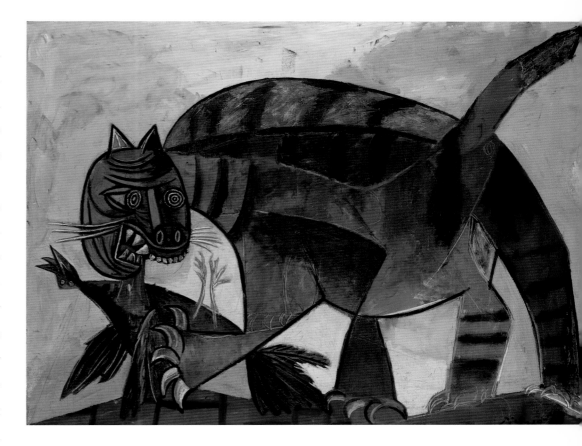

muzzle full of malevolence and without pity . . . and almost human. Of course it is a wild cat—we were in deep country at Tremblay-sur-Mauldre—but that scene so full of injustice must have thrown my father, alert as he was to everything going on in the world and around him. He must have seen and felt in it a likeness to the present and to our future. These two paintings are the only two in the Ganz group in which violence appears in its full atrocity. They have an incredible power, even though the figures are ordinary, familiar animals. Each of them only reflects everyday life, and yet the Ganzes were sensitive to their power.

After those two still lifes (*nature morte* is certainly the right term), in 1967 they bought from a well-known dealer the portrait of Eva done in 1913, more often anonymously called *Woman in an Armchair*, which I had never seen.

Of course I never knew Eva, but I heard so much about her in the course of my walks alone with my father that I stood for a long time looking at that portrait in which one can intuit everything that exalted, in my father's mind

Picasso, *Cat and Bird* (1939)

and body, the elusive person she was and remained in her lover's life. Only her naked torso appears there, as though he did not want to reveal to just anyone the rest of that beloved body. The breasts seem to be moving, the shimmering colors send us reflections from the amorous brazier that filled my father's heart in regard to his model. It is a mysterious painting for those who would like to know Eva's face. It is Eva: felt, sensed, loved, adored by Picasso—a young, jealous Picasso, but with that uncommon force that only my father could translate in his fashion onto canvas with his paint.

That was how I learned that Victor had owned a portrait of Françoise in which her narrow, narrow waist contrasts with her sober, massive artist hands; in which she looks frozen in her young beauty, haloed by her windblown hair.

Naturally I asked Victor if at the time his idea was to collect my father's mistresses. He burst into laughter at my notion. Eva, Marie-Thérèse, Françoise, Jacqueline—all four of them "beacons" of love for my father—I thought it seemed obvious. It wasn't only he who would be interested in the various representations of each woman's body movements.

Marie-Thérèse seemed to be Victor's favorite; he talked about her and asked me a thousand questions about her. They had owned the terrifically sensual painting from 1932 of Mama playing with a ball and dressed in a bathing suit with seven triangles on it. She springs forth, frenetic, under the August sun as was her way. It is a picture as strong as my mother was, the symbol of Perfect Love seen by a man the right age to taste with ecstasy that love's thousand-and-one secrets. It took amazing temperament to

dare to display in one's home a picture with such obvious meaning—like those ceiling mirrors that double a lover's pleasure.

The other Marie-Thérèse, *Woman in a Red Hat* of September 18, 1934, is a different thing, quite as unsettling. There she is a flower among flowers, a reader (such a reader!) grown pensive from it. I recognize my mother's gaze there. This is a serene picture in which only her face is prominent, so much so that it hides half the sun. As always, the details are true: Mama very often wore Hermès berets, in all colors, including a plaid one that my father kept for years, even doing a portrait of, I think, my little brother Claude (or perhaps it's Paloma) wearing that fetish hat.

The Studio (1956)—I lived in that villa. The high, wide windows show the palm trees in the garden; to the left all is dark—a darkness cast by the many giant eucalyptus trees that crowded the house but perfumed my room, which was on that side. Why did the Ganzes choose this painting? I do not know. Probably for the calm that emanates from it. Summer is near; it is April, not yet vacation time, still a few months' respite before the start of visits, which are more or less agreeable but above all so very numerous. Now that he was an international star, the crowds hurried to the door. Our caretakers Lucette and Antoine played Cerberus all summer, with a hand from Jeannot, our chauffeur and general factotum. How was my father able to work during those summer months? Often only at night, and especially then. Lighting mattered little to him; enormous movie floodlights gave him some illumination; that was all he wanted. It was true that he could rely on a patriarchal knowledge of color.

From the moment we arrived in the villa La Californie—Papa, Jacqueline, and

I—he took over the salon, the left and central area (the one in *The Studio*). The area to the right became a kind of studio/dining room protected from his invasion by a great table on which—among the linoleum blocks and the mail, not to speak of papers—the three of us managed to clear space for our dinner plates. We never were formal bourgeois types with family rules and rituals, to the degree that when by chance Simone Signoret, Yves Montand, Serge Reggiani, or someone stayed to lunch we would have not so much as a key to the sardine can or other preserves, or any table wine, since we never drank it. I saw those random guests drinking Banyuls—a rather syrupy wine—with a chunk of meat, and happy to have that!

But to return to the Ganz collection: among all the marvels there is one landscape worth its weight in gold. Very large, it is not only a winter landscape of the little village Vallauris, where we resided at the time; it reflects the atmosphere of anxiety the world was living in then: the Korean War, which my father was to picture some days later, is already going on. Only the palm tree seems a release from that torment. The other trees are fitted out with the mechanical hands of the terrifying robots in nuclear plants. They move about like Titans before the final combat. But Hope is present: the Future, symbolized by the wreck of the plow jammed into the frozen earth, is only awaiting good weather. My father, more overwhelmed than other people by the fratricide of the war, could not be unaffected by it, void of all common sense because it was being roiled up by outside forces.

This is a realistic painting that avoids the sentimentality of a banal subject. It is so strong that we can easily understand why Victor Ganz drew his wife along into the choice. He had the gift of grasping all my father's various emotions. The cold, winter, fear, anguish all emanate from the canvas.

I think it would be utterly appropriate that the dictionary definition of the term *collector* should cite the Ganzes as examples. The selectivity they brought to the work, the careful choice, is incredible. They had only a very few drawings, but what drawings! The one they needed: the very first in the explosion, or rather in the recognition, of my father's talent in 1912. A drawing in which he reports his renown approved and acknowledged in the newspaper *La Publicidad*. This drawing is a still life entitled *Qui*, to which he added ICIDAD, to link it to the periodical which, on that glorious day, published two full pages on Cubism, articles doubtless procured by Manolo or Casanovas, two of his friends. The pieces speak of "developments that my talented friend Picasso, the Málagan painter, trained in Barcelona, will bring to those who consider him their prophet, in order to see who's right." This was written by Miquel Utrillo in his article entitled "The Cubists Hit Barcelona."

My father was never pretentious, but he was very happy to have his talent acknowledged, as on the day—I was fifteen—when he came into my room with a gift of a Larousse dictionary. Uh-oh! I already had such a lot of them! "No, but see, this one is different—look up 'Picasso'!" Being in the *Dictionnaire Larousse*, to him, was worth more than getting into the Academie française.

All those works of my father I had the good fortune to see in the Ganz house, in the company of Victor, who was excited at the happiness and surprise I felt at seeing or reseeing them. He would sometimes describe to me how he had searched them out in the world, and how he had had to detach himself from one canvas in order to meet the dealer's price for another one that he himself considered more in line with his idea of my father's inspired work and with his own collection.

Translated from the French by Linda Asher

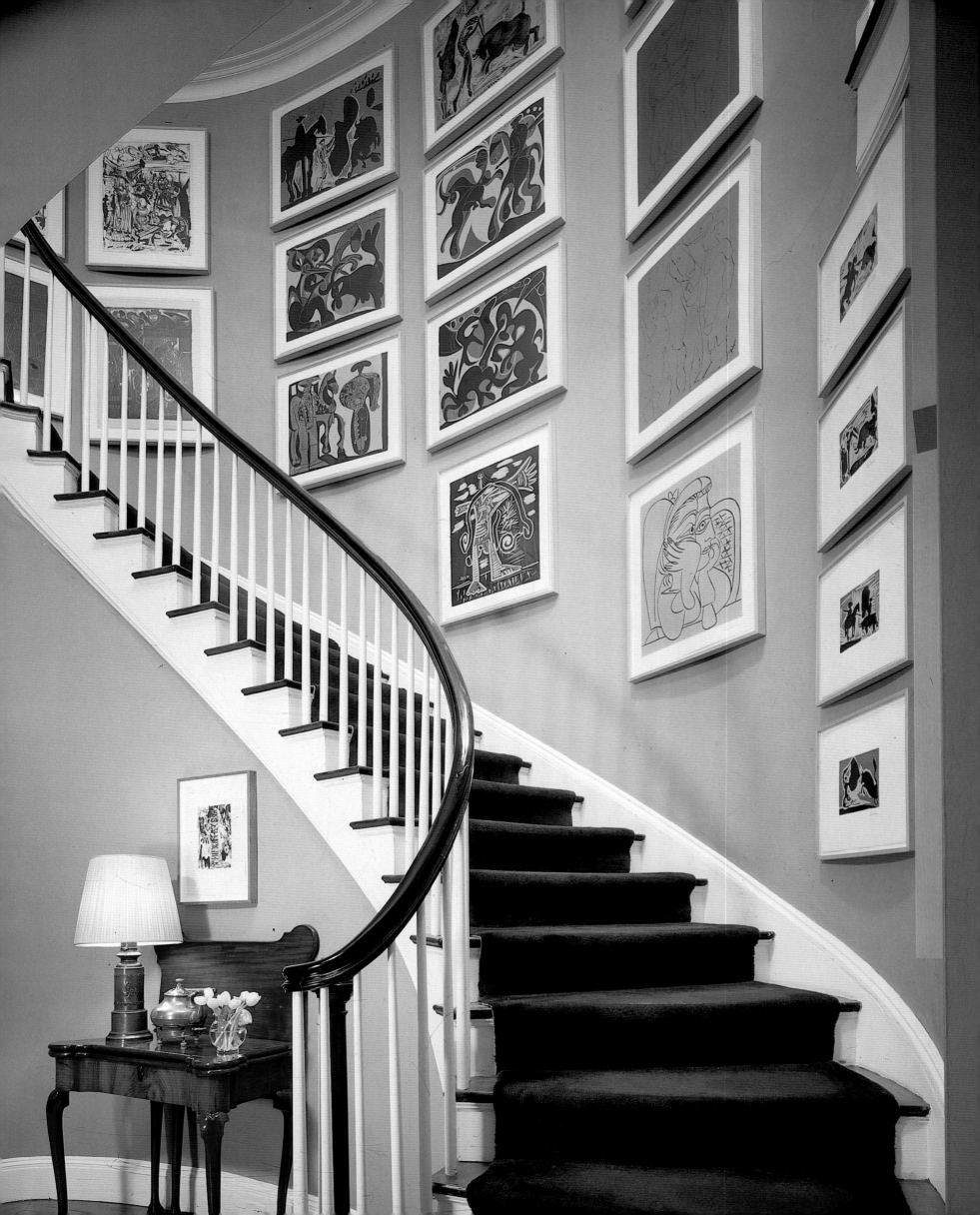

PICASSO

BRIGITTE BAER

Victor Ganz's company made costume jewelry, what the French call *bijoux de fantaisie*. This costume jewelry must have been beautiful, for Ganz succeeded in becoming a collector of jewels of art.

Where Picasso's works were concerned, Ganz was a collector of *true* jewels: the paintings he owned are museum quality. Some are more than famous, such as *The Dream* (1932) and of course *Woman in the Armchair* of 1913. He wasn't as rich as some oil king; therefore he chose carefully, buying only what he loved; he even sold other things that he liked less. And he had great taste, a taste for strong, even ferocious pictures. One of the first—perhaps *the* first, but certainly one of the few such collectors, he acquired those

fantastic paintings that date from the German Occupation, those works from Picasso's real maturity, those works that speak of the war, of anguish, those works that even now the public is not truly willing to accept. I met Victor Ganz only once. He was very nice. But it is because of these "war" paintings that I admire him as a man of sure taste, personal taste, precisely the thing they used to call *le grand goût*.

Victor loved Picasso's work in all its variety, and in 1946 he acquired one of the artist's most beautiful, wildest engravings, *Woman with a Tambourine*, which dates from the first half of January 1939 but which was only printed in 1942 and published by the Leiris Gallery in 1943 [Baer 646]. Perhaps unconsciously, he understood the bacchante's

On the Ganzes' staircase, Picasso prints

75

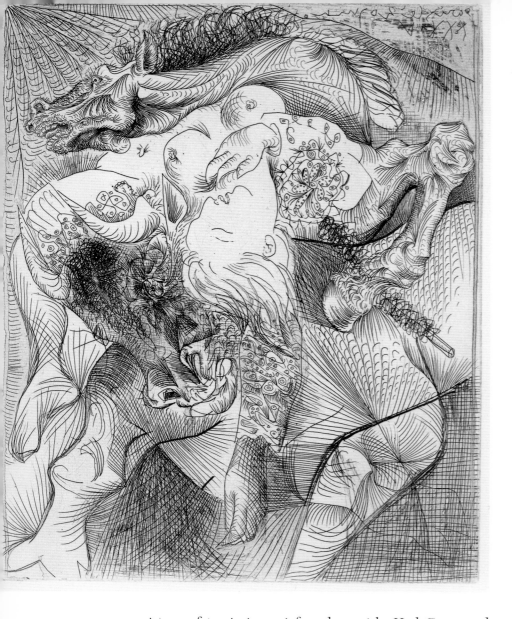

mixture of tragic joy, grief, and anguish. Had Ganz read Euripides? Did he know Pentheus's fate? Probably no better than Picasso himself did! But the Greek tragedians aimed at the center of the target, the deepest reaches of the human soul, the unconscious. Picasso, who had lost his mother on January 13, 1939, after one of those idiotic accidents (she fell and broke her spine while dressing behind the closet door out of decency because there were children in all the beds—civil war was raging in the Barcelona streets at the time), started off by setting the upper body of a maenad onto the lower body of a woman at her toilette, which he borrowed from Edgar Degas, the master of unstable balance. Probably without realizing it, he was fretting over his mother's fall, for neither the woman figure nor the composition had equilibrium, and despite everything he kept struggling, in two further states that he worked over elaborately, to keep his woman in the original

position. Only in the fourth state (the last being just a refinement) did he decide to resort to the master of equilibrium, Nicholas Poussin, and to the maenad from *Bacchanale* in London's National Gallery; he scratched out the leg thrust to the rear on the aquatint ground, which was later restored.

That was the stroke of genius: the woman and the plate both achieve their balance; the maenad becomes wild, and the plate, doubtless from that erasure which leaves a hint of what lay underneath, becomes a veritable "vision," simple, fluid, with no hint of the enormous labor that was required to get to the final result. The maenad is like some handsome, huge butterfly pinned on black velvet. And more—it is also the mother of Picasso's childhood, gay, dancing (she was half Málagan, half Italian), and so fascinating to her young firstborn son that an indissoluble bond was formed between them. The maenads became for Picasso the "sign," the symbol if you will, of the hand-to-hand combat in the streets, and in fact it was just about when he must have completed his engraving that Barcelona fell to Franco's Falangists. Picasso, as we know, took up the theme again, at the time of the liberation of Paris.

Victor Ganz was not a traditional print collector. His first purchases seem to have followed the artist's taste for violence, but he found one of the three proofs on parchment of *Female Bullfighter* of September 8, 1934—a proof, by the way, that I have never managed to place, a hugely rare proof of a remarkably beautiful and insane plate, extremely violent, paranoid in composition: the poor bull, with his worn, ruined teeth, his "little elephant eyes" that Picasso attributed to Rembrandt, and those close-set, unspread horns that are no great danger to a bullfighter. That poor bull, carrying his love on his back, is assailed from all sides, as if he had fallen into a nest of vipers, and been assailed by puppetlike creatures (look at the wheels

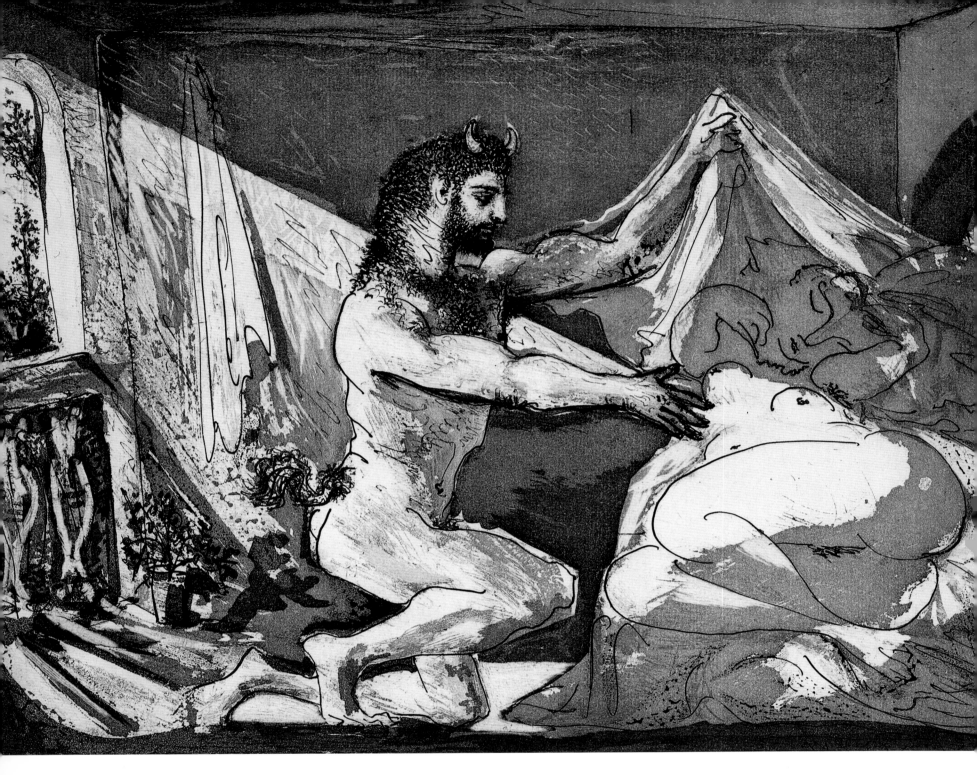

under the horses' hooves). His face (for it's not a muzzle) shows all the rage of human suffering. And then there's no air, no perspective, no space, just plain horror. That plate [Geiser/Baer 433] is a marvel and one of my favorites, signed or not, rare (the signed ones are very rare) or not, because it's the image that is beautiful, that shocks you, that harpoons you, that grabs your guts.

Ganz also had the great *Female Bullfighter* [Geiser/Baer 425] of June 12, 1934. He chose an unsigned proof, much less expensive, which the second-hand dealer had bizarrely numbered as one of twelve. Its lyricism contrasted strongly

with the painting *Bullfight* when they were hung together.

In the late 1950s and into the 1960s, Ganz bought many prints the way a person goes shopping. The images amused him; they were cheery, decorative, and he enjoyed them. Many of these were sold to acquire *Woman in an Armchair*.

There were two *Françoise with Claude and Paloma* (1953) etchings for the children's bedrooms. Ganz also bought some lithographs, such as the four published states of *David and Bathsheba* after the picture by Cranach the Elder in the Berlin Museum, of which Kahnweiler had sent him a postcard. Picasso changed nothing, interpreted

Picasso, *Faun Unveiling a Woman* (1936)

nothing in the composition (which is necessarily in reverse) except for the bush transformed into a succulent plant because the artist did badly with the vegetable world. From that time on, however, he was always obsessed by the characters of Bathsheba and of David. We find Jacqueline as Bathsheba washing her feet or doing her nails, sometimes with an elderly Celestina at her feet, in many drawings and pastels. In March and April 1970 [Baer 1881], he takes up the theme again in another form, introducing (and then suppressing) the husband, Uriah the Hittite, and the notion of "sin" in the form of the severe and fearsome prophet Nathan. Here Bathsheba, very lovely beneath her veil, is the center of the composition in bust and form.

Victor Ganz also acquired several of those very funny and inventive small prints that display Picasso's amusement when he started to learn lithography in late 1945 and early 1946. There is the last state of the big bull [Mourlot 17], which becomes that strange and very funny diagram of a bull with a pin head and miniscule genitalia. There is one of those marvelous plates, made with collaged elements that he could move around at his whim since the forms did not disappear as would have happened with a drawing. The *Bullfight* lithograph of January 7, 1946 [Mourlot 26], is so humorous; the matador has not yet unfurled his *muleta*, so that he looks to be handing the bull a kind of schoolroom slate with something like "It's between you and me now!" written on it. And then there are the *Eight Silhouettes* of Françoise [Mourlot 29], of January 29, 1946—a charming print on which découpages make an open space on the scumbled ground of lithograph ink.

Then Ganz threw himself into linoleum prints. They were graphic and strong and at the time inexpensive enough so that one could have a lot of them to hang in a series on the walls.

The matrix—the linoleum itself—is worked by the artist (at least in Picasso's case), but it is a soft material that carves easily with a penknife. Children make them in school. As one knows, it is the relief that prints, as in woodcuts, but the labor is much less difficult. Afterward the linoleum, set on a block as type once was, is printed at high speed by a typographic press, each proof coming out exactly like its fellows. The inks, which are also industrial in a late Léger palette, have no variation; they are opaque and completely cover the color beneath (except when the artist is after some special effect such as, for example, Picasso's cream-white on black, which makes a blue-gray).

It is important to realize that Picasso invented his trick of piling colors one on top of the other generally using only one single linoleum block. Usually, for any print in colors it is necessary to have a separate block for each color. In 1958 (after a failed effort on July 3), on July 4, Picasso attacked an interpretation of Cranach the Younger's *Portrait of a Young Girl* from the Vienna Kunstmuseum [Friedlander-

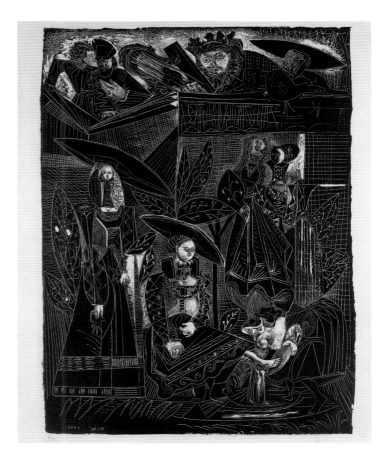

Picasso, *David and Bathsheba, after Cranach* (1949)

79

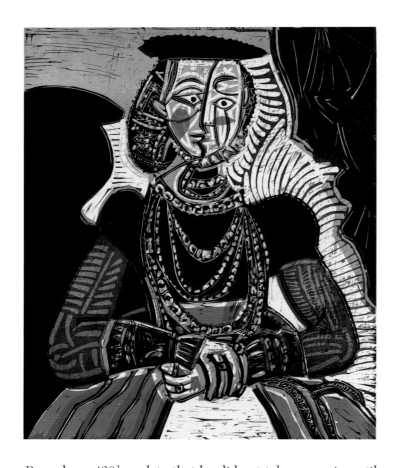

Rosenberg 430], a plate that he did not take up again until December, what with the difficulties of matching the five blocks and the troubles he encountered with another plate begun in December, a portrait of Jacqueline [Baer 1054]. He finished the Cranach in December; Arnera was assigned to find a product that, if added to the inks and left with enough time to dry between passes, would make the color cover. Apparently it involved a thing I know nothing about, being neither a chemist nor a paintseller, but which is called, or was called, "Wonderpaste." For better or worse, the Cranach got done [Baer 1053]. The one thing that always astonished me is this: why *this* portrait (another postcard from Kahnweiler)? I suppose it amused Picasso because Cranach's Cranach looks like those pictures that people used to have taken at street fairs and that delighted the Surrealists: you put your head, your face, through a hole cut out of a painted panel, showing a ship's captain or the Mona Lisa or a dancer doing the flamenco or the

French can-can, and so on, and the photographer took your picture. That's exactly what this portrait looks like, with its licked-clean, static face, its style totally different from that of the gown and the hangings.

Picasso pondered (certainly not continuously) until August 23, 1959, and in the calm of Vauvenargues he hit on his "gimmick," which undoubtedly he alone had a sure enough hand to carry off, given that the final composition must be in mind from the start. On a solid ground he printed a block on which he had carved, hollowed out, his "subject" (as framers say); he did this in a color resembling linoleum—milk chocolate or chestnut. Arnera printed enough proofs to cover any accidents (about eighty at the start, then in 1962 a hundred). Picasso took back the block, cut out everything he wanted to keep brown, leaving only what he wanted to print in another color—at that period, black. Then the proofs went through the press again, for the black, and the thing was done. That process produced, probably on his return to Vallauris, the five little corridas [Baer 1219 to 1223]. When he had doubts, he enhanced a proof from the first printing with China ink to determine exactly the area to preserve for the black.

Later on, there was nothing left to do but elaborate on the process, piling one color on top of another until sometimes all that was left on the block was a few curves, as in the black state of *Still Life with Hanging Lamp* [Baer 1313].

In the summer of 1962, the artist had exhausted his interest in linoleum printing and did not use it again except as a favor to someone, or to salvage a print of the *taille douce* sort: those were the "rinsed" linogravures. But by 1967, Victor Ganz had moved on from Picasso, although not entirely, because he did after all keep his "real jewels."

Translated from the French by Linda Asher

Picasso, *Bust of a Woman, after Cranach the Younger* (1958)

Picasso, *Still Life with Hanging Lamp* (1962), detail

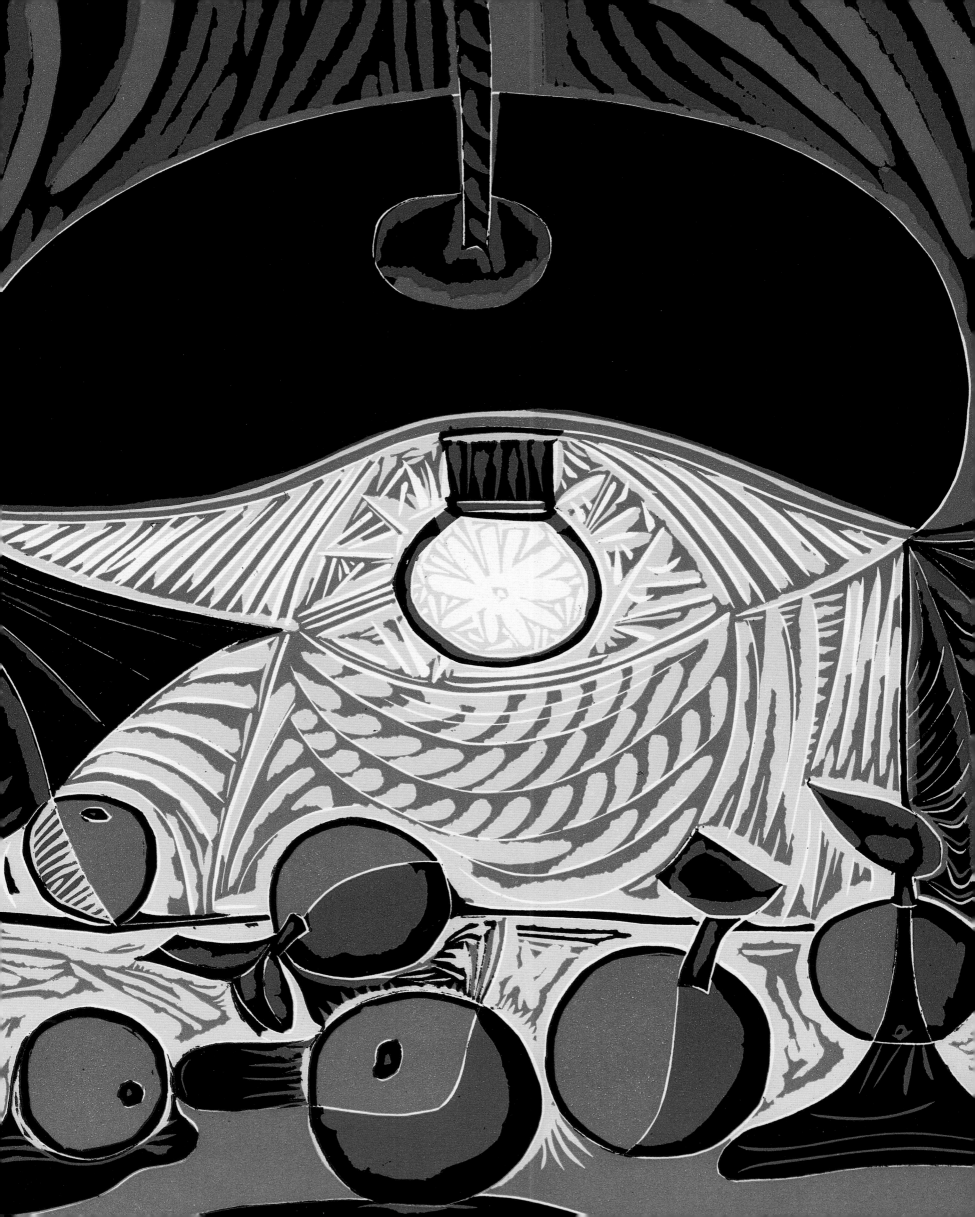

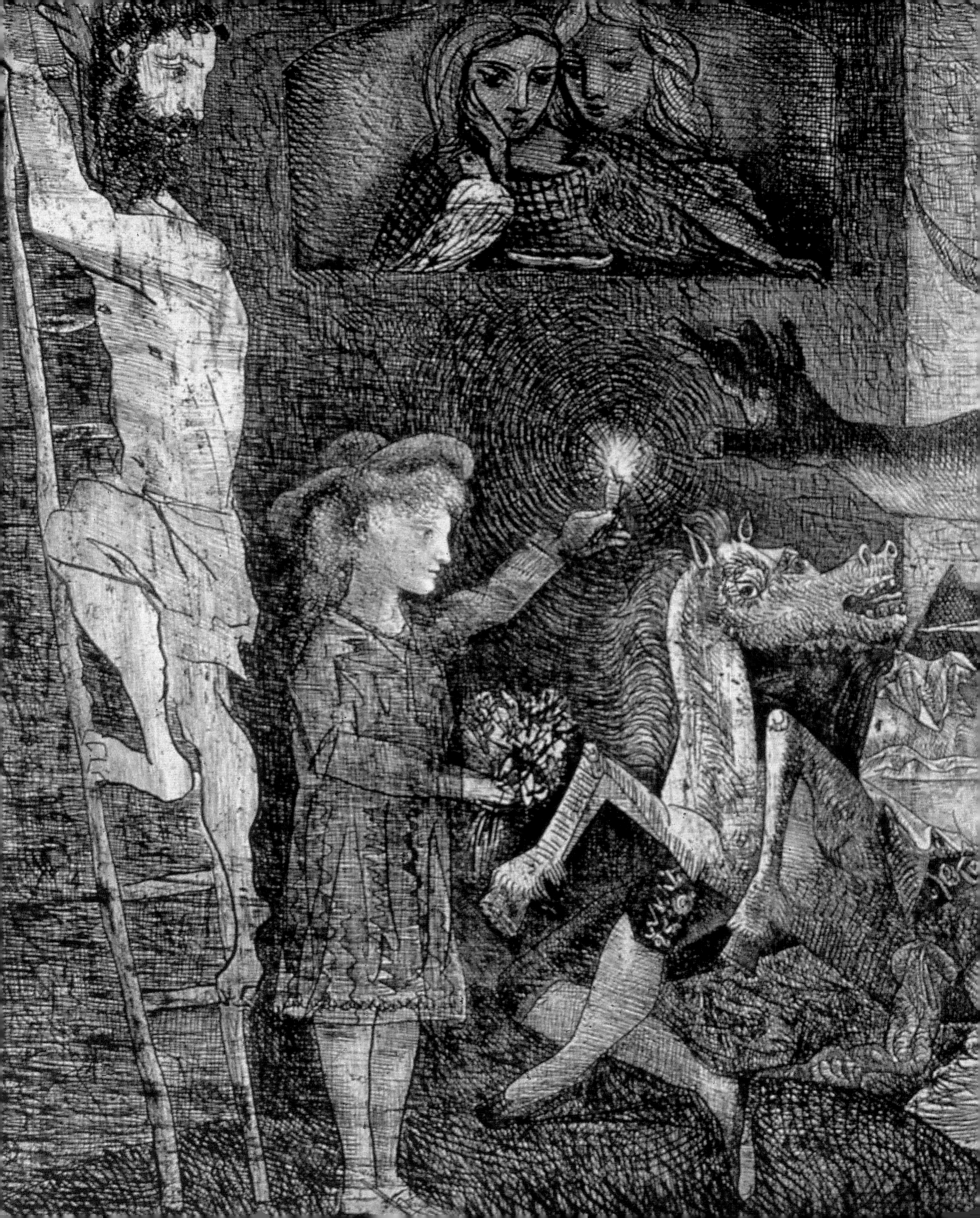

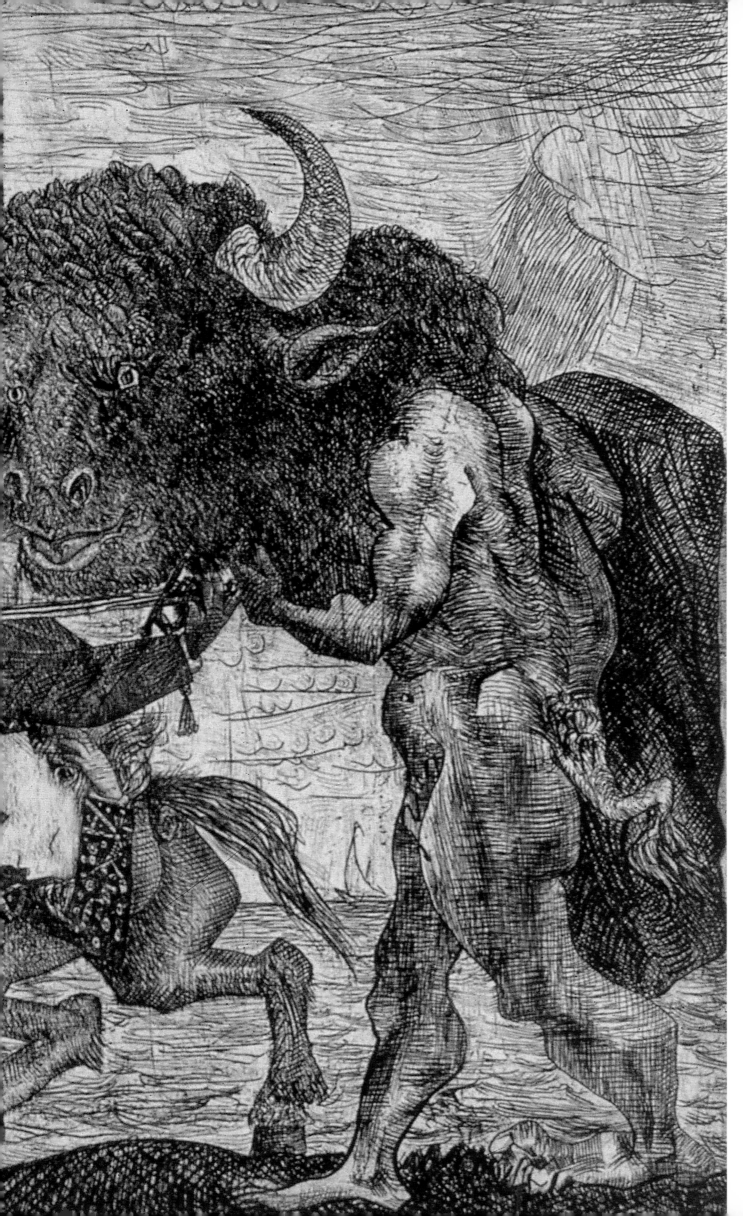

Picasso,
Minotauromachy
(1935)

LEO CASTELLI

AN INTERVIEW BY MICHAEL FITZGERALD

MF Victor and Sally's first acquisition from your gallery was the *Flag* drawing by Jasper Johns, which they bought on February 28, 1961. Had you met them a long time before that date?

LC Probably, yes, but our relationship developed as they became more and more interested in contemporary American art, especially because, before that, their focus was almost entirely on Picasso. Then we developed a friendship in part because I had a number of artists they became interested in. So, thanks to Victor and these circumstances, we became very good friends

MF How did they make that courageous decision to shift from exclusively collecting Picasso?

LC Victor did not listen to what other people said. He just made his own decisions. He looked carefully, very carefully. He wasn't one of those people, like most, who just see an exhibition and forget about it. He thought about it. He wanted to know all of the information—how it came about, what were all the steps. He was, I wouldn't say unique, but he was almost unique. He was so interested in everything about the artist. From devoting all of his efforts exclusively

to Picasso for a long time, and perhaps in part due to our relationship, he got interested in some of the artists in my gallery, most of whom were related to Picasso. So that was how it started. And Victor decided to follow them. And then there was no end to it. He wanted to know everything that an artist had done. Nothing he did was superficial. You didn't have to tell Victor anything. Victor had a very deep interest in what was going on. Of course, The Museum of Modern Art was the first thing he was interested in. And in order to make his choices, he went to the various galleries that had the particular artists he was interested in. The Museum of Modern Art was certainly the starting point. When he got interested in something, he was immensely thorough and never gave up.

MF Did he spend a lot of time in your gallery?

LC Oh, yes. I would say that Victor was almost unique in the way he looked at paintings. Lots of people look at paintings carefully. He did it in a very special way. He became interested in a little detail and then related it to what the artist had been doing before making that particular painting. He was very thorough. I don't know anybody who had

that same kind of intensity about looking at art.

MF Did he often visit artists and talk with them a great deal?

LC Well, he got to be friendly with some of them, especially those artists one could talk to. These relationships were very important for him. He was very thorough, very scholarly. He was an amateur, yet he knew more about everything than most museum people or other professionals.

MF Did he also read a great deal about art?

LC He read a great deal, but what made him really special was how carefully he looked. Other people, good collectors and museum people, look at paintings—as we all do. But he had a way of thinking and thinking. He would analyze a painting, dissect it in a way that hardly anyone else I knew at that time did. He was quite exceptional. He went from Picasso to artists like Rauschenberg and Johns. He made a big step and got interested in artists other than Picasso.

MF Did he think of Johns and Rauschenberg in relation to Picasso—perhaps as the equivalents of Picasso in our time?

LC Well, he certainly drew his conclusions because he didn't do anything casually. To begin with, he did relate everything that he saw to Picasso. Then, little by little he got interested in artists like Johns and Rauschenberg—independent of Picasso.

MF One of the ways he seems to have been unusual was that he chose to focus on a relatively small number of artists rather than entire movements.

LC Yes, he did that because he thought they were important artists. He saw certain things in them that he could relate to the other artists. He worked with the idea that there are a few artists who are basic and that the other ones are more or less related to these. He had that capacity for making decisions and not wasting his time and not looking at things that were not important.

MF When he was developing a group of pictures by, for example, Robert Rauschenberg or Jasper Johns, did he choose the pictures because he believed that individually they were great, or was he trying to represent the artist's career?

LC He wanted the best, but he also wanted specimens that showed other aspects of the artist. He didn't think that there were only masterpieces around. He wanted works that contained fresh, new elements and other directions that might lead to masterpieces. He was very thorough.

MF What was he like as a person? Did he talk a great deal or was he more contemplative?

LC He was rather quiet, but when he talked, it was for a purpose. It was not just for the sake of talking. There was some kind of economy about that. There are collectors who are very enthusiastic and go ahead and put together the collection. In his case, it was all very carefully thought about and studied. If he did anything, it was related to certain ideas he had developed about an artist or a certain movement in art.

Victor and Sally at Leo Castelli Gallery, c. 1969

MF So, generally he would study an artist's work and career before buying?

LC Before. After. To what they were related. To whom they were related.

MF He was thinking of them in the context of the history of art?

LC Oh, absolutely. He was more than a professional. I wish there were other collectors or other people in the art world who had that kind of passion.

MF Do you have any thoughts about why he chose Jasper Johns as the first artist he would collect after Picasso?

LC Well, he had a certain idea about the development of contemporary art. The first departure, as we know, was Picasso. And then Victor tried to find people who in one way or another were part of the main current that started with Picasso.

MF Would you say that he saw a particular affinity between Picasso and Johns?

LC Oh, yes. He thought that most of contemporary art derived in one way or another from Picasso, that Picasso was a sort of father for most of the artists of our time.

MF Was it important for your artists to be collected by someone who had this collection of Picassos?

LC Of course. To be in the Victor Ganz collection was really an honor for them, a distinction that the artist could stand up to that competition.

MF And did it help develop their reputations?

LC Oh, yes. Collectors, museums, professionals would closely follow what Victor was doing. All in all, he was the best collector that we had.

MF He was able to go through so many generations of artists—from Picasso to Johns and Rauschenberg and beyond. Eva Hesse, for example.

LC Eva Hesse, well, she died young. Nobody, or hardly anybody gave a thought to her. Victor discovered her and the way she developed out of Picasso. He was, well, ahead of his time.

MF So, even with Eva Hesse, would you say that for Victor, the roots of her work were in Picasso?

LC Yes. He discovered the historical roots.

MF As we said, he focused on particular artists, not necessarily ones that others would choose?

LC Absolutely. He was not one of those who followed trends. He could get interested in an artist for some initial reason and then he would follow up on that interest with great research. He operated as a professional, not just on impulse. I wish there were more like him.

MF Would he go out and hunt for new artists, or would he wait for you to bring them to his attention?

LC He had to rely on me and on other sources for information. He had a business to run. He couldn't spend all of his time looking around for himself. But he was very good at making his own choices and pursuing the artists he had chosen. He certainly did buy many important works. Difficult, too. Some were so large that he had to arrange for space in the basement of his house. Whatever was too large for the apartment would go down there. The Stellas were very large at that time and he had a lot of Stellas in the basement. [Laughs] This didn't mean that they were less important. It was just a question of space.

MF That is an interesting demonstration of his devotion to the art rather than to his own convenience.

LC Yes, he had an incredible devotion. Nothing was done casually.

MF He was also very generous in letting young artists and art historians visit the collection.

LC Oh, yes. In a relatively short time he accomplished wonderful things. For anyone who wants to know about this period, they must only look at Victor and apply his lessons.

MF Do you have any idea why he did not buy any works by the Abstract Expressionists?

LC He was not drawn to expressionist art, not just Abstract Expressionism. He would have been delighted, of course, to have a Pollock, but it really was not his direction.

MF He seems to have been attracted to difficult pictures—ones that are large or literally dark.

LC That was not Victor's goal, yet some of them are very large and so dark that you can hardly see a thing. He saw them. Other people didn't. Or, didn't take the trouble to see them. They were dark, but he could see them. And he would always discover things that other people hadn't seen.

MF Do you think he found the difficult pictures more challenging?

LC Well, that's interesting, but I wouldn't suppose that was necessarily the case. Most people don't look. Or, they look sort of superficially. They get an impression but they don't know why. Victor would get that first impression that we all get when we see something new, but then he would analyze why it was so.

MF Did he discuss his analysis of the paintings?

LC Occasionally, yes. With like-minded people.

MF Did he learn a lot from talking with the artists?

LC He learned from everything. He learned from the artists but above all from looking. He enjoyed talking to me, to Bob [Rauschenberg], and to other people who were careful.

MF Art must have absorbed most of his life.

LC Well, he had a business—something to do with plastics, I don't know. It was really of no special importance to him, except to make money to buy art. I wondered how he could stand spending his days in a business that didn't seem interesting from the point of view of art, but that didn't seem to bother him. It was there. It had to be done in order to get the means to buy the paintings.

MF So did he look at art on the weekends, or did he take off time during the week?

LC Oh, well, he became the boss, so he could do whatever he wanted to do. He arranged his life in such a way that the business took care of itself and he could devote most of his time to art. Which means that you have to go to museums. Not just see new shows in galleries every week. It's a full-time occupation. He was a great example.

MF Although Victor was a wealthy man, he spent a great deal of his resources on art. He must have believed firmly in the lasting importance of the work he acquired.

LC Well, he certainly was very careful about it. Sometimes he would become enthusiastic about some young artist who perhaps didn't work out. But generally speaking, he made good choices. And if he got interested in a young artist it was often because of the relationship Victor saw with the other artists' work.

MF What role do you think Alfred Barr played in shaping Victor's decisions?

LC Alfred Barr was immensely important for all of us. He was really a great genius. Certainly, he was important for Victor. Although I would say that Victor probably had a more curious mind than Alfred. Alfred was a little bit rigid. Still, Alfred had a wonderful mind, and he discovered Jasper Johns.

MF That was a remarkable time. Your optimism and willingness to support the artists was crucial. It reminds me of a book that has just been published, *How Proust Can Change Your Life*. One of the lessons is that we should never consider anything boring because if we do, we simply haven't looked at it carefully.

LC Then it seems to me that there is a very good parallel between Proust and Victor. That captures him very well.

JOHNS

ROBERTA BERNSTEIN

The Ganz collection of works by Jasper Johns is one of the most complete private or public collections of the artist's work ever assembled. The works, acquired between 1961 and 1995, included nine paintings and eleven drawings along with over two hundred prints. The paintings and drawings were collected primarily between 1964 and 1975. Of these, a significant number are indisputably among Johns's major works: *Gray Rectangles* (1957), *Liar* (1961), *Diver* (1963), *Souvenir 2* (1964), *Decoy* (1971), and *Corpse and Mirror* (1974).

The scope and consistently high quality of the Ganz collection of Johns's works may be traced to the extraordinary rapport between collector and artist. Victor's person-

ality and his visual and intellectual acuity were a perfect match for the qualities of Johns's art. Victor savored the work's complex, multilayered meanings and appreciated the craft and invention in Johns's use of artistic media of different kinds. He relished following the continuity and change in Johns's constantly evolving iconography and the rigorous logic evidenced in it. He responded particularly to the repressed emotional tone that characterizes so much of Johns's art. In addition, Victor's love for Picasso matched Johns's regard for this modern master. While Victor was the Johns collector, Sally responded enthusiastically to the qualities Victor admired, bringing her own remarkable intelligence and understanding to Johns's work. Both

Jasper Johns, *Diver* (1963), detail

Johns, *Flag* (1957)

detail, in which the numbers 0 to 9 are repeated in sequence twelve times in a grid of eleven by eleven units. By leaving the first space blank, Johns set up a closed system in which the numbers follow sequentially when read in either horizontal or vertical rows. Along the diagonals are alternating rows of odd and even numbers in one direction and rows of like numbers in the other. The unpretentious cerebral complexity of the work, combined with its elegant simplicity, was what made it so appealing to the Ganzes. During the time they lived at Gracie Square, *White Numbers* always hung within view of Rauschenberg's *22 The Lily White* (1949). This rare, early Rauschenberg is a white painting with a numbered game board. The positioning of these two paintings in the Ganzes' home acknowledged their recognition of the profound relationship between the works of these artists.

Figure 2 (1962), one of the largest and most beautifully painted of Johns's figures, remained in the Ganz collection for only a few years, between 1966 and 1969, before they moved to Gracie Square. Individual numerals were among the first subjects Johns took up in 1955 after his first Flags and Targets. He called them "figures" as a pun on figure painting and as a play on the figure-ground dichotomy in art. He began to paint numbers again in 1959 and during the next decade did over a dozen paintings and several series of prints of this subject. *Figure 2* is a dark monochrome, mostly black and gray with traces of white, violet, red, and blue. Johns used a variety of encaustic brushstrokes, charcoal markings, and collage materials. I remember looking closely at this painting with Victor, puzzling over the initials T.B., and noticing intriguing snippets of collage, including a small reproduction of the Mona Lisa. This was the first appearance of what was to become a prominent motif for Johns. In the early 1960s, he combined cryptic autobiographical details and expressive brush strokes to bring an emotional resonance to even the most familiar objects and signs.

Gray Rectangles, the earliest Johns painting that Victor collected, is one of the first examples of Johns's use of hidden imagery. The title refers to the three rectangles in the lower section of the larger square canvas. The rectangles are small panels inserted into the canvas and flush with its surface, accentuating the tangible presence of the painting's canvas-on-stretcher construction. Except for a strip exposing the bare canvas, the entire surface has been painted with gray encaustic in the tight, layered brushwork characteristic of this period. Close inspection reveals that each "gray rectangle" is painted in one of the primary colors, as evidenced by traces of red, yellow, and blue at the panel's edges and as drips visible below the rectangles. In its minimalist construction, *Gray Rectangles* is one of the

Johns, *Reconstruction* (1960)

Johns, *Untitled (Device Circle)* (1963)

most challenging examples of Johns's rigorous examination of the process of perception. This kind of challenge was the "toughness" that Victor loved in Johns's art.

Several abstract works that focused on the painting's physical construction follow from *Gray Rectangles*, including *Tennyson* (1958), *Reconstruction* (1959), *Out the Window* (1959), and *Painting with Two Balls* (1960). The Ganzes acquired drawings based on two of these paintings: *Tennyson* (1967) and *Reconstruction* (1960). In the painting *Tennyson,* two joined vertical panels nearly disappear behind a piece of folded canvas. The overflap of the fold ends just short of the bottom edge, leaving a space where the Victorian poet's name appears as a cryptic inscription. The exposed surfaces are painted in gray encaustic, but drips and traces of color suggest that the hidden sides of the folded canvas may be painted in the primary colors. In the drawing, as in most of his graphic art, Johns translates a three-dimensional painting into a two-dimensional image. Using graphite wash and gouache on a piece of Japanese wrapping paper, Johns depicts the seams and folds of the painting's structure and simulates its monochrome coloration. This work is the last of three Tennyson drawings: a small ink drawing predates the painting, and a chalk drawing was done in 1959.

The drawing *Reconstruction* (1960) is based on another painting using canvas collage. In this painting the canvas was folded over at both ends to create three rectangles stacked vertically. These form three registers of a larger rectangle. As in *Tennyson*, the canvas collage literally reconstructs the space through folding and layering. *Reconstruction* was one of the first paintings in which Johns shifted from the more restrained surfaces of his preceding works to a new style of applying paint. These overlapping, gestural brushstrokes create a spatial illusionism that counteracts the physical presence of the layers of

folded canvas. In the charcoal drawing, Johns followed almost stroke by stroke the black-and-white painting's dynamic brushwork. One of the striking features of this drawing is Johns's inventive use of the white paper. In some places he erased charcoal to simulate areas of the painting where white encaustic overlaps black.

One of the most important works by Johns that the Ganzes acquired is *Liar* (1961). As in *Tennyson*, its title appears as an inscription in the work, bringing ambiguous content into an otherwise abstract painting. Johns originally intended it as a study for a painting but in the process felt the work to be complete as it was. The paper itself is unusual in its thickness and texture conveying the heft of canvas, and it is painted in encaustic, a medium Johns used only rarely for works on paper. Handwritten notations identify objects and materials. The word LIAR appears twice. The mirror-image lettering results from the printing block described in Johns's label as a "wood block with raised letters." Below the printing block is an area made of Sculp-metal meant to serve as the surface to receive the impressions. Presumably, if such a work were constructed, the block, left hinged to the canvas, could be shown either raised or lowered, causing the words to disappear. Johns's involvement with printmaking, which he had taken up the year before, may have inspired this image of a printing device and reversals of lettering.

By 1960 words became a central feature of Johns's art. Earlier, Johns had used words such as THE and TENNYSON that focus on language itself. The color names were introduced in 1959 in *False Start* and *Out the Window*, in which they highlight the relationship between language and vision. In *Liar* and other works from the same year—*No, Disappearance, Water Freezes, In Memory of My Feelings (Frank O'Hara)*—the words take on more expressive overtones, while still engaging in cerebral meditations on

Johns, *Gray Rectangles* (1957)

the nature of art. On a personal level, "liar" might be an accusation from the artist to someone who has deceived him. Or the "liar" may be the artist who sets up quandaries about what is true and what is false. This is a strategy Johns employs in his art to situate the viewer in a position of uncertainty.

In recent years *Liar* and *Tennyson* hung on either side of *Diver* in a prominent position in the Ganzes' living room, a testament to Victor's extraordinary eye for works on paper. Another important drawing acquired the same year as *Diver* is *Untitled (Device Circle)* (1963). The arm and handprint in *Untitled* are reminiscent of the diver's arms tracing an arc. Here, however, the outstretched arm is an isolated fragment framed by a semicircle. The circle has been marked and scraped by a stick across a bumpy surface. An

impression of the stick remains in the circle. The elements of *Untitled* are closest to the painting *Periscope (Hart Crane)* and the lithograph *Hatteras*, both done the same year. All three contain the encircled arm juxtaposed with the primary color names as their main iconographical motifs. In *Untitled*, the "colorless" words RED YELLOW BLUE stand as independent forms besides functioning as signs labeling applied colors. Red, yellow, and blue lines drawn in pastel divide the horizontal registers. A red spot made by spraying paint marks the "red" section but drips down into the "yellow" one next to a piece of yellow masking tape. The fourth register contains letters sprayed with green paint through stencils spelling out the superimposed color names. *Untitled* is an unusual work for Johns in its extensive use of the unmarked sheet of paper. The paper functions as both surface and void, adding to the drawing's complex spatial layering and the play of the opaque and transparent.

Another major drawing the Ganzes acquired in the mid-1960s is *Watchman* (1966). This is the last of four *Watchman* drawings based on the 1964 painting of the same title and the one that follows the details of the painting most closely. This work is now in the collection of The Museum of Modern Art, given by Sally in Victor's memory. The painting contains the first of many incarnations of the "watchman," an enigmatic figure described by Johns in his sketchbook notes as falling "into the trap of looking." The watchman is presented in the form of a wax cast of the legs of a figure seated on a chair. The cast and chair are attached upside down and project beyond the upper right corner of the canvas. The faintly visible color names are painted in gray on gray. Red, yellow, and blue rectangles, reminiscent of *Gray Rectangles*, are centered along the right edge. Using a stick shown resting against a ball, Johns has scraped tonal gradations across the word BLUE. Johns uses graphite and metallic powder wash to

Johns, *Harlem Light* (1969)

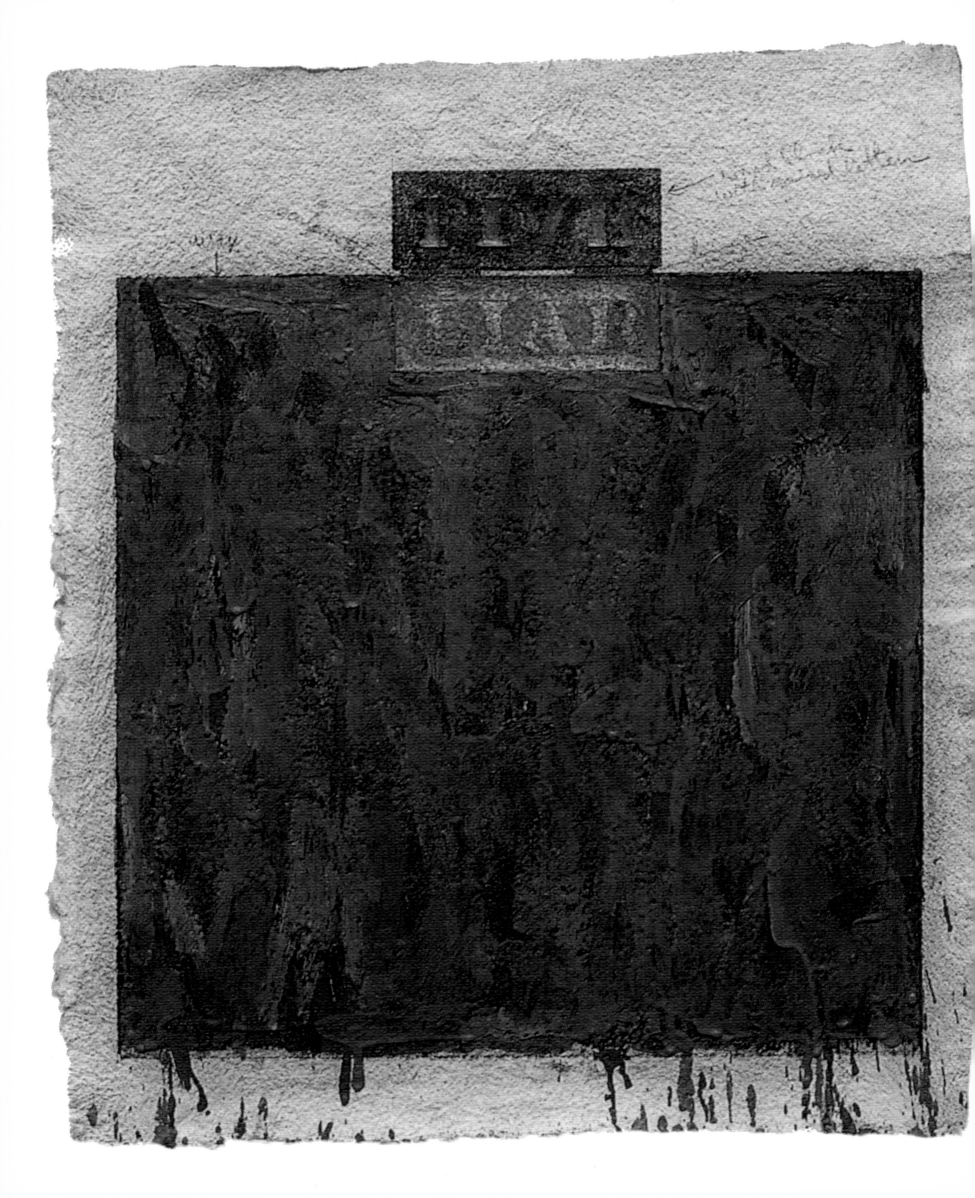

echo the brushing, staining, and scraping in the oil painting. The assemblage objects are rendered in diagrammatic outlines. The upside-down seated figure is shown as a flattened, negative shape traced from a photograph. This may be Johns's first use of this technique for transferring images from one medium to another. The entire image is outlined in white pastel, a detail Johns carries over to the lithograph *Watchman*, done the next year, for which this drawing served as a model. Another detail that is different from the painting is the reference to Edisto Beach, South Carolina, where Johns maintained a home until it was destroyed by fire the year this drawing was made.

The *Watchman* painting was done during his stay in Japan in 1964. During that same visit Johns painted *Souvenir* and its companion, *Souvenir 2*. The pair of *Souvenir* paintings are the same size and contain dishes, flashlights, and mirrors placed in identical positions. The first is painted in gray encaustic and the second in oil with traces of color. The most obvious difference between them is the addition of a smaller canvas displayed backward in *Souvenir 2*. As in Johns's 1956 painting titled *Canvas*, the small canvas is fixed so that its front remains hidden from view. The title comes from the souvenir plates with photographs of famous athletes and family groups that Johns saw in a shop in Tokyo. Johns had two souvenir plates made using his photograph framed by the primary color names, one printed in black and white, the other in color. Johns gave the Ganzes a drawing as a gift with the original photograph used for the souvenir plates collaged onto it. The drawing diagrams the flashlight's beam of light directed to reflect off the mirror and onto the dish. While this effect never worked (and the batteries have long been removed from the flashlight in the Ganzes' painting), it is central to Johns's conception of the piece and the viewer's response to it. The image of Johns on a plate

suggests the artist is offering himself and his art to be metaphorically consumed by the viewer. In describing *Souvenir* in his sketchbook notes, Johns deflected this uncharacteristic focus on himself, ending with an ironic pun: "Thinking anything could be a souvenir of something else, not specifically a self-portrait. Ego was not clear. Maybe another way of dishing up a Johns."

From 1966 to 1971, Johns made works that combined self-conscious links to the past and radical breakthroughs to new images and new concepts. Victor followed this work with great fascination and added several important paintings and drawings from this period to the collection— *Studio II* (1966), *Screen Piece II* (1968), *Harlem Light* (1969), *Wall Piece II* (1969), and *Decoy* (1971). *Studio II* was a work I first saw in Victor's office at D. Lisner & Co., where it hung with a large Combine by Rauschenberg titled *Rigger* (1961) and several prints by the two artists. When Victor retired, these works were moved to the newly created basement gallery at Gracie Square. In retrospect, *Studio II* gains importance as a key piece in Johns's continually evolving theme of the artist's activity in the studio and the physical and psychological aspects of the creative process. *Studio II* and its companion piece, *Studio* (1964), present a new kind of picture space for Johns's art. In the earlier *Studio* Johns imprints the screen door of his Edisto studio, in effect transforming the canvas into a fragment of the studio wall. In *Studio II* Johns imprints windows, creating the same effect. Johns's use of extensive areas of bare canvas, along with a color scheme dominated by white, pink, and orange, creates the illusion of bright light shining through the windows and illuminating the artist's work space. The artist's presence in the studio is indicated by a white-on-white handprint prominently displayed near the center. The artist's tools include the primary colors shown as narrow rectangles along the

Johns, *Liar* (1961)

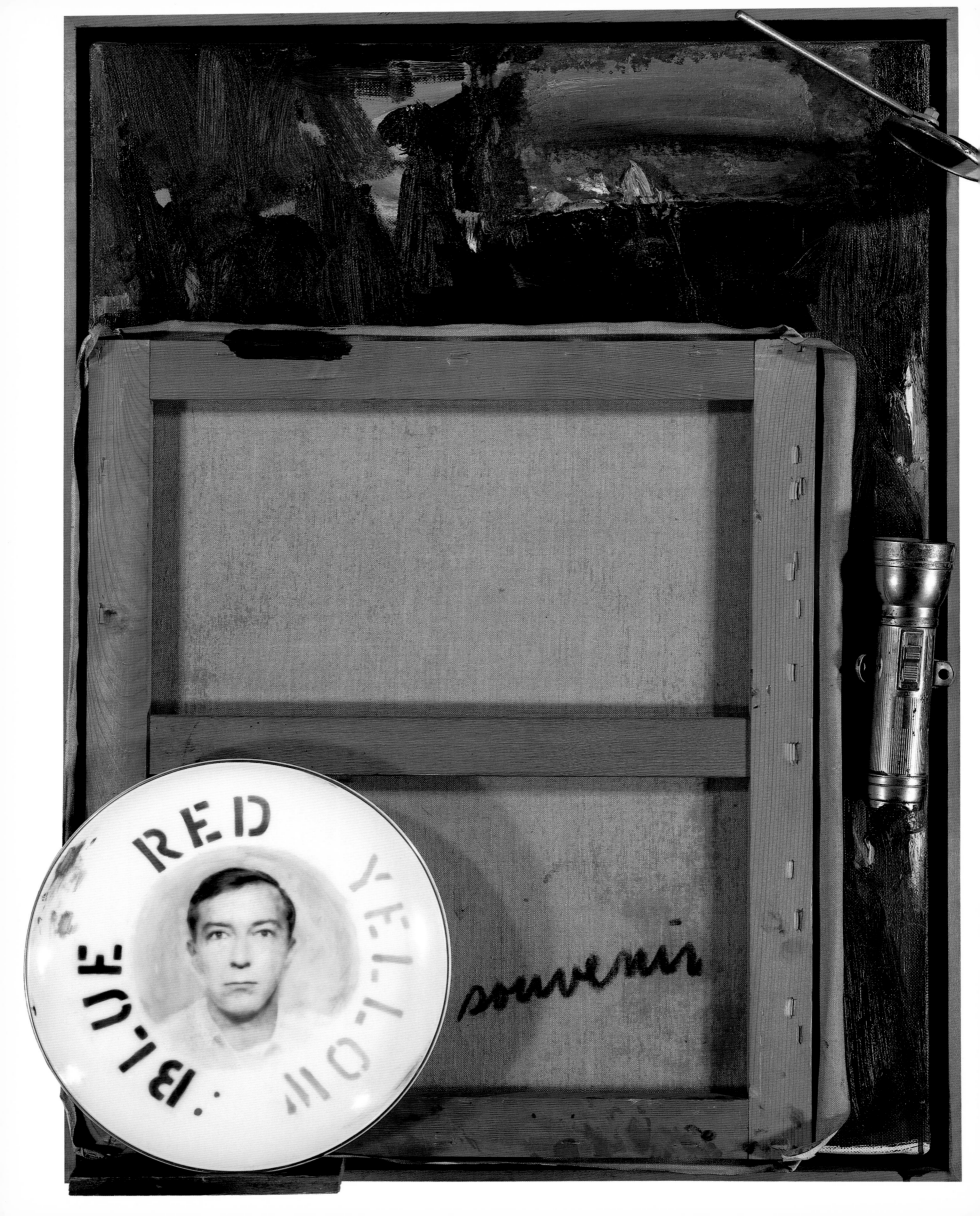

Johns, *Souvenir 2* (1964)

Johns, drawing for *Souvenir 2* (1964–65)

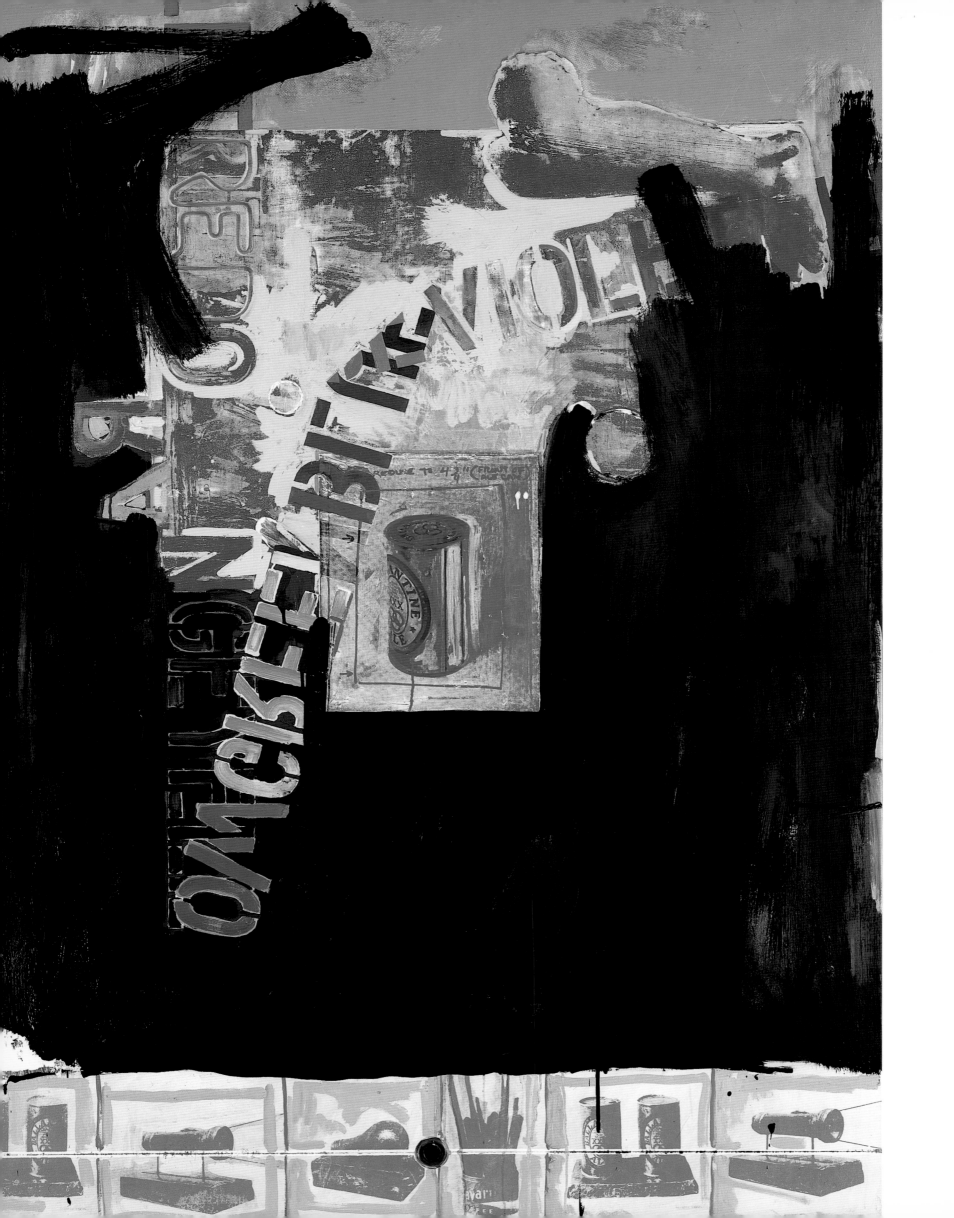

upper edge and a ruler in the upper right corner.

Rulers and other devices for marking and measuring first appeared in Johns's art in *Painting with Ruler and Gray* (1960). Starting with *Studio II* and continuing through *Decoy,* the objects themselves are no longer attached to the canvas. Instead, rulers and other objects are either hand painted, like the ruler in *Studio II,* or silkscreened as in Screen Pieces, a group of paintings from 1967–68 that focus on measurement and scale. Victor acquired *Screen Piece II,* a gray painting with primary colors along the top edge. The title refers to the process of painting through wire screens with meshes of varying sizes, creating a textured, relief like surface. The title also refers to the extensive use of the technique of silkscreening, allowing Johns to use reproductions of objects to alter size and to engage further the issues of instability of measurement and shifting scale. In the Screen Pieces Johns begins to escalate the complex interplay among images taken from different media that culminates a few years later in *Decoy.* The reproduction of a hanging fork and spoon comes from the painting *Voice* (1964–67), via the lithograph of the same title from 1967. In the process of preparing the photoplate for the lithograph, Johns included instructions to enlarge the objects to life-size by writing FORK SHOULD BE 7" LONG. For the Screen Pieces Johns had a silkscreen made from this same photograph enlarging the objects to over life-size. The fork is now twelve inches long, the same length as the silkscreened ruler in the yellow rectangle along the top edge.

Two drawings extend the scope of the Ganz collection of work from this period. *Harlem Light* (1969) closely follows the 1967 painting of the same title. The painting alludes to *Studio II* in its use of an imprinted window, here slightly tilted and projecting out from the canvas. A hand painted ruler is positioned in the same location as the ruler in *Studio II,* and another is silkscreened near the color rectangles in the center panel. To the left is a new motif used for the first time in *Harlem Light,* a pattern of flagstones inspired by the artist's memory of a wall painted to look like stones that he saw while driving through Harlem on his way to the airport. In the drawing Johns muted the painting's luminosity with a veil of gray. He used three overlapping sheets of paper, following the painting's three-panel structure, and used pencil, graphite wash, pastel, and gouache to rework inventively the painting's imagery. In the painting *Wall Piece II,* Johns combined a detail of the flagstones and color rectangles from *Harlem Light* with the hanging fork and spoon from the Screen Pieces. Johns did a pair of drawings in 1969 based on *Wall Piece II,* the first in color, the second, the one that Victor acquired, in black. In the latter version Johns exploited the fluidity of ink on plastic to create a sensuous monochrome of darkened luminosity.

Decoy is a work that combines the cerebral complexity and emotional qualities that the Ganzes admired most in Johns's art. This major work summarizes the themes of disorientation, disintegration, discontinuity, and fragmentation that had dominated Johns's work for the past decade. *Decoy* is intellectually rich and sensuously alive, yet weighted with a dark pessimism evoked by the area of black that surrounds and threatens to obliterate. This large painting, packed with references to earlier works, is full of fascinating interplays of imagery and media. An unusual feature is that the painting follows the details of a print that was in progress and nearly complete when the painting was begun. This represents a rare reversal of Johns's usual procedure in which graphic work follows paintings or sculptures. This approach is particularly apt for a work meant to focus on the nature of reproductions. It is an acknowledgment of the increasing influence of the

Johns, *Decoy* (1971); overleaf: **Johns,** *Corpse and Mirror* (1974)

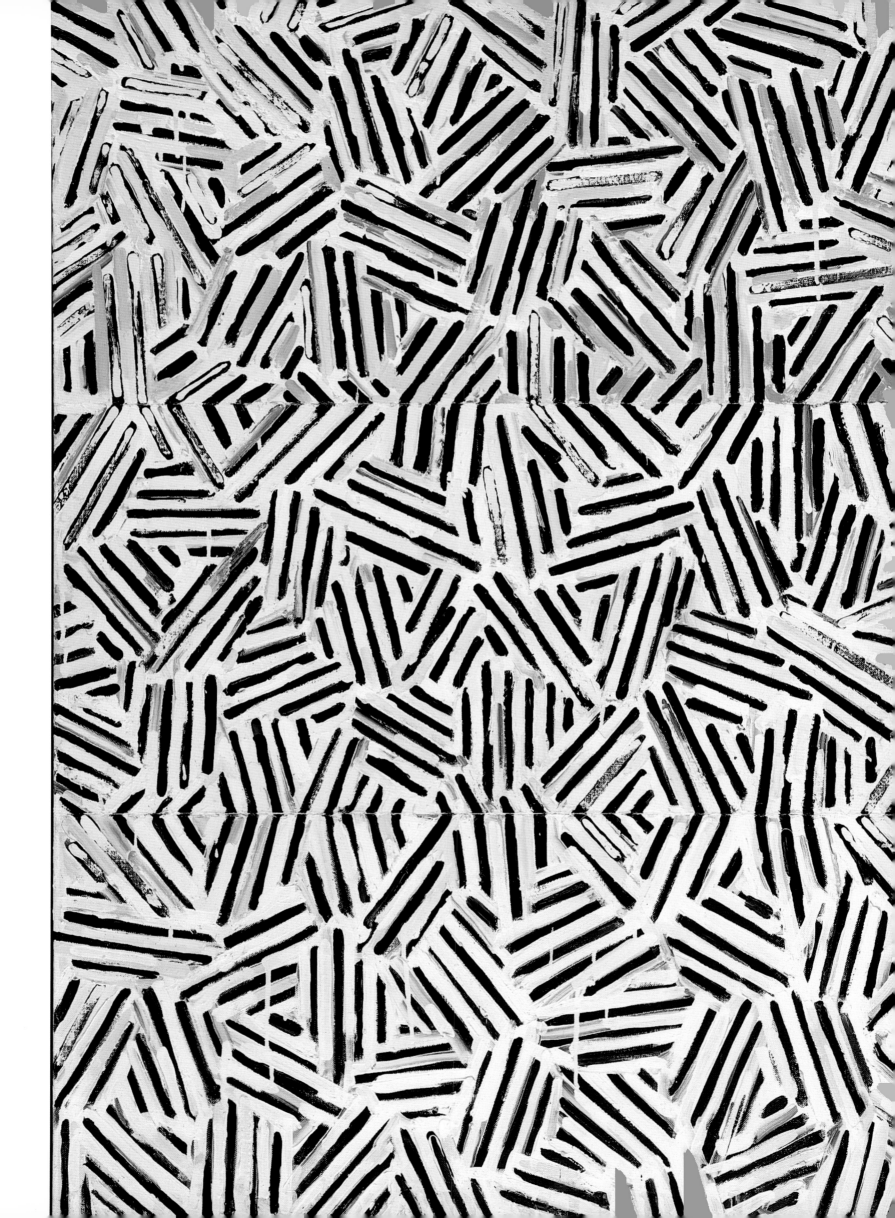

printmaking process in Johns's art that results in the reversal, mirroring, and layering of images. This is most evident in the letters that cut across the picture space, spelling out the full color spectrum as it follows a convoluted path, shifting from foreground to background and reversing direction.

A decoy is something that pretends to be another thing in order to lure or entice into a trap or danger. *Decoy* is a fitting title for these works, in which the artist presents an obsessive cataloguing of things that stand in for other things. The print and the painting both use photographic reproductions to enhance the complicated interplay of illusion and reality and shifting scale. The "watchman," now a smaller fragment of the seated figure, is reproduced by means of a photoplate in the lithograph and a silkscreen in the painting. Another reproduction is the image of a Ballantine Ale can, specifically the one used as a model for Johns's *Painted Bronze* (1960). The artist's instructions to REDUCE TO 4¾" (FRONT OF ALE CAN) are reproduced with the object. In the print the can is 4¾ inches high in true-to-life scale, whereas in the painting it is over-life-size. The reverse occurs with the legs, smaller than life in the print and life-size in the painting. Both print and painting reproduce Johns's sculpture in a predella-like row below the main image. The complicated spatial layering and illusionism are literally punctured by holes in the paper and canvas.

After the complex reworking of his past art in *Decoy*, Johns found a new image that would dominate his art during the next decade. This was an abstract linear "crosshatch" pattern inspired by a design he saw painted on a car that passed him on the Long Island Expressway. One of the first of these abstractions is *Corpse and Mirror* (1974), whose predetermined pattern inspired ideas for ways of relating disjointed parts to each other in the works that follow. These often complicated visual puzzles demand mental concentration while simultaneously appealing to the senses through their luminous colors and tones and rich handling of media. Most have intriguing titles that add an undercurrent of expressive meaning. The title *Corpse and Mirror* makes a cryptic reference to the "exquisite corpse" game invented by the Surrealists, where each player drew a picture on a folded sheet of paper but was unaware of what the others had done. Johns followed the process of the game by painting the three sections of the left panel without reference to each other. He paired this panel with its mirror image, muted with a veil of white and altered by the addition of an iron imprint, a pink brush stroke, and a large x. Johns further differentiated the mirrored patterns by painting the left in oil and the right in encaustic and collage.

Corpse and Mirror was the last painting Victor acquired for the collection. As the prices of Johns's paintings and drawings escalated, the Ganzes continued to add to their already extensive collection of prints and to maintain their avid interest in all of Johns's work. The last time I saw Victor was at the opening of Johns's exhibition of his series The Seasons at the Leo Castelli Gallery in February 1987. Sally and Victor had arrived early, as I had, to see the new works before the crowds arrived. That memory matches my first impression of Victor's visceral and intellectual responsiveness to John's work. None of us knew the importance of Picasso for The Seasons when we first saw them. Victor must have been fascinated to learn that the series was inspired by Picasso's *Minotaur Moving His House* (1936). While he knew how much Johns enjoyed looking at the Picassos in his home, Victor did not live to see the full extent of the important role Picasso's imagery has played in Johns's later work through his extensive use of imagery appropriated from Picasso's art.

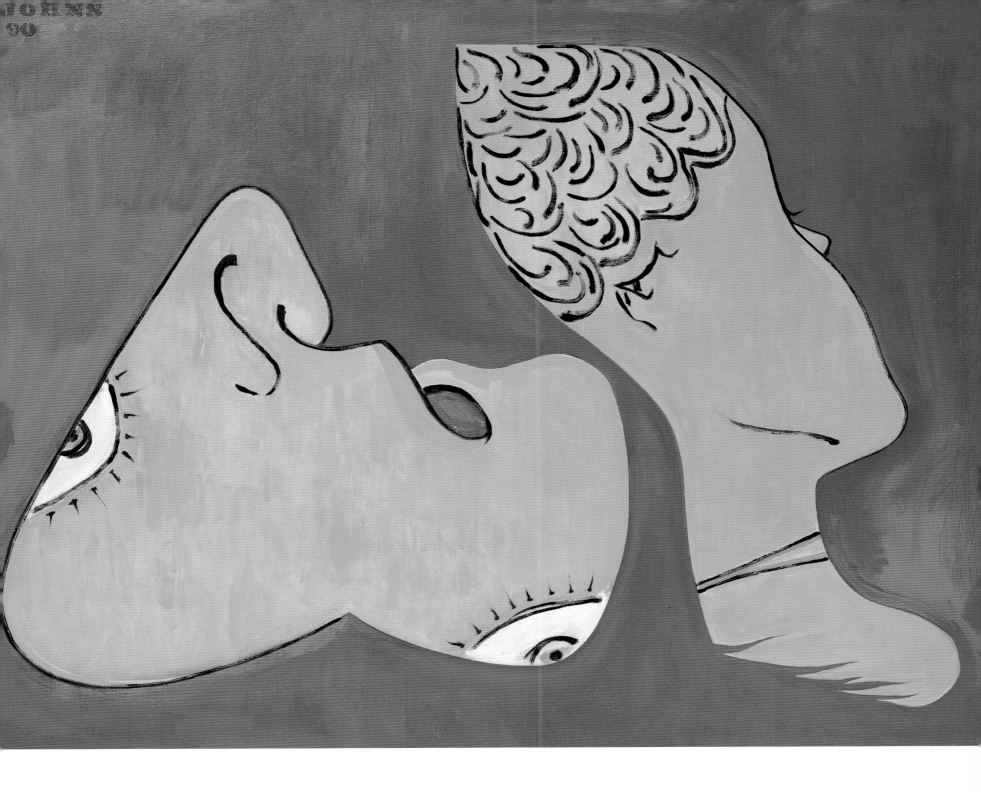

After Victor died, Sally was the primary spokesperson and articulate enthusiast for the collection. While she had never seen herself as a collector, Sally did acquire two works, both by Johns. Her choice reflects a profound, personal connection to these pieces. One was *Untitled* (1990), with its eccentric color scheme of pink and green and its cryptic, abstracted women's faces, one borrowed from Picasso. The 1995 mezzotint is another variation on the obsessive faces that haunt Johns's recent work. Sally loaned several pieces to the Johns retrospective at The Museum of Modern Art that opened in the fall of 1996. She enjoyed the role of lender to this exhibition and took great pleasure in seeing the Johns pictures she had lived with placed within the full context of his work. Sally savored the opportunity the exhibition afforded to affirm her family's long-standing association with Johns and his work and to participate in celebrating it with her friends.

Johns, *Untitled* (1990)

PICASSO, JOHNS, AND GRISAILLE

DAVID SYLVESTER

One hesitates to suggest that anybody as tough and intelligent as Victor Ganz was not the master of his fate, but, given the time when he started to collect and given his obsessive, relentless mentality, it seems quite unsurprising that his collecting began with Picasso and long remained fixated on Picasso. It began just four years after the making and showing of *Guernica* and two after Alfred Barr's exhibition and monograph, *Picasso: Forty Years of His Art*. And the great impact of those events upon the public did not come out of the blue. There was already a far larger literature on Picasso than on any other modern artist, and at this time it was virtually a point of faith that the most interesting modern art was that which inspired the most exegesis. So Picasso was a supremely puzzling and protean and demanding artist who constantly made you sit up and take

notice, whereas Matisse lulled you (hadn't he said as much himself?) and Mondrian was a monomaniac who gave you nothing concrete to talk about. It was no contest. Victor was monotheistic for twenty years.

When he finally started going after strange gods he might have got involved, as other distinguished American collectors did, in the two great Europeans of the next generation, Giacometti and Dubuffet, who had found solutions to the overwhelming problem of working in Picasso's wake. Or he might have got involved in some of those artists—Gorky, de Kooning, Rothko, Still, Newman, Pollock—who had lately been making American painting great. What he did do was to skip a generation. In 1961 he bought a Jasper Johns and, after a gap, other Americans a dozen or more years younger than himself: Rauschenberg, Stella, Twombly, Morris, Smithson, LeWitt, Marden, Tuttle, Hesse, Rockburne, Bochner, et al. At the same time

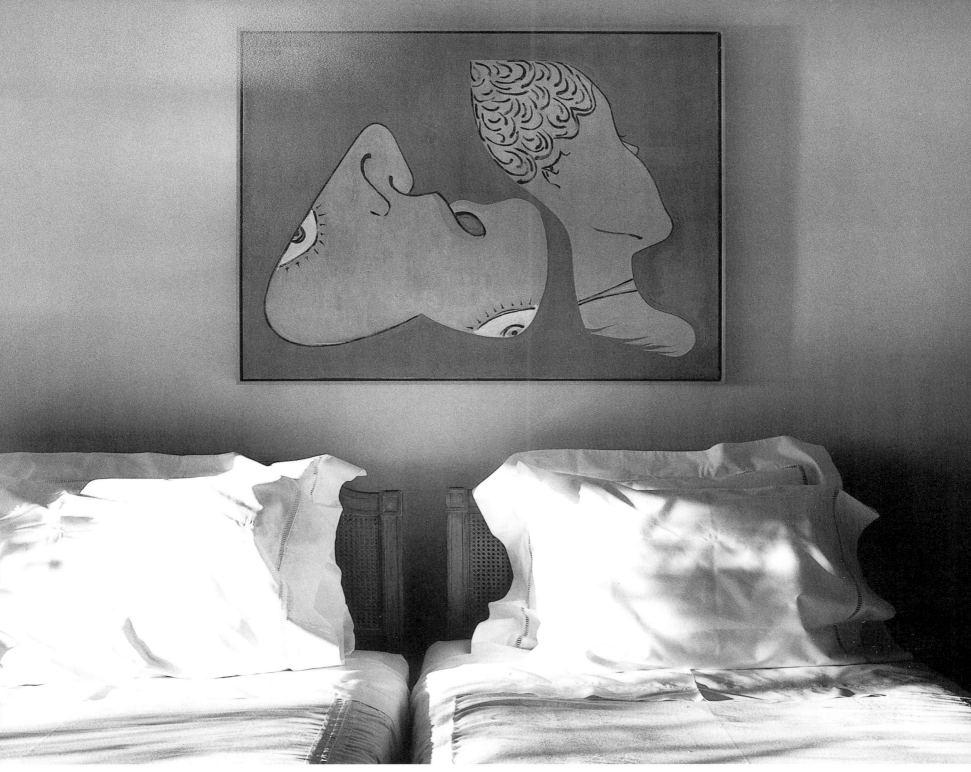

In the Ganzes' master bedroom, Johns, *Untitled* (1990)

he went on buying his chosen European master, who was thirty-odd years older than he was. It was a very distinctive collection.

As one wandered around the Ganzes' apartment, the collection seemed a lot less varied than it did on paper, seemed very much dominated by two artists, Picasso and Johns, not least because the corridors and staircase were so full of their prints and drawings. To set the record straight, this was partly because their work fitted physically into a

New York apartment; a gallery in the basement below was dominated by Rauschenberg and Hesse, while Stella ruled in Victor's office in another part of town. Still, it can fairly be said that at home Victor and Sally and members of their family lived in an environment created by Picasso and Johns plus an eclectic selection of distinguished furniture and hundreds of framed snapshots of the family.

The ubiquity of those snapshots made it clear that, while there was a great deal of great art here, this was no

museum. Further bearers of that message were the table-lamps stuck in front of many of the masterpieces. (Johns told me long ago that the lamps were what he especially liked about the way the Ganzes hung their pictures.) All this insistence on domesticity would not have been surprising if the pictures had been by Renoir or Modigliani, but most of these pictures were extremely severe and uncompromising. While the Picassos included two of his brightest and most rapturous images of Marie-Thérèse, they did on the whole tend to be pretty harsh and brutal, or at least abrasive. And the Johnses too were mostly difficult works, albeit difficult in very different ways. Indeed, Johns's profound differences from Picasso must have been one of the factors that made him attractive to Victor. At the same time, there was one quality Johns and Picasso had in common that strongly suited Victor's taste—their mastery of grisaille, the more somber the better.

The fundamental difference between them is that there has never been a more forthright artist than Picasso, one who makes his meanings more palpable, and that there has never been an artist more enigmatic than Johns, one who provokes more questions and uncertainties. Turning from content to form, there's the primordial difference that Picasso is a linear painter, Johns a painterly painter. And as a pictorial architect Johns was for a time effectively in total opposition to Picasso. Throughout his career Picasso swallowed up the great structures of the mandarin tradition of Western painting and regurgitated them in demotic idioms. Johns started his career as if all but the most rudimentary forms of design were proscribed. Symmetry was good. Diagonals were out. Series of equidistant parallel lines were highly approved, giving rise to stripes, concentric circles, and checkerboard patterns; the rectangle of the canvas or the sheet of paper frequently had a floating rectangle set within it, or was divided into two or three vertical rectangles or three or four horizontal rectangles. All this was given life through the introduction of numbers, letters, stars, and emblems such as a schematic hand, but above all through the fact that the elementary, standardized frameworks were filled with and bent by free, nuanced strokes of the brush or charcoal or pencil.

The work was focused on this interplay between austere impersonal structures and conspicuous personal marks, and Victor tended to acquire examples in which the antithesis was confrontational: the pastel *Flag* (1957), *White Numbers* (1959), *Liar* (1961), and *Diver* (1963) (the huge drawing which, with that dialectic in mind, I have described elsewhere as a Newman done over by Rembrandt).

Halfway through the 1960s Johns, probably inspired by Rauschenberg, started producing far freer compositions. Victor bought an explosive example, *Decoy* (1971), a painting at once euphoric and dramatic, a combination of pale sky blue, chalky gray, and transparent purply black that makes one think of Tiepolo. When Johns moved on into his "crosshatch" phase, Victor again acquired an elegantly beautiful example but one that also reasserted his love of grisaille, *Corpse and Mirror* (1974), a painting in black and white with a patch of ultra-pale pink. His daughter Kate accompanied him to Leo Castelli's when he bought it in 1975. "He chose the one without the distraction of color, the most skeletal, the one reduced to its bare bones."

It was the last *painting* by Johns that Victor acquired, though he went on collecting until his death in 1987. But in 1991 a new Johns painting was added to the collection—the only work of art by anyone that Sally had ever bought or was to buy thereafter. It was an extremely uncompromising piece, probably the toughest Johns in the collection. Sally hung it over their twin beds, removing a large and magnificently powerful Picasso, *Reclining Nude* (1942), to make room for it.

Painted in 1990 and untitled, the Johns is a hard, sardonic picture consisting of two grass-green shapes floating on a flat hot-pink ground. Both shapes are versions of found caricatural images of the human head which Johns started quoting continually in the mid-1980s, quite often in the same picture: a double-take image, a drawing by W. E. Hill published in 1915, which can be seen from one angle as the head of a pretty woman and from another as that of a crone, and a Picasso head of 1936, *Woman in Straw Hat*. Johns's choice of the first image is not puzzling; he has a taste for ambiguous images—such as the famous drawing that can be seen either as a duck or as a rabbit—and Hill's is one of the most ingenious examples. The choice of the Picasso is more surprising. It is a very peculiar Picasso, grotesque and rather gratuitously ugly, in that its ugliness makes it more repulsive than expressive. One may well ask oneself whether Johns didn't take pity on it the way one does when one goes to choose a puppy from a litter and returns home with the runt. But perhaps he chose it for its comic possibilities. At any rate its presence meant that Sally still had a Picasso over the bed.

In most of their appearances in Johns's work those borrowed images are enclosed within a rectangle standing for the edges of a canvas or sheet. In Sally's painting the images are isolated from any background but the one they share: they are simply two adjacent shapes, biomorphic and caricatural—caricatures of caricatures. They make a strange, stark, challenging, but for me reticent, picture. I saw it at the time Sally bought it, greatly coveted her ability to respond to such a difficult Johns, but not the work itself. This reaction was not shared by a young painter, Cecily Brown, who happened to make a first visit to the Ganz apartment shortly thereafter, fastened onto this picture, and looked at hardly anything else.

"On seeing this painting for the first time I was in sudden floods of tears, inexplicable tears which increased the harder I looked. The same thing happened when I saw it again five years later. During the interval I made many drawings and paintings related to it, perhaps in an attempt to understand the effect it had had on me.

"I have tried to pin down what it is that moves me. There is something in the placement of the very particular forms on that ground (painted with confectioners' colors and the detached passion of Velasquez) that disarms me with an overwhelming sense of something like déjà vu. The shapes are at the same time familiar and remote, known and elusive. It is as though their shadows or reflections were stamped onto a part of the unconscious usually allowed to lie dormant—and it's in the effort to locate their likenesses in the psyche that a floodgate in consciousness is opened, allowing a great surge of sensation to enter. It is not surprising that a woman near the end of her life should want to live with this painting, for it seems to embody old age, memory, youth, death, and the passing of time."

VICTOR AND CORPSE AND MIRROR

ROBERT MONK

I n 1975, as a young man working at the Leo Castelli Gallery, I had the great good fortune to meet Sally and Victor Ganz. Most of the important collectors of that time passed through the gallery on the second floor of the town house at 4 East Seventy-seventh Street. They were there to see Leo; most were laconic in conversation, insulated from contact with the staff. Sally and Victor were different. Although close to Leo, they were interested in other members of the gallery as well. Sally was lovely and elegant, with that wonderful voice. Victor, charming, friendly, and open, had a look of animated intelligence that was striking. When they visited the gallery, they would occasionally ask me what I was up to and what I thought of the work currently being exhibited. Often Victor would spend a good amount of time in the main gallery, going from one painting to the next, looking intently and sometimes

discussing the work in detail with me. After a long while Sally would say, "It's time to go, Victor."

In January 1976, Johns had an exhibition of new paintings at Castelli. Victor and Sally had purchased *Corpse and Mirror* (1974) six months earlier. These paintings had already generated a lot of talk both inside and outside the gallery, because of the abstract nature of the "crosshatch" images. Many people in the art world didn't like them or confessed to being totally baffled by them; it is ironic now to recall how negatively some people reacted initially. In one of our frequent talks about the new paintings, I told Victor quite a few people had stopped by the gallery to talk with Leo about these works, or to ask to see transparencies of them. Only Tom Hess, who spent time looking at the work during the installation of the exhibition at the gallery, was able to see quickly that these beautiful abstract paintings also contained elements of great interest both within

and on the surface of the paintings. Writing in *New York* magazine, he described the systems one could see as well as structures that could be built in the mind's eye on viewing the paintings. Victor had discussed Tom's discovery with him and was fascinated by the paintings, and Victor told me one day that he had made a discovery of his own. He mentioned to me a late painting by Edvard Munch titled *Self-Portrait between the Clock and the Bed* (1940–42), which has a coverlet on the bed that strongly resembled the "crosshatch" pattern in Jasper's new paintings. During the opening, when I asked Victor if he had mentioned the Munch painting to Jasper, he said he had. Jasper had smiled and told him he hadn't noticed the similarity, not having

looked at the painting or a reproduction of it recently.

At Johns's exhibition of new work at Leo Castelli's Greene Street gallery in 1984, we were immediately aware that several of the paintings, including *Perilous Night* and *Racing Thoughts*, were much more personal than previous works. Three of the largest paintings were titled *Between the Clock and the Bed.* Each had large and animated "crosshatched" surfaces onto which another smaller "crosshatched" work was silkscreened, at the same angle as Munch's bed quilt. As Victor and I were looking at these paintings, he observed, "But wait, there is something even more interesting about these pictures. Isn't that Duchamp's *Nude* moving across the painting?"

Johns, *Corpse and Mirror* (1974), detail

3/25

JOHNS

SUSAN LORENCE

The first artwork a visitor to the Ganz apartment saw was a small print. *Red, Yellow, Blue* by Jasper Johns is a black-and-white lithograph from 1963 that contains the artist's footprint and the words RED YELLOW BLUE as its central images. This print and its placement speak simply and eloquently of the manner in which the Ganz family lived with the art they collected. Prints, drawings, and paintings were often placed side by side. The apartment was first a home, rather than a contrived space for the exhibition of art, and the collection was as much a reflection of the life of the family as anything else in the apartment.

The *Red, Yellow, Blue* lithograph also served as an introduction to the imagery characteristic of much of

Johns's work of the early 1960s, represented most importantly in this collection by the monumental 1963 drawing *Diver*, one of the extraordinary works in the living room, off the entrance hall. The footprints of *Diver* are echoed in the early lithograph, and impressions of the artist's hands, feet, and face appear in other early prints in the collection, most notably *Hatteras*, *Hand*, *Skin with O'Hara Poem*, and *Pinion*, all also dating to 1963.

Victor and Sally Ganz collected Johns's prints along with his drawings and paintings starting in the early 1960s, and that involvement continued through the 1970s and 1980s. Their print collection reflects an interest in Johns's use of various graphic mediums and an understanding of

Johns, *Red, Yellow, Blue* (1963)

the dialogue in his work between painting, drawing, and printmaking. As collectors they were fascinated by his imagery and use of process and recognized the place printmaking held as a primary medium in his work. In a collection that focused on a limited number of artists, the Ganzes were committed from the beginning to collecting Johns's work in depth.

In 1962, The Museum of Modern Art began acquiring a copy of every print produced by Johns at ULAE. Its founder, Tatyana Grossman, often took the train from West Islip, Long Island, to New York City with new publications. She arrived at The Museum of Modern Art with number

Johns, *Target* (1960)

one from the edition, and at Victor Ganz's office with number two. With the exception of nine or ten very early lithographs from 1960 and 1962 that they purchased in 1964, the Ganzes acquired all of the prints at the time of publication. They purchased all but three of the ninety-one prints produced by Johns at ULAE between 1960 and 1978—the three omissions being the color versions of *False Start* (1962) and the *0–9* portfolio (1963), works that they owned in black and white or gray, and the second version of *Coathanger I* (1960). There was clearly a desire to acquire almost every print that Johns made, but there is no question that some must have been more meaningful to the Ganz family than others, particularly when those prints reflected the paintings and drawings in their collection.

Their first purchase of a work by Johns was in 1961: a pastel drawing with collage, *Flag*, from 1957. Eleven prints with images of a flag or flags in lithography, etching, and silkscreen, and a lead relief, became part of the collection. Notable among these are the three flag lithographs from 1960, in particular *Flag II*, one of only seven impressions. The three together are early examples of a practice used by Johns to great effect throughout his graphic oeuvre: the transformation of an image through alterations in the drawing, ink color, and type and size of paper. *Flag I* is printed in black ink on white paper, *Flag II* in white on brown kraft paper, and *Flag III* in gray on white. Johns reworked the stone for each edition; the three versions together illustrate his practice of creation and re-creation, and demonstrate that the latter can embody originality to the same extent as the former. In Johns's work, transformation is part of the process of reinvention, and in this respect printmaking has been an indispensable tool. Other early examples of this process in the Ganz collection are *Two Maps I* (1966) and *Two Maps II* (1966), *Passage I* (1966) and *Passage II* (1966), *Target I* (1967) and *Target II*

(1969), and *1st Etchings* (1968) and *1st Etchings, 2nd State* (1967–69).

In 1964, the Ganzes purchased the painting *White Numbers* (1959), and the collection eventually included forty-eight prints in various mediums relating to numbers. They purchased two of the three versions of the portfolio *0–9*, Johns's first venture in lithography, although one that would take three years to complete. Innovative and time-consuming, the project involved printing the three portfolios (each in an edition of ten) from one lithographic stone: one set in black, one in gray, and one in colors. This entailed the editioning of ten copies of each of the three

versions of the 0 before it could be replaced by the 1, and the printers repeated this procedure throughout. Each number bears some traces of the previous number or numbers, a result that could only have been achieved through the printmaking process. It was an astounding approach for an artist embarking on his first lithographic project. While the 0 was the first drawing that Johns made on a stone, ULAE had published sixteen other prints by the time the editioning of the portfolios was completed in 1963. The Ganzes included all but two of the sixteen in their collection.

A distinctive aspect of their approach to collecting Johns's graphics was an evident preference for black and

Johns, *Flag II* (1960); overleaf: **Johns,** *0–9* (1963)

121

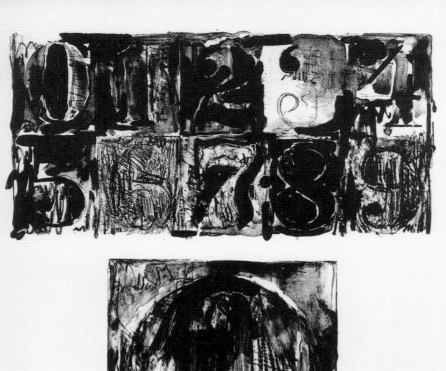
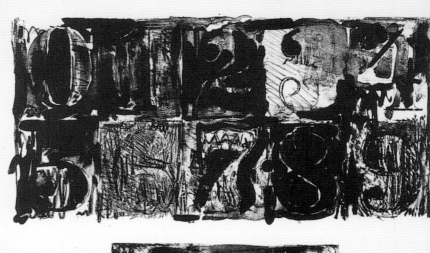

a/c 3/10

a/c 3/10

a/c 3/10

a/c 3/10

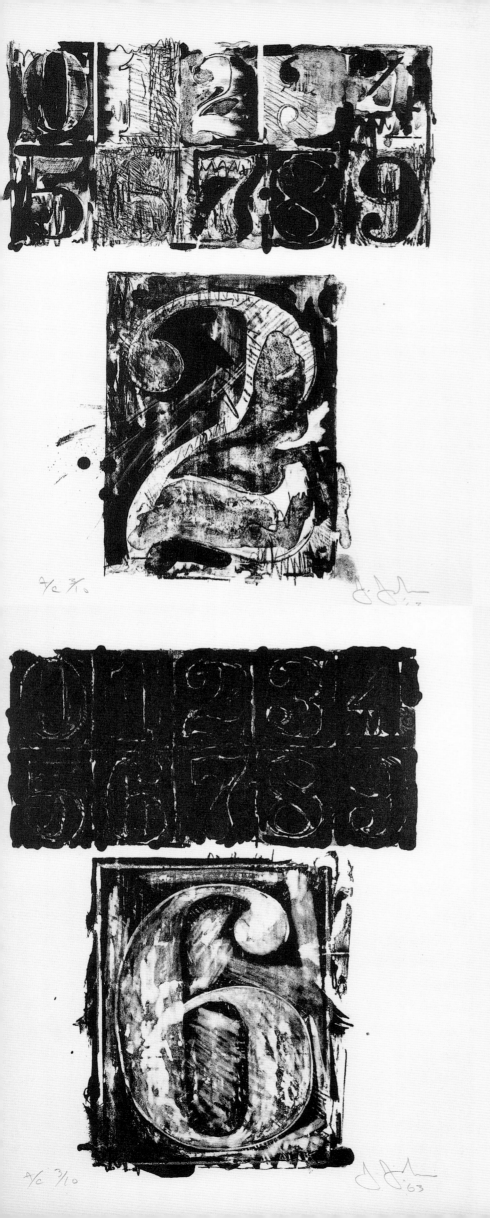
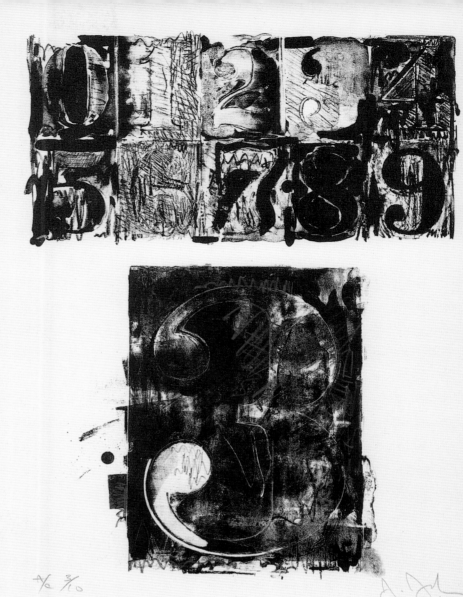
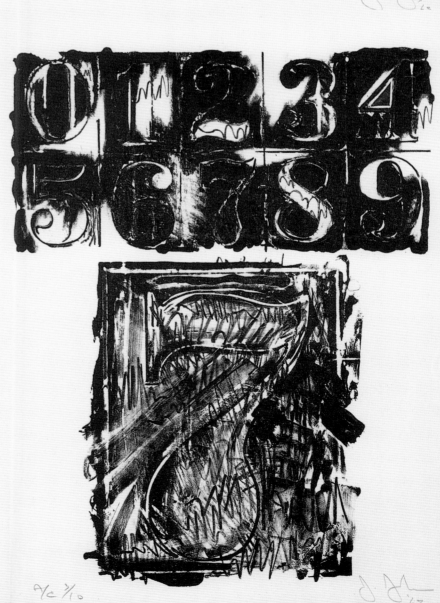

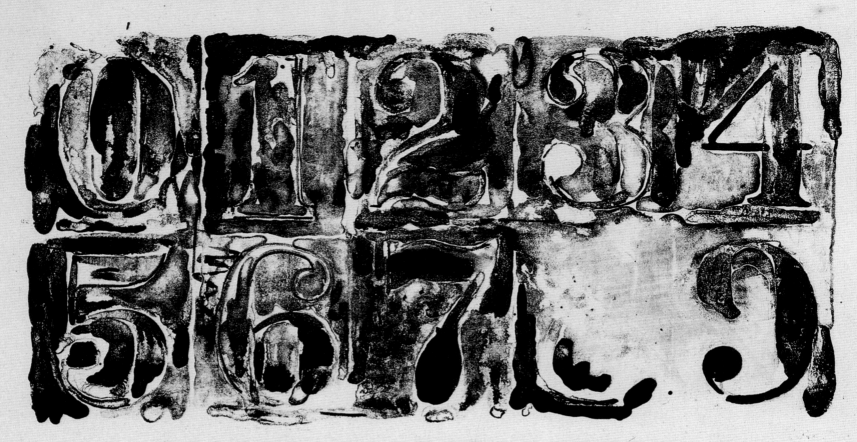

A/C ³/₆₀

AC 3/20

J. Johns '63

had given them in the painting, "fragmenting" them, and making each the subject of a new work. The six prints *Fragments— According to What* are individually titled *Bent "U," Bent "Blue," Bent Stencil, Coat Hanger and Spoon, Hinged Canvas,* and *Leg and Chair.* The Ganzes acquired the series in 1971, and hung the prints in their apartment.

Three years later, when Johns called to thank the Ganzes after a dinner at their home, Victor told him that a water leak had resulted in damage to two prints. Johns suggested that they send the prints to him to see what might be done to repair the damage. He returned the two works after adding watercolor and gouache to cover the water-damage, transforming the prints into new and unique works. Besides changing the orientation of *Bent "U"* from vertical to horizontal, Johns covered virtually the entire surface with marks and brush strokes, and rubbed out and relocated his signature. Victor naturally called Johns to

45/50

Johns, *Souvenir* (1970), detail

thank him, and when asked what he had been up to, Victor replied: "I am pouring water on all the other prints." What he did do was to buy unaltered copies of the two reworked prints so that both versions could hang side by side.

For Johns, an artist whose work revisits its own history, printmaking has been an ideal medium, offering opportunities to reverse or superimpose images and effect changes in their size and color. To reuse an image, one has only to save the original plate or stone, alter it with further work, and print it again. A compelling example of this process is *Decoy*, one of two instances in Johns's work when a print inspired a painting, rather than following it. Here, the Ganzes owned the painting and two copies of both versions, *Decoy* and *Decoy II*, published by ULAE in 1971 and 1973. *Decoy* is a complex and innovative print and represents Johns's first work on a hand-fed lithographic offset proofing press. This process and the use of aluminum plates instead of stones simplified his incorporation of elements from earlier prints.

In traditional lithography, an inked image is transferred directly from the stone or plate onto the paper, reversing the artist's original drawing. In offset lithography, the inked image is transferred from the plate onto a roller, which then deposits it on the paper. This double reversal returns the image to its original orientation. *Decoy* includes images from previous lithographs, *Passage I* and *Passage II* of 1966, a photograph of a Ballantine Ale can, relating to the 1960 *Painted Bronze* sculpture of two ale cans, and the six canceled photoengravings of Johns's sculptures and reliefs that appeared in the portfolio *1st Etchings, 2nd State.*

The Ganzes owned both the *Passage* prints, the lithograph *Ale Cans,* and *1st Etchings, 2nd State.* Typically, these works were not added to the collection after the *Decoy* painting, as a way of assembling its references, but

Johns, *Fragment—According to What—Bent "U"* (1971 and 1974)

had been purchased at the time of publication. For the painting, Johns made changes in scale, and images from the lithograph were screened onto the canvas. Screened photographs of four of the sculptures replaced the frieze of the canceled plates from *1st Etchings, 2nd State*, which appears along the bottom of the print.

Decoy revisits images from previous works in lithography, etching, sculpture, and painting, combining and integrating them into a new work by means of new techniques that changed Johns's approach to lithography. These techniques transformed offset lithography, normally used for commercial printing, into a vehicle for limited art editions. *Decoy* is also the first print in which Johns incorporated elements from other prints. The inclusion of images from his graphic work in the painting *Decoy* was a natural development for an artist who had often made his work the subject of his work. This integration speaks for a consideration of all his work, in all mediums, as a unified body. The Ganzes understood this underlying idea very

Johns at ULAE in the early 1970s

well. Without owning every painting or drawing by the artist, they were able, through their collection of his prints, to possess what was a virtual catalogue raisonné of his work.

After completing *Decoy*, Johns worked at Gemini on a group of eight images closely related to paintings from 1961 to 1964: *Good Time Charley*, *Zone*, *Device*, *Fool's House*, *Souvenir*, *"M,"* *Evian*, and *Viola*. He then reworked each of these to produce a black state. The sixteen prints that resulted follow the compositions of the paintings but use lithographic technique to introduce effects possible only through the use of that medium. All of these works were acquired by the Ganzes in 1972 at the time of publication.

Between 1973 and 1975, Gemini published a series of works referring to the *Untitled* four-panel painting of 1972. The Ganzes chose to buy two sets each of the black-and-gray and color versions of *Four Panels from Untitled 1972*. Editioned in 1973–74 from one stone and twenty plates for the black-and-gray version, and forty-eight plates for the color, the lithograph was printed on four separate sheets of paper. Embossing each of the four sheets with the image from the previous sheet, Johns used a printing technique to suggest the correct sequence of the images.

Corpse and Mirror, a predominantly black-and-white painting from 1974, was added to the Ganz collection in 1975. By 1976, when Johns began work on prints relating to this painting, he had been exploring the medium of silkscreen printing for several years at Simca Print Artists in New York. As he had with offset lithography in 1971, Johns was able to use this medium to convey the nuances and complexities of his work. With multiple screens and transparent inks, he created richness and depth of color and an illusion of halftone that replaced the flat monochromatic tones usually associated with screen printing. The screen print *Corpse and Mirror* (1976) was based on

Johns, *Corpse and Mirror* (1976), detail

Corpse and Mirror II, a 1974–75 painting in primary colors. In order to differentiate the surface of one mirrored half of the print from the other, wax was mixed with the ink and printed through thirty-six screens. Of the three print versions of *Corpse and Mirror*, the Ganzes owned two: the silkscreen and the lithograph, but not the etching. Printed in white on black, the 1976 lithograph suggests a negative version of their painting, reproducing the pattern of hatched marks and other elements, except the imprint of an iron, which Johns replaced with a circle.

In keeping with their interest in groups of work that examine an image from varying points of view, the Ganzes acquired all versions of *Voice 2*, a series of five lithographs produced at ULAE in 1982 and 1983. Relating to *Voice 2* from 1968–71, the prints represent the three sections of the painting, altered by changes in technique, scale, color, and juxtaposition. They illustrate the different permutations suggested by the painting, and are one of many examples of invention through revision that exist throughout Johns's graphic work.

Usuyuki is another image of which the Ganzes owned every version, five prints in all: three screen prints and two lithographs. The fourth, produced between 1979 and 1981, is a screen print in thirty-one colors. Using an inking technique similar to the one for the spectrum in *Figures 0–9*, different color inks were spread on the squeegee that forced the ink through the screen. To achieve a consistent edition of eighty-five impressions in this manner was only one difficulty overcome during the making of this hauntingly beautiful and technically brilliant work.

At the time Johns was working on *Usuyuki*, extra impressions of an earlier screen print, *Cicada*, from 1979, were discovered, and Johns undertook six color variations, each in a small edition. Following the color spectrum, red, orange, yellow, green, blue, and violet were printed over the existing impressions. The Ganzes' acquisition of these screen prints afforded visitors to their home an opportunity to see one of only seven sets of this rare series.

Of the 270 prints produced by Johns between 1960 and 1986, Victor and Sally Ganz owned more than two hundred. The collection reflects both the artist's vocabulary and his range of techniques. The Ganzes' commitment to these aspects of his work was such that when Johns made his first mezzotint in 1995, it was added to the collection, the only one of his prints purchased by Sally Ganz after Victor's death in 1987.

Despite the size of their collection, every print became important as it was acquired. As the collection grew, each work retained its unique focus, yet each functioned as part of a whole, informing and complementing all of the other works. I doubt that there exists another private collection reflecting such acquisitive interest in Johns's work. The collection surely rivals that of most museums. It is a tribute to both an extraordinary body of work and the Ganzes' own vision.

Johns, *Decoy* (1971), detail; overleaf: **Johns,** *Usuyuki* (1979–81)

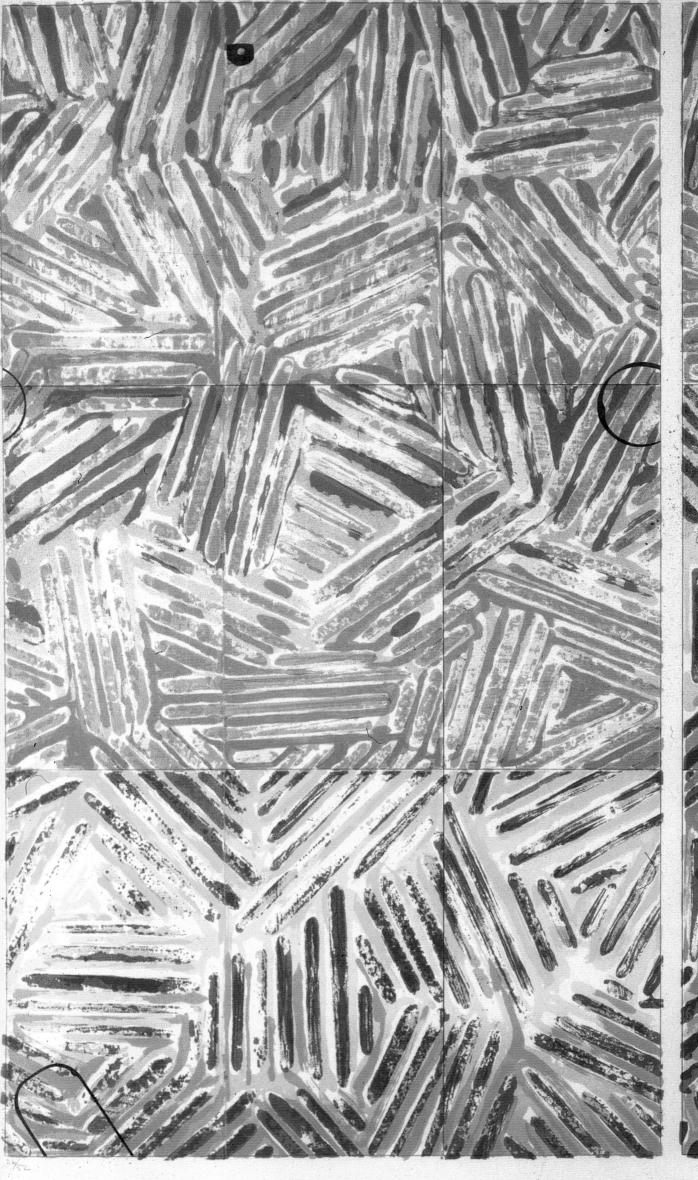
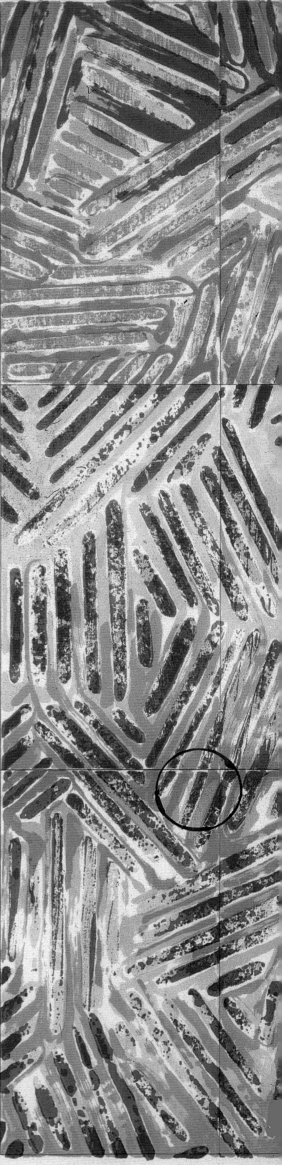

24/52

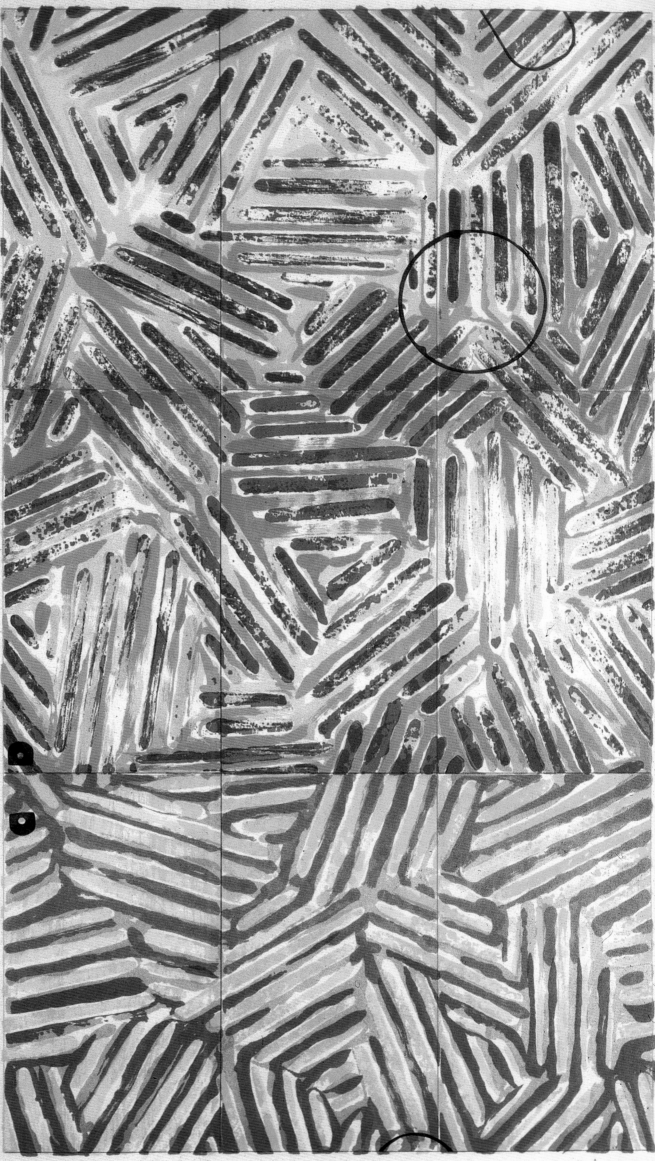

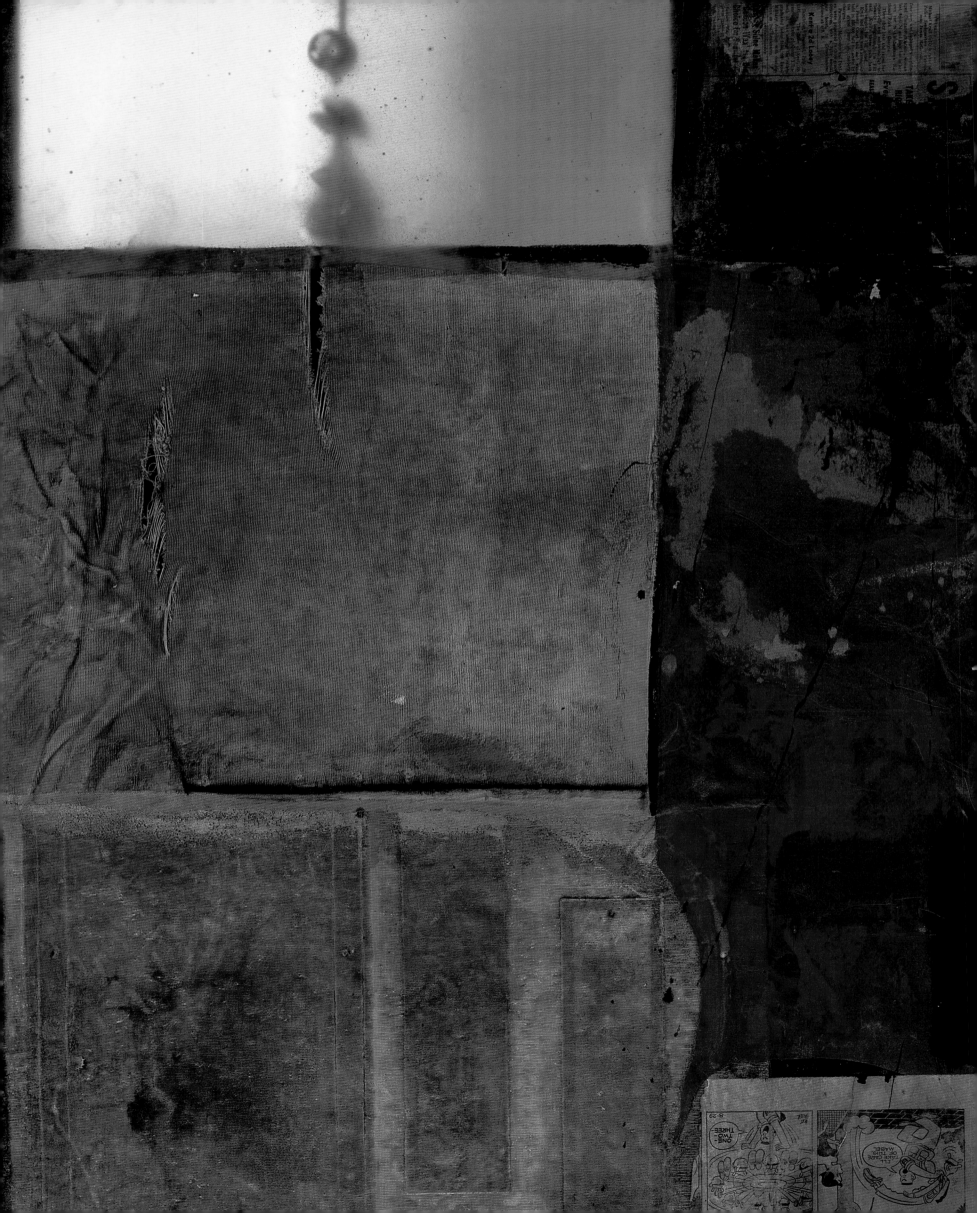

RAUSCHENBERG

RONI FEINSTEIN

Robert Rauschenberg's early-career retrospective at the Jewish Museum in 1963 made a favorable impression on Victor and Sally Ganz. Within two weeks of the show's closing they began to form what was soon to become one of the most comprehensive collections of the artist's work to be found anywhere in the world. On May 22, 1963 (ten days after the show closed), they purchased *Winter Pool*, a Combine of 1959, and *Airplane*, a transfer drawing of the year before. It appears that in early June, they acquired one work from every print edition Rauschenberg had made to date at ULAE and made the commitment to acquire the second print in every edition made thereafter (this was to continue through 1969). The just-completed black-and-

white Silkscreen Painting *Overdraw* (1963) was purchased in July. During the course of 1963, *Allegory* (1959–60), *Rigger* (1961), *License* (1961), *Site (for CORE Benefit)* (1963), and *Creek* (1964) all entered the collection in rapid succession; the drawings *Fast Slip* and *Drawings for Dante's 700th Birthday* followed in 1965 and 1966. *Odalisk* (1955) was probably bought in 1966 and *22 The Lily White* (1949) and *Red Interior* (1954), the earliest works in the collection, were added to the list of acquisitions in 1967. *The Tower* (1957), a latecomer, entered the collection in 1976.

The Ganzes' decision to collect Rauschenberg's art in-depth came two years after their first acquisitions of works by Jasper Johns, and it seems natural that these artists'

Robert Rauschenberg, *Red Interior* (1954), detail

works be collected in tandem. Rauschenberg and Johns have long been linked as major transition figures between Abstract Expressionism and Pop art (Rauschenberg's art also having been instrumental to the emergence of the late-1950s Assemblage). These artists were, moreover, intimates from late 1954 to 1961, a period that witnessed the creation of each artist's most historically significant work, and, for Rauschenberg, the years in which he developed his extended series of Combines (works that "combined" aspects of painting and sculpture).[1] During this artistic period, Rauschenberg and Johns saw each other's work daily and engaged in a dialogue with their art—one that continued on the walls of the Ganz apartment. Rauschenberg's *22 The Lily White* and Johns's *White Numbers* (1959), juxtaposed for decades in the Ganzes' all-white bedroom, ably demonstrate why the personalities of these artists and the character of their art are generally conceived in terms of polar opposites. Rauschenberg's work is loosely structured and playful, filled with wit and personal reference; the Johns, while sensually painted, is an impersonal work, rigorous in organization and conception. Rauschenberg's painting, however, like all of his art, is deceptive in its casual appearance; it probably served as a primary source of influence on Johns. Leo Steinberg wrote in *Other Criteria* in 1972, "I once heard Jasper Johns say that Rauschenberg was the man in this century who invented the most since Picasso. What he invented above all was . . . a pictorial surface that let the world in again." Of primary importance for Johns and many others was Rauschenberg's conception of the canvas as a literally flat surface that served as a repository for familiar, man-made objects and images appropriated from the culture. In his art, Rauschenberg exploited found objects and printed images as triggers for ideas and information about both the culture and the self. Although the Combines (and the

Silkscreen Paintings that followed) embraced multiplicity and inclusion, particular themes and subject matter can be discerned within individual works. While not didactic, Rauschenberg's art demonstrates how to receive and process information and how to find connectivity and order in an apparently haphazard and discontinuous environment (i.e., the contemporary world).

The Ganz collection, by the late 1960s, featured more than a dozen major works by Rauschenberg as well as a comprehensive survey of his ULAE prints, about forty in all. Whereas no selection process seems to have been involved in the purchase of the prints ("one of everything" seems to have been the rule), the acquisition of the Combines and other unique works that span the artist's early career was a completely different matter. These works did not merely record major developments, such as the move from Combines to Silkscreen Paintings, but they also marked some of the most subtle shifts and turns in his art, which would have been visible only to the most astute observers. Represented among the works in the Ganz collection were works of strongly contrasting structure, composition (material makeup), intention, and content. Together, these works captured the full range of mood and expression found in Rauschenberg's art: from the public to the private, from the playful to the elegiac, and from the intellectually and formally oriented to lusty indulgences in pure sensuality. Among them were some of the finest and most significant works Rauschenberg was to produce during this phase of his career. They are landmark works in which Rauschenberg not only defined himself as an artist but identified for himself what a work of art can be.

The survey of Rauschenberg's early career that can be made with works from the Ganz collection begins with one of the artist's earliest surviving paintings, *22 The Lily*

White. It was included in his first solo show in New York, held at the Betty Parsons Gallery in 1951. The work was withdrawn from this exhibition before its close so that it could be hung in the Ninth Street Show, an artist-organized exhibition that included work by first-generation Abstract Expressionists as well as by a few younger artists. Although the painting's inclusion demonstrates Rauschenberg's early acceptance into the New York School, even at this early stage Rauschenberg was clearly "off on his own tangent," as Betty Parsons later recalled.

The painting features an allover mazelike design that was scratched into a heavily textured white ground with a lead pencil; touches of gray and of a golden tone are also seen. Incised within the fretted-key pattern of boxes are a seemingly random sequence of numbers, the words FREE and OUT, the intitials L.B., and the painting's title. These inscriptions are oriented in different directions, causing some uncertainty as to which end is up, which is further confused by a switching in the pattern of the boxes near the bottom edge.

The painting can be seen as Rauschenberg's version of a pictograph, the works of this type by Adolph Gottlieb and

Rauschenberg, *Airplane (Venus, White Square, Life Boat)* (1958)

139

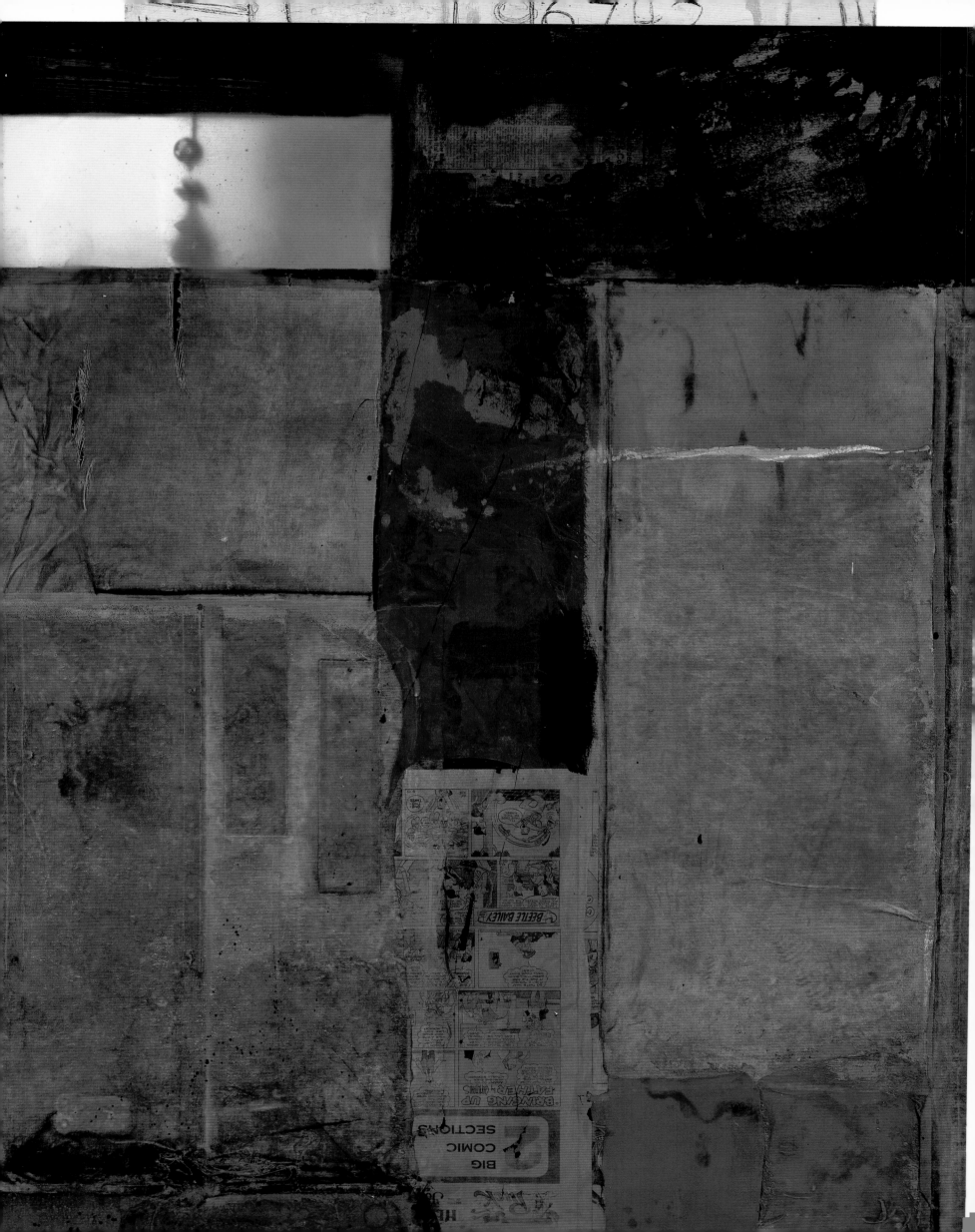

One can lift the curtain on the "window" in the painting's upper left to reveal a tiny, weighted gray sack (it is filled with pebbles); the sack is suspended by a string from a little porcelain pulley. This strangely poignant object provides a note of mystery, a kind of poetic interlude within the work. While in keeping with the tactility of the painting's velvet surfaces, it stands outside the "homey interior" theme. The same may be said of the other newspaper collage contained within the work: "Rookie Cop Subdues F.B.I.–Wanted Ex-Con," ". . . .Steals a Bus, and All for Love," "Crazy Cuts Price Upped" (a report from California where barbers voted to raise the price of "crazy" haircuts), a story about a Harvest Moon Ball, and a "Beetle Bailey" comic in which two soldiers fight over a girl (one picks the other up and spins him like a wheel).

If *Red Interior* represents a wall in an interior, the monumental, multipanel *Rebus* suggests a wall in a public space, and indeed this Combine, which is one of the central, defining works of the artist's early career, offers a public statement about Rauschenberg's art and intentions. With the Combines, Rauschenberg moved away from monochrome painting to what he referred to as "crowd" color, meaning that as on the city street, many colors are present but none is dominant. Paint is used sparingly: it activates and articulates the works' surfaces, ties elements of collage together, and often serves as an aspect of content.

A rebus is a puzzle consisting of signs, letters, and pictures of objects that, when taken together, suggest words or phrases. A partial phrase, THAT REPRE, appears at the left edge of Rauschenberg's painting, suggesting that the composition, which is laid out along a horizontal band, is to be read from left to right like a written text. *Rebus*, however, is not a rebus. Instead, it demonstrates how in Rauschenberg's art nonhierarchical clusters of collage materials are used to evoke chains of association in the

Rauschenberg, *Red Interior* (1954)

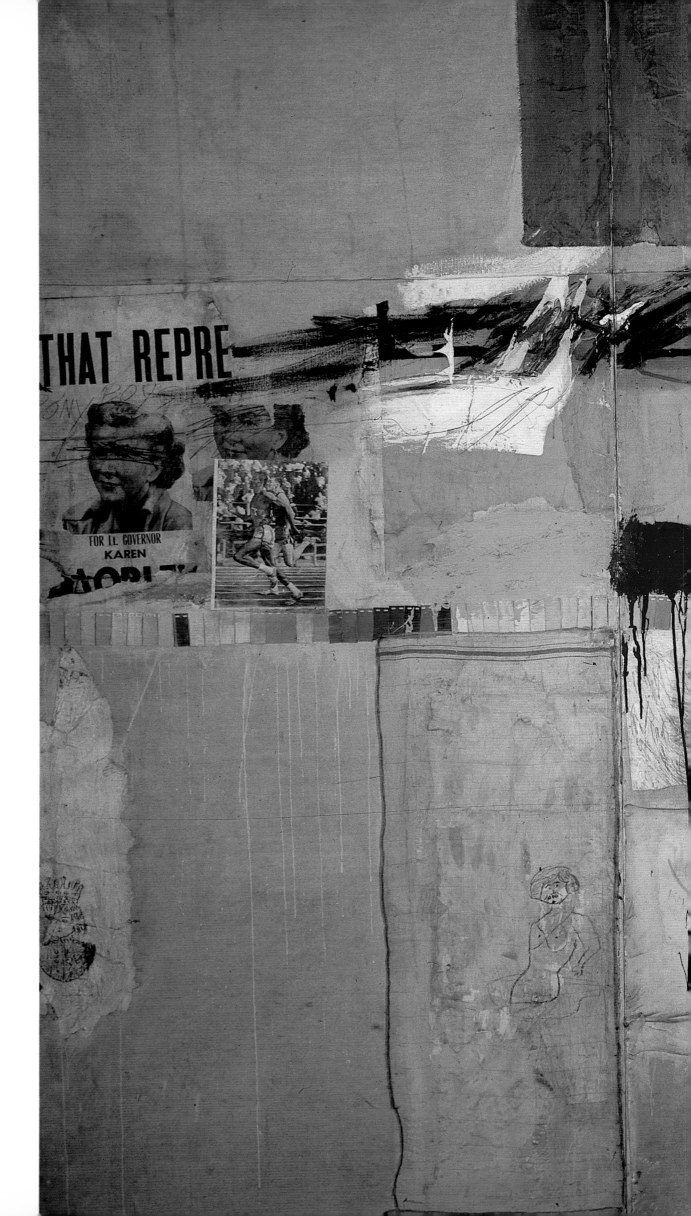

Rauschenberg, *Rebus* (1955)

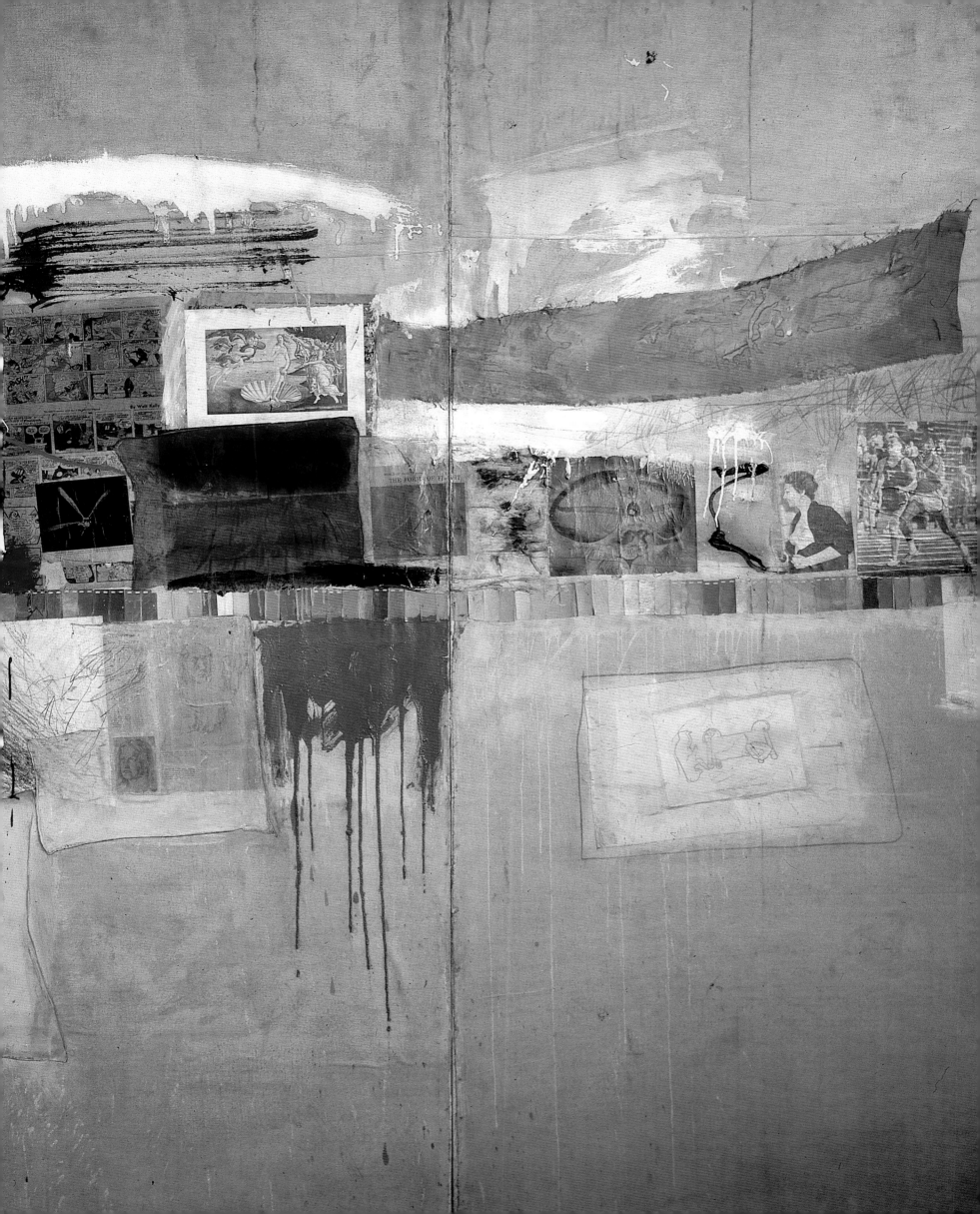

viewer's mind (the title serves as an invitation to "read" and participate in the work).

In *Rebus*, photographic reproductions taken from books and magazines, newspaper comics, poster fragments, children's drawings and a page from a child's coloring book, a variety of fabrics (including what appear to be a handkerchief and dish towel), and a few tightly controlled and deliberate passages of paintwork are assembled on a surface formed by a series of cheap drop cloths (Rauschenberg has said that at the time he executed the work, he could not afford that much canvas; the work was later mounted on canvas). The flat, rectangular elements of collage are arranged above and below

Rauschenberg, *Odalisk* (1955)

tabs from a paint store color-sample book that extend across the Combine's width (the sequence of the tabs is scrambled so no consistent color scale appears).

Virtually every mark, image, and form engages in a "conversation" with other marks, images, and forms; these range from simpleminded plays of opposition or correspondence (as seen in the yellow paint applied over poster letters spelling the word SUN) to commentaries upon female stereotypes in our culture. A double poster image of a woman "running" for political office is set beside the image of two Olympic runners (hence, a verbal pun) and above a childlike drawing of a queen (a second image of a woman in power). Images of insects in flight evoke the winged deities in the reproduction of Botticelli's *Birth of Venus* located directly above them (the goddess representing yet another "woman's role"), while the red cloak held by the goddess's attendant is echoed by the great sweep of red fabric that extends across the work's right-hand panel. The theme of drawing also figures prominently: it is represented by the comics, a reproduction of a sheet of Albrecht Dürer drawings, the children's drawings, and, remarkably, an actual drawing by Rauschenberg's friend Cy Twombly.

Johns told Victor Ganz sometime after it was completed that he was disturbed by the casual manner in which Rauschenberg treated this highly important work with regard to its preservation. Johns then tried to secure certain areas to ensure their greater permanence.

At once shocking, laughable, and poignant, the freestanding Combine *Odalisk* (1955) is yet another central work in Rauschenberg's early career. As against the public statement of intention with regard to modes of thought and vision found in *Rebus*, *Odalisk* offered a public statement of a different order—one that was quasi-autobiographical, replete with references to Rauschenberg's life, experiences,

and earlier art. It is also one of the largest and most intricately realized of a group of related works of the mid-1950s that dealt with the theme of male-female relations.

The work's title itself represents a conjoining of the male and female, of an "odalisque," a languid female nude, with an "obelisk," an erect, overtly phallic monument (one that, significantly, is tattooed with symbols). In Rauschenberg's construction, a collage-covered wooden crate is supported by a single furniture leg that thrusts into a small square pillow, a representation of the union of the "obelisk" and "odalisque." The white, stuffed rooster (or cock) perched at the top of the box reinforces the erotic nature of the subject matter.

The crate is collaged on three of its four sides with photographs and reproductions of various sorts, although comic strips, pieces of cloth, a man's necktie, a soap pad, a bit of artificial grass, and other objects are included. While a number of the materials collaged upon the work's surface reinforce the work's predominant sexual theme (among them images of naked women taken from pornographic magazines, a small reproduction of Rauschenberg's 1951 nude female photogram, and a postcard reproduction of Picot's *Cupid and Psyche* which shows Cupid getting out of Psyche's bed), family photographs are also included (one shows a smiling older woman, another a boy in overalls with his father, another a little girl on a tricycle). Religious imagery and other categories of matter are also found. Paint is used sparingly and appears almost exclusively in the form of scumbles and lines squeezed directly from the tube; there are also crayon and pencil scribbles. The fourth side of the box consists largely of a transparent scrim of fabric that offers a view into the fabric-lined interior of the box; three or four concealed light bulbs blink on and off, activating this otherwise empty interior and enhancing the work's theatrical nature.

Rauschenberg, *The Tower (Combine for Paul Taylor)* (1957)

The performance quality Rauschenberg introduced to many of his works of the 1950s was at least in part influenced by his involvement, initiated in 1953, designing sets, costumes, lighting, and on at least one occasion, a score for the Merce Cunningham and the Paul Taylor dance companies. *The Tower* (1957) was constructed for Paul Taylor's dance of that name (costumes by Jasper Johns), performed as part of "Seven New Dances" at the Kaufman Concert Hall of the 92nd Street YM-YWHA in New York City. Since the work is free-standing and of near-human scale, it functioned not as a backdrop or set, but as a surrogate performer in the dance. Assembled from furniture parts, a broom, a light bulb, and reflectors, among other objects, and topped by an opened umbrella, it would have stood as an abstracted, Surrealistic personnage in the midst of Taylor and his dancers, calling to mind Picasso's 1933 etching *Model and Surrealist Figure* from the "Suite Vollard." (One cannot help but wonder whether the Ganzes, with their keen familiarity with Picasso's art, might not have recognized this correspondence as well.) In

Picasso's etching, which Rauschenberg could have known from The Museum of Modern Art, a female nude model stands before a concoction of furniture parts, a mop, and other objects that together produce a figure that, like Rauschenberg's, is of sexually ambiguous anatomy.

The Combine *Winter Pool* (1959) also has a performative aspect: it consists of two collaged canvas panels set at a distance from one another, the gap between them bridged by a wooden ladder that seems to invite the spectator to climb into the picture space. While the ladder and title suggest a plunge into the depths, the work strongly asserts its non-illusionistic nature. The ladder serves as an extension of the "windows" that Rauschenberg had been cutting into his surfaces from the early 1950s (as seen in *Red Interior*), devices that undercut illusionism by asserting the literal presence of the wall behind. Another "window," framed by metal, appears at *Winter Pool*'s upper left. At the bottom of the same panel, a square white handkerchief mounted against a black-painted ground teases the viewer's eye by suggesting yet another "window," while asserting the flatness of the picture surface. Still another "window" is referred to below by the wooden frame that once held a glass-plate negative: a smudged, painted gray scale appears within the frame, simulating atmospheric perspective and offering a highly self-conscious suggestion of painterly depth in an otherwise emphatically flat painting.

In strong contrast to *Winter Pool*'s scaffoldlike organization and "art about art" content stands *Allegory* (1959–60), a monumental, multipanel work with a fluid and open structure, expressionist handling (both of paint and objects), and irreverent, "art about life" subject matter. *Allegory* is the final work—the climax, as it were—in a series of

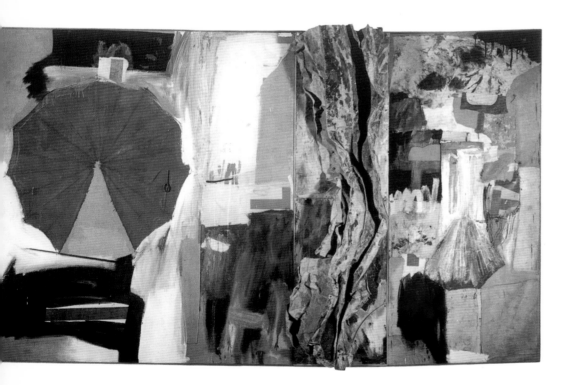

Rauschenberg, *Allegory* (1959–60)

Rauschenberg, *Winter Pool* (1959)

Combines of 1959 devoted to the theme of homosexual love. As against the overt treatment of the subject of male-female relations seen in *Odalisk*, in *Allegory* the theme of male interrelations is heavily encoded and veiled, as is suggested by the painting's title (an "allegory" being a picture or story with a hidden, underlying meaning). For this and the series of related works in 1959 (which include *Photograph*, *Dam*, *Canyon*, *Kickback*, and *Wager*, among others), Rauschenberg invented an iconography consisting of verbal cues, articles of men's clothing, and private symbols, many of which require a stretch of the viewer's mind and imagination.

A man's shirt, undershirt, trouser leg, handkerchief, and a few pockets are collaged on *Allegory*'s right-hand panel, seeming to imply the stripping or disrobing of a male figure. A segment of a red umbrella covered with white paint appears just below the center of the panel attached to the trouser leg. To the left of this element is a series of brushstrokes that appear to spell the word MY.

The narrow central panel presents a large, bulldozer-crumpled piece of aluminum mounted vertically against an upright mirror in a wood frame. The crinkled metal suggests the active drapery of figures in Baroque allegories. Bodily implications are reinforced by the flesh-toned underside of the metal and by the full-length mirror, which is generally used to reflect the human form. The large, expressionistically painted left-hand panel is dominated by a flattened-out red umbrella whose missing segment was already seen on the panel with the clothing. In a manner that "courts the

impossibility of sufficient visible memory to transfer from one like object to another the memory imprint," an idea of Marcel Duchamp that held particular appeal for Rauschenberg (as it involved challenging himself and the viewer by substituting an object with an unlikely double), the flattened umbrella with the puckered circle at its center represents human buttocks. The segment of red umbrella to the right, attached to the trouser leg, may be a surrogate phallus.

Considerable changes occurred in the nature, form, and content of Rauschenberg's art in 1961. Most notable among them were the move toward painterly painting on the one hand and toward sculpture on the other, as represented in the Ganz collection by *Rigger* and *19346 (License)* of that year. Both bodies of work employed fewer, larger elements of collage; the newspaper clippings, comics, and photographic images that had figured so prominently in earlier Combines all but disappeared (that *The Tower*, *Wager*, and *Allegory* were free of these materials made them unique among the works of their time). *Rigger* presents an open, airy field filled with lush, gestural paintstrokes in bright, glowing colors. Whereas Rauschenberg had previously sought to avoid indulging in painterly effects that strongly resembled those of his Abstract Expressionist elders, he now gave himself over to an enjoyment of paint and color, revealing himself as a most able gesture painter.

Rigger stands on the edge of representation, suggesting (as its nautical

Rauschenberg, *Rigger* (1961), detail shown left

151

title would appear to confirm) a seascape filled with sun, light, air, and movement. A ship seems to float on the blue and gray expanse, while flags, connoted by a shirt and fragments of poster letters, flutter in the breeze above; the rusted barrel suspended from a rope suggests the anchor dropped over the side.

In direct opposition to the expansive and buoyant *Rigger* is the cubic, heavy, floor-bound *19346 (License)*. It is one of a group of about seven small-scale sculptures of 1961 assembled from found objects, most of them raw and battered materials. *License* is in the form of a cage made with wire mesh stretched over an open-frame wooden box; the top is open and a metal plate bearing the number 19346 is attached to one side. A cement-filled bucket stands inside the cage. This oddly moving work, which may look back to Rauschenberg's childhood experience of keeping a variety of pets (chickens, a goat, etc.), is apparently fraught with private meaning, especially as the bucket and cage (together with the accompanying themes of containment, confinement, heaviness, and transparency) recurred with some frequency in the artist's work. In *Gift for Apollo* (1959), for example, a cement-filled bucket seemed to connote a feed pail for the charioteer's horses; a photographic image of a pail filled with water also seemed intended for use by horses in *Rodeo Palace (Spread)* (1975–76). In Rauschenberg's art performances of the mid-1960s, birds, people, and often birds *and* people were contained in wire cages: in *Map Room II* (1965), a female performer's costume consisted of a wire mesh cage containing three live doves.

While photographs were for the most part eliminated from the Combines after 1960, in 1958 Rauschenberg had begun to produce a vast body of work in which photographic images played a central role: the transfer drawings.

These drawings were an ingenious solution to the problem of how to translate the juxtapositions of found objects and abstract markings basic to the Combines, into the medium of drawing (and onto a two-dimensional surface). In these drawings, magazine and newspaper illustrations were transferred (through the use of a solvent) onto sheets of drawing paper where they were intermingled with abstract washes and marks made with watercolor, pencil, crayon, and gouache. These drawings—together with the prints begun a short time later—served as the bridge between the Combines of the 1950s and the Silkscreen Paintings of 1962 to 1964.

Fast Slip (Racing Car, Crossword, and Lobster) (1964) and *Untitled (Dove and Running Man)* (1968) are classic transfer drawings. Each has an open and fluid structure, its paper surface randomly, and rather sparingly, spotted with images and abstract marks. While a certain rhyming and repetition of like or related images can be found in both works, their content appears to be as generalized and free-floating as their form (the sheer proliferation of images in the transfer drawings leading the artist to embrace an even wider range of reference than was his norm).

The early transfer drawing *Airplane (Venus, White Square, Life Boat)* (1958), executed on buff paper, is unique among the drawings for a number of reasons: it has a rectilinear, compartmentalized structure, its entire surface is covered with marks and images, and it features an extensive use of washes (with blue and yellow tones dominant). Its content also seems more directed than that of most transfer drawings. Isolated on the right side of the drawing is a large image of a man's head seen in profile. The man appears to regarding the myriad of representations and signs set out before him. Below the head, to the left, is the transferred (hence backward) image of a handwritten shopping list. In the center of the composition, an

odalisque looks out at the viewer (her form echoed by the letter "S" on its side to the left); she is surrounded by sexually suggestive imagery, among them a reproduction of Claude Monet's *Cliffs at Etretat* (the orifice in the cliffs having long ago been nicknamed "*porte de dame*"), a missile, and the phallic forms of two cigarettes. The erotic content of the work is furthered and its ironic quality (given Rauschenberg's homosexuality) enhanced by the juxtaposition of the languid, "come hither" female nude with the pileup of male bodies in the image of the football game in the lower left. As per both of the titles that have been assigned to the work since the time of its execution, modes of transportation also figure prominently: a rowboat, airplane, and sinking ship, among other images.

Rauschenberg returned to the device of the near-life-size head seen in profile in *Site (for CORE Benefit)*. This is yet another atypical work in Rauschenberg's oeuvre as it is one of only two transfer drawings on canvas (all of the other work on canvas at this time was executed in the medium of silkscreen). As against the private (and perhaps autobiographical) nature of *Airplane*'s imagery, the reproductions seen by the head in *Site* are public and topical, as would have been appropriate for a work made for a charity benefit of CORE—the Congress of Racial Equality.

Politically charged imagery also played a part in the two large-scale works on paper, *Dante's Inferno: Drawings*

for Dante's 700th Birthday (1965). From 1958 to late 1960, Rauschenberg had labored upon one of the most formidable (and successful) projects of his career: he used the transfer drawing technique to illustrate each of the thirty-four cantos of Dante's *Inferno*. In 1965, he was commissioned by *LIFE* magazine to create yet another work on the theme of Dante to commemorate the 700th anniversary of the author's birth. (Rauschenberg's drawings were reproduced in two foldout sections in the December 17, 1965, issue.) Photomontages created by means of a silkscreen process, the drawings consist largely of images of contemporary evils derived from *LIFE* and similar magazines: John F. Kennedy's assassination, a concentration camp, members of the Ku Klux Klan, an atomic bomb explosion, soldiers, and other images of violence, oppression, and pain. A ray of hope is found in the second drawing in the form of the astronaut silhouetted in yellow and accompanied by a comic-strip balloon filled with rainbow colors. He is a heavenly messenger bearing a message of promise amidst the gloom.

Shortly before he began to work in silkscreen, Rauschenberg made his first lithographs. Although Tatyana Grossman of ULAE had suggested to Rauschenberg several years earlier that he make prints, he had resisted, famously having claimed that "the second half of the twentieth century is no time to start drawing on

Rauschenberg, *Booster* (1967)

154

rocks." In 1962 he relented, and his first major lithographs—*Urban* and *Suburban*—were made at ULAE that summer. These prints featured clusters of images, which were the result of impressions made on the lithographic stone by lead type and zinc cuts of newspaper photographs acquired from the picture morgue of *The New York Times*. The images were intermingled with areas of wash as well as with imprints of found objects (a saw in *Suburban* and a leaf and sheet of notebook paper in *Urban*). Whereas the transfer drawings had a delicate, evanescent quality and were rendered in pastel tones, the lithographs were bold, graphic, and predominantly black-and-white, much like the early Silkscreens.

Rauschenberg's Silkscreen Painting Series of 1962–64 consisted of about eighty works, the first half of which were executed in black and white, the second half in color. In these works, commercially prepared screens were used to transfer onto canvas images derived from newspapers, magazines, as well as some of his own photographs. Like photographic negatives, the screens could be reused, and the images repeated, any number of times.

The monumental, two-panel *Overdraw* (1963), one of the largest and final works in the Black-and-White Silkscreen Paintings Series, shows Rauschenberg fully in control of his media and imagery. It is a work densely packed with churning rhythms produced both by the recurrent use of circular images and by the manner in which these images are rotated, framed, and otherwise handled. Among the array of round images are the following: gears, dials, and buttons on the

Kate Ganz and Rauschenberg in his studio, date unknown

control panel of an airplane; diagrams of a clockface and a series of circular graphs; and a globe. Several repeated, fragmentary images of baroque ornament contibute to the sense of flux. Set into the context of this seemingly weightless, antigravitational field is the image (seen at the lower right) of a man viewed from below, suggesting a floating astronaut (it is actually a soldier scaling a wall). The image of a bald eagle, reinforcing the notion of flight as well as the seeming allusions to the U.S. space program, is at the top center of the composition. While not displaying the surface variation (the tactility and object quality) of the Combines, it is nevertheless apparent that in the Silkscreens Rauschenberg produced variegated and sensually worked surfaces through an expressionistic and painterly use of the silkscreen medium. In his hands, a mechanical process ironically became malleable and sensitive, open to improvisation and the touch (via the squeegee) of the artist's hand. That handpainted passages continued to play an important role is seen in *Overdraw* in the manner in which Rauschenberg exploited the contrast between the red parallelogram at the painting's center (the only note of color in the work) with the smeared, irregularly shaped "clouds" of paint in white and gray to the extreme left and right.

A parachuting astronaut silkscreened in blue is among the more prominent images in the large, single-panel Color Silkscreen *Creek* (1964). Almost immediately after beginning this new painting series, Rauschenberg abandoned the method of sticking pins through his canvases so as to align the separate screens used to lay in each of the colors as required in the four-color

separation process. His thirst for improvisation and his frustration with the time-consuming nature of the procedure quickly gave way to a more fluid system: abandoning the pins, he accepted the imperfect registration of the colors and began to silkscreen images in three, two, or just a single color. On the left, "female" side of *Creek* are two partial images of women, each screened in red and yellow—Venus, from Peter Paul Rubens's *Venus at Her Toilet*, and the Statue of Liberty. Venus's image is ringed by a color Rauschenberg once described as "fingernail polish pink." The "male" side of the painting is larger, more densely packed with images, and harsher in tone. It features the image of the parachuting figure and of a male swimmer screened in black at the upper right.

Rauschenberg worked in silkscreen on canvas until spring 1964, during which time he also made prints, worked with the Merce Cunningham Dance Company, and staged his first art performances. When he won first prize for painting at the Venice Biennale in the summer of 1964, he telephoned a friend in New York and asked him to destroy the screens that were used to make the Silkscreen Paintings, thereby ensuring that he would not repeat himself but would move on to something new. For the remainder of the 1960s, he devoted himself to performance art and to experiments in art and technology (these generally taking the form of large-scale, audience-interactive installation works).

Although it was not perhaps his intention, Rauschenberg thus effected a fissure in his career, one that separated the early work from that which came later and one that apparently impacted the Ganzes' engagement with his art. By the time he returned to more conventional modes of artmaking in the 1970s, the Ganzes had become involved acquiring works by Eva Hesse, Robert Smithson, Mel Bochner, Richard Tuttle, and others involved with the more current tendencies of Earthworks and Process, Post-Minimal, and Conceptual art.

The Ganzes' preoccupation with collecting Rauschenberg's art belonged to a brief period, from 1963 to 1969. Not only was 1969 the year in which they made their final purchases of Rauschenberg's prints from ULAE (the only multiple acquired thereafter was the cardboard *Cardbird III*, published in 1971 by Gemini G.E.L.), but in August of 1969, the Color Silkscreen *Creek* was sold back to Leo Castelli. (Castelli then sold it to W. Hawkins Ferry, who gave it to the Detroit Institute of Arts). Then in 1971, *Odalisk* and *Allegory* were sold to Dr. Peter Ludwig in Cologne (both are now in the Ludwig Museum). *Overdraw* was sold in 1972 (and acquired by Kunsthaus Museum, Zurich). While the sale of these works was in each case financially motivated and deeply regretted, the loss of the Combines caused the greater and more lasting sorrow. Rauschenberg's Silkscreen Paintings had stood apart from Pop art in their multipart structures, expressionistic handling, and evocative content; they shared, however, Pop's flatness of surface, posterlike effects, and use of commercial processes, and Pop was a movement to which neither of the Ganzes ever truly warmed. Rauschenberg's Combines, however, with their tactilely rich surfaces, high physicality, formal and conceptual intelligence, and wit, continued to be held in the highest esteem and to have pride of place in both the Ganzes' collection and their home.

1. For Victor's sixty-ninth birthday in 1982, Sally purchased a photograph Rauschenberg had taken of Johns in 1955. It shows a thin young Johns in an overcoat standing beside an advertising column collaged in the manner of one of Rauschenberg's Combines.

Rauschenberg, *Drawing for Dante's 700th Birthday* (1965)

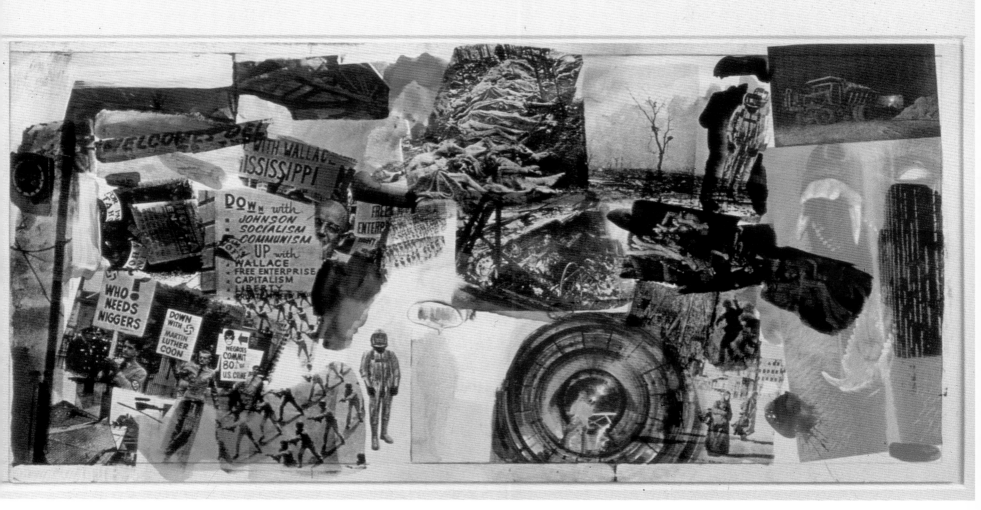

STELLA

JUDITH GOLDMAN

Victor Ganz first saw Frank Stella's paintings in 1959 in the "Sixteen Americans" show at The Museum of Modern Art. There were four large, abstract, implacably black pictures, and Ganz had looked at them in passing and moved on. They didn't interest him. At that time, he had one master. He was under Picasso's spell, enthralled by the Spaniard and his expansive repertoire of conflated profiles, rotating nudes, and converging planes. For twenty-two years, Ganz collected no one else. No other artist mattered. He studied the Picasso literature. And twice when traveling in France, he had managed to visit him. His obsession was all consuming, and it is not surprising that he initially missed the point of Stella's Black paintings. The stark, dark

rectangles seemed so far removed from Picasso. They had insistently flat surfaces, repetitive patterns, and mournful titles that alluded to decay, depression, and Nazi horrors. They suggested not life but death.

In June 1958, a year and a half before the "Sixteen Americans" show opened, Frank Stella arrived in New York. He was twenty-two years old and planned to spend the summer painting, before returning home to face the draft. He was already knowledgeable about the art scene. In his last year at Princeton, he had often traveled to New York to visit museums and galleries. He had seen Jasper Johns's 1958 exhibition and been particularly impressed by

Frank Stella, *Turkish Mambo* (1959), detail

Johns's use of repetition in the Flag paintings. He kept up. He read the art magazines; he was steeped in the rhetoric of Abstract Expressionism, which regarded the artist as a romantic figure. He didn't know how to achieve it, but he hoped to make pictures someday that were free of the "hullabaloo" that afflicted Abstract Expressionism. He wanted "to make paintings that couldn't be written about."

He had a little money, enough to rent a storefront studio on Eldridge Street until the fall, and to buy stretchers and cheap paint in odd, acrid colors that no one else wanted. That summer he painted landscape-inspired pictures in an Abstract Expressionist style. Setting soft-edged squares against fields of color and stripes, he worked improvisationally, painting and repainting pictures to produce direct compositions that showed the influence of Robert Motherwell, Mark Rothko, and Adolph Gottlieb.

He made his first Black painting by accident. While working on a black-and-red-stripe composition he ran into trouble and kept obliterating the problem areas with black paint. The final painting, *Delta* (1958), consisted of wide black bands with hints of red showing through the black ground. Painted loosely, *Delta* was still rooted in Abstract Expressionism. But when he studied the picture, Stella decided that he had outperformed himself, that he was close to making what he considered real painting.

Stella painted two more transitional Black pictures, *Reichstag* (1958) and *Moro Castle* (1958); after that, from late 1958 to 1960, he finished twenty-one Black paintings (thirteen with rectilinear patterns and eight with diamond patterns). He completed most of them in 1959 and gave them depressing, downbeat titles. Many pictures, like the complexly patterned *Turkish Mambo* of 1959 (the name of a composition by Lennie Tristano, a blind bop-jazz pianist), took their titles from jazz and blues music.

The small diagrammatic sketches that preceded each

Black painting appeared schematic but followed no order or system. Stella was improvising. With the same enamel paint he had used for *Delta*, he built up dense surfaces by layering paint onto the raw canvas. In early pictures, sometimes he'd cut the paint with white, which gave the black a murky brownish tone, but no light. The Black paintings held no light or shadows or gradations of tone. They had no drawing either, or color or depth or volume or pictorial illusions or relational pieces and parts. They were nonreferential, flat, symmetrically patterned pictures without visual incident.

"God damn it, if you're going to paint an abstract painting, make an abstract picture. . . . My painting is based on the fact that only what can be seen there *is* there. What you see is what you see. . . . " Stella spoke as bluntly and directly as he painted. In his paintings, rectilinear patterns reinforced the picture's frame and shape. Densely painted, symmetrically patterned surfaces forced illusionistic space out of paintings at regular intervals. Initially, the Black pictures appeared radical—so adamantly anti-illusionistic and relentlessly spare—that their debt to Jackson Pollock's all-over patterns and Barnett Newman's Zip paintings passed without notice. But the critic and art historian Robert Rosenblum saw their "drastic clarity" and how they called into question all the art that preceded them.

As Victor Ganz recalled, one evening in the early 1960s he reached an important decision. He didn't know what prompted him, but he remembered that he arrived home, walked into his living room, looked at the pictures on the walls, and then turned and proceeded down the apartment's hallway. Walking slowly, he stopped along the way, glancing at walls and into rooms that adjoined the hall. All he saw were Picassos. They were everywhere—paintings, drawings, prints. His house looked like a museum devoted to the octogenarian artist. That night, Ganz realized that

Stella, *Tuftonboro I* (1966)

he had been twenty-eight years old when he acquired his first Picasso and that he was now fifty. Maybe it was time to collect other artists. Ganz mentioned this to Sally. He didn't know why it had happened, but he knew he had fallen out of love. "I still respected the artist and the work," he said, but "I lost the love affair. . . . I would no longer go anywhere to see the next picture." [1]

Collecting Picasso had never stopped Ganz from visiting galleries and museums or following work by other artists. He had once wanted to buy some Paul Klee paintings, but he never did. He felt too connected to Picasso to make the move. Fortunately Abstract Expressionism had never tempted him. "You like paintings in which the artist has already made up his mind," Jasper Johns once observed. But with Picasso it was different; no matter how emotionally entwined he might be with a subject, his pictorial intelligence prevailed.

With an unrelenting focus, Frank Stella continued to explore the issues raised by the Black paintings. With each new series, he varied the givens, changing the nature of

Stella, *Chodorow II* (1971)

the problem he set himself. In the Aluminum series (1960–61), surface pattern reiterates the shape of the notched canvas; in the more radically structured Copper series (1960–61), pattern and structure merge. In the centerless polygons of the later Purple series (1963), Stella's focus switched to the framing edge.

Stella kept moving forward, finding new ways to pare painting down to its essential attributes. To some, Stella's focus on the material presence of a painting seemed narrow. However, Stella never regarded his vision as limited but as inclusive. He regularly upset expectations. Whenever he appeared to be heading for a modernist cul-de-sac, he changed courses. He didn't hesitate. His pallid palette of noncolors gave way to the bright primary and secondary colors of the Benjamin Moore series (1961). From those, he moved to the multicolored Concentric Squares (1962–63), bringing illusionism into the picture. In the Notched V's and Running V's (1964–65), movement dominated as color raced through the jagged bands of the shaped canvas.

By fall of 1965, Stella was considered among the most ambitious and prolific artists of his generation. He had completed eleven series, 262 paintings, had had numerous one-man shows in London, Paris, New York, and Los Angeles, and had represented the United States (along with Robert Rauschenberg, Morris Louis, and others) at the 1964 Venice Biennale. Meanwhile, Victor Ganz had started to collect work by younger artists and had become a regular at the Leo Castelli Gallery. By then, Stella had exhibited in three one-man shows at Castelli, where he had shown his Aluminum, Copper, and Purple paintings. Ganz saw them all, but as much as he appreciated Stella's rigor and ambition, he didn't buy anything. Stella probably seemed too severe and intellectual. Years later, in 1980, Ganz rectified his omission by acquiring the 1959 *Turkish Mambo*.

The Irregular Polygons that Stella began in the fall of 1965 represented not only a major change in style but also a new freedom. All the expected characteristics—the traditional geometric shapes, symmetry, parallel stripes, and primary and secondary colors—were gone; in their place were expanses of unlikely colors with contrasting matte and shiny surfaces and unusually shaped polygons. Parallelograms sat inside rectangles, triangles and trapezoids inhabited squares, and from these eccentric mergings came entirely new shapes, ungainly, random-looking, interlocking shapes that Stella filled with intuitive color.

Stella had explored eccentrically shaped canvases before, but in the Irregular Polygons, the problems were far more complex. Color was no longer monochromatic or contained in bands but covered large areas of the picture, and the illusionism that he had so emphatically banished from earlier pictures was back. At the same time, Stella kept the pictures' diverse elements united.

The Irregular Polygons received mixed reviews from Stella's small but loyal public. Critics were troubled by the incipient illusionism. And when Lawrence Rubin, Stella's friend and art dealer, first saw the Irregular Polygons, he disliked them so much that he declined to show them. But Leo Castelli showed them, and Victor Ganz bought *Tuftonboro I* from the 1966 exhibition. It was Ganz's first Stella, and it marked the beginning of a long romance between the collector and the abstract painter.

In 1967, the year he finished the Irregular Polygons, Stella began the monumental-scale Protractor series. Once again, Stella made a startling turn, this time away from the confines of literalist abstraction toward ornamental, decorative painting. But a by now familiar logic was at work. Like earlier paintings, the Protractors relied on surface pattern and shape. Stella had simply added another ingredient to his aesthetic equation—

circular forms. As in the Irregular Polygons, color plays a central role in the thirty-one Protractor compositions. Breathtaking arcs of color veer upward, fan out, and swirl in circles; multicolored bands in bright primaries, gaudy fluorescents, and elegant muted hues intersect and loop over and under each other, scaling ten-foot heights and spanning twenty-five-foot widths.

While he was working on the Protractor paintings, Stella kept thinking about the Irregular Polygons. He didn't feel that he had resolved the earlier series. The Irregular Polygons had given rise to ideas about spatial illusions and planar dimensions that he wanted to take further but didn't know how. His reputation was as a literalist, a painter of flat, abstract pictures, who pared painting down to its essentials. As much as he wanted to, he wasn't ready to explore new notions of space, and in the meantime the complex patterns of the Protractors offered him incredible latitude in terms of color and shape.

In 1970 The Museum of Modern Art mounted a retrospective of Stella's work. He was just thirty-three years old, the youngest artist to be accorded such an honor,

Stella, *Chyrow III* (1972)

Stella, *Hiraqla III* (1968)

compositional theme of 1963. And the order of Stella's ambition brings Picasso to mind—for Stella wants nothing less for painting than to reinvent its space with the infusion of new attributes and dimensions.

Victor Ganz probably saw more of the Picassoesque in Stella than Stella did. It wasn't until the 1980 Picasso retrospective at The Museum of Modern Art that Stella began to rethink Picasso. As a young artist, Stella, like other painters of his generation, had turned his back on Picasso, whose art had come to represent expressive, emotional, and figurative content, qualities Stella wanted to keep out of his art. But the 1980 retrospective had a powerful effect. Artists could not help but measure themselves against Picasso's achievement. By 1984, David Hockney was painting Cubist landscapes and constructing photographs out of fractured planes. Jasper Johns had expanded his layered, enigmatic imagery to include allusions to Picasso's life and fragments of his art.

William Rubin, who had directed Stella's retrospective, also organized the Picasso show, which gave Stella special access to the exhibition. Stella saw the show countless times and told Rubin, "The struggle to make the forms in painting 'real,' to make them physically present, is the lesson—if I can call it that—that I learned from Picasso. It's not the presence of a recognizable figure in Picasso that in itself makes things real, but his ability to project the image and to have it be so physical, so painted. It's so aggressively painted that it bursts out into image, and that image has a sense of being real, of breaking through pictorial boundaries to coexist in our everyday space. For me, painting these metal reliefs is a way

of infusing the piece with life; the brush strokes, the flow of paint, might be compared to the circulatory process in the body. Abstraction has to be made real in Picasso's pictorial sense of the word." [4]

In 1980 Stella began work on the Circuit series, a group of sixty-four metal reliefs. Titled after the American and European speedways Stella loved to frequent, the Circuits burst with energy and represented his most complex reliefs to date. To transmit the speed, danger, and thrill of Formula One racing, Stella crowded the space of the Circuits with the overlapping curving shapes of mechanical templates. New forms also appear. In *Nogaro* (1981), bendable flexicurves sinuously wind their way across the composition, joining together its varied parts and pieces. There are other forms too—eccentric, often evocative shapes that Stella cut himself or salvaged from debris he found on the factory floor.

The Circuits aptly demonstrate the lessons Stella learned from Picasso. They teem with life: their forms carry momentum; paint is applied freely; surfaces are marked with etched lines that further fragment shapes. Stella improvises more than ever before. Nothing stands still or remains constant except the suggestion of the rectangle. Sometimes it is the fragment of a right-angled corner, other times it is a straight line, but Stella always keeps his medley of moving forms anchored. He never loses sight of his pictorial ambitions.

Or of Picasso. After the 1980 retrospective, Stella kept thinking about Picasso. In 1982, he spoke on Picasso at the College Art Association. And in 1983 and 1984, he delivered the Charles Eliot Norton lectures at Harvard and again addressed the subject

Stella, *Dove of Tanna* (1977), detail shown left

of Picasso. The lectures, titled "Working Space," concerned the plight of abstract painting and how "abstract painters . . . in an effort to be advanced, to be smart, to anticipate critical accolades had managed simply to accommodate themselves to the neatness of literary taste." In short, Stella maintained that the state of abstract art was moribund and that artists had painted themselves into a corner. In an attempt to reinvent abstraction, Stella looked for solutions to the great artists of the past, from Caravaggio to Picasso.

In his lecture on Picasso, Stella asked why after painting his great Cubist pictures, Picasso had returned to the classical human figure. He answered that Picasso must have felt that Cubism was played out and that planar abstraction had diminished pictorial space. "Without volume," Stella maintained, "the space available to abstraction is simply too closed, too dull, too unimaginative."[5] According to Stella, Picasso's return to the figure was a return to volume and to life—a means to articulate space and renew his art. Taking his cue from Picasso, Stella intends to reinvent the space of abstraction by investing it with "unabashed volume."

For the better part of two decades, Stella has been pursuing "unabashed volume." His second career, his maximalist phase, is now longer than his first by half. In the Cones and Pillar series (1984–89), Stella fittingly took his new forms from a nineteenth-century French engineering book, *Traite theorique et practique de la stéréotomie,* a volume of printed illustrations that demonstrated how to create three-dimensional forms from flat designs. In Cones and Pillars, Stella attempted to rotate three-dimensional forms in real space. He is after the same deep volume with which Picasso enlivened his *Bather with Beach Ball* (1932) and *Sleeping Nude* (1932).

From 1959 to 1980, *Bather with Beach Ball* was in Victor Ganz's collection along with *The Dream,* another curving voluptuous woman of the same year. Both are paintings of Marie-Thérèse Walter, Picasso's young mistress. Both overflow with volume and aggressive physicality. Stella undoubtedly saw both pictures in the Ganzes' living room. He and Victor shared a similar taste and appetite for art (which Victor must have sensed, for he collected Stella's paintings for almost as long as he did Picasso's).

Stella has given *Bather with Beach Ball* a lot of thought. He wrote that "[Abstraction] has been hard-pressed to give us anything resembling what Picasso did in *Bather with Beach Ball.*"[6] Stella wants to bring to abstraction the same order of passionate feeling that Picasso felt for Marie-Thérèse. And he has done just that. In the ongoing, never-ending Moby Dick series (1985–97), Stella fills metal constructions with new verve and breath. The reliefs, like their main symbol, a wave, rise and fall and billow with space. They too bring to mind Picasso. In the fullness of space, Stella has found new life for abstraction.

for Sally + Victor love, Frank

Photograph of Frank Stella inscribed to Sally and Victor, c. 1985

1. Interview with the author, May 21, 1987.
2. William Rubin, *Frank Stella 1970–1987* (New York: The Museum of Modern Art, 1987), p. 14.
3. Ibid., p. 32.
4. Ibid., p. 73.
5. Frank Stella, *Working Space, The Charles Eliot Norton Lectures 1983–1984* (Cambridge, Mass.: Harvard University Press, 1986), p. 77.
6. Ibid.

Stella, *Il Drago e la cavalina fatata* (1985)

HESSE

LINDA SHEARER

Altogether Victor and Sally Ganz acquired a total of twenty-two works by Eva Hesse. Six of these were drawings; the remaining sixteen were sculptures, many of which were among the most important works made during the artist's dizzyingly productive but tragically short lifetime. The first works were bought at the time of Hesse's 1968 one-woman exhibition at the Fischbach Gallery in New York; the last were three drawings bought in 1973, augmented shortly after by a gift from Helen Hesse Charash, the artist's sister. Compressed between these few years much happened to this young artist and her work: just as she was beginning to make an impact on the

contemporary art world at the end of the 1960s, she was diagnosed with a brain tumor and died in 1970 at the age of thirty-four. At the same time Victor and Sally Ganz had committed themselves to her work with an astounding and characteristic wholeheartedness.

I began work at the Solomon R. Guggenheim Museum as a curatorial assistant in 1969. Under the tutelage of Diane Waldman, then an associate curator, I soon developed a passion for contemporary art, especially the work of younger, lesser known artists. Invited to organize an exhibition for the School of Visual Arts for their Visual Arts Gallery in 1971, I put together a small show of Eva Hesse's

Eva Hesse, *Untitled (Horizontal Lines)* (1968)

sculpture, an appropriate choice since she had taught there in 1968–69. While I had not known her, I had a limited familiarity with her work from exhibitions, but it was the lead article in the May 1970 *Artforum*, whose cover reproduced *Contingent* of 1969 in a mesmerizing yellow glow, that made her accomplishments known to me as well as to a wider audience. That encounter with her work from the School of Visual Arts show inspired me to propose a larger, retrospective exhibition to the Guggenheim. My proposal was accepted with Diane Waldman as the overseeing sponsor.

One can well imagine my awe at visiting the apartment of Victor and Sally Ganz for the first time, filled as it was with major works by Picasso, Johns, Rauschenberg, and Stella. This first visit to their apartment to look at the Hesses was a revelation: I realized it was possible for real families to actually live with major works of art and at the same time to share them with the larger world. Even more significantly, it was possible for individuals to make a deep emotional and intellectual commitment to the art they considered important.

The exhibition, "Eva Hesse: A Memorial Exhibition," opened in December 1972 and then traveled to four other museums in the United States. While I never knew Eva Hesse personally, through organizing this exhibition, I came to know her work, her friends, and her family with a closeness, a respect, and a friendship that are all too rare. One of these friendships was with Victor and Sally Ganz. To visit them was always a joy, especially to be able to see a miniretrospective of Eva's work every time I went there. They graciously opened up their home to my students from the School of Visual Arts on several occasions. And I had the pleasure and the honor of serving on the Battery Park City Fine Arts Committee under Victor's chairmanship during the 1980s.

But without a doubt the link for us was Eva Hesse. Victor and Sally first met her around the time of her 1968 Fischbach Gallery show. They soon clearly developed a warm and close relationship with her. Sally wrote to me in a Christmas card, soon after the retrospective opened in December 1972, ". . . I wish you had known her—she was so truly wonderful—Eva's short years of work are a memorial in themselves, and a legacy for us, but your interpretation does them proud." Like adopted parents, they oversaw and protected Eva's legacy with a loyalty and generosity that was remarkable.

When they first saw and purchased her work, she was not established like the other artists in their collection. The dealer Donald Droll, whom Hesse first met in 1966, was an ardent and dedicated champion of her work from his time as director of the Fischbach Gallery during her lifetime, through his co-ownership first of Fourcade-Droll Gallery and later of Droll-Kolbert Gallery, when he was the representative of her estate. He was largely responsible for the commercial dissemination of her work and it was through him that the Ganzes bought their first pieces. In retrospect, their earliest acquisitions seem tentative—two drawings, two small test pieces made of latex, and one latex floor piece called *Schema* (1966–67), especially in light of their subsequent selections. These first purchases were not the more ambitious or commanding pieces in that show, like the Accession pieces, *Repetition 19* (1967–68) or *Sans II* (1968). Nonetheless they clearly demonstrated her experimental and adventurous spirit, tempered by the overall minimalist aesthetic so integral to her approach.

Ellen Johnson, an early and avid supporter of the work, wrote about these two 1968 drawings: "The sheet with two large white ovals . . . is as minimal as [Ad] Reinhardt's work and as starkly powerful as [Richard] Serra's. However, over the reductive structure, Hesse allows texture and

Hesse, *Untitled (Two Circles)* (1968)

touch to play; the slightly irregular lines begin to falter and to give way to the encroaching atmosphere. . . ."[1] Johnson continues by drawing a comparison between this drawing and the work of Robert Ryman, an artist whose work Hesse knew. The three artists mentioned here—Reinhardt, Serra, and Ryman—are logical artists to associate with Hesse. It was, however, probably a trace or memory of Jasper Johns's work—a reliance on the grid for structure, a feeling for material and texture, a painterly surface, a layered or veiled image, and a play between the deadly serious and a hidden irony, if not humor—that "spoke" most compellingly to the Ganzes.

The works the Ganzes saw in 1968 revealed an artist at a clear point of maturity—in spite of her youthfulness. She had in fact traveled a long distance since her beginnings. Much has been made of Hesse's biography and its relation to her art, and not without reason. Born in Hamburg, Germany, in 1936, Eva and her older sister Helen were sent to Amsterdam in 1938 to escape Nazi persecution. They took refuge in a Catholic children's home there, to be reunited with their parents three months later. In 1939 the family emigrated to New York City and settled in Washington Heights; except for her sixteen-month sojourn in Germany in 1964–65, she always lived in New York City. In 1945 her parents divorced; her father remarried, and her mother was hospitalized for depression. The next year, when Eva was ten years old, her mother committed suicide. The fear and anxiety created by these historical and personal events haunted the artist throughout her life; upon learning that her father contracted pneumonia when she was in Europe, she wrote that, "I feel and am terrified that my family, my life is cursed."[2] Nonetheless, she never deviated from her resolve to pursue a career in art: by the time she graduated from junior high school, she had decided to become an artist. After graduating from the High School of Industrial Arts in 1952, she attended Pratt Institute of Design before deciding to take classes at the Art Students League and work at *Seventeen* magazine. She was enrolled at Cooper Union from 1955 to 1957; that fall, she entered the Yale School of Art and Architecture, from where she graduated in 1959 with a B.F.A. At Yale she studied with Josef Albers, and he considered her an excellent student—"I did very well with Albers. I was Albers's little color studyist. . . . But he couldn't stand my painting, and of course I was much more serious about the painting."[3] Her student years were entirely devoted to painting and drawing, and she demonstrated enormous facility.

Returning to New York, she began to show and sell her work with increasing regularity. Her work was included in the "21st International Watercolor Biennial" at the Brooklyn Museum and in a group exhibition, "Drawings," at the Wadsworth Atheneum in Hartford, Connecticut, among others. Meeting more artists, including the abstract sculptor Tom Doyle, whom she married in 1961, she fast became part of a serious and loosely knit community of young artists. At the time, Doyle was a better-known artist than Hesse. Alternately tumultuous and exhilarating, their relationship was a conflicted one, and the marriage ended in 1966. In spite of the growing tendencies toward political activism and sexual liberation that characterized much of the 1960s, this was an historical moment predating the feminist movement. While Hesse fully understood the complexity of the role she needed to play as a woman artist in an overwhelmingly male art world, she lacked the vocabulary and context with which to confront it directly. She cherished her independence and increasingly resented her dependence on her husband, with whom she felt professionally competitive. Equally, she resented his stereotypical expectations of her as a wife. The breakup of their marriage was cause for debilitating pain and suffering

Hesse, *Hang-Up* (1965–66)

for Hesse; like so much else for her, it was a relationship marked by intensity and ambivalence.

Without a doubt, however, the time Doyle and Hesse spent together in Kettwig, Germany, from the summer of 1964 to early fall of 1965, represents a pivotal moment in Hesse's development as an artist. They had been invited by the industrialist and art patron F. Arnhard Scheidt to work in one of his abandoned factories near Düsseldorf. Removed from the ferment and competition of the art world of which they were both a part, she was able to experiment and explore. Encouraged by correspondence with her close friend, Sol LeWitt, whom she had met in 1960, she took chances and made choices that she most likely would never have made under the watchful eyes of her art teachers and the New York art world. A very different form of encouragement occurred in her reading of Simone de Beauvoir's *The Second Sex*; the book was significant enough to her thinking at that time that she made note of it in her letters to friends. Although it was a time of stress for Hesse emotionally—the combination of returning to Germany with lingering memories of trauma and abandonment and the ongoing disintegration of her marriage—she matured both artistically and personally.

It was in Kettwig that she began her first reliefs. Distinguished by a garishness of color and an organic-mechanical imagery, they were refreshingly awkward, erotic, both playful and menacing, with titles such as *Leap of a Walking Bull* and *Two Handled Orange Keyed Utensil*. Built-up plaster and papier-mâché on Masonite, cords were often glued and wound around bulging forms;

Eva Hesse, date unknown

movable elements such as leftover machine parts or loose string were frequently attached and dangling. These pieces did more than hint at her growing belief in the role of the absurd in her work; they are profoundly strange hybrid pieces that adhere to none of the so-called rules of artmaking. In her letters and notebooks at the time, she makes numerous references to the work as "weird," a quality like absurd or dumb, that Hesse seemed to relish. Her writings began to betray a confidence, an excitement, a knowledge that she was on to something.

The seeds that were sown in Germany took root back in New York: her marriage ended and her career began to thrive. Hesse wrote down her most private thoughts in diaries, date books, and correspondence with a rigor and honesty that was impressive; this need and ability was perhaps a result of years of therapy. It is telling that her most prolific periods of writing occurred between 1957 and 1961, and again between 1964 and 1967. As her career took hold, the content and tone of her writings began to change: they became far less personal and confessional, with a focus on the more pragmatic side of her daily life and work, such as calendar appointments and art supplies.

What never changed, however, was her clear love of, and respect for, language. Mel Bochner, her friend and fellow artist also represented in the Ganz collection, gave her a thesaurus to which she often referred in determining titles for pieces.[4]

Had she been born fifteen years later, would we have seen language and writing integrated into the actual sculpture? I think possibly. Hesse's sculptures and drawings are resolutely abstract, with no

figurative elements represented per se; the body is nonetheless a constant reference point, its skin, its bones, its limbs, its skeleton, its aging, its dying, its morphology. For Hesse, language was inherent to the work's capacity to communicate and make associations, but never explicit. But what role did her insecurity in a male world play, where conceptually oriented artists like her friends LeWitt and Robert Smithson were well-known for their facility with language? Instead, Hesse relied on sheer physical presence; utilizing many of the strategies of her Minimalist colleagues, she proceeded to undermine and subvert these very devices.

Although these strategies were not yet fully realized in *Hang-Up* of 1965–66, which Victor and Sally Ganz bought in 1972, Hesse mined the latent implications of the German reliefs in this piece to the fullest degree. It is a work of art residing precariously on the cusp or border between divergent worlds; it goes beyond the dualities so often associated with her work, far beyond. While it lacks the transcendent authority of her last works, it makes up for it in its relentlessly disorienting, albeit mute attack on (or is it an embrace of?) the viewer and invasion of his or her space. Stressing the physical and psychological play with negativity, Robert Storr wrote, "As in the best of minimalist art, the work's implicit figuration derives from the body with which it interacts. A physical and perceptual double-negative. . . ." [5]

Hang-Up has seemed to inspire all of Hesse's biographers and critics. She told Cindy Nemser in the 1970 interview for *Artforum* that it is "the most important early statement I made. . . . It was the first time where my idea of absurdity or extreme feeling came through. . . . It is a frame, ostensibly, and it sits on the wall and it is a very simple structure. . . . The frame is all tied up like a hospital bandage—like if someone broke an arm. . . . The whole

Hesse, *Unfinished, Untitled, or Not Yet* (1966)

thing is absolutely rigid, neat, cored around the entire thing. It is very pure and naive like a primitive. It is also the extreme—that is I like it and I don't like it. It is so absurd [that rod] out of that structure—this little thing comes out here and there. And it comes out a lot—about ten or eleven feet out and it is ridiculous. I mean that is the most ridiculous structure I have ever made and that is why it is really good. . . . Oh more absurdity. The whole thing is ludicrous."[6] Bill Barrette recounts how it was made: "The construction of the work was carried out by Doyle and LeWitt to Hesse's specifications. A stretcher was wrapped with bedsheets and a half-inch steel tube wrapped with cord was made to project from it. . ."[7]

Indeed, the Ganzes owned five pieces of sculpture made in 1966, including *Hang-Up*, which were all bought in 1972, at the time that the Guggenheim exhibition was being prepared. None of that group are quite as disquieting as *Hang-Up*. At the same time that Tom Doyle was helping Hesse to construct this piece, he was in the process of moving out of their apartment into his studio across the street. The distress of this year was compounded by the death of her father in August. Just before learning of her father's death, she had nearly her entire year's work photographed. Her writings during that August reveal exactly how conflicted she was: "There is lots [of work]. It is good! Very good. A most strange year. Lonely, strange, but a lot of growth and awkward search. . . . I realize how hung up I am about always feeling what I do is wrong, not good enough. . . . Always that it will break, wear badly, not last, that technically I failed. It does parallel my life for certain. . . . I have grown so this year. Last Aug. 28 we came back to America. Since then in fact I have lost my husband (through separation) and my father through death. . . . My only weapon is art, my friends. . . ."[8]

All monochromatic, the other four pieces from 1966 in the Ganz collection eloquently map her artistic trajectory

Hesse, *Metronomic Irregularity III* (1966)

over the course of that year. From the overtly erotic *Vertiginous Detour* and *Not Yet*, to the more geometrically structured *Ennead* and *Metronomic Irregularity III*, her development is more than apparent. At the time and shortly after, *Vertiginous Detour* and *Not Yet* were seen as not overly successful, both by Hesse herself as well as by her most sympathetic friends and critics. In today's climate, however, I think they would be reconsidered, and appreciated, as highly suggestive of a feminist, sexually charged statement that transgresses artistic convention and manners. It is Hesse's unusual choice and subsequent manipulation of materials in these pieces—rope, papier-mâché, black net bags, weights wrapped in clear polyethylene—and less so her consciously formal treatment, that seems to dictate the final configuration of these pendulous hanging balls and sacks which more than anything else resemble male testicles. These pieces also point to her uneasy relationship to the notion of freestanding sculpture, echoing her own insecurities about her ability to stand on her own. For Hesse, her sculpture continued to rely heavily on the wall, less on the floor, and rarely on a pedestal or base, just as she relied more and more on her friends and, later, assistants.

Ennead and *Metronomic Irregularity III* are clear manifestations of her increasing tendency to undo the order of the symmetrically organized structure of the grid. The title *Ennead* refers both to a grouping of nine gods associated with the mythology of ancient Egypt and to a set of nine, providing the piece with a narrative and associational source, as well as with a pragmatic, mathematically based structure. Hooked onto a nail on a perpendicular wall, the tangled strings actually come out of an ordered configuration of raised hemispheres on the gridded papier-mâché form. Her last gradated work, she wrote, "It started out perfectly symmetrical at the top and everything was perfectly planned. . . . Yet it ended up in a jungle of strings. . . . The further it went toward the ground, the more chaotic it got; the further you got from the structure, the more it varied. I've always opposed content to form or just form to form. There is always divergency. . . ." [9] Around this same time, she began to produce drawings based on the grid, using circular elements. Predominantly ink with wash and pencil, these drawings, rather than her sculptures, with their repetitively uniform and delicately shaded circles, are what aligned her most closely with her Minimalist artist friends, but without the obvious masculine bravado. While her incorporation of circles can readily be identified with images of the female anatomy, especially in a sculpture like *Ennead* where the dimensionality creates a literal breast-shaped mound, she resolutely, and somewhat naively, denied any intention of gendering her art.

Nonetheless the overall sexual connotations of her work did not go unrecognized. Included in two well-publicized New York gallery exhibitions that year, "Abstract Inflationism and Stuffed Expressionism" at the Graham Gallery and "Eccentric Abstraction" at the Fischbach Gallery, these titles allude to a biomorphic, Surrealist-based eroticism in the work of a number of younger artists. In addition to Hesse, Louise Bourgeois, Bruce Nauman, Keith Sonnier, and Frank Lincoln Viner, among others, were included. That none of her more conceptually driven friends participated demonstrates the fine line she constantly straddled professionally and personally. *Metronomic Irregularity II* was included in Lucy Lippard's "Eccentric Abstraction"; the Ganzes' *Metronomic Irregularity III*, along with the first version were models for the large-scale piece. Its horizontal format and its scale were new to Hesse and pointed to future major pieces she would make over the next few years. The Ganzes' piece

was the only one constructed on a single fifty-inch piece of plywood to which three ten-inch square boards of Masonite were attached. Connected by a crisscrossing of cotton-covered wires, the space between the gray panels is equal to the size of each panel. Handwritten on the invoice is the phrase "(like circuit board)," descriptive of the kind of chaotic wiring the piece resembles. It reconfirms her hybrid approach to her work; her training as a painter reemerged in this piece as she conflated the two-dimensional form with the three-dimensional. It was the large-scale work in this series that generated the first public discussion of her relationship to Jackson Pollock and her conscious tendency toward a style of three-dimensional drawing.

Sharing an ordered structure undermined by the addition of tangible lines (cord, rubber tubing, nylon string), three of the works from 1967 all display an increasing sense of confidence and self-assurance. The sculptures make no attempt to be ingratiating. *Addendum* was included in the 1967 "Serial Art" exhibition at Finch College organized by Mel Bochner. Hesse's own description for the Acoustiguide audiotape details the piece's components in mathematical and objective terms: "the title of this work is Addendum; a thing added or to be added." She continued, "The chosen nine-foot eleven-inch structure, the five-inch diameter semi-spheres, and the long thin rope are as different in shape as possible. . . . To further jolt the equilibrium the top of the piece is hung seven feet high. . . . Series, serial, serial art, is another way of repeating absurdity."[9] While one of her more rigorously ordered pieces and least overtly eccentric, she invested it with contradictions, relishing its "absurdity." Further, *Addendum* reinforces her identification of repetition with this notion of absurdity, one not shared by the majority of her colleagues, like LeWitt or Donald Judd,

another sculptor she admired. What we also start to realize is that repetition can lead to fragmentation and disintegration; indeed, artists such as Bochner, as well as Carl Andre, Robert Morris, and Richard Serra, all made forays into sculptural expressions of dematerialization and dispersal. None, however, pursued that direction to the extreme that Hesse did in her last pieces.

Her willingness to deviate from the prevailing avant-garde tendencies and to embrace an increasingly unfashionable penchant toward expressionism continued to distinguish her from many of her peers. This distinction was most vividly articulated in her adherence to a quality of the handmade—work that revealed the touch and the feel of the artist—in contrast to the smooth, uninflected, fabricated metal surfaces of a piece by Judd, for example. Bill Barrette's description of *Constant* (1967) explains how she achieved its particular sense of touch: ". . . Hesse pushed black extrusions through a dense black square whose surface was made of a thick concretion of wood shavings, glue, and acrylic paint. The black field is energized by the imprint of the artist's fingers obsessively tracking over the surface, and by numerous knotted extrusions."[11] The tubing of *Constant* is echoed in the nylon string of the 1968 *Circle Drawing* belonging to the Ganzes, but the final effect is altogether dissimilar: the hairy rubberlike thickness of the former piece is in stark contrast to the delicacy and subtlety of the latter. The drawing shows Hesse's affinity with the most prominent woman artist of the Minimalist movement, Agnes Martin, although of course Hesse deliberately remained an outsider. Both of these pieces bear the telltale sign of "women's work," not just the necessity for a repeated, compulsive action, but associations with crafts, like sewing, weaving, needlework, threading, knitting, handiwork. Part of Hesse's radicality derives from her ability to transform an activity long

Hesse, *Ennead* (1966); overleaf: **Hesse,** *Addendum* (1967)

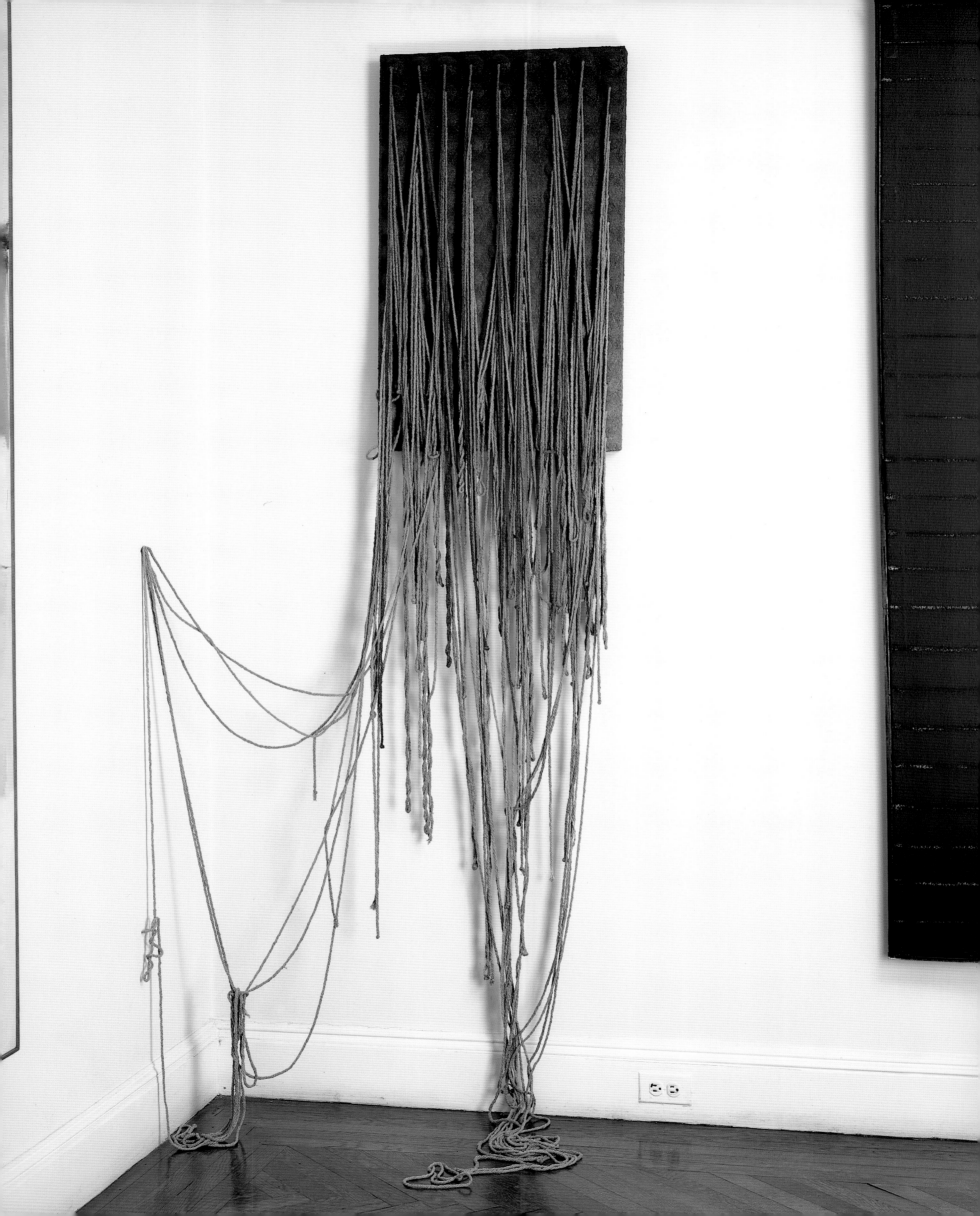

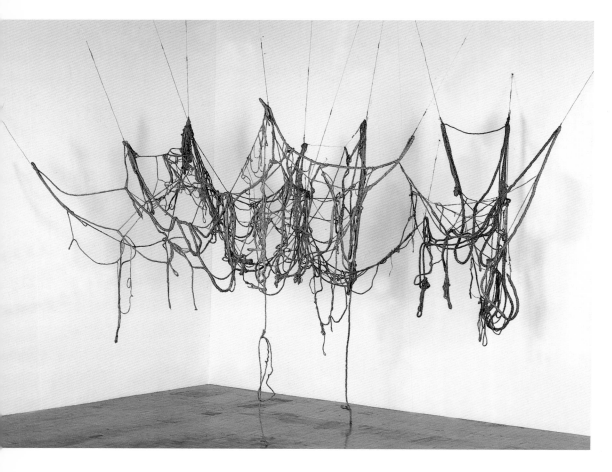

egy learned from Brancusi and well mined by many contemporary artists like LeWitt and Andre. Not surprisingly, her interest in latex confirms a predilection for soft pliable materials; almost a synthesis between sculpture and paint, it was controllable, yet it had a finite life of its own. Undoubtedly its fragility and general impermanence appealed to her interest in the mutability of form.

It was *Schema* and the two test pieces that helped the Ganzes to acquire *Vinculum I* of 1969. Made of reinforced fiberglass, vinyl tubing, and metal screen, the work was completed with the assistance of Doug Johns and Martha Schieve. Hesse had met Johns in 1968 when he had helped with her first experimentations with fiberglass and polyester resin at Aegis Reinforced Plastics; Schieve had begun to work as Hesse's assistant in early 1969. Fiberglass allowed Hesse to reintroduce light and color into her work in an entirely new and integrated way. By the completion of *Vinculum I* Hesse had already experienced her first symptoms of illness, approximately the same time as her fall 1968 Fischbach exhibition, "Chain Polymers." The show included four important fiberglass pieces and four latex pieces, and the reviews were generally enthusiastic. Her statement for the occasion read in part, "I would like the work to be non-work. This means it would find its way beyond my preconceptions. . . . It is my main concern to go beyond what I know and what I can know. The formal principles are understandable and understood. It is the unknown quantity from which and where I want to go. . . . It is something, it is nothing." [12] A statement like this, written for publication, attests to the artist's mastery of

associated with a domestic and essentially private enterprise of little larger significance into a powerful public statement that demands our attention.

The year 1967 witnessed her abandonment of certain of her most favored materials, like rope and papier-mâché, as she turned to more sophisticated materials and means of construction. It was at this time that she began to experiment with latex, as well as agreeing to have a piece, the galvanized steel *Accession II*, fabricated at Arco Metals. (The Ganzes owned two of the Accession drawings of 1968.) Furthermore, she began to make fewer wall pieces, concentrating instead on works placed directly on the floor, or leaning; box or vessel shapes appeared with greater frequency. The Ganzes exchanged two of their first purchases for *Schema* (1967–68) in 1968. An early latex sculpture that was exhibited in her 1968 exhibition, *Schema* rested flat on the floor. Its "base" was the latex ground of the work itself; in other words, the base was part of the sculpture, a strat-

Hesse, *Untitled (Rope Piece)* (1969–70)

Hesse, *Vinculum I* (1969), detail

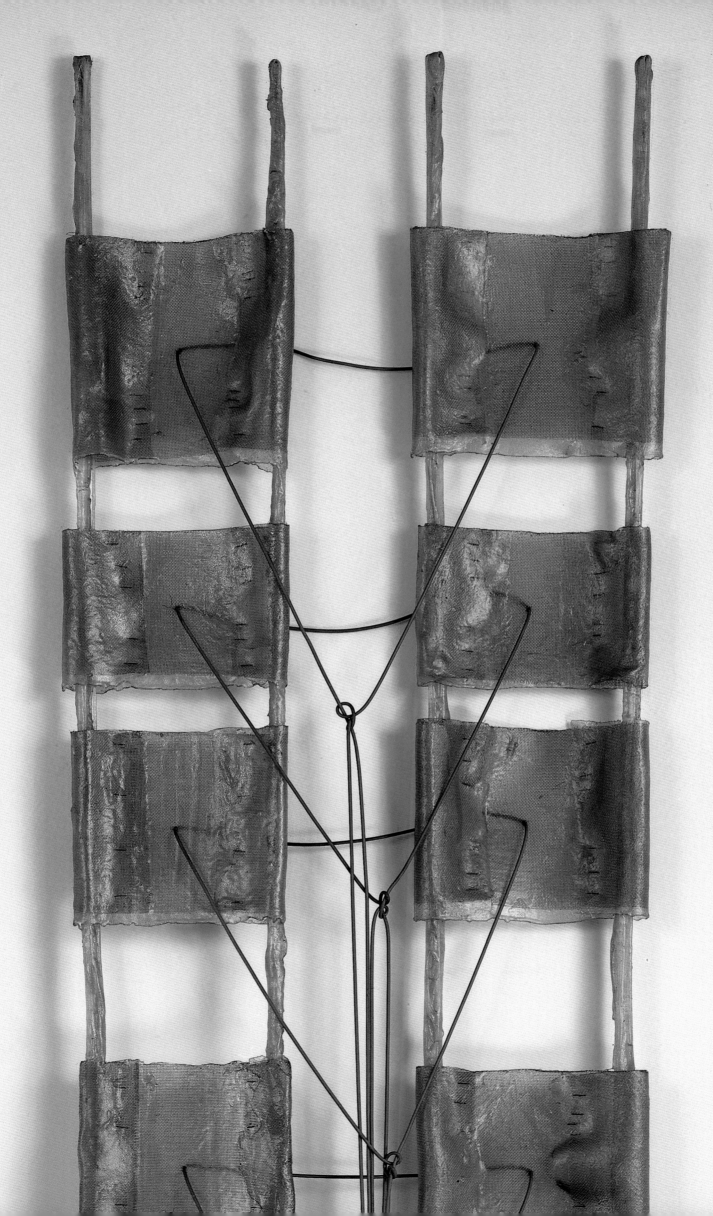

language and ability to express herself well in writing.

For the Ganzes to choose *Vinculum I* in 1969 made sense; it had a presence and authority about it, but was appropriate for an apartment. So much of her last work was on a scale that could be handled only in a public or museum space. That the Ganzes proceeded to acquire her three last pieces, which decidedly exceeded standard domestic space, is ultimately not surprising. After *Vinculum I*, Victor and Sally Ganz did not buy more of her work until 1972, two years after her death, at which time they bought a total of twelve pieces.

In discussing the collaborative process of making *Vinculum I* necessitated by her growing weakness, Hesse told Nemser that "it was a very complex piece, but the whole attitude was different, and that is more the attitude I want to work with now. . . . That was one of the last pieces I did before I got so ill. . . . I just described the vague idea . . . and we went and just started doing it."[13] It became clear that she gained a freedom from the dynamics of the collaboration and it allowed her to continue a kind of risk-taking that she clearly relished.

The other sculpture from 1969 belonging to the Ganzes was *Connection (Icicles)*. Suspended from the ceiling, it was made soon after *Vinculum I*, again with the assistance of Johns and Schieve. The work, probably unfinished in Hesse's mind, consists of twenty units, each made of reinforced fiberglass over cloth-covered wire, resembling icicles. After wrapping pieces of fiberglass soaked with resin around the wire armatures, according to Barrette, "the shapes were formed by the action of gravity on the fiberglass resin. . . ." [It is] strangely organic, visceral yet bloodless and anticipates Hesse's piece, *Seven Poles*."[14] To me, it more than hints at a sense of mortality; it bears an eerie resemblance to human bones, dangling and unattached to bodies. Its fragmentation belies its

desire to "connect." During my research for the 1972 exhibition, I interviewed Dr. Samuel Dunkell, Hesse's psychiatrist; he noted her persistent need to feel "connected" emotionally to other people, an observation that rings especially true in light of the work's title, as well as her "relentless use of cords and elements which gropingly reach out to the viewer." It was made just before her first operation. A second operation took place in August of 1969 and the year ended with a triumphant showing of *Contingent*. Then she spent Christmas and New Year's in the hospital.

Untitled (Wall Piece) was begun at the end of 1969, but finished in January 1970 after Hesse's return from the hospital. Returning to a wall orientation and traylike structure, it combines fiberglass and latex; it also combines the hardened brittle and irregular wall units with dangling organic tentacles. She oversaw the making of this piece almost entirely from her bed, but evidently never flagged in her insistence to the detail of excessively wrapping $^3/_8$-inch aluminum wire with gauze. These knotted latex-covered wires seem to literally "grow" out of the wall, vividly illustrating Dr. Dunkell's point. Could the piece represent the back of "alien" canvases attached with other worldly hanging devices? On the other hand, this piece always reminds me of the remains of some tragic breed of prehistoric animal.

The last two major works in the Ganz collection, *Untitled (Rope Piece)* (1969–70) and *Untitled (Seven Poles)* (1970), have been generally recognized as masterpieces within a body of work that had attained a level of emotional and formal authority unequaled among her generation. Hesse herself drew the comparison between the "knot piece," as she called it, and Jackson Pollock's work when she told *LIFE*, "This piece is very ordered. Maybe I'll make it more structured, maybe I'll leave it changeable.

Hesse, *Constant* (1967)

189

When it's completed its order could be chaos. Chaos can be structured as non-chaos. That we know from Jackson Pollock."[15] Violating a structure of containment, she denied the concept of stability, as well as a sense of mastery. Seeming to materialize the psychic forces of painting, this piece could be seen as Pollock's worst nightmare; unleashing the repressed and the unspoken, the unconscious seems to be making a massive return here. Just as attitudes changed over time about Pollock's drip paintings which were initially considered by the uninitiated not to be legitimate art—and certainly without a sense of traditional beauty—so too Hesse's uncompromising statement has assumed its own kind of resonance and aesthetic clarity. An ugly, indeed grotesque, version of the earlier gossamer-threaded fiberglass web of *Right After, Untitled (Rope Piece)* it is made of latex over rope, wire and string—a logical extension of the rubberized "roots" virtually exploding out of the untitled wall piece. Hung from the ceiling, its

Hesse, model for *Untitled (Seven Poles)* (1970)

installation is mutable, time-consuming, and challenging; according to Barrette, there is no "right" way to install it. Made over a period of several months, it was set aside when work began in March of 1970 on *Untitled (Seven Poles)*, which had been commissioned by the Owens-Corning Fiberglass Center in New York City, but never finally bought by them.

Her last work, *Untitled (Seven Poles)*, was well received when it was shown that May; she died on May 29 at New York Hospital and never saw it. Its model, given to the Ganzes by Helen Hesse Charash in 1974, provides clues into her original thinking about the piece. Not only were the poles intended to be tied together, but the piece was to be placed on a mat. The final version is made of reinforced fiberglass over polyethylene over aluminum wire and is suspended from the ceiling (its poles could never stand alone). It is generally agreed that the original inspiration came from a 1968 trip to Mexico that Hesse took with her friend the artist Ruth Vollmer, where they saw an eight-inch-high group of Olmec figurines.

These eerily translucent legs are not without both humor and pathos; Hesse's insistent oppositional forces come into play yet again. The more structural or pragmatic formal contradictions of her earlier work have been replaced with more psychologically laden ones: absence and presence, inner and outer, life and death. The wires that hold the legs together are visible through the murky fiberglass; they are there and not there; they are alive and dead.

These last pieces exemplify the appeal Hesse has exerted on a younger generation of artists, especially women, like Kiki Smith, for example. A forerunner to the experience that has been theorized as abjection, Hesse's work breaks a long-held silence and dares to speak out triumphantly with a loud voice without ever explicitly naming that which has been unspoken and invisible. She dared to

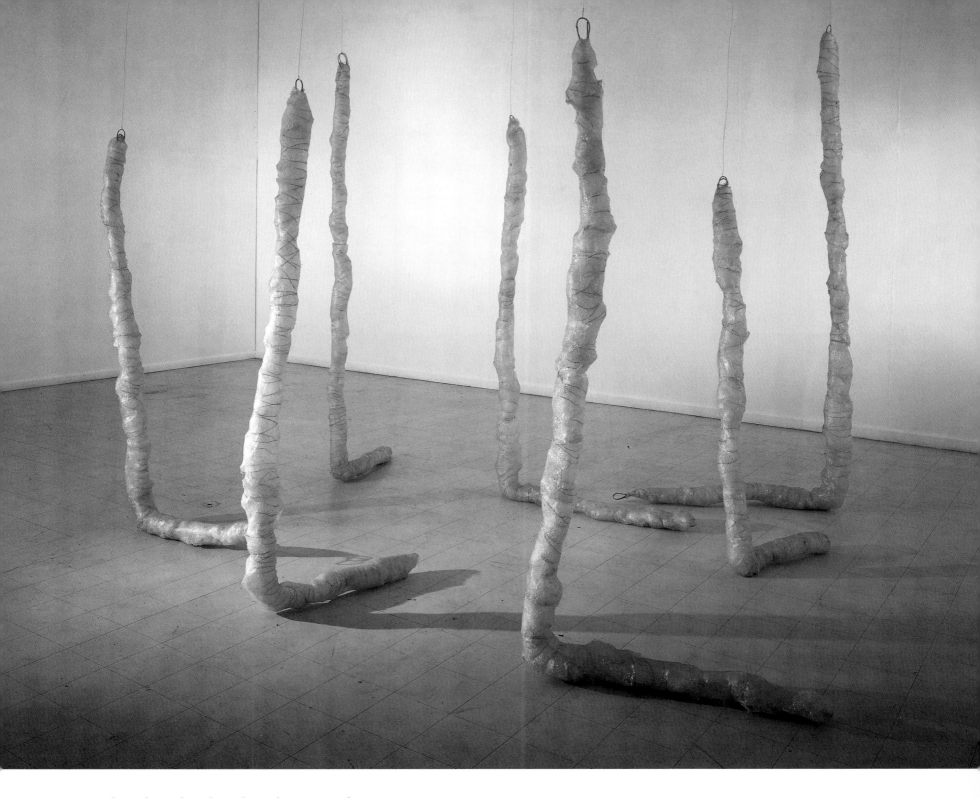

take risks and explore the unknown. In their commitment to her work, Victor and Sally Ganz reinforced those risks that Eva Hesse took during her lifetime. They became collaborators of a sort with the artist, both during her lifetime and after her death.

1. Ellen H. Johnson, *Eva Hesse: A Retrospective of the Drawings* exhibition catalogue (Oberlin, Ohio: Allen Memorial Art Museum, Oberlin College, 1982), p. 22.

2. Quoted in Helen A. Cooper, *Eva Hesse: A Retrospective*, exhibition catalogue, (New Haven: Yale University Art Gallery, 1992), p. 31. This publication includes the most detailed chronology to date of Eva Hesse.

3. Ibid., p. 20.

4. Ibid., p. 17. All of Hesse's critics have noted her proficiency with language and love of words, albeit expressed mostly privately. Cooper's discussion of the role that writing played for Hesse is informative.

5. Ibid., from Robert Storr, "Do the Wrong Thing: Eva Hesse and the Abstract Grotesque," p. 92.

6. Quoted in Storr, p. 92

7. Bill Barrette, *Eva Hesse: Sculpture* catalogue raisonné (New York: Timken Publishers, Inc., 1989), p. 66.

8. Quoted in Cooper, p. 39.

9. Quoted in Lucy R. Lippard, *Eva Hesse* (New York: New York University Press, 1976), p. 62.

10. Ibid., p. 96.

11. Barrette, p. 124.

12. Cooper, p. 45.

13. Barrette, p. 210.

14. Ibid., p. 216.

15. "Fling, Dribble and Drip," in *LIFE*, February 27, 1970, p. 66.

Hesse, *Untitled (Seven Poles)* (1970)

191

EVA HESSE AND THE GANZES

BILL BARRETTE

Much has been written about the life and work of Eva Hesse in the last thirty years, but little attention has been paid to the development of the artist's career and the establishment of her stature as an artist of world renown. For Eva Hesse (1936–70), this process took place almost entirely after her death. To be sure, she was aware toward the end of her life that she was poised for success. But it was not until twenty years after she died—following retrospectives at Yale University and the Jeu de Paume in Paris—that her work gained wide acceptance by the art public.

During this long period, Victor and Sally Ganz—as primary collectors of her work and enthusiastic promoters of her reputation—played a key role in assuring Hesse's ultimate success. Yet the Ganzes' relationship to Hesse has, until now, not been discussed in print. During the last two years of Hesse's life, I was one of her studio assistants and after her death the person most often called on to install her work for exhibition. I met the Ganzes for the first time shortly after the artist's death, and although our relationship centered around Hesse, it developed into a close friendship. In addition to personal memories, I have been able to draw on a filmed interview Joan Simon made with the Ganzes in the spring of 1987. This interview corroborates many of my own memories, and I will quote from it below.

The Ganzes' involvement with Eva Hesse began during the artist's first and only one-person sculpture show, held at Fischbach Gallery in November 1968. This was a watershed year in her life. In a diary entry from April of that year, Hesse notes:

> If I can forever lose panic, I know that I am capable of being a great artist, great person. The terror so

stands in my way. It is a haunting, a paralyzing experience, one of which I stand in dread of occurring, and when it happens it is even worse than I anticipated. . . . It is easy in my work now. I know the important thing's there, but in life, yet a way to go.

Hesse's demons were never too far from her door, but in matters of art she had many reasons to feel buoyant. Her advance through the art world of the mid-1960s was impressively rapid. Leaving Yale in 1959, she struggled with her painting until 1965, when she began to make her first sculptures. Her new work was quick to gain the support of a circle of artists, critics, and curators who would be influential in determining the course of the final phase of Minimalism. In March 1966 her sculpture appeared in a show entitled "Abstract Inflationism and Stuffed Expressionism" at the Graham Gallery, and in September, in the landmark show curated by art critic Lucy Lippard, "Eccentric Abstraction" at the Fischbach Gallery. In both shows, Hesse's work was singled out for critical praise.

Lippard's exhibition brought Hesse to the attention of Donald Droll, Fischbach's director, and the artist was offered representation in 1967. Fischbach was a high-profile gallery at that time, presenting the work of Robert Ryman, Robert Mangold, Ronald Bladen, and Alex Katz among others. Droll was unusual if not singular among dealers in the art world of the 1960s and 1970s in his willingness to represent the work of women artists. In addition to Hesse, he gave important early shows to Louise Bourgeois, Jo Baer, Pat Steir, Ree Morton, and

Jasper Johns and Eva Hesse at the Ganzes' apartment, 1968

many others. And Hesse's relationship with Droll proved to be a fateful one as he became an executor of her estate and one of the principle architects of her posthumous career. Droll's trajectory through the art world in the 1970s would bring him and the Hesse estate from Fishbach to the Knoedler Gallery, after which Droll opened the Fourcade-Droll Gallery in partnership with Xavier Fourcade in 1972. In 1976, Droll left Fourcade to open a gallery with Frank Kolbert, a partnership that lasted until 1980. At that time, Droll's involvement with the art world declined until he relinquished control of the Hesse estate in 1983, two years prior to his death. While active, Droll established the landmarks of Hesse's reputation: the Ganz purchase of eleven of Hesse's major works in July 1972; the December 1972 Guggenheim retrospective curated by Linda Shearer; the publication of Lucy Lippard's much admired critical biography of Hesse in 1976; the Hesse retrospective at London's Whitechapel Gallery in 1979, originated by Nicholas Serota; and Ellen Johnson's book and traveling exhibition on Hesse's drawings in 1982. These and subsequent events were crucial to Hesse's survival in public memory, and the Ganzes—in their capacity as collectors, lenders, and discreet advocates—played a role in them all.

The Ganzes' first encounter with Eva Hesse's work took place on a Saturday in November 1968 when, as was their custom, they were out with a list of eight or nine shows they wanted to see on Fifty-seventh Street. Toward the end of the afternoon, Sally's feet gave out, and she left Victor to see the last two shows by himself. He stopped by the Francis Bacon

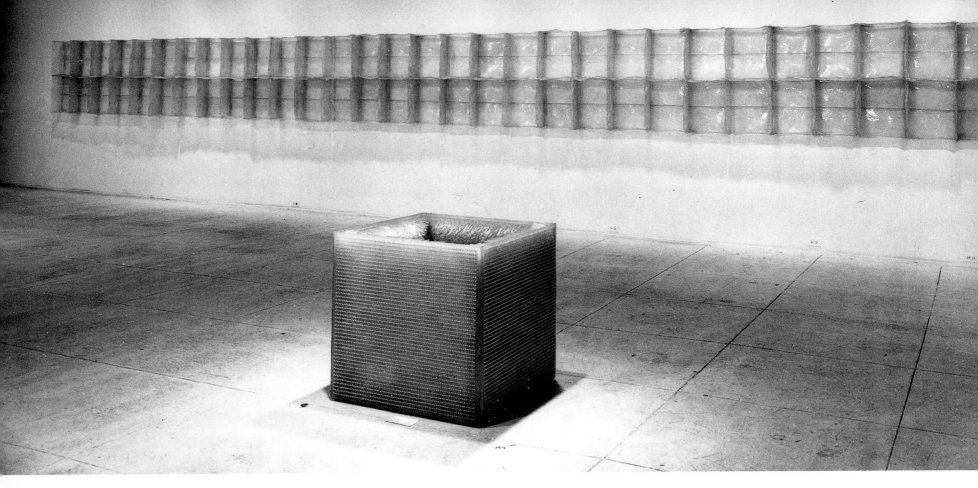

Installation view, front room, Fischbach exhibition, November 1968

opening at the Marlborough Gallery, which he described as "filled with wealthy collectors, chatting away like a giant cocktail party. And I was so turned off that I ducked out after fifteen minutes. Then I went to this oasis which was the Fischbach Gallery, where practically nobody was, and the experience was so completely and utterly opposite with what I had just come from, that I'm sure that also softened any resistance I might have had to making any purchases. I suddenly saw this array of art which I felt was the most beautiful thing I'd ever seen, and the most fascinating. . . . [The pieces were] were very amusing, very funny, but at the same time it was very serious and very beautiful."

Ganz was much taken by the latex materials that some of the pieces were made of, and, after inquiring about the prices and finding them to be modest, proceeded to buy a pail that had a rubber tube coming out of it (*Test Piece for Repetition Nineteen II*, 1967–68), a stack of what looked like plastic pancakes (*Model for Augment and Aught*, 1968), a latex floor sculpture (*Schema*, 1967), and three wash drawings.

The Fischbach Gallery space was divided into two rooms, a large main gallery and a much smaller back space. Hesse's large-scale fiberglass and resin sculptures, which had been fabricated especially for the show, were exhibited in the main gallery and were obviously to be considered the central pieces of the exhibition. In the back space, smaller, handmade latex pieces were shown, most of them dating from 1967. Ganz's initial attraction was to the latex pieces with their visceral and erotic overtones; he makes no mention in the interview of Hesse's more ambitiously scaled fiberglass works.

A year later, after getting to know the artist and her work better, Ganz came to feel that the purchased pieces were "relatively minor" and traded them back to the gallery for a "big important piece," the fiberglass and resin sculpture *Vinculum I* (1969). It was the only sculpture in the Ganz collection at the time of Hesse's death.

When the Ganzes were considering their large purchase of the artist's works in 1972, Droll discouraged them from purchasing her latex pieces, fearing that they

might not structurally "withstand the passage of time." As a result, they purchased only one latex piece, *Untitled (Rope Piece)* (1969–70). This was unfortunate since this side of Hesse's work is often missing from exhibitions and represents some of her most radical and beautiful sculptures.

On that first memorable Saturday when Ganz was concluding his initial purchases, he was asked if he would like to meet the artist, who happened to be visiting the gallery at the time. In the Simon interview he admits that he was immediately charmed by her.

> She looked, to begin with, she was very young, but she looked considerably younger than I later found out her age to be, and she reminded me of my daughter [Kate]. She was very enthusiastic, and very cute, and very bright, and I fell for her immediately, and we got along famously. . . . In fact, we got along so well that I finally said to her, "You know that I just bought that little pile of pancakes," and said, "There's one thing about the pile of pancakes that would improve it." She said, "What's that?," and I said, "I think it would be a help if you made the pile a little bit higher." She said, "Oh all right, I can make a couple more pancakes . . . and I'll send them to you when they're completed." They were loose and there were a little pile of these, I think there were six; I thought eight would be better. I like pancakes. And anyway, we got along fine.

This first encounter ended with Ganz extending an invitation to a "sort of art party" the following week at the Ganzes' apartment. To entice the young artist, Victor told her that Alfred Barr and John Russell would be there. Hesse demurred until he mentioned that Jasper Johns would also attend. This clinched it for Hesse, as she admitted that Johns was one of her heroes and that she had never met him. Victor returned home and excitedly reported to Sally what had happened and proceeded to call Johns to plead with the famously reticent artist to "make a real effort to be nice to her because she thinks you are a god and she will be thrilled if you pay some attention to her." The arranged meeting of Hesse with Johns went off smoothly, and a photo was taken to document the special event. It is easy to imagine the elation Hesse felt at this moment. There had been many indications prior to her show that success was near, but here was validation that she had indeed arrived at the art world's version of the Promised Land, and that she would have a place in it too.

The party was the beginning of a close friendship with the Ganzes, the first of many evenings Hesse spent in their apartment. In the 1987 interview, Victor supplies a sidelight that reflected that relationship. When she came to dinner and it was time to go home to her studio on the Bowery, Ganz—who had recently purchased a Maserati—would delight in driving the artist home. "She loved the notion of taking a little ride in the car. . . . She was in many ways completely unspoiled and rather naive. And that was a big event, so I felt that she was like one of our children." Victor's parental feelings increased after the artist's death, intensifying his sense of responsibility and duty to further her reputation.[1]

At this point, in late 1968 and early 1969, the doors of the art world opened wide for Hesse. Her work began to be included in numerous important gallery and museum shows and she was included in a *LIFE* magazine spread on emerging artists. It was becoming difficult for her to meet the increased demand for her work.

Hesse's elation was to be short-lived, however, as she was diagnosed with a brain tumor in April 1969. There followed a harrowing year of three brain operations, a year

in which she nevertheless realized many of her greatest works. By the time she was diagnosed, the Ganzes had not only befriended her, but had become "sort of a surrogate family for her." Sally recalled:

> We enjoyed Eva even when she was ill. When she came for dinner she would sit at the table and she had a large bag, it looked like a camera case, and out of it she took not one or two but twenty different prescriptions and they were all lined up on the table in front of her, and she had to keep taking this medicine but she never talked about her health or complained or let you feel that she was sick or weak in any way. She was just so full of life that it was very hard to see her at that time, and to accept the fact that it was going to be a short life. Her death was a very sad time for us. She was in the hospital for quite a long time and then it was over. I do often think about her little funeral. It was very small, not very many people there. Just a service at, I think, the Riverside Chapel. And when that coffin was pushed out of the room, you could only think, "How could such a tiny box contain such a tremendous spirit and talent as Eva had."

Hesse's death at such an early age and at such a moment of bright promise intensified the Ganzes' feeling for her art, and led them to make an extraordinary purchase of eleven major pieces in July 1972. This purchase was not typical of the Ganzes, and the only other time they bought a large ensemble of work in one grand gesture was in 1956, when Victor acquired the entire series—fifteen paintings and two lithographs—of Picasso's *Women of Algiers*. What prompted the Hesse purchase? I believe that the Ganz relationship to Hesse was fundamentally different from those they formed with the other artists they collected. In Hesse's case, they felt—justifiably so—that she was their discovery. Furthermore, they had developed a very personal relationship with her. Thus, they sensed with her death that the burden of sustaining her memory fell most directly on them. The decision to purchase was made by both Victor and Sally, but it is also true to say that at this point Hesse's work was primarily Victor's passion. Sally stated in a letter to her daughter Kate shortly after the purchase:

> I don't think I wrote you that Daddy has bought practically all of Eva's remaining pieces of sculpture—a very large buy. There is going to be a show at the Guggenheim in the fall—he has a stronger and stronger feeling of her importance. . . . We will try and give them, on loan, to museums who want them as they are almost impossible to store— Donald Droll is going to arrange it if he can. The day we went to Donald's studio to see them all again was so moving—they are such completely personal statements, and so many of the late ones are so bandaged and painful to look at. . . . Helen [Eva's sister] was pleased that Daddy wanted them, and pleased that they will be lent to museums. There is very little and the prices have risen astronomically; it seems a terrible pity that she has had so little of the sweet taste of success.

The consequences of the sale of so many key Hesse works in July 1972 were enormous. In the short term, the funds from the sale enabled the estate to publish Lippard's biography of the artist, a popular book that brought the work to the attention of a large audience. In fact, as Linda Norden pointed out in her essay for the Yale catalogue, "Over time, as much of Hesse's work began to deteriorate,

in ways anticipated but not fully intended by the artist, the book became an evocative reclamation and displacement of a body of work no longer visible in its original state."

Over the longer term, the ways that the Ganzes chose to display Hesse's work within the context of their collection played a significant role in calling attention to her importance as a sculptor. The Ganz collection, with its special concentration of important works by Picasso, Johns, Robert Rauschenberg, and Frank Stella, provided an unusual if not unique context for the young artist. A visitor to the Ganz residence at 10 Gracie Square would pass through a room containing major works by Picasso and Johns and enter the dining room where two Hesse sculptures—*Ennead* (1966) and *Vinculum I* (1969)—flanked *Rebus*, Rauschenberg's seminal Combine painting of 1955. On the wall to the left was Picasso's large synthetic Cubist painting of 1923, *Bird Cage,* and on the wall opposite, Stella's early black-period painting, *Turkish Mambo* (1959). This linkage to Picasso by way of Johns, Rauschenberg, and Stella rarely failed to impress, and, over time, to convince even the more skeptical visitor of the importance of Hesse's work. In the Simon interview, Sally commented on the Picasso-Hesse connection:

> It reminds me that when we first used to have young artists come to see us, they were very interested in the Picassos, and Degas was their god. And it came to pass over the years, that Picasso became to them an old master, and the young people who came here were absolutely turned on by Eva's work.

The next phase in the display of the Ganz collection took place after Victor retired in 1981. He renovated a series of rooms in the basement of their apartment building for the purpose of exhibiting larger works that had previously been on view in his office or in storage. The rooms were renovated in the austere gallery style of the period—white walls, gray floors, and track lighting—and they had quite a different feeling from the rooms of the apartment. The basement gallery was to provide a focal point for many of Hesse's most impressive works at a time when interest in her work was beginning to subside.

This installation coincided with the period of Donald Droll's gradual withdrawal from the Hesse estate, and the beginning of the bull market of the 1980s. Hesse's work, with its unmistakable aura of hard-won authenticity, seemed out of step with the prevailing values then current. It was not until 1986 that strong interest in Hesse's work would return, in the form of a number of important survey exhibitions that sought to reposition her in relation to the larger art historical and cultural developments of the century. In the early 1980s, there were few exhibitions of Hesse's sculpture, and for many visitors to the basement gallery it was the first encounter with some of her strongest work. Sculptures such as *Vertiginous Detour* (1966), *Hang-Up* (1965–66), *Constant* (1967), *Connection (Icicle)* (1969), *Rope Piece* (1969–70), and *Untitled (Wall Piece)* (1970)—many not seen in New York since the Guggenheim show of 1972—made a strong impression on first-time viewers and art world professionals alike. Many of the young visitors to whom the Ganzes made their collection available would become the art historians, critics, and curators who would reevaluate Hesse's work in years to come. In a sense, the Ganzes re-created, in their repository of Hesse's work, a 1980s version of the "oasis" experience that had so impressed Victor at the Fischbach Gallery in 1968, a calm space in which to reflect on Hesse's work.

Victor's retirement also afforded him time for a greater involvement in the art world, both in his capacity as trustee

and vice president of the Whitney Museum and as chairman for the Battery Park City Fine Arts Committee. His unbounded curiosity and infectious enthusiasm made him an influential advocate for the artists he valued. The great period of collecting for the Ganzes had now come to a close, and they were in the enviable position of seeing the tough choices of earlier decades validated. This validation must have been particularly satisfying in the case of Hesse, whose career they had nurtured since its inception.

During Victor's lifetime, he was to sell only two of Hesse's sculptures. Hesse's sister, Helen Hesse Charash, told me that Victor indicated to her and to Eva that he would place Eva's work in museums. The first sale, *Addendum* (1967), was to the Tate Gallery at the time of the Whitechapel retrospective in 1979. The second sale—*Untitled (Seven Poles)* (1970)—was to the Centre Pompidou in 1986, at the time of Margit Rowell's exhibition "Qu'est-ce que ce la sculpture moderne?" in which *Seven Poles* was featured. Both sales followed lengthy solicitation by the institutions, and as Sally reminded a curator, "You know, my husband is quick to buy but slow to sell." Both sales were important to the extension of Hesse's image into Europe, and that factor was key in Victor's decision to sell. In the case of *Seven Poles*, there was the added factor of the Ganzes' frustration over being unable to arrange a long-term museum loan for the room-sized work. Several institutions had been solicited over the years and none would agree to keep the piece on view.

After Victor's death in 1987, Sally continued to make good on this pledge to place Hesse's works in museums. The decision came about in 1988, when Sally—overcome by her husband's death and by feelings of responsibility to care for such a large collection—decided to close the downstairs exhibition space. Two of the six Hesse pieces were placed on extended loan to museums, and four were sold through the Robert Miller Gallery, the new representative for the artist's estate. Works of that quality had not been on the market since Hesse's death, and Miller was able to quickly place them with four different North American museums. *Hang-Up* went to the Art Institute of Chicago; *Vertiginous Detour* to the Hirschhorn; *Untitled (Wall Piece)* to the Des Moines Art Center; and *Untitled (Rope Piece)* to the Whitney.

The effect of the transfer of so many key Hesse works to museums ushered in a new phase of the artist's career. A different dynamic was involved as curators interested in mounting exhibitions had to deal with other institutions for loans and try to fill gaps with loans from the Ganz collection. This was exactly the reverse of the situation that had applied until 1988. A further consequence of these sales was that they established a new market level for Hesse's work, further indicating her arrival at the stature of major artist.

It is very difficult to compare the art market of today with that of the late 1960s and early 1970s. The art world was a smaller place then, and the monetary needs and expectations of an artist were on a correspondingly smaller scale (the rent of Hesse's duplex studio was $135 a month at the time of her death); the era of large-scale prices for contemporary art didn't really begin until the late 1970s or very early 1980s. The Ganzes made their Hesse purchases between 1968 and 1972, and I introduce the subject of prices here to give some perspective on the scale of their commitment to Hesse's work.

In the interview with Joan Simon, Victor related that when he purchased pieces from the Fischbach show, he found the prices modest. When one considers the very large scale of the fiberglass works that dominated the main gallery there, and the fact that the gallery had paid toward their fabrication costs, the prices ($1,500, $2,500, and

$4,000) do indeed seem modest. Perhaps their pricing reflected a difficulty in finding clients for museum-scale work of an artist making her debut, but in the back gallery, Hesse's smaller-scale latex sculptures, models, and drawings were priced from $250 to $1,000. The sculptures that Victor bought that Saturday were *Model (Rubber Pail)* (1968) ($175), *Model (Pancakes) Stack of 10* (1968) ($400), and *Schema* (1967–68), a floor sculpture ($800). A year later, when the Ganzes decided to trade in the earlier purchases for a more sub-

Installation view, back room, Fischbach exhibition, November 1968

stantial work—*Vinculum I*, a piece the artist was very fond of—they did so for $2,500, less the amount credited for the returned works. In early 1970, I recall working on *Untitled (Seven Poles)*, Hesse's last and one of her largest sculptures. It was a commission from the Dow Corning Corporation for $4,000, the highest price offered for a Hesse work up to that time. We marveled at the huge amount of money. (The commission was subsequently withdrawn, and the piece was sold to the Ganzes two years later.)

When the Ganzes made their purchase of the large group of Hesse works, it was a few months before the opening of the artist's retrospective at the Guggenheim. The show must certainly have been a major factor in Droll's decision to raise prices substantially, in most cases five to seven times above what they would have been before her death. The total came to $150,700, to which a 25 percent discount was applied. The prices ranged from

$3,500 for the smallest work—*Metronomic Irregularity III* (1966)—to $28,000 for large, late works such as *Untitled (Rope Piece)* and *Untitled (Seven Poles)*. This must be considered a major purchase within the context of the early 1970s art market, especially for a very young artist with one solo sculpture exhibition. By way of comparison, a large painting by Joan Mitchell—an artist more established than Hesse at the time and represented by the same gallery—would sell for $12,000–$14,000 in 1974. To me this demonstrates the Ganzes' great confidence in their assessment of Hesse as an important artist. In the two years they had waited to purchase her work, the ante had been raised considerably, and still they didn't blink.

This discussion of careers and markets has taken us far afield from what was essential in the relationship of Victor and Sally Ganz to Eva Hesse, that is, her art. The Ganzes were able to recognize the special quality of her work years, if not decades, before Hesse was accepted by the art

public. Just what was it about her art that appealed to them? In the 1987 interview, Sally reflected,

> I had thought [Hesse's work] had an extraordinary toughness and gutsiness, but at the same time it had a kind of vulnerable quality about it; it was the first thought and the first feeling that I had about it, and it really increased as she went along. . . . Work that appeals to me has to do with the emotions and the eye as much as anything else, more so than with [Victor]. I think [he has] a much drier look at things than I do.

Victor continued,

> I think the thing that was so new and so exciting—in addition to the materials involved—was the fact that she, I suppose she was really a Minimalist in a sense, she did things in a serial way, and so on and so forth, but it was a Minimalism with a new kind of extra component. And that was the very feminine thing that Sally refers to, the kind of warm emotional sentiment that was there that had been totally turned against, in a sense, by other Minimalists at the time. So that she gave it a poetic dimension that it really had lacked, and which I think gave it an importance which has only increased over time.

The Ganzes claimed that their approach to art was largely instinctive, that the work they purchased had to have an "immediate gut appeal" for them, and that there was no underlying philosophy governing their choices. They did not define themselves as "collectors," as that term was used in the 1980s. We have seen that their attraction to Hesse's work was immediate and profound, reflecting, I believe,

Hesse, *Circle Drawing (With Plastic Threads)* (1968)

Victor's and Sally's own complementary energies of intellectual rigor and great emotional depth.

The last question Victor Ganz responded to in the 1987 interview was, What did he think would happen to Hesse's work in the future?

> Well, especially in the case of her reputation and her whole history and her career, it is extremely important to me that those things that we have permitted to be sold would appear in important, if possible, public institutions—like the Pompidou or the Tate, institutions of that kind. It is very difficult to think about the future in that way because, actually, the day will come when the collection will become available to our children, and they will have to make these decisions for themselves—because of the very, very disproportionate amount of our assets now in our collection. . . . I don't think we could properly leave the collection as some people are able, to a museum or museums. And under those circumstances, it will probably be the decision of our heirs.

We know that most of the objects that made up the Ganz collection will now be dispersed. But Victor and Sally's legacy as models of civilized and passionate engagement with the art and artists of their time will remain intact for as long as those artists continue to be celebrated.

The Ganz interview was made for Joan Simon's film "Four Artists: Robert Ryman, Eva Hesse, Bruce Nauman, Susan Rothenberg" (1987; Michael Blackwood, producer) but was not included in the film. The author is extremely grateful to Joan Simon for use of the interview, and also thanks Jill Weinberg Adams, Helen Hesse Charash, Kate and Tony Ganz, Robert Miller Gallery, Linda Norden, Barry Rose, and Nicholas Serota for information used above.

1. I would like to thank Nicholas Serota, director of the Whitechapel Gallery at the time of Hesse's exhibition and longtime friend of the Ganzes, for highlighting this point for me.

CON TEMPOR ARIES

CARTER RATCLIFF

In 1966 a small New York journal called *Art Voices* published "The Domain of the Great Bear," a collaborative essay by Mel Bochner and Robert Smithson.[1] The Great Bear is the constellation Ursa Major. Its domain is the night sky of the northern hemisphere, the starry spectacle splashed across the dome of New York City's Hayden Planetarium by an elaborate system of projectors. Focusing on the illusion of wheeling stars and glittering planets, most visitors to the Hayden are content to be impressed. Rejecting illusion, Bochner and Smithson focused on the mechanics of projection and the massive structure of the dome itself. Adopting a tone of deadpan literalism, they subjected "The Domain of the Great Bear" to art criticism in the Minimalist manner.

Richard Tuttle, *Blue Pole* (1965)

Recent arrivals on the New York scene, Bochner and Smithson emerged toward the end of the 1960s as leading figures of their generation. In 1966 they were known as artists only to Sol LeWitt, Eva Hesse, and a few other friends. Others in the art world knew them as writers. Reviewing New York exhibitions for *Arts Magazine*, Bochner commended the geometric severities of LeWitt, Carl Andre, Dan Flavin, and Donald Judd—in short, the most stringent of the Minimalists, artists with no use for the splashy, angst-laden precedent of Willem de Kooning and his followers. Smithson was particularly impressed by the hard-headed elegance of Judd's objects. In a 1965 museum catalogue, he noted the older artist's "consciousness

0 1 2 3 4 5 6 7 8 9 10 11 12 13 14 15 16 17

0 1 2 3 30 29 28 29 10 11 12 23 22 21 20 19

5 14 2 3 4 13 7 8 9 12 11 12 13 14 15 16 17 10 9

20 21 22 23 24 25 26 27 28 29 30 31 32 33

21 22 23 24 25 26 27 28 2 5 4 3 32 1 0

7 6 5 23 24 4 3 2 1 0 7 28 29 30 31 32 33

CONTINUOUS/DIS/CONTINUOUS
MEL BOCHNER 1971 (1987)

Mel Bochner, *Continuous/Dis/Continuous* (1971)

Dorothea Rockburne, *Golden Section Painting* (1974)

of structure. . . . His crystalline state of mind is far removed from the organic floods of 'action painting.' He translates his concepts into artifices of fact, without any illusionistic representations."[2]

To praise a Minimalist sculptor, Smithson restated a Minimalist axiom: illusion is bad, whether it offers a spatial effect or the assurance that profound emotions inhere agitated pigments. In contrast, fact is good. Since the late 1950s, Judd had been writing reviews for *Arts Magazine*, and a liking for plain fact not only guided his judgments but also gave his language a down-to-earth clarity. Reporting on their visit to "The Domain of the Great Bear," Bochner and Smithson adopted the self-consciously unpoetic style of Judd's prose. Yet their collaboration was not a straightforward homage to the Minimalist ideal of the emotionally neutral fact.

The Hayden Planetarium had just reopened after extensive renovations. Bochner and Smithson are precise about the shift from the "beaverboard . . . glass and plywood" of the 1930s to the "Formica . . . chrome and Plexiglass" of the 1960s. They note with accuracy the symmetries of the dome and the patterns of light that signify the movements of the solar system. The lecturer's monotone, the reproduction of an Aztec calendar stone, the Viking rocket on display in an adjoining gallery—it's all set down with sober exactitude. As facts accumulate, a tone of melancholy seeps into the essay. Equipped for endless repetitions of its heavenly display, the planetarium is "a chamber of ennui." Seated in circular rows, the audience is "silent and inert." Smithson, if not Bochner, savored this inertia.

A few months earlier, Smithson had glimpsed signs of bafflement and stasis in the art of Judd and his colleagues. "Mistakes and dead ends mean more to these artists than

any proven problem," he wrote in an essay called "Entropy and the New Monuments."[3] Oddly, these were terms of praise. Though he never joined Smithson in his appreciation of entropic breakdown, Bochner did acknowledge that Minimalist clarity can be puzzling. Obviously, he wrote in 1967, a LeWitt grid is orderly. Yet, "how to apprehend or penetrate it is nowhere revealed. Instead one is overwhelmed with a mass of data—lines, joints, angles."[4] From order comes confusion. In Minimalist art, Bochner and Smithson were finding decidedly un-Minimalist possibilities.

With Euclidian basics—line, plane, right angle—the Minimalists brought form under strict control. Purged of expressiveness, a squared-away grid or box invited viewers to cultivate the calm detachment of a scientific observer. Enumerating the visible facts of a Minimalist sculpture, one would dismiss as negligible the object's allusions to furniture or the body. At most, one might note how concisely the sculpture's form echoed the walls and corners—the gallery space—containing it. This sort of observation was permissible and even encouraged, for it required one to turn a literalist eye on every detail of one's surroundings.

At least since the late 1920s, new developments in modern art had been formally introduced to the audience in a setting of austere architectural drama: the white-walled gallery. Minimalism reduced the modernist object to a distillate of that purified space. In the perfectly adjusted relationship between a Minimalist box and its pristine site, many saw the triumphant clarity of an endpoint. For a few seasons in the mid-1960s, certain New York galleries seemed to contain the culminating essence of the modernist experiment. Though they respected the Minimalists, Bochner and Smithson disliked this feeling of containment. To them, the white-walled gallery felt claustrophobic. As dreary as the fake infinite of the Hayden Planetarium might be, it was preferable to the enclosures of the art-world hive.

Smithson died in an airplane crash in 1972, while scouting the Texas prairie he had chosen as the site of his third major earthwork. Having broken out of the gallery, he was taking imaginative possession of the Western immensities. By then, Bochner felt he had crossed a historical border. It is possible, he said in 1971, that the modernist period is over. A "post-modernist" aesthetic is appearing, as younger artists explore new territory in which concepts loom as large as objects.[5] Like Judd and Morris before him, Bochner suggested without saying it

Barry Le Va, *Two Center Points* (1970–71)

outright that his theoretical speculations found their best realization in his own work. He also championed the art of Dorothea Rockburne. Besides Smithson, other skeptical inheritors of Minimalism included Richard Tuttle and Barry Le Va.

Pieces by all these newcomers entered the collection of Victor and Sally Ganz, who had long been devoted to the high modernist tradition. Now modernism was receiving one of its first serious challenges from within—Bochner's use of the phrase "post-modern" is among the earliest on record. The Ganzes might have recoiled. Remarkably, they instead followed Bochner, Smithson, and the others into zones that sprawled, uncharted, far beyond the walls of the modernist gallery.

The works that made Bochner a focus of critical attention seem, at first glance, not merely to accept but to insist on the power of gallery walls to enclose a chunk of space.[6] *In Measurement Room* (1969), for example, the artist applied lengths of black tape to all the interior surfaces of the Heiner Friedrich Gallery in Munich. Ruler straight, these lines were broken only by figures indicating the height or width of the underlying wall.

Bochner later said, "I thought that if I simply measured the space of the gallery, that would make the space itself into an artwork. It would project an idea about the space . . . onto that space. There would be no scale because everything would be its real size."[7] Wishing to preserve the "real size" of "everything," Bochner aspired to a Minimalist literalism as strict as any attained by Donald Judd.[8] Yet his measurement pieces inflected sheer fact with a quality that began to attract notice when these works were new.

Toward the end of the 1960s, members of the New York art world had trained themselves to see the obdurate thereness of a Minimalist object and the "purely optical"

effect of a Color-Field painting by Morris Louis or Kenneth Noland.[9] Now, as Bochner and others moved beyond Minimalism, the initiated eye tried to focus on the invisible—the artist's concept or idea. Those who posed this challenge came to be known, fittingly enough, as Conceptual artists. The extremists among them insisted that palpable things, even sheets of paper bearing typewritten texts, had become obsolete. Aesthetic value had migrated to concepts unencumbered by physical matter.[10]

Demurring, Bochner argued that things and ideas do not belong to entirely separate orders of being. "There is no art that does not bear some burden of physicality," he wrote in 1970.[11] Conversely, there is no art that lacks a conceptual component, a truth his measurement pieces rendered explicit. By projecting an idea about space onto gallery walls with his measuring and taping, Bochner didn't question physical fact so much as amplify it with reminders of the perceptual procedures that orient us in places like galleries.

With an extreme economy of means, Bochner made a startling suggestion. Close attention to the structure of a room will open it to the realm of concepts that render our perceptions intelligible. And this conceptual realm is boundless. Thus Bochner escaped the claustrophobic gallery of the mid-1960s by remodeling it—by rethinking it so thoroughly that gallery space was seen to be continuous with the far reaches of speculative thought. As Bochner elaborated the measurement pieces, notations of feet and inches gave way to number sequences. The sequence is deceptively simple in *Continuous/Dis/ Continuous* (1971), which is included in the Ganz collection along with a second version of the work made by the artist in 1987.

The Ganzes also acquired several of the number drawings Bochner produced before he launched the

Bochner, *Counting* (1971)

263 264 265 266 267 268 269 270 271 272
273 274 275 276 277 278 279 280 281 282 283
284 285 286 287 288 289 290 291 292 293 294
295 296 297 298 299 300 301 302 303 304 305
306 307 308 309 310 311 312 313 314 315 316 317
318 319 320 321 322 323 324 325 326 327 328
329 330 331 332 333 334 335 336 337 338 339
340 341 342 343 344 345 346 347 348 349
350 351 352 353 354 355 356 357 358 359 360
361 362 363 364 365 366 367 368 369 370 371 372
373 374 375 376 377 378 379 380 381 382
383 384 385 386 387 388 389 390 391 392

measurement pieces. In a typical drawing of this kind, a sequence of single digits fills a symmetrical pattern of squares. Bochner has described this meshing of numbering and diagramming as "a totally abstract, self-contained enterprise." [12] Reluctant to add new objects to the world, he was transposing the clarity of the Minimalist box to the flatness of a paper sheet. The measurement pieces allowed him to enter real space without cluttering it with things.

Bochner kept his art in real space, but just barely, with the works he grouped under the title *Theory of Sculpture* and placed on the gallery floor. Made in the early 1970s, these pieces employ chalk or masking tape, pennies or pebbles, in patterns that raise some point in logic or mathematics. A clue to the issue in play was often to be found in a statement inscribed on the floor. Yet these verbal hints led to no solutions, for Bochner's visual configurations posed no puzzles.

Much of his early work was driven by the conviction that language and visual imagery can never be commensurate. Words do not provide a transparent window onto the meaning of images, nor can images be relied on to deliver the meaning of a statement. So we must forever negotiate our way through the several, impinging orders of significance, a process Bochner intended his art to render self-conscious. The "aesthetic experience," he has said, begins when "the viewer is caught up in thinking through the work, and the problems the work presents"—problems to be grappled with, pleasurably, by the imagination. [13]

"Works of art are not illustrations of ideas," Bochner wrote in 1970. [14] He wrote it again two years later, when *Artforum* invited him to introduce the work of Dorothea Rockburne. [15] In those days, Rockburne was soaking pieces of chipboard in oil and rubbing graphite onto sheets of

Rockburne, *Copal #5* (1976)

paper. Then she would arrange these materials on the gallery wall in orderly configurations. Surely, critics assumed, she was a process artist. Or if not, perhaps her dark but somehow elegant patterns of soaked-in oil gave her an affinity with a monochrome painter like Brice Marden. No, said Rockburne, her arrangements of chipboard and paper reflected her interest in set theory—the branch of mathematics concerned with relationships of the sort indicated by words such as *and*, *if*, and *or*.

An intuitive feel for the conjunctive *and* or the conditional *if* gave Rockburne a starting point. She turned to her materials, experimenting with formal possibilities, and a work developed terms of its own. That is why Bochner felt it necessary to "offer a word of caution: Rockburne's art has no one-to-one correlation to mathematical set theory. These are not illustrations." Rather, Rockburne's flat, geometric wall pieces are condensations of the Minimalist object. Frankly physical, they are just as frankly imbued with thought. As Rockburne's thinking grew more supple, her forms became more concise and her materials more refined. It was in the early stages of this development that work by Rockburne entered the Ganz collection.

Bochner and Rockburne broke through gallery walls by rendering them permeable to thought. This was, of course, a metaphorical escape—and subtly daring, too, for a prohibition against metaphor was foremost in the legacy these artists inherited from Minimalism. As Barry Le Va made his escape from the confines of the gallery, he took time off to demonstrate that, in literal fact, walls are unbreachable things. *Velocity Piece #1* (1969) is a taped recording of the artist running full tilt across the floor of his loft. Next comes the crash of his body against a wall, more footsteps, another crash. These sounds continue,

with increasing signs of weariness, for nearly two hours.[16] Impersonating the Minimalist object, Le Va enacted the frustration of its imprisonment.

To relieve that frustration, he encouraged a kind of devolution. Exchanging Minimalism's rigid, stable forms for ball bearings and scraps of felt, Le Va scattered these materials across the gallery floor in no readily discernible patterns. On occasion, he added flour or powdered chalk to the mix. Slipping through hardwood planks, these materials made an actual escape from the confining geometries of the gallery. More to the conceptual point, Le Va dispensed with the reassuring clarities of Euclidean form. In their place he put the complex and private systems that guide the distribution of his materials.

Minimalism's insistence on the physical persists. Le Va's tangles of felt are as aggressively present as Judd's sheets of galvanized iron or Andre's plates of steel. Yet

Tuttle, *Ten Sided Pale Orange* (1967)

Le Va's forms are elusive. Baffled, the eye enlists the mind in the effort to find the clues, as the artist calls them, that will reveal the logic of his apparently random scatterings. The Ganz collection includes a Le Va drawing from 1970–71 that offers some help. Or, anyway, it has the helpful look of an explanatory diagram. Yet Le Va's drawings offer bafflements of their own—lines and angles rendered with a clarity that knowingly defeats itself, setting us adrift in a boundless zone of interpretive possibilities.

The Ganzes also acquired a group of works by Richard Tuttle, another of the small band of friends and colleagues who could see a future in the end points, the seemingly final clarities, attained by Minimalism. The earliest is *Blue Pole* (1965), a wooden relief sculpture fifty-five inches long and one and three-quarters of an inch thick. Bluntly descriptive, its title is also an allusion to *Blue Poles* (1952), perhaps the most ambitious of Jackson Pollock's late drip

paintings. A quiet irony removes every vestige of heroic intent from Tuttle's work, leaving it unburdened, as well, by the stubborn assertiveness of Minimalist sculpture.

In 1970 Tuttle said, "I started out making thick wood pieces and they got thinner and thinner. They turned into cloth. And now I am doing paper." [17] Though he hung them on the wall, Tuttle's cloth pieces hardly counted as paintings. Eccentric in outline and casually wrinkled, these hand-dyed objects had no sculptural presence, either. Impossible to categorize, they were nonetheless recognizable as products of Tuttle's restrained yet relentlessly distinctive sensibility. Though delicate, his touch gives him complete possession of his materials.

On his way from cloth to paper pieces, Tuttle constructed a few "wire bridges"—spindly forms rendered strong by a charge of his unabashedly individual intention. According to the Minimalist faith, geometry banishes individuality. Properly deployed, straight line and flat

Robert Morris, *Untitled* (1965)

plane purify the object of its maker's self. Of course, this purification never occurred. Each of the major Minimalists is a grandly idiosyncratic stylist. Yet the ideal of purity lingered, prompting Tuttle to say of the printmaker's paper, "I have a hatred for this white thing. I can't stand the kind of purity that white implies in our environment."

With this unusually vehement outburst, Tuttle commandeered the untouched sheet of paper as a vehicle for his impatience with all the purities that overawed the art world of the 1960s: the purely impersonal intention that fills the purely Cartesian space of the gallery with purely physical objects. The most recent Tuttle piece in the Ganz collection is a print from 1976. Despite the artist's feelings about the print medium, this work employs two sheets of the highest quality paper—handmade Royal Watercolor Imperial. And Tuttle left these pristine fields of white unmarred except for the strip of black that reaches, with beautiful deliberation, across the line of their abutment.

The Minimalists themselves were capable of questioning their own certainties. Sol LeWitt, especially, was disinclined to see artworks merely as palpable objects immersed in the gallery's sterile space. Alert to the formative relations between things and thoughts, he published statements on "Conceptual Art" in the late 1960s.[18] These writings were particularly important to Bochner and Rockburne, so it's fitting that a LeWitt drawing from 1974 keeps works by these younger artists company in the Ganz collection. The Ganzes' early works by Pat Steir fit comfortably, as well, for Steir was another member of the circle that gathered around LeWitt toward the end of the Minimalist decade.

With the publication of his "Anti-Form" essay in 1968, the once-Minimalist Robert Morris joined the generation that dismantled Minimalism.[19] He is represented in the Ganz collection by a piece that elaborates his preoccupations at an earlier stage in his career. *Untitled* (1965) is the work of the pre-Minimalist Morris, who borrowed an ironic sense of play from Duchamp and Johns. With its wire brush and tangle of rope, this sculpture is a machine for mocking the idea of efficiency. It demonstrates the trait of inutility, which since the eighteenth century has been a hallmark of the aesthetic. Borrowing dark tones and a contemplative mood from Johns, Brice Marden's ink-and graphite drawing defines the aesthetic differently (but just as traditionally) as the outward display of an inward state of feeling.

Bochner, *Three Sets, Rotated Center* (1966)

Of the artists who looked for a way beyond Minimalism, Robert Smithson is the one most represented in the Ganz collection. He no longer made sculpture by the time the Ganzes became interested in him, so they concentrated on the drawings that accompanied his proposals for large, outdoor pieces—the earthworks. Most of the sixteen drawings acquired for the collection were made in 1969 in response to an invitation from the Los Angeles County Museum of Art. Under the museum's auspices, artists were encouraged to collaborate with manufacturers in producing work for an "Art and Technology" exhibition. Smithson approached two large corporations—Kaiser Steel and the American Cement Company.

Both companies rejected Smithson's proposals, possibly because they convey so powerfully his fascination with disorder and ruin. Several of the Kaiser Steel drawings show a strip of metal snaking through heaps of slag. Another pictures a "slag spill-over" and suggests that "dearchitectured material from Kaiser steel sites . . . be placed on random sites . . . in the region of the museum." What Smithson means by the word *dearchitectured* is made clearer by his drawing for the cement company project, which includes a sketch of a concrete building smashed into ragged chunks.

A few of these fragments, he felt, should be included in the Los Angeles County Museum of Art's "Art and Technology" show. For Smithson was not an optimist. He believed that, as technology grew more complex, its collapse into disorder become more likely. Intricate machines, ordinary objects, minds, cultures, even space

Robert Smithson, *Portland Cement Sites: A Dearchitectured Project* (1969); **Smithson,** *Project for Japan American Cement* (1969)

and time are steadily sinking into undifferentiated chaos, as promised by the Second Law of Thermodynamics. Smithson saw reminders of this process everywhere he looked. At the Hayden Planetarium, he found a prophesy of time's eventual cessation in the schematized repetition of the heavens' nightly cycles. Throughout "The Domain of the Great Bear," Bochner's levelheadedness is so heavily tinged by Smithson's pessimism that the essay seems entirely his.

Bochner and Smithson were friends; until Smithson's death, Richard Serra was his twin sensibility—though unidentical. In 1980 Serra recalled that his "dialogue" with Smithson "was in part a response to Andre, LeWitt, and Flavin." These Minimalists were promulgating closed systems and defending them with "a presumption of authority. . . . We thought that closed systems were doomed to fail." For Serra and Smithson, the Minimalist object offered the primary and always the most egregious example of presumptuous order. Acutely alive to forces of disorder, the two artists "shared a general empathy," says Serra, "he . . . for the notion of collapse in my early lead props and I for his notion of site and entropy—sticking a rock in the mud and letting it sink."[20] Sometimes Smithson helped entropy along.

In 1970 Smithson was invited to construct an outdoor work on the campus of Kent State University, in Ohio. Rather than build a new structure, he destroyed an existing one—an abandoned shed. At the artist's instruction, a backhoe operator heaped earth on the shed's roofbeam until it collapsed. The Ganz collection contains

Smithson, *The Museum in World's Fair* (1969); **Smithson,** *For Kaiser Steel* (1969)

a drawing for a related but never completed project, *Island of the Dismantled Building* (1970), which Smithson proposed for a site near Vancouver. There are also drawings for heaps of broken plate glass and for a spiral of palm trees that would have repeated on land the pattern of *Spiral Jetty* (1972), his best-known work.

Flirting with entropy, encouraging it when he could, Smithson noticed it at work in his own seeing, thinking, remembering. "One's mind and the earth are in a constant state of erosion, mental rivers wear away abstract banks, brain waves undermine cliffs of thought, ideas decompose into stones of unknowing," he wrote in 1968.[21] Smithson understood the Minimalist object as a quixotic denial of decomposition and its inevitability. This denial was echoed by Minimalist aesthetics and echoed again by the modernist gallery, that white-walled enclosure so inhospitable to ordinary realities.

With essays, films, and works of art, Smithson argued that we can only gain by breaking through the gallery wall, immersing ourselves in the mundane realities of a world that is running down as surely as a badly made watch. Feeling entropic forces in himself, he felt unified with the world. Exhilarated, he made art that celebrates entropy, the force that tirelessly bears the universe back to its origins in primordial chaos. Inverted heir of Romanticism, artist of the entropic sublime, Smithson was devoted to a dream of apocalypse—not the ultimate revelation but the ultimate darkness, and he felt most alive when he believed he had glimpsed it.

1. Mel Bochner and Robert Smithson, "The Domain of the Great Bear" (1966), in *The Writings of Robert Smithson*, edited by Nancy Holt (New York: New York University Press, 1979), pp. 24–31.

2. Robert Smithson, "Donald Judd" (1965), in *Writings*, p. 22.

3. Robert Smithson, "Entropy and the New Monuments" (1966), in *Writings*, p. 10.

4. Mel Bochner, "Serial Art (Systems: Solipsism)," *Arts Magazine* 41, no. 8 (Summer 1967): 42.

5. Mel Bochner, quoted in Robert Pincus-Witten, "Mel Bochner: The Constant as Variable," *Artforum* 11, no. 4 (December 1972): 29.

6. See Robert Pincus-Witten, "Bochner at MoMA: Three Ideas and Seven Procedures," *Artforum* 10, no. 4 (December 1971): 28–30, Robert Pincus-Witten, "Mel Bochner: The Constant as Variable," Artforum 11, no. 4 (December 1972): 28–34.

7. Mel Bochner, "Out of Context," fragments of interviews from 1972 to 1989, edited by Melissa Marks, *Teme Celeste* 21 (July–September): 62.

8. For Minimalist literalism, see Donald Judd, "The Specific Object" (1965), in *Art in Theory, 1900–1990: An Anthology of Changing Ideas*, edited by Charles Harrison and Paul Wood (Cambridge, Mass.: Blackwell, 1993), pp. 809–13.

9. For "purely optical" pictorial effects, see Clement Greenberg, "Louis and Noland" (1960), in *The Collected Essays and Criticism*, 4 vols., edited by John O'Brian (Chicago: University of Chicago Press, 1993), vol. 4, pp. 95–97.

10. See Joseph Kosuth, "Art After Philosophy" (1969), in *Conceptual Art*, edited by Ursula Meyer (New York: E. P. Dutton, 1972), p. 164.

11. Mel Bochner, "Excerpts from Speculation" (1967–70), in *Conceptual Art*, p. 57.

12. Mel Bochner, "Out of Context," *Teme Celeste* 21: 61.

13. Ibid.

14. Mel Bochner, "Excerpts from Speculation," in *Conceptual Art*, p. 52.

15. Mel Bochner, "A Note on Dorothea Rockburne," *Artforum* 10, no. 7 (March 1972): 28.

16. "Barry Le Va: … a continuous flow of fairly aimless movement," an interview with Liza Bear (1971), in *Theories and Documents of Contemporary Art: A Sourcebook of Artists' Writings*, edited by Kristine Stiles and Peter Selz (Berkeley: University of California Press, 1996), pp. 609–14.

17. Robert Pincus-Witten, "The Art of Richard Tuttle" (1970), in *The New Sculpture: 1965–1975*, ex. cat., edited by Richard Armstrong and Richard Marshall (New York: Whitney Museum of American Art, 1990), p. 206.

18. Sol LeWitt, "Paragraphs on Conceptual Art" (1967), "Sentences on Conceptual Art" (1969), in *Art In Theory, 1900–1990*, pp. 834–39.

19. Robert Morris, "Anti-Form" (1968), in *Continued Project Altered Daily: The Writings of Robert Morris* (Cambridge, Mass.: MIT Press, 1993), pp. 41–46.

20. Richard Serra, interview with Barnard Lamarche-Vidal (1980), in *Richard Serra: Writings, Interviews*, edited by Clara Weyergraf (Chicago: University of Chicago Press, 1994), p. 112.

21. Robert Smithson, "A Sedimentation of the Mind: Earth Projects" (1968), in *Writings*, p. 82.

Carroll Dunham, *Untitled* (1985)

THE WHITNEY

BRENDAN GILL

Victor Ganz was a short, stocky man, with a well-shaped head and a resonant voice; behind large, black-framed spectacles, his eyes were exceptionally alert and, on the many occasions that we shared as trustees of the Whitney, nearly always merry. It is a commonplace to speak of collectors as having a good "eye"—a gift that Victor had in abundance—but eyes in the plural are also worthy of praise, as being in physical terms extensions of the brain and therefore the means by which we are able to look into people's minds and pass accurate judgment on them. What shone out of Victor's eyes was high intelligence, and eagerness to be in affectionate contact with his fellow human beings. He and Sally Ganz were accustomed to speak their minds, openly and with humor but also, where need be, with compassion. The number of distinguished collectors is very large; the number of distinguished *lovable* collectors is, shall we say, comparatively small, and Victor and Sally have been notable among them.

Victor contributed to the Whitney in many capacities. His advice was welcome because he possessed a rare mingling of aesthetic discrimination and common sense. He was a successful figure in the world of business and a successful frequenter of the world of art; being at ease with artists and in sympathy with their needs, and being no less at ease with and in sympathy with the needs of the curatorial staff of the Whitney, he was constantly being sought out, both formally and informally, to serve as a bridge between differing views of the possible. Before a decision had to be made, many of us would ask of a colleague, sotto voce, "What does Victor think?" Speaking for myself, whenever it happened that what I thought coincided with what Victor thought, I felt a sense not merely of fiduciary reassurance but also of something like a schoolboy's delight—I felt that I had, in effect, passed a

secret test of considerable importance and that I might yet win, on graduation day, a prize for improvement.

No matter what circumstances the Whitney faced from year to year, Victor remained calm and cheerful; his confidence became our confidence, and it is not too much to say, a decade after his death, that the echo of Victor's strong voice and the memory of his calm cheerfulness continue to steady our hands and lighten our hearts.

FLORA BIDDLE

When I first met Victor and Sally, many years ago, in the home of mutual close friends, I went home in a state of shock. Victor was extraordinarily charming, knowledgeable, and brilliant—and his criticism of the Whitney was incisive and impassioned.

I started wishing then and there that this compact and wise dynamo would help to implement some of the ideas he articulated so eloquently—especially the importance to our museum of collecting the best work of our time, whether by mature artists or by younger artists.

Recognizing his criticism as a sign of how much he cared, I asked him often to join us. He offered ideas and counsel with great generosity but declined again and again to make it official. Perhaps he pictured being on the board as a sterile, static role, unrelated to the vitality and energy of art and artists, although he did join the Museum's new Drawing Acquisitions Committee in 1976. Little did we know that the very meaning of the word "trustee" would be redefined for us by the grace with which Victor wore that mantle.

The Whitney Biennial opened on Wednesday, February 4, 1981. After dinner with the artists, and an exhilarating time, I noted that punk was in and that Alexis Smith wore white bobby sox with one green shoe and one purple shoe, and, my journal continues, "ended evening with drinks in Trustees room, with Victor agreeing to join Board, saying 'I've lost my virginity'—was so pleased."

We all were, because he represented all that was best about the art world, and what we wanted the Whitney Museum to be. His integrity, his passion, his intelligence, his humor, his thoughtfulness and kindness—all poured into our institution because once committed his involvement was total.

Victor's crossover from the business world to the world of art and artists made him particularly qualified to understand and contribute to financial and programmatic deliberation. He would spend hours with the Whitney's financial officer, before Budget and Operations Committee meetings, asking detailed questions, probing in order to understand fully.

At acquisition meetings, he always brought us back to essentials—to looking and thinking and making hard choices. Looking at art with him was getting inside—one realized in one's stomach the centrality of art to life. And how one laughed with Victor!

THOMAS ARMSTRONG

The capacity to have an honest and joyous affair with modern and contemporary art is a talent possessed by few. During my twenty-eight years as director of four museums, I shared this level of devotion to art with fewer than a dozen individuals, and even in those cases there was always the temptation to identify

219

with the artist as a celebrity rather than with the work.

One person will always remain with me as someone possessed by works of art—how they were conceived, constructed, and interpreted. Anyone who knew Victor Ganz knew that the defining force in his life was his desire to identify quality and meaning in works of art, and the extraordinary focus and integrity with which he pursued this passion drew us all to him.

Everyone at the Whitney wanted Victor as their leader. At first, he was reluctant to serve on a committee. To my knowledge he had never had a formal relationship with any museum in New York City. Within a few years he was the only trustee who served on each of the three acquisition committees. He also served on the Operations and Budget Committee and was revered by the staff for his complete grasp of the difficulties of running a museum whose sources of revenue were unpredictable.

We first asked him to serve on the Drawing Committee, and I promised to raise the necessary funds and to bring together a knowledgeable and compatible group. Meetings were a cherished experience as we watched the intellectual pyrotechnics resulting from the camaraderie of people such as Ed Bergman, Richard Brown Baker, Walter Fillin, Glenn Janss, Lydia Winston Malbin, and Steve Paine, who exchanged ideas like lovers with a private language. Victor was the unacknowledged leader whose powers of persuasion encouraged the committee to assemble the finest collection of twentieth-century American drawings in the world.

Preoccupied as he was with works of art, Victor could not help but be devoted to his artist friends, whom he treated with respect and compassion. He was one of the first to recognize the importance of the work of Eva Hesse, and his respect became the basis for a strong bond with the artist herself. With Sally and the children, he helped Hesse

to confront the ordeal of her terminal illness.

But it was Victor's relentless search for the meaning of works of art—how they should be interpreted—that distinguished him. He studied works of art intensely, read prodigiously, and then came to his own conclusions. And he worried about the creative process, about how artists make works of art. We once shared concern about how Jasper Johns would eventually move out of the "cross-hatch" motif in his work. I was dumbfounded when I learned that Victor had later discussed this with Johns, a conversation I would never have had the temerity to initiate. But because of the extraordinary intellectual curiosity and abiding concern with which Victor engaged in this dialogue, I feel certain that Johns enjoyed the volley with a skillful player.

Several days before Victor died, Sally called to say he wanted me to visit. I entered the oppressively overheated room on their second floor where my wife, Bunty, and I had enjoyed many joyful moments with both of them, in the somewhat intimidating presence of Picasso's *Women of Algiers*. Victor was sitting with his back to the door. I soon realized I had come to say good-bye. Many times I have asked myself why he arranged this meeting. I think I know now that he wanted to convey how much he regretted that the ambitions we shared for the Whitney Museum were unfulfilled. But in his ordered scheme of things, he would be at peace if we could share instead an unspoken farewell.

BATTERY PARK CITY

CALVIN TOMKINS

In 1980 Victor became the chairman of the Fine Arts Committee that was set up to commission works of art for the public spaces of Battery Park City (BPC). BPC is the huge, 90-acre tract that had been added to lower Manhattan on landfill in the Hudson River. Its overall budget was many millions of dollars; and since New York City allots a small percentage of the budget on capital construction to works of art, the sums to be spent here on art were not inconsiderable.

I wondered how Victor would fare in the rough-and-tumble of urban politics, which is what committees like his inevitably get dragged into. Victor loved New York, of course—really wasn't comfortable anywhere else. I remember once he and Sally were invited to a country weekend somewhere and told to bring old clothes, and Victor had to go out and *buy* some, because he didn't have any. But he had never been involved with the public sector before, and I frankly wasn't sure he'd be tough enough. Well, he was. There was a good deal of rough-and-tumble, as it turned out, and I think Victor relished every bit of it. His commitment to the highest standards of artistic integrity was absolutely ferocious and amazingly effective. The funny thing was that, as Victor soon came to realize, our committee had no real power at all. We were there to make recommendations, which the client, the Battery Park

City Authority, could accept or reject or do whatever it felt like. But Victor acted as though we did have real power in all matters involving art—a kind of moral authority that transcended budgets and politics—and amazingly enough this usually worked. Once, at the end of a particularly frustrating session with the bureaucrats, Victor said in his quiet way that he thought he would have to put in a call to Abe Rosenthal of *The New York Times* about the dispute. Now, Victor didn't actually know Abe Rosenthal, but this was not evident from his tone of voice. The problem was resolved before the next meeting.

Victor played a decisive role in the committee's major decision, which was that we would not just commission artists to make the kind of "plunk-down" sculpture, as he called it, that you saw in so many bank lobbies and corporate plazas. The summer before our committee began to function, he and Sally had gone around Italy looking at great public spaces such as the Piazza Navona, so many of which had been laid out by men for whom art and architecture were aspects of the same profession. The trip had strengthened his belief that artists should be brought into the design process at Battery Park City at an early stage so that their thinking, their particular vision, could be brought to bear on all aspects of a public area, including the way that area was going to be used by individuals or groups. This is a concept that some municipal authorities and a great many modern architects have trouble with. It sounds chaotic and it sounds expensive—

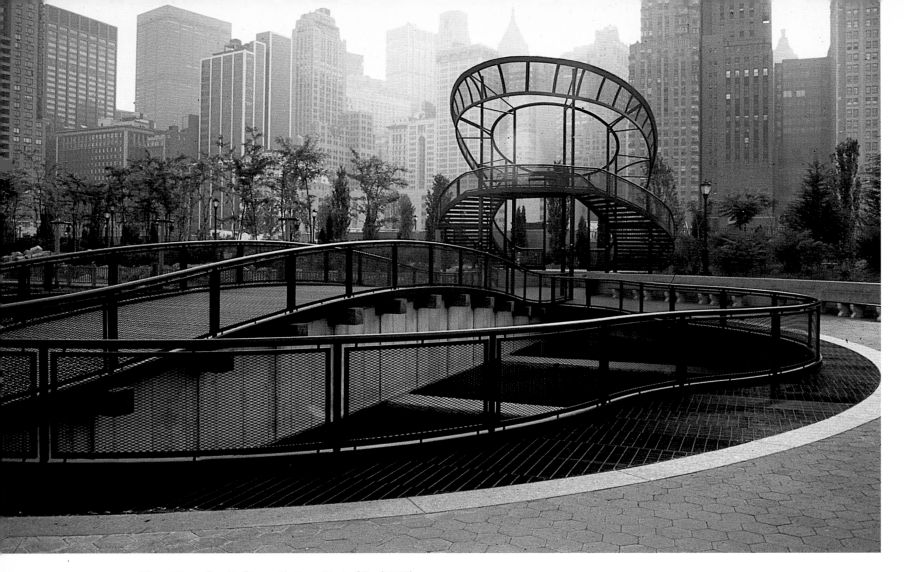

Mary Miss, South Cove, Battery Park City (1988)

who wants artists coming into the hugely complicated design process and throwing out wild ideas? By great good fortune, though, a number of highly talented artists had been thinking similar thoughts about public spaces for several years, and these were the artists we turned to. Thanks in large part to Victor's tenacity, his toughness, and his commitment to excellence, we were able to commission Siah Armajani, Scott Burton, Mary Miss, Ned Smyth, Richard Artschwager, R. M. Fischer, and Jennifer Bartlett to collaborate with architects, landscape architects, and urban designers in the creation of some truly magnificent public spaces at Battery Park City. And BPC's art program has become the model for similar undertakings in other cities not only here but also in Europe, which is just what Victor hoped would happen.

I think the real key to Victor's success in this new area of urbanism was his wonderful, sustaining, childlike faith in artists. He literally fell in love with artists—first with Picasso, then with Rauschenberg and Johns and Stella and Eva Hesse and Mel Bochner and Dorothea Rockburne and others. The artist meant as much to him as the work. Talking with artists was an exhilarating experience for Victor, and it's not hard to see why he got so charged up about the possibilities for artists to play a more active role in society through their work in public spaces. Some people may even have found him a bit naive in this respect, and perhaps he was. But his naiveté was the source of his strength as a collector, as a public citizen, as a friend, and as a lovely, lovely man.

MARY MISS

As an artist my experiences with Victor and Sally Ganz ranged from the public to the most private. Victor was the head of the Fine Arts Committee of the Battery Park City Authority when I started my collaborative project for the South Cove of Battery Park City. His vision of how art could exist outside of museums, integrated into the public domain, had a great deal to do with my being selected for this public commission. He believed that an artist could act as a "responsible citizen" and work with an interdisciplinary group to make a place where the public aspects of a gathering space could be overlaid with the intimate reflections that art can engender. He and I both shared this ideal. Getting the place built was an entirely different matter. That the South Cove was completed in a manner so close to the original vision had a great deal to do with Victor. Victor was a partner who was willing to be as willful as I was in insisting that the project not be compromised: no, the pilings couldn't be removed; yes, the smooth curve of a railing was important; no, the "island" could not be eliminated. He took the time to listen, negotiate, charm, and make the demands necessary for this project to happen. In my mind Victor was my collaborator, and the South Cove will always be his place.

Victor invented a role for himself as a different kind of "Patron of the Arts," a role that I have only come to fully appreciate with the passing of time. These complex, large-scale, unwieldy public projects are virtually impossible for an artist to accomplish alone; there must be an individual in a position of authority who is willing to make the commitment to have it happen. Victor saw that, and understood there was a new kind of patronage to be defined in the late twentieth century. Not only the art and artist but the collector and patron could cross into the public realm to deal with the complicated issues of our times.

After Victor's death Sally became equally important in very different ways. She was tirelessly interested and supportive in following the progress and failures of a "public artist." She was a good listener with undiluted responses and excellent practical advice.

Victor and Sally were immensely important to me in my life as an artist. The care, intimate investigation of a situation, and passion which I try to bring to my work were met step for step by both of them. It put us on equal footing and yet provided the kind of suppport that artists rarely receive.

AGNES GUND

My association with both Sally and Victor Ganz has been educational, joyful, and full of wonders. Their company was as refreshing as a brimming glass of iced tea on a summer afternoon—and considerably more intoxicating, for the potion with which their lives were filled is a particularly addictive one called the visual arts. Although I had occasionally met Sally and Victor in the art world and as patrons of the Whitney, my first working relationship with them came when Victor asked me to sit with him to form the Battery Park City Fine Arts Committee.

Richard Kahan, then chairman of Battery Park City, was pivotal in the formation of this group.[1] His selection of Victor as our leader was a stroke of genius. Every committee member had a keen interest in this project, and, although we didn't always agree, we spent many hours evaluating the work of various artists before choosing those whose works, we believed, would make the most lasting, profound, and vitalizing contributions to their various sites.

Victor receiving the Doris C. Freedman Award from Mayor Ed Koch (1984)

Under Victor's leadership, we selected Nancy Rosen to put together slides and profiles of a large spectrum of possible artists, and to schedule meetings and interviews for the artists with Battery Park City officials.

At our first working meeting, Victor discussed his approach to public art. He clearly believed, because of the Ganzes' many visits to Italian towns, that public art should provide an experience of a place, not just an opportunity to gaze upon a single object. He cited Siena's beautiful piazza, the way the houses and stores surround it, and the way the pavement flows towards a central base that faces the imposing façade of the municipal building. He said the details of the space contribute to making it a place where all sorts of meetings, greetings, sitting, and walking take on special meaning. This was the type of public art he would like us to consider, rather than simply placing a piece of sculpture "plunk" in the midst of an area to which it had no relation. The term "plunk" in reference to sculpture was hereafter clearly understood by all of us as anathema.

Why else was Victor such a good leader? First, he worked in perfect unison with Nancy. Second, he never failed to recognize and support the artists' needs and abilities. He gave a great deal of time and thought to each project. Third, he was willing and able to keep constant pressure on the Battery Park City Authority to follow through with all the administrative details. Fourth, he and Sally respected everyone's time and restored our souls by treating us to meetings, dinners, and luncheons in their marvelous art-filled home.

Victor was able to persist in solving problems and inspiring people to work together to achieve the most eloquent dialogue between spaces and their sculptures, to the interest and amazement of an ever-increasing public. After Victor died, the Battery Park City Fine Arts Committee was never again so forceful, dogged, and successful.

Many of us from that committee continued to draw strength from our relationship with Sally. She welcomed us into her friendships with artists, into her interests in literature, and, especially exhilarating to me, into a wonderful involvement with The Museum of Modern Art. She and Victor had lent their masterpieces to Bill Rubin's Picasso show in 1980, and to "Picasso and Braque: Pioneering Cubism" in 1989. Sally continued the relationship with the museum and expanded her associations with curators and artists. She generously supported a show of Philip Guston's works in 1992, and funded a catalogue that was free to the public. This fostered a very strong friendship with Rob Storr, the curator of the Guston exhibition. Then again, Sally, with her great respect for Bill Rubin, enthusiastically lent her Picassos to his "Picasso and Portraiture" exhibition in 1996. Finally, a deep friendship over many years with Jasper Johns and a newer admiration for Kirk Varnedoe, chief curator of painting and sculpture at The Modern, were joined in the Johns retrospective.

The love and admiration Sally and Victor felt for artists and their art gave all of us who loved them a much enriched and more exuberant life. Alas, we can never feel again the pulsating beauty of the experience they created in that perfect Italian piazza, their home.

1. Members: Elizabeth Baker, Amanda Burden, Victor Ganz, Michael Graves, Agnes Gund, Barbara Haskell, Richard Kahan, Carl Lobell, Linda Nochlin, Robert Rosenblum, Linda Shearer, Calvin Tomkins

MoMA

Jasper Johns, *Watchman* (1966)

WILLIAM RUBIN

We all know how rare it is to find people who exude the sympathy, kindness, and encouragement that surrounded Victor like an aura. And I'm sure everyone who knew him will feel the loss of his love. But those of us in the professional curatorial world are also going to miss something even rarer: a person who really looks extremely hard at pictures with an open and unbiased eye, a person whose hunger for visual experience is unquenchable.

Back when we were lucky enough to be able to reinstall the big Picasso retrospective a week early, we made the galleries available for a number of days to friends of the museum. Hundreds of people—many of them artists—came in to see the exhibition at their leisure. None came as often, stayed as long, or looked as hard as Victor and Sally. During the week they came not once, but every day, and they often stayed four to five hours. On one of those occasions, I walked all the way through the show with them, and our conversation about various pictures made me realize how extraordinarily acute Victor's eye was. His hunger to study these objects, combined with the quality of his judgment, made me feel that even if there were only a couple of Victor Ganzes in the world, they alone made the curator's efforts worthwhile.

KIRK VARNEDOE

Was ever a grande dame such a great dame? When I saw Sally for the last time, at the de Kooning dinner here, I watched her move through the room (to get a smoke, of course), regal in a large red wrap and choker, and I was struck again by how her special spark was struck off barely-veiled flint. You saw these contradictions from the moment she spoke, and they only deepened: how could such a saxophone authority issue from such a piccolo package? How could someone be so blunt and so sharp at the same time? How could one so demanding be so giving, hold so many ideals with so few

Victor seated before Picasso's *Seated Woman* (1959)

illusions, or embrace so much compassion while tolerating so little sentiment?

She and Victor collected art not as a solace from life but as a vehicle of engagement, and it showed: from Picasso's *Cock and Knife*—I still see Sally pulling her forefinger across her neck and sticking out her tongue to make a descriptive point—to Johns's black-and-white *Corpse and Mirror,* and beyond, their taste only got tougher as time passed, and they never confused comfort with quality.

But I knew Sally principally in her last ten years, thus alone, and through her aging. Words such as *elegance* and *grace*, with their suggestions of mellowing, just don't cut it. Her independence was stiffened by regret and

melancholy. But contemptuous of easing into genteel widowhood, she formed a whole new, younger circle. Her enduring devotion to Victor then coexisted with a libido that became more saltily overt, in unapologetic appreciations of men she thought sexy—which in no way conflicted with her forming her closest bonds with strong, achieving, younger women. Sally enjoyed the "to hell with you" privileges of her seniority; they licensed a frankness she found completely congenial. She operated with a sense that there was no longer enough time to waste on niceties or equivocation, and no percentage whatsoever in following the moment's fashion. Hence the fierce avidity of her claims for honesty and quality in all her experiences and relationships: this goading urgency had nothing to do with selfishness, but was about boiling life down to things and people she really cared about, to distill and focus her energies on them. Thus her curtness and her steadfastness, the quick snap and the tenacious hold, all intensified as time grew shorter. Nothing was briefer and more efficient than the way Sally said, "I love you:" open, unguarded, fearless, terse—and permanent. Nothing meant more to me personally, in my own dark days, than that unblinking affirmation that I had somehow earned this special woman's concern; for she gave it unstintingly, never lightly. I loved her, too, her deep laughter and irascible seriousness in equal and linked measure; and her passing took from me, as from so many others, an irreplaceable counselor of wise encouragement.

I am consoled only that her death came as she lived—not attenuated or trailing down, but directly arrested, in the presence of the art she cherished, in the midst of a week filled with the family and friends she so clasped to her and to whom she gave such a lasting testament of unique, uncompromising human mettle.

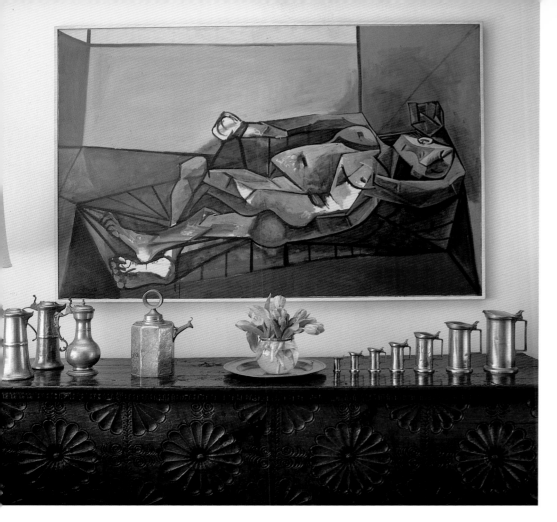

In the dining room: Picasso, *Reclining Nude* (1942)

MEL BOCHNER

I f the Ganz collection had ended with Picasso, it would still have been one of the major collections of our time. But Victor Ganz discovered a thread, which nobody else seemed to have noticed, leading from Picasso into the labyrinth of contemporary art. It led him to Rauschenberg, Johns, and Stella, and from there to Hesse, Smithson, and myself. Victor and Sally Ganz bought the works of artists that nobody else wanted at the time. They were drawn to art that was austere and audacious, often choosing the darkest and most difficult pieces, works where the conceptual intersected the visual, and the psychological undermined the formal.

For me, it was not only the individual objects that made the Ganz collection great, it was the network of invisible affinities among them.

GABRIELLA DE FERRARI

I met Sally eleven years ago. Victor died shortly after and I watched Sally build her life alone. The Sally I remember at the dinner party where I first encountered her is very different from the Sally who celebrated her eighty-fifth birthday a few days before her death. From a woman determined to give her husband the center stage, *she* became center stage—a formidable, nurturing force. Slowly her days evolved into a life with a fierce appetite for friends, books, ideas, music, and a strong desire for rich and intense experiences. She was in a rush to do it all, to finish things she'd started and to launch projects she'd wanted to start. When she felt that her age slowed her down, she was relentless in encouraging those of us who were younger to go forward and live to the fullest. From her little red room, surrounded by her favorite pictures, Sally became a magnificent woman who played a loving and directive role in the lives of those she chose to love. She invited us to embark especially on those demanding friendships—with their share of pain and questioning—that allowed us, in turn, to be demanding and questioning. Sally's friendship had a unique way of making us feel firmly planted in its wealth of warmth, strong opinions, and humor.

We all have our own very personal memories of Sally. I am not the only one who shared her joy for the beauty of a passage in a particular painting (she called them pictures), for an especially well-crafted piece of writing, for the pleasure of wearing a chic Fortuny dress, for a long, quiet walk in the country, or for the little bouquets of

Sally on the staircase, date unknown

conceived. Sally's purchase of Jasper's *Untitled* (1990) was clearly her first act of independence. It was an appropriate choice because in Jasper's work Sally found the elements that she considered most important in art: beauty, infinite opportunities to discover meanings, genius, and above all, the enigma of mortality. The very day she died she took me to see Jasper's *Diver.* In front of this mysterious work Sally pondered over her own mortality. She also talked about Picasso's *The Dream*, and sex, color, joy, and exuberance. Art not only entered Sally's life as the expression of great statements and great concerns, but also in more intimate ways, such as the pleasure she derived from a beautiful drawing by her friend Tom Levine. Her collection was her silent friend, and she turned to it for sustenance and shelter in moments of doubt and despair as well as joy and triumph. Sally, on the last day of her life, chose *Diver* and *The Dream* as companions for her solitary travel.

Now when I think of Sally, I think of her as a beautiful, sprawling tree, the kind that spreads horizontally and often grows in the American South, where she came from. Under the shade of its foliage, so many of us were sheltered by our friendship with this remarkable woman. As with all great trees, some branches were strong, some were not. Sally said that a tree can be tough but also tender and vulnerable. We are lucky that she knew that the great answers come, not only from the heart and the inquisitive mind, but also from the knowledge that in good friendships, both strong and weak branches offer love. Our memory and admiration for Sally, our sheltering tree, will always be a comfort and refuge.

wildflowers she loved so much. And we admired her lack of tolerance for what she considered mediocre or phony.

There were some special moments that I had the privilege of sharing alone with Sally. I shall never forget the afternoon, not long after Victor died, when she invited me into her bedroom and showed me the very first painting she had bought by herself. She was so proud of her decision. She had placed it above her bed. As she often did, she waited for my reaction before she explained, in that deep voice of hers, that she especially admired it because it had the ambiguity she loved in life. She spoke about it, as if it had a life of its own, and she strove to discover what could have been in the artist's mind the moment the work was

In the living room Picasso, *Still Life with Sausage* (1941); Johns, *Diver* (1963); Johns, *Tennyson* (1967)

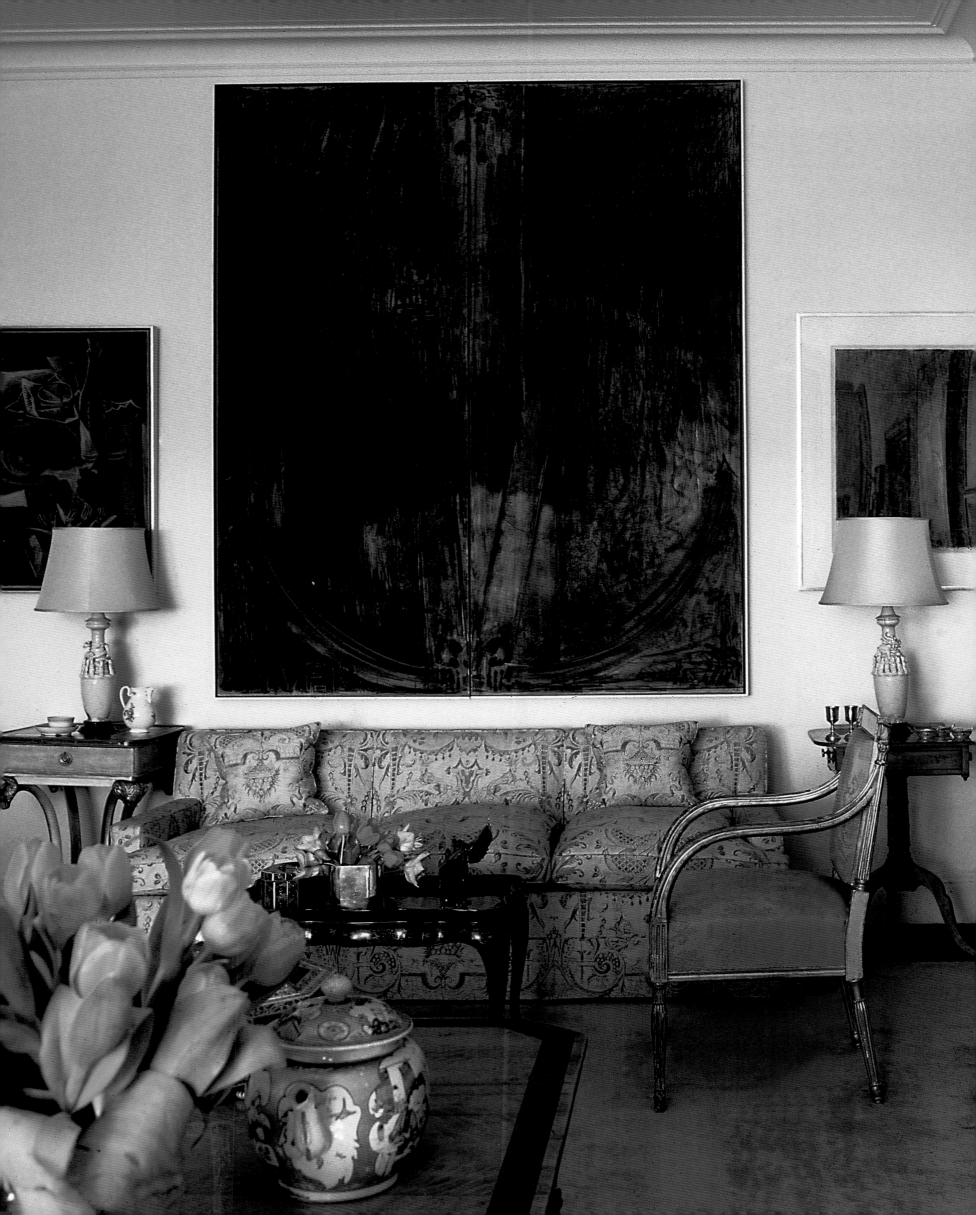

CHRONOLOGY

This chronology is based on a catalogue that the Ganzes prepared in the early 1980s and updated in the mid-1990s. Records are sometimes incomplete, particularly those pertaining to early acquisitions. In the case of paintings, drawings, and sculpture, we have attempted to list every item owned by the Ganzes, including those they sold over the years. In the case of prints, inclusions are highly selective since they owned, over six decades of collecting, more than a thousand. In contrast to other parts of the collection, prints were regularly sold to finance new acquisitions, particularly in an auction at Parke-Bernet, New York, on April 7, 1965, and as partial payment to Heinz Berggruen for Picasso's *Woman in an Armchair* in April 1967. Print entries include references in parentheses to appropriate catalogues raisonnés.

1930s

Before 1934 **Louis Eilshemius.** *Shelter Island, Maine.* c. 1908. Watercolor on paper, 151½ x 14⅝" (29.2 x 36.8 cm). Acquired from Valentine Gallery, New York.

Before 1934 **Jules Pascin.** *Untitled (Atlantic City).* Date unknown. Watercolor on paper, 7½ x 10½" (19.1 x 26.7 cm). Acquired from Downtown Gallery, New York.

Before 1934 **Raphael Soyer.** Subject and date unknown. Oil on canvas.

1940s

August 30, 1941 **Pablo Picasso.** *The Dream.* January 24, 1932. Oil on canvas, 51¼ x 38¼" (130 x 97 cm). Acquired from Meric Gallery, New York, for $7,000.

December 24, 1943 **Pablo Picasso.** *The Family.* 1938. Pen and ink wash, 17½ x 26⅝" (44.5 x 67.6 cm). Acquired from Valentine Gallery, New York, for $1,400 and sold to Stephen Mazoh & Co. on November 19, 1984.

December 24, 1943 **Pablo Picasso.** *Three Women.* August 5, 1938. Pen and ink wash, 17½ x 26½" (44.5 x 66.3 cm). Acquired from Valentine Gallery, New York, and sold to Stephen Mazoh & Co. on July 12, 1984.

January 2, 1946 **Pablo Picasso.** *Woman with Tambourine* (B 310, Ba 646). 1939. Etching and aquatint, 26³⁄₁₆ x 20¼" (66.5 x 51.4 cm). Acquired from Bucholz Gallery, New York, for $606.

Pablo Picasso, *The Family* (1938)

September 29, 1947 **Pablo Picasso.** *Minotauromachy* (B 288, Ba 373). 1935. Etching, 19⅞ x 27¼" (49.8 x 69.3 cm). Acquired from the Bucholz Gallery, New York, for $663. Sold to E. V. Thaw & Co. in 1974.

February 14, 1948 **Pablo Picasso.** *Still Life with Sausage.* May 10, 1941. Oil on canvas, 35 x 25½" (88.9 x 64.8 cm). Acquired from Bucholz Gallery, New York, for $5,000.

October 29, 1949 **Pablo Picasso.** *Cock and Knife.* March 21, 1947. Oil on canvas, 31⅞ x 39⅜" (81 x 100 cm). Acquired from Samuel Kootz Gallery, New York, for $5,000.

1950s

February 16, 1950 **Pablo Picasso.** Study for *Les Demoiselles d'Avignon.* 1907. Watercolor on paper, 24¾ x 18½" (62.9 x 47 cm). Acquired from Parke-Bernet, New York, for $484.

May 5, 1950 **Pablo Picasso.** *Owl and Arrow.* June 7, 1945 and November 23, 1946. Oil on canvas, 36½ x 28½" (92.6 x 72.4 cm). Acquired from Samuel Kootz Gallery, New York, for $5,000.

October 16, 1950 **Pablo Picasso.** *Concierge's Daughter with Doll.* March 3, 1947. Oil on canvas, 36½ x 28½" (92.6 x 72.4 cm). Acquired from Samuel Kootz Gallery, New York, for $4,000.

February 3, 1952 **Pablo Picasso.** *Sailor.* 1943. Oil on canvas, 52 x 32" (81.3 x 132.1 cm). Acquired from Harry Abrams, New York, for $11,000.

June 30, 1952 **Pablo Picasso.** *Woman on a Red Couch.* 1939. Oil on canvas, 38½ x 51" (97.8 x 130 cm). Acquired through Perls Gallery, New York, for $13,000 and sold c. 1970.

September 2, 1952 **Pablo Picasso.** *Bullfight.* 1934. Oil on canvas, 50¾ x 38⅜" (129 x 97 cm). Acquired from Frua de Angeli through Interart S.A., Lucerne, for $12,000 and sold to E. V. Thaw & Co., New York, on February 6, 1969.

1953 (probably) **Pablo Picasso.** *Owl.* 1953. Painted bronze, height: 13" (33 cm). Acquired from Curt Valentin.

March 27, 1953 **Pablo Picasso.** *Winter Landscape.* 1950. Oil on wood panel, 40½ x 49½" (102.9 x 125.7 cm). Acquired from Galerie Louise Leiris, Paris, for $12,000.

September 14, 1953 **Pablo Picasso.** *Bird Cage*. 1923. Oil on canvas, 70¼ x 55¼" (178.4 x 140.3 cm). Acquired from Paul Rosenberg & Co., New York, for $30,000 and sold at Sotheby's, New York, on November 10, 1988.

September 7, 1954 **Pablo Picasso.** *Woman in a Red Hat*. 1934. Oil and Ripolin on canvas, 64 x 51" (162.6 x 129.5 cm). Acquired from Paul Rosenberg Gallery, New York, and sold at Sotheby's, New York, on November 10, 1988.

Robert Rauschenberg, *Creek* (1964)

May 2, 1956 **Pablo Picasso.** *Seated Woman*. 1946. Oil on canvas, 51 x 35" (129.5 x 88.9 cm). Acquired from Samuel Kootz Gallery, New York, for $19,500 and sold at Sotheby's, New York, on November 10, 1988.

June 8, 1956 **Pablo Picasso.** Acquired from Galerie Louise Leiris, Paris, fifteen paintings constituting the entire series of *Women of Algiers* for $212,953. Subsequently sold ten for approximately $138,000 and kept the following five (prices are those allocated by Galerie Leiris):

Women of Algiers "C." December 28, 1954. Oil on canvas, 21½ x 25⅝" (59.6 x 63.8 cm). Acquired for $8,518 and sold at Sotheby's, New York, on November 10, 1988.

Women of Algiers "H." January 24, 1955. Oil on canvas, 51 x 65" (129.5 x 163 cm). Acquired for $8,518.

Women of Algiers "K." February 6, 1955. Oil on canvas, 51 x 65" (129.5 x 163 cm). Acquired for $8,518.

Women of Algiers "M." February 11, 1955. Oil on canvas, 51 x 78" (129.5 x 198.1 cm). Acquired for $31,810.

Women of Algiers "O, final version." February 14, 1955. Oil on canvas, 44⅞ x 57½" (114 x 146.1 cm). Acquired for $26,632.

June 12, 1956 **Pablo Picasso.** *Two Ballet Dancers*. 1919. Pencil on paper, 12¼ x 9¼" (31.1 x 23.5 cm). Acquired from Bucholz Gallery, New York.

October 11, 1956 **Pablo Picasso.** *Reclining Nude*. 1942. Oil on canvas, 51 x 78" (129.5 x 198.1 cm). Acquired from Galerie Louise Leiris, Paris, for $31,500.

April 30, 1958 **Pablo Picasso.** *Jardinière*. 1956. Oil on canvas, 63¾ x 51¼" (162 x 130 cm). Acquired from Galerie Louise Leiris, Paris, for $35,890 and sold to Saidenberg Gallery, New York, on May 1, 1973.

July 31, 1958 **Pablo Picasso.** *Studio*. 1956. Oil on canvas, 35 x 45¾" (89 x 116.2 cm). Acquired from Galerie Rosengart, Lucerne, for $31,000 and sold at Sotheby's, New York, on November 10, 1988.

July 31, 1958 **Pablo Picasso.** *Battle of the Centaurs*. August 23, 1946. India ink and gouache on paper, 19¾ x 25½" (50.2 x 64.8 cm). Acquired from Galerie Rosengart, Lucerne, for $4,000.

September 22, 1958 **Pablo Picasso.** *Little Bull*. 1958. Bronze with brown patina, 22⅜ x 43¾" (6 x 12.1 cm). Acquired from Galerie Louise Leiris, Paris, for $1,190.

October 20, 1958 **Richard Hunt.** *Sky Form, Number 2*. 1957. Welded and brazed iron and steel, 37¼ x 21⅞ x 14¾" (94.6 x 55.6 x 37.5 cm). Acquired from Alan Gallery, New York, for $360.

April 25, 1959 **Pablo Picasso.** *Bather with Beach Ball*. August 30, 1932. Oil on canvas, 57½ x 45" (146.1 x 114.3 cm). Acquired from Samuel Kootz Gallery, New York, for $55,000 and donated (partial gift) to The Museum of Modern Art in December, 1980.

1960s

April 14, 1960 **Pablo Picasso.** *Still Life with Bullfight Poster*. 1912. Pen and ink on paper, 6¾ x 4¾" (17.1 x 12.1 cm). Acquired from Pierre Loeb, New York, for $4,000.

November 7, 1960 **Pablo Picasso.** *Baboon and Young*. 1951. Bronze after found objects cast by Valsuani, 21 x 13¼ x 20¾" (53.3 x 33.7 x 52.7 cm). Acquired from Otto Gerson Gallery, New York, for $41,200 and sold to E. V. Thaw & Co., New York, c. 1970.

February 28, 1961 **Jasper Johns.** *Flag*. 1957. Pastel, fabric, and print collage on gesso plate, 14½ x 18¼" (36.8 x 46.4 cm). Acquired from Leo Castelli Gallery, New York, for $1,545.

April 27, 1961 **Pablo Picasso.** *Man with a Stick (Figure with Javelin)*. 1958. Bronze with black patina, cast by Valsuani, 45⅝ x 13¾ x 33⅞" (115.9 x 34.9 x 86 cm). Acquired from Otto Gerson, New York, for $22,500.

April 27, 1961 **Pablo Picasso.** *Figure with a Spoon*. 1958. Bronze with black patina, cast by Valsuani, 48⅛ x 18½ x 7⅛" (122.2 x 47 x 18.1 cm). Acquired from Otto Gerson, New York, for $22,500.

December 28, 1961 **Jasper Johns.** *Liar*. 1961. Encaustic, pencil, and Sculp-metal on paper, 21⅜ x 16⅞" (54.3 x 42.3 cm). Acquired from Leo Castelli Gallery, New York, for $1,545.

May 10, 1962 **Pablo Picasso.** *Head of a Woman* (B 1067, Ba 1280). 1962. Linocut in colors, 25¼ x 20⅞" (64 x 53 cm). Acquired from Michael Hertz, New York, for $721.

May 10, 1962 **Pablo Picasso.** *Head of a Woman* (B 1065, B 1285). 1962. Linocut in colors, 25⅜ x 20⅞" (64.5 x 53 cm). Acquired from Michael Hertz, New York.

May 10, 1962 **Pablo Picasso.** *Bust of a Woman in a Hat* (B 1072, Ba 1318). 1962. Linocut in colors, 25 x 20⅝" (63.5 x 52.5 cm). Acquired from Michael Hertz, New York, for $721.

October 31, 1962 **Pablo Picasso.** *Still Life with Hanging Lamp* (B 1101, Ba 1312). 1962. Linocut in colors, 20⁷/₈ x 23¹/₄" (53 x 64 cm). Acquired from Michael Hertz, New York, for $462.

January 1, 1963 **Pablo Picasso.** *Cat and Bird*. 1939. Oil on canvas, 38 x 51" (96.5 x 129.6 cm). Acquired from Perls Gallery, New York, in exchange for *Concierge's Daughter with Doll* (1942) and *Owl and Arrow* (1945–46) and valued at $29,000.

May 22, 1963 **Robert Rauschenberg.** *Airplane (Venus, White Square, Life Boat)*. 1958. Watercolor, gouache, graphite, crayon, and solvent transfer/paper, 23¹/₂ x 35³/₄" (59.7 x 90.8 cm). Acquired from Leo Castelli Gallery, New York, for $1,048.

May 22, 1963 **Robert Rauschenberg.** *Winter Pool*. 1959. Combine painting, 89¹/₂ x 58¹/₂" (227.3 x 148.6 cm). Acquired from Leo Castelli Gallery, New York, for $7,500 and sold at Sotheby's, New York, on November 10, 1988.

May 29, 1963 **Robert Rauschenberg.** *Rigger*. 1961. Combine painting, 102 x 60" (259 x 152.4 cm). Acquired from Leo Castelli Gallery, New York, for $8,240.

July 2, 1963 **Robert Rauschenberg.** *Overdraw*. 1963. Oil on canvas, 2 panels, 60 x 60" each (152.4 x 152.4 cm). Acquired from Foundation for Contemporary Performance Art, New York, for $8,500 and sold in 1972.

October 23, 1963 **Pablo Picasso.** *Seated Woman*. 1959. Oil on canvas, 57¹/₂ x 45" (146.1 x 114.3 cm). Acquired from Samuel Kootz Gallery, New York, for $66,000 and sold at Sotheby's, New York, on November 10, 1988.

1964 **Pablo Picasso.** *Jacqueline* (B 923, Ba 1245). 1959. Linocut in black and blue, 25¹/₄ x 20⁷/₈" (64 x 53 cm). Acquired from Berggruen Gallery, Geneva.

January 1, 1964 **Roy Lichtenstein.** *Hand Shake*. 1962. Oil on canvas, 32 x 48" (81.3 x 121.9 cm). Acquired from Leo Castelli Gallery, New York, for $2,500.

January 1, 1964 **Roy Lichtenstein.** *Mustard on White*. 1963. Magna on Plexiglas, 24 x 32" (60.9 x 81.3 cm). Acquired from Leo Castelli Gallery, New York, for $1,200.

February 10, 1964 **Jasper Johns.** *0–9* (Field 17–26, ULAE 17). 1963. The set of ten lithographs, all 19⁷/₈ x 15¹/₄" (50.5 x 38.7 cm). Acquired from ULAE for $900.

February 10, 1964 **Jasper Johns.** *0–9* (Field 27–36, ULAE 18). 1963. Set of ten lithographs in grays, 20¹/₂ x 15³/₄" (52.1 x 40 cm). Acquired from ULAE for $1,000.

February 19, 1964 **Jasper Johns.** *Reconstruction*. 1960. Charcoal on paper, 26 x 19¹/₂" (66 x 49.6 cm). Acquired from Leo Castelli Gallery, New York, for $1,684.80.

Roy Lichtenstein, *Hand Shake* (1962)

February 19, 1964 **Jasper Johns.** *Diver*. 1963. Charcoal, pastel, and watercolor on paper mounted on canvas, 86¹/₂ x 71" (219.7 x 180.3 cm). Acquired from Leo Castelli Gallery, New York, for $7,280.

February 19, 1964 **Jasper Johns.** *Untitled (Device Circle)*. 1963. Charcoal, red, yellow, and green paint on paper, 42¹/₂ x 30" (108 x 76.2 cm). Acquired from Leo Castelli Gallery, New York, for $2,808.

May 5, 1964 **Robert Rauschenberg.** *Creek*. 1964. Oil on canvas, 72 x 96" (183 x 240 cm). Acquired from Leo Castelli Gallery, New York, for $12,000 and sold to the gallery on August 10, 1969.

May 5, 1964 **Jasper Johns.** *Gray Rectangles*. 1957. Encaustic on canvas (four panels), each 60 x 60" (152.4 x 152.4 cm). Acquired from Leo Castelli Gallery, New York, for $15,000 and sold at Sotheby's New York, on November 10, 1988.

June 9, 1964 **Robert Rauschenberg.** *Allegory*. 1959-60. Combine painting, 72 x 120" (182.9 x 304.8 cm). Acquired from Leo Castelli Gallery, New York, for $15,500 and sold to the Ludwig Museum, Aachen, Germany, on June 21, 1971.

June 9, 1964 **Robert Rauschenberg.** *19346 (License)*. 1961. Pail and wire cage construction, 19¹/₄ x 15 x 15" (48.9 x 38.1 x 38.1 cm). Acquired from Leo Castelli Gallery, New York, for $1,500.

June 9, 1964, **Robert Rauschenberg.** *Breakthrough I* (Foster 26). 1964. Lithograph, 41¹/₂ x 29⁷/₈" (105.3 x 75.8 cm). Acquired from ULAE for $180.

September 24, 1964 **Robert Rauschenberg.** *Site (for CORE Benefit)*. 1963. Gouache and solvent transfer on canvas, 30 x 40" (76.2 x 101.6 cm). Acquired from Leo Castelli Gallery, New York, for $2,000.

November 27, 1964 **Jasper Johns.** *White Numbers*. 1959. Encaustic on canvas, 53¹/₄ x 40" (135.5 x 101.5 cm). Acquired from Leo Castelli Gallery, New York, for $15,000.

1965 **Robert Rauschenberg.** *Breakthrough II* (Foster 27). 1965. Lithograph in colors, 48¹/₂ x 34" (123.3 x 86.3 cm). Acquired from ULAE for $297.

January 4, 1965 **Jasper Johns.** *Souvenir 2*. 1964. Oil on canvas with flashlight, rearview mirror, painted plate, reversed stretched canvas, 28³/₄ x 21" (73 x 53.3 cm). Acquired from Leo Castelli Gallery, New York, for $3,600.

January 4, 1965 **Jasper Johns.** Drawing for *Souvenir 2*. 1964–65. Pencil and collage on paper, 8¹/₄ x 6¹/₄" (21 x 16 cm). Gift of the artist.

February 16, 1965 **Robert Rauschenberg.** *Fast Slip (Racing Car, Crossword, Lobster)*. 1964. Solvent transfer on paper, 15¹/₄ x 22³/₄" (38.7 x 57.8 cm). Acquired from Leo Castelli Gallery, New York, for $1,200.

1966 **Jasper Johns.** *Two Maps I* (Field 51, ULAE 10). 1965–66. Lithograph in gray on black paper, 33¼ x 26" (84.4 x 66 cm).

After March 1966 **Robert Rauschenberg.** *Odalisk.* 1955. Combine, 81 x 25 x 25" (205.7 x 63.5 x 63.5 cm.) Acquired from Ileanna Sonnabend, New York, and sold to the Ludwig Museum, Aachen, Germany, on June 21, 1971.

April 13, 1966 **Claes Oldenburg.** *Soft Toilet.* 1966. Vinyl filled with kapok, painted with Liquitex, wood, 50½ x 32⅝ x 30⅞" (128.3 x 82.6 x 78.2 cm). Acquired from Sidney Janis Gallery, New York, for $6,300 and given to the Whitney Museum of American Art, New York, on December 12, 1979.

April 27, 1966 **Frank Stella.** *Tuftonboro I.* 1966. Alkyd and epoxy on canvas, 99 x 109" (251.5 x 277 cm). Acquired from Leo Castelli Gallery, New York, for $2,835.

May 16, 1966 **Jasper Johns.** *Two Maps II* (Field 52, ULAE 26). 1966. Lithographs in white on black paper, both 33 x 26" (83.8 x 66 cm) Acquired from ULAE for $225.

May 31, 1966 **Robert Rauschenberg.** *Drawings for Dante's 700th Birthday.* 1965. Two-panel Combine drawing, oil, watercolor, and solvent transfer on two panels in one mount for *LIFE* magazine layout, 2 panels each 15 x 31½" (38.1 x 80 cm). Acquired from Leo Castelli Gallery, New York, for $4,000.

November 2, 1966 **Frank Stella.** *Cinema di Pepsi.* 1966. Fluorescent alkyd on canvas, 63 x 136" (160 x 345.4 cm). Acquired from Leo Castelli Gallery, New York, for $5,400.

November 21, 1966 **Jasper Johns.** *Watchman.* 1966. Graphite, metallic powder, and pastel on paper, 38 x 26½" (96.5 x 67.3 cm). Acquired from Leo Castelli Gallery, New York, for $2,700 and given to The Museum of Modern Art, New York, on October 10, 1988.

December 16, 1966 **Jasper Johns.** *Figure 2.* 1962. Encaustic and collage on canvas, 51½ x 41½" (130.8 x 105.4 cm). Acquired from Leo Castelli Gallery, New York, for $15,500.

December 16, 1966 **Jasper Johns.** *Studio II.* 1966. Oil on canvas, 70 x 125" (178 x 452 cm). Acquired from Leo Castelli Gallery, New York, for $20,000 and given to the Whitney Musuem of American Art, New York, on October 28, 1988.

March 10, 1967 **Jasper Johns.** *Tennyson.* 1967. Graphite and wash on paper, 36¼ x 24¼" (92.1 x 61.6 cm). Acquired from Leo Castelli Gallery, New York, for $2,700.

April 13, 1967 **Robert Rauschenberg.** *22 The Lily White.* 1949. Oil and pencil on canvas, 39½ x 25½" (100.3 x 64.8 cm). Acquired from Leo Castelli Gallery, New York, for $5,000.

Jasper Johns, *Flags I* (1973)

April 20, 1967 **Robert Rauschenberg.** *Red Interior.* 1954. Combine, 56½ x 61½" (143.5 x 156.2 cm). Acquired from the artist for $11,000.

April 21, 1967 **Pablo Picasso.** *Woman in an Armchair.* 1913. Oil on canvas, 57½ x 45" (146.1 x 114.3 cm). Acquired through Heinz Berggruen, Zurich, for $158,550, plus 38 prints valued at $41,450 for a total of $200,000.

June 21, 1967 **Robert Rauschenberg.** *Booster* (Foster 47). 1967 Lithograph in colors, 72 x 36" (182.9 x 91.4 cm). Gift of the artist.

February 28, 1968 **Jasper Johns.** *Screen Piece II.* 1968. Oil on canvas, 72 x 50" (182.9 x 127 cm). Acquired from Leo Castelli Gallery, New York, for $15,000 and sold at Sotheby's, New York, on November 10, 1988.

March 26, 1968 **Robert Rauschenberg.** *Rebus.* 1955. Combine painting, 96 x 130½" (243.8 x 331.5 cm). Acquired from the artist for $61,200 and sold at Sotheby's, New York, on November 10, 1988.

April 1, 1968 **Frank Stella.** *Hiraqla III.* 1968. Fluorescent acrylic on canvas, 120 x 240" (304.8 x 609.6 cm). Acquired from Leo Castelli Gallery, New York, for $6,750 and sold at Sotheby's, New York, on November 10, 1988.

June 3, 1968 **Neil Williams.** *Slipped Disc.* 1967. Acrylic on canvas, 108 x 57" (274.3 x 144.8 cm). Acquired from Andre Emmerich Gallery, New York, for $1,890.

October 9, 1968 **Robert Rauschenberg.** *Untitled (Dove and Running Man).* 1968. Solvent transfer and gouache on paper, 22½ x 30" (57.2 x 76.2 cm). Acquired from Leo Castelli Gallery, New York, for $2,250.

December 5, 1968 **Eva Hesse.** *Untitled (Two Circles).* 1968. Gouache over watercolor and pencil on paper, 14¾ x 12" (37.5 x 30.5 cm). Acquired from Fischbach Gallery, New York, for $225.

December 5, 1968 **Eva Hesse.** *Schema.* 1967–68. Latex sheet, 42 x 43" (106.7 x 109.2 cm), hemispheres 2½" (6.3 cm) in diameter each. Acquired from Fischbach Gallery, New York, for $800.

December 5, 1968 **Eva Hesse.** *Model (Pancakes) Stack of 10.* 1968. Latex on cheesecloth, 6 x 4½ x 6" (15.2 x 11.4 x 15.2 cm). Acquired from Fischbach Gallery, New York, for $360.

December 5, 1968 **Eva Hesse.** *Model (Rubber Pail).* 1968. Latex, 5¾ x 11" (14.6 x 27.9 cm). Acquired from Fischbach Gallery, New York, for $175.

December 5, 1968 **Eva Hesse.** *Untitled (Horizontal Lines).* 1968. Gouache over watercolor and pencil on paper, 15½ x 11" (39.4 x 27.9 cm). Acquired from Fischbach Gallery, New York, for $225.

January 1, 1969 **Brice Marden.** *Untitled.* 1968. Ink and graphite and wax on paper, 26 x 40" (66 x 101.6 cm). Acquired from Bykert Gallery, New York, for $259.90.

February 1, 1969 **Cy Twombly.** *Untitled.* 1968. Oil on canvas, 68 x 85" (172.7 x 215.9 cm). Acquired from Leo Castelli Gallery, New York, for $2,700 and sold at Christie's, New York, on May 6, 1986.

February 1, 1969 **Cy Twombly.** *Untitled.* 1968. Oil on canvas, 30 x 40" (76.2 x 101.6 cm). Acquired at Leo Castelli Gallery, New York, for $800 and sold at Christie's, New York, on May 6, 1986.

February 3, 1969 **Frank Stella.** *Yazd II.* 1968. Fluorescent acrylic on canvas, 60 x 180" (152.4 x 457.2 cm). Acquired from Leo Castelli Gallery, New York, for $10,000.

Pablo Picasso,
Untitled (Bearded Man) (1970)

February 3, 1969 **Cy Twombly.** *The Veil of Orpheus.* 1968. Oil on canvas with crayon and pencil, 90 x 192" (228.6 x 487.7 cm). Acquired from Leo Castelli Gallery, New York, for $6,000.

February 7, 1969 **Jasper Johns.** *0–9* (Field 104–113, ULAE 59–68). 1969. Set of ten lithographs in colors, 38 x 31" (96.5 x 78.7 cm). Acquired from Leo Castelli Gallery, New York, for $14,715.

November 6, 1969 **Eva Hesse.** *Vinculum I.* 1969. Fiberglass, rubber tubing, and metal screen, in two parts each 104 x 8½" (264.2 x 21.6 cm). Acquired from Fischbach Gallery, New York, for $2,500.

1970s

February 11, 1970 **Jasper Johns.** *Wall Piece II.* 1968. Ink on plastic film, 19¾ x 31 1/16" (50.2 x 78.9 cm). Acquired from Leo Castelli Gallery, New York, for $7,000.

May 8, 1970 **Pablo Picasso.** *Untitled (Bearded Man).* June 8, 1970. Pen and ink on paper, 12 x 9" (30.5 x 22.9 cm). Gift of the artist.

May 8, 1970 **Pablo Picasso.** *Untitled (Bearded Man).* June 8, 1970. Pen and ink on paper, 6 x 6" (15.2 x 15.2 cm) inside mat size. Gift of the artist.

December 4, 1970 **John Tweddle.** *Crosshatch Painting.* 1969–70. Acrylic on canvas, 78½ x 120" (199.4 x 304.8 cm). Acquired from Richard Bellamy, New York, for $1,500.

January 1, 1971 **Mel Bochner.** *Continuous/Dis/Continuous.* 1971. Watercolor, felt-tip pen, and tape on paper, 12 x 24" (30.5 x 61 cm). Gift of the artist.

January 19, 1971 **John Tweddle.** *Untitled (Nude Transmogrified into Landscape).* 1970. Wax crayon on paper, 19 x 24" (48.3 x 61 cm). Acquired from Richard Bellamy, New York, for $212.

October 1, 1971 **Frank Stella.** *Odelsk I.* 1971. Mixed media, 90 x 132"

(228.6 x 335.3 cm). Acquired from Lawrence Rubin Gallery, New York, for $16,500.

October 25, 1971 **Frank Stella.** *Chodorow II.* 1971. Mixed media on canvas, 108 x 106" (274.3 x 269.2 cm). Acquired from Lawrence Rubin Gallery, New York, for $16,500.

November 24, 1971 **Jasper Johns.** *Decoy* (Field 134, ULAE 98). 1971. Lithograph in colors, 41 x 29" (104 x 73.7 cm). Acquired from ULAE for $1,500.

January 1, 1972 **Jasper Johns.** *Harlem Light.* 1969. Graphite, pastel, gouache, and pencil on paper, 25¼ x 52¾" (64.1 x 134 cm). Acquired from Leo Castelli Gallery, New York, for $18,000.

January 13, 1972 **Jasper Johns.** *Decoy.* 1971. Oil on canvas with brass grommet, 72 x 50" (182.9 x 127 cm). Acquired from Leo Castelli Gallery, New York, for $60,000.

July 10, 1972 **Eva Hesse.** *Hang-Up.* 1965–66. Acrylic on cloth over wood and steel, 72 x 84 x 78" (182.9 x 213.4 x 198.1 cm). Acquired from Fourcade-Droll Gallery, New York, for $18,000 and sold to the Art Institute of Chicago on March 1, 1988.

July 10, 1972 **Eva Hesse.** *Connection (Icicles).* 1969. Fiberglass cloth on wire, 20 units, each 16 x 65½ x 3" (40.6 x 166.4 x 7.6 cm). Acquired from Fourcade-Droll Gallery, New York, for $9,000.

July 10, 1972 **Eva Hesse.** *Circle Drawing (with Plastic Threads).* 1968. Pencil and wash drawing with plastic threads on paper, 15⅛ x 15⅛" (38.4 x 38.4 cm). Acquired from Fourcade-Droll Gallery, New York, for $900.

July 10, 1972 **Eva Hesse.** *Vertiginous Detour.* 1966. Enamel, rope, net, and plaster, length: 23" (58.4 cm), circumference: 40" (101.6 cm). Acquired from Fourcade-Droll Gallery, New York, for $6,500 and sold to the Hirshhorn Museum, Washington, D.C., on May 13, 1988.

July 10, 1972 **Eva Hesse.** *Addendum.* 1967. Painted papier-mâché, wood, and cords, 5 x 119 x 6" (12.7 x 302.3 x 15.2 cm). Acquired from Fourcade-Droll Gallery, New York, for $10,500 and sold to the Tate Gallery, London, on November 1, 1979.

July 10, 1972 **Eva Hesse.** *Constant.* 1967. Wood shavings, glue on board, acrylic and rubber tubing, 60 x 60 x 5¾" (152.4 x 152.4 x 14.6 cm). Acquired from Fourcade-Droll Gallery, New York, for $7,500.

July 10, 1972 **Eva Hesse.** *Untitled (Rope Piece).* 1969–70. Latex over rope, wire, and string, height of 3 units: 144, 126, 90" (365.8, 320, 228.6 cm) (height varies with installation). Acquired from Fourcade-Droll Gallery, New York, for $28,000 and sold to the Whitney Museum of American Art, New York, on April 25, 1988.

July 10, 1972 **Eva Hesse.** *Untitled (Seven Poles).* 1970. Fiberglass over polyethylene over aluminum wire, height of each of 7 units: 74–111" (188–281.9 cm), circumference of each unit: 10–16" (25.4–40.6 cm).

Acquired from Fourcade-Droll Gallery, Inc., New York, for $28,000 and sold to the Centre Pompidou, Paris, on June 4, 1986.

July 10, 1972 **Eva Hesse.** *Untitled (Wall Piece).* 1969–70. Fiberglass over wire mesh, latex over cloth wire, each of 4 units: 34–42¾ x 23–34 x 2–6" (86.4–108.6 x 58.4 cm). Acquired from Fourcade-Droll Gallery, New York, for $25,000 and sold to the Des Moines Art Center on October 20, 1988.

July 10, 1972 **Eva Hesse.** *Metronomic Irregularity III.* 1966. Painted wood, Sculp-metal, and cotton-covered wire, 10 x 50 x 21¼" (25.4 x 127 x 54 cm). Acquired from Fourcade-Droll Gallery, New York, for $2,625.

July 10, 1972 **Eva Hesse.** *Unfinished, Untitled, or Not Yet.* 1966. Nine dyed net bags with weights and clear polyethylene, 72 x 24 x 14" (182.9 x 61 x 35.6 cm). Acquired from Fourcade-Droll Gallery, New York, for $3,375.

July 28, 1972 **Eva Hesse.** *Ennead.* 1966. Dyed string and painted papier-mâché, 36 x 22 x 1½" (91.4 x 55.9 x 3.8 cm). Acquired from Fourcade-Droll Gallery, New York, for $10,500.

October 13, 1972 **Pat Steir.** *Untitled (72) #4.* 1972. Watercolor, black and colored pencil, and pastel on paper, 26 x 19" (66 x 48.3 cm). Acquired from Paley and Lowe, Inc., New York, for $250.

October 13, 1972 **Pat Steir.** *Cellar Door.* 1972. Oil on canvas, 72 x 108" (182.9 x 274.3 cm). Acquired from Paley and Lowe, Inc., New York, for $2,400.

October 13, 1972 **Pat Steir.** *Untitled #5.* 1972. Pencil on paper, 11¾ x 10" (29.8 x 25.4 cm). Acquired from Paley and Lowe, Inc., New York, for $150.

October 28, 1972 **Anthony Caro.** *Stretch (Floor Piece Gimel).* 1969–72. Stainless steel, 9½ x 88½ x 61" (24.1 x 224.8 x 154.9 cm). Acquired from Andre Emmerich Gallery, New York, for $7,650.

January 1, 1973 **Dorothea Rockburne.** *Untitled.* 1973. Ink on folded Strathmore paper, 29 x 39" (73.7 x 99.1 cm). Acquired from Bykert Gallery, New York, for $1,170.

January 9, 1973 **Eva Hesse.** *Accession (Nine Circles).* 1968. Gouache over watercolor and pencil, 22¼ x 15" (56.5 x 38.1 cm). Acquired from Kurt Olden for $375.

January 9, 1973 **Eva Hesse.** *Accession.* 1968. Pencil and gouache on paper, 15¼ x 11¼" (38.7 x 28.6 cm). Acquired from Kurt Olden for $375.

January 9, 1973 **Eva Hesse.** *Untitled (Boxes).* 1968. Gouache on paper, 15" x 11" (38.1 x 27.9 cm). Acquired from Kurt Olden for $375.

April 25, 1973 **Pablo Picasso.** *Bust of a Woman, after Cranach the Younger* (B 859, Ba 1092). 1958. Linocut in colors, 25⁹⁄₁₆ x 21¹⁄₁₆" (65 x

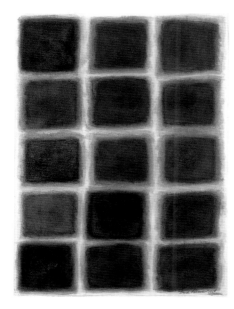

Eva Hesse, *Untitled (Boxes)* (1968)

53.5 cm). Acquired from Michael Hertz, New York, for $750.

June 21, 1973 **Mel Bochner.** *Ten to 10: Theory of Sculpture #2.* 1972. Black and colored ink and pencil on paper, 7½ x 9¾" (19.1 x 24.8 cm). Acquired from Sonnabend Gallery, New York, for $400.

June 21, 1973 **Mel Bochner.** *Counting.* 1971. Black and colored ink and pencil on paper, 15 x 10" (38.1 x 25.4 cm). Acquired from Sonnabend Gallery, New York, for $500.

June 21, 1973 **Mel Bochner.** *Theory of Sculpture: Principal of Detachment.* 1973. Black and colored ink and pencil on paper, 13½ x 11" (34.3 x 27.9 cm). Acquired from Sonnabend Gallery, New York, for $500.

June 21, 1973 **Mel Bochner.** *Number Drawing with Swastika.* 1966. Black and red ink on graph paper, 16 x 20¾" (40.6 x 52.7 cm). Acquired from Sonnabend Gallery, New York, for $700.

June 21, 1973 **Mel Bochner.** *Diagonals Constant.* 1967. Felt-tip pen and colored ink on graph paper, 18½ x 24" (47 x 61 cm). Acquired from Sonnabend Gallery, New York, for $700.

October 2, 1973 **Jasper Johns.** *Decoy II* (Field 169, ULAE 125). 1971–73. Lithograph in colors, 41 x 29" (104.1 x 73.7 cm). Acquired from ULAE for $3,250.

October 18, 1973 **Robert Morris.** *Untitled.* 1965. Polished Sculp-metal on Masonite with lead, twine, and wire brush, 72 x 139 x 3" (182.9 x 353.1 x 7.6 cm). Acquired through Sotheby Parke-Bernet, New York, for $16,050.

December 7, 1973 **Jasper Johns.** *Flag I* (Field 173, ULAE 128). 1973. Screenprint in colors, 27¼ x 34¾" (69.2 x 88.3 cm) Gift of the artist.

January 1, 1974 **Mel Bochner.** *Untitled (Belvedere Courtyard).* 1974. Pencil on paper, 5½ x 6" (14 x 15.2 cm). Gift of the artist.

January 10, 1974 **Eva Hesse.** Model for *Untitled (Seven Poles).* 1970. Plaster over wire and cloth-covered wire, seven units, each 4¾ x 6¾", base 5 x 5" (12.1 x 17.1 cm, base 12.7 x 12.7 cm). Gift of Helen Hesse Charash and donated to the Menil Foundation on December 7, 1991, for transfer to the Centre Pompidou, Paris.

September 18, 1974 **Mel Bochner.** *Pitch.* 1973. Charcoal on paper, 38 x 50" (96.5 x 127 cm). Acquired from Sonnabend Gallery, New York, for $3,000.

September 18, 1974 **Mel Bochner.** *Compound/Complex (V.).* 1973. Charcoal and Conté on paper, 38 x 50" (96.5 x 127 cm). Acquired from Sonnabend Gallery, New York, for $3,000.

September 18, 1974 **Mel Bochner.** *Equal and Equals.* 1974. Charcoal and Conté on paper, 38 x 50" (96.5 x 127 cm). Acquired from Sonnabend Gallery, New York, for $3,000.

September 18, 1974 **Mel Bochner.** *Three Tangent*. 1974. Sanguine on paper, 38 x 50" (96.5 x 127 cm). Acquired from Sonnabend Gallery, New York, for $3,000.

September 18, 1974 **Mel Bochner.** *Triangular and Square: First Diagonal*. 1974. Pastel and charcoal on paper, 38 x 50" (96.5 x 127 cm). Acquired from Sonnabend Gallery, New York, for $3,000 and given to the Whitney Museum of Americn Art, New York, on January 17, 1983.

September 18, 1974 **Mel Bochner.** *Triangular and Square: Second Diagonal*. 1974. Pastel and charcoal on paper, 38 x 50" (96.5 x 127 cm). Acquired from Sonnabend Gallery, New York, for $3,000 and given to The Museum of Modern Art, New York, on March 15, 1983.

November 5, 1974 **Sol LeWitt.** *A Not-Straight Line Drawn from a Point*. 1974. Pencil and ink on paper, 15 x 15" (38.1 x 38.1 cm). Acquired from Art Lending Services of The Museum of Modern Art (Change, Inc.), New York, for $918.

January 1, 1975 **Mel Bochner.** *Untitled (Four Black Shapes)*. 1975. Gouache and pencil on paper, 5³/₄ x 8¹/₄" (14.6 x 21 cm). Acquired by exchange with the artist.

January 14, 1975 **Dorothea Rockburne.** *Golden Section Painting*. 1974. Clear varnish, gesso, and blue plumb line on folded linen, 68¹/₈ x 110¹/₈" (173 x 279.7 cm). Acquired from John Weber Gallery, New York, for $10,800.

April 9, 1975 **Dorothea Rockburne.** *Indication Not Executed (Navajo)*. 1973. Carbon paper and graphite on paper, 49¹/₄ x 37¹/₄" (125.1 x 94.6 cm). Acquired at Sotheby Parke-Bernet auction for Oberlin College for $1,700.

June 5, 1975 **Robert Smithson.** *Kaiser Steel Sites: A Dearchitectured Project*. 1969. Pencil on paper, 16¹/₂ x 13³/₄" (41.9 x 34.9 cm). Acquired from Ace Gallery, Venice, CA, for $1,125.

June 5, 1975 **Robert Smithson.** *Island of the Dismantled Building*. January, 1970. Pencil on paper, 8¹/₂ x 11" (21.6 x 27.9 cm). Acquired from Ace Gallery, Venice, CA, for $1,125.

June 5, 1975 **Robert Smithson.** *Palm Spiral*. 1972. Pencil on paper, 9 x 11¹/₂" (22.9 x 29.2 cm). Acquired from Ace Gallery, Venice, CA, for $1,125.

June 5, 1975 **Robert Smithson.** *Portland Cement Sites: A De-Architectured Project*. 1969. Pencil on paper, 16¹/₂ x 13³/₄" (41.9 x 34.9 cm). Acquired from Ace Gallery, Venice, CA, for $1,125.

June 5, 1975 **Robert Smithson.** *Partially Buried Island Hut*. 1969. Pencil on paper, 18³/₄ x 23³/₄" (47.6 x 60.3 cm). Acquired from Ace Gallery, Venice, CA, for $1,125.

June 5, 1975 **Robert Smithson.** *Kaiser Steel Wall Japan*. 1969. Pencil on paper, 14 x 16¹/₂" (35.6 x 41.9 cm). Acquired from Ace Gallery, Venice, CA, for $1,125.

Pablo Picasso,
Figure with a Spoon (1958)

June 5, 1975 **Robert Smithson.** *For Kaiser Steel*. 1969. Pencil on paper, 13³/₄ x 16¹/₂" (34.9 x 41.9 cm). Acquired from Ace Gallery, Venice, CA, for $1,125.

June 5, 1975 **Robert Smithson.** *The Museum in World's Fair*. 1969. Pencil on paper, 16¹/₂ x 13³/₄" (41.9 x 34.9 cm). Acquired from Ace Gallery, Venice, CA, for $1,125.

June 5, 1975 **Robert Smithson.** *Circular Island*. 1971. Pencil on paper, 19 x 23" (48.3 x 58.4 cm). Acquired from Ace Gallery, Venice, CA, for $1,125.

June 5, 1975 **Robert Smithson.** *Gate to the Jungle*. 1969. Pencil, felt pen, and crayon on paper, 23¹/₂ x 20" (59.7 x 50.8 cm). Acquired from Ace Gallery, Venice, CA, for $1,125.

June 5, 1975 **Robert Smithson.** *Spiral Film Plan for Island of Broken Glass*. 1969. Pencil on paper, 18 x 24" (45.7 x 61 cm). Acquired from Ace Gallery, Venice, CA, for $1,125.

June 5, 1975 **Robert Smithson.** *Project for Japan American Cement*. 1969. Pencil on paper, 13³/₄ x 16³/₈" (34.9 x 41.6 cm). Acquired from Ace Gallery, Venice, CA, for $1,125.

June 5, 1975 **Robert Smithson.** *Broken Clear Glass Displacement*. 1969. Pencil and red pencil on paper, 14 x 16¹/₂" (35.6 x 41.9 cm). Acquired from Ace Gallery, Venice, CA, for $1,125.

June 5, 1975 **Robert Smithson.** *Island of Buried Pipes*. 1969. Pencil on paper, 19 x 23¹/₄" (48.3 x 59.1 cm). Acquired from Ace Gallery, Venice, CA, for $1,125.

June 5, 1975 **Robert Smithson.** *Broken Glass Displacement*. 1969. Pencil on paper, 13³/₄ x 16¹/₂" (34.9 x 41.9 cm). Acquired from Ace Gallery, Venice, CA, for $1,125.

June 5, 1975 **Robert Smithson.** *Tin Sheet*. 1969. Pencil on paper, 16¹/₂ x 13³/₄" (41.9 x 34.9 cm). Acquired from Ace Gallery, Venice, CA, for $1,125.

June 23, 1975 **Jasper Johns.** *Corpse and Mirror*. 1974. Oil, encaustic, and collage on canvas, 50 x 68¹/₈" (127 x 173 cm). Acquired from Leo Castelli Gallery, New York, for $80,000.

July 15, 1975 **Mel Bochner.** *Three Sets, Rotated Center*. 1966. Colored ink and felt-tip pen on graph paper, 16¹/₂ x 21¹/₂" (41.9 x 54.6 cm). Acquired from Finch College Museum of Art, New York, for $900.

September 13, 1975 **Robert Smithson.** *Suspended Chambers (Enantiomorphic Chamber)*. 1965. Colored pencil on paper, 12 x 14" (30.5 x 35.6 cm). Acquired from Champlain Ravagnan, New York, for $900.

January 16, 1976 **Richard Tuttle.** *Ten Sided Pale Orange*. 1967. Acrylic on canvas, 47¹/₂ x 62¹/₂" (120.6 x 158.8 cm). Acquired from Betty Parsons Gallery, New York, for $7,500.

March 18, 1976 **Richard Tuttle.** *Blue Pole.* 1965. Painted wood, 55 x 10½ x 1¾" (139.7 x 26.7 x 4.4 cm). Acquired from Betty Parsons Gallery, New York, for $3,750.

March 18, 1976 **Richard Tuttle.** *First Wire Bridge.* 1971. Metal wire mounted on the wall with metal nails, 40 x 40" (101.6 x 101.6 cm). Acquired from Betty Parsons Gallery, New York, for $3,750.

June 8, 1976 **Robert Rauschenberg.** *The Tower (Combine for Paul Taylor).* 1957. Umbrella and painted wooden objects, broom, metal cans, canvas, fabric, and electric lights, 119¼ x 16 x 48" (302.9 x 40.6 x 121.9 cm). Acquired from Betty Parsons Gallery, New York, for $40,000.

Frank Stella, *Nogaro* (1981)

July 13, 1976 **Barry Le Va.** *Two Center Points.* 1970–71. Ink and colored pencil on graph and tracing paper, 21 x 29" (53.3 x 73.7 cm). Acquired from Sonnabend Gallery, New York, for $1,000.

November 13, 1976 **Dorothea Rockburne.** *Copal #5.* 1976. Blue chalk and varnish on folded kraft paper, 28½ x 39½" (72.4 x 100.3 cm). Acquired from John Weber Gallery, New York, for $4,000.

June 1, 1977 **Frank Stella.** *Dove of Tanna.* 1977. Mixed media, 156 x 216 x 108" (396.2 x 548.6 x 274.3 cm). Acquired from Leo Castelli Gallery, New York, and given to the Whitney Museum of American Art, New York, in 1990.

September 28, 1977 **Jasper Johns.** *Savarin* (Field 259). 1977. Lithograph in colors, 45 x 35" (114.3 x 88.8 cm). Acquired from ULAE for $4,000.

1978 **Jasper Johns.** *Savarin* (ULAE S18). 1978. Monotype in red, yellow, blue, and silver, 27¼ x 19½" (68.6 x 49.5 cm). Acquired from the artist for $6,000.

February 16, 1979 **Frank Stella.** *Ram Gangra.* 1978. Mixed media and aluminum, 115 x 90½ x 43½" (292.1 x 229.9 x 110.5 cm). Acquired from Leo Castelli Gallery, New York, for $27,500.

1980s

March 6, 1980 **Frank Stella.** *Grajau II.* 1975. Mixed media on aluminum, 82 x 134" (208.3 x 340.4 cm). Acquired from Susanne Hilberry Gallery, Detroit, for $52,000.

June 9, 1980 **Pablo Picasso.** *Reclining Woman.* May 20, 1941. Pencil on paper, 8 x 10¼" (20.32 x 26 cm). Acquired from Galerie Kohler, Zurich, for $9,900.

June 13, 1980 **Frank Stella.** *Turkish Mambo.* 1959. Enamel on canvas, 90 x 134" (228.6 x 340.4 cm). Acquired from Ted Ashley, Los Angeles, for $250,000.

November 6, 1980 **Frank Stella.** *Glinne II.* 1972. Mixed media, 118 x 88½" (299.7 x 224.8 cm). Acquired from Leo Castelli Gallery, New York, for $25,000 and sold at Sotheby's, New York, on November 10, 1988.

November 6, 1980 **Frank Stella.** *Chyrow III.* 1972. Felt, enamel, and canvas on corrugated panel, 114 x 100½ x 5" (289.6 x 255.3 x 12.7 cm). Acquired from Leo Castelli Gallery, New York, for $25,000.

October 5, 1981 **Frank Stella.** *Nogaro.* 1981. Mixed media on aluminum and fiberglass, 115 x 10 x 24" (292.1 x 25.4 x 61 cm). Acquired from M. Knoedler Gallery, New York, for $90,000.

February 25, 1982 **Jasper Johns.** *Cicada* (Segal 24–34, ULAE 215). 1979–81. Set of six screenprints in colors, 22 x 18½" (55.9 x 47 cm). Acquired from Sunica Print Artists for $20,000.

December 1, 1983 **Bill Barrette.** *Double Leaf #6.* 1983. Encaustic, dye, and pigment on paper, 22 x 30" (55.9 x 76.2 cm). Acquired from Leila Taghinia-Milanio, Inc., New York, for $1,100.

March 1, 1985 **Susan Rodgers.** *Hiroglyph.* 1984. Welded steel, 67 x 43 x 25½" (170.2 x 109.2 x 64.8 cm). Acquired from the Sculpture Center, New York, for $3,000.

September 30, 1985 **Carroll Dunham.** *Untitled.* May 26, 1985. Mixed media on wood, 42 1/8 x 28¾" (107 x 73 cm). Acquired from Baskerville & Watson Gallery, New York, for $1,894.

October 16, 1985 **Frank Stella.** *Il Drago e la cavalina fatata.* 1985. Mixed media and aluminum, 120 x 137¼ x 35½" (304.8 x 348.6 x 90.2 cm). Acquired from Leo Castelli Gallery, New York, for $124,487.

December 11, 1986 **John Newman.** *Trumpeter's Case.* 1986. Bronze with patina, 36 x 68 x 34½" (91.4 x 172.7 x 87.6 cm). Acquired from Jeffrey Hoffeld Gallery, New York, for $31,176.

March 15, 1991 **Jasper Johns.** *Untitled.* 1990. Oil on canvas, 31⅜ x 41⅛" (79.7 x 104.4 cm). Acquired from Leo Castelli Gallery, New York, for $730,687.

The dates of acquisition for the following works are unknown.

Pablo Picasso. *Women Dancing on a Beach (Playing on the Beach).* November 20, 1932. Pen and black ink on white paper, 9¾ x 13¾" (24.8 x 34.9 cm). Acquired from Gerald Craemer, Geneva.

Pablo Picasso. *Blind Minotaur Guided by a Little Girl in the Night* (B 225, Ba 437). 1934. Aquatint, 9¾ x 13⅝" (24.7 x 34.7 cm). Acquired from Berggruen Gallery, Geneva.

Pablo Picasso. *Faun Unveiling a Woman* (B 230, Ba 609). 1936. Aquatint, 12½ x 16½" (31.7 x 41.7 cm). Acquired from Berggruen Gallery, Geneva.

CONTRIBUTOR BIOGRAPHIES

Michael FitzGerald is chairman of the Department of Fine Arts at Trinity College in Hartford, Connecticut. He wrote *Making Modernism: Picasso and the Creation of the Market for Twentieth-Century Art* (Farrar, Straus & Giroux, 1995).

John Richardson is writing a projected four-volume biography of Picasso. Volumes one and two of *A Life of Picasso* were published by Random House in 1991 and 1996.

Leo Steinberg is professor emeritus at the University of Pennsylvania. In 1995–96, he delivered the Norton Lectures at Harvard University.

Maya Picasso is the daughter of Marie-Thérèse Walter and Pablo Picasso.

Brigitte Baer edited *Picasso: Peintre-Graveur* (Kornfeld, 1986–96), a six-volume catalogue of the artist's engravings and etchings.

Linda Asher has translated Milan Kundera's last several books from the original French. She has been an editor at *The New Yorker* for sixteen years.

Leo Castelli owns the Leo Castelli Gallery in New York City.

Roberta Bernstein is an associate professor of art history at the State University of New York, Albany. Her most recent publication is in The Museum of Modern Art's Jasper Johns retrospective catalogue.

David Sylvester CBE, wrote *About Modern Art: Critical Essays 1948–1997* (Henry Holt, 1997). He is currently preparing a volume of his interviews with artists, including Jasper Johns, Robert Rauschenberg, and Frank Stella.

Robert Monk is a private dealer in contemporary art.

Susan Lorence is a private dealer in contemporary art.

Roni Feinstein catalogued the Ganzes' collection in the early 1980s and curated the Robert Rauschenberg exhibition at the Whitney Museum of American Art in 1990.

Judith Goldman was adjunct curator of prints at the Whitney Museum of American Art in the 1980s and is working on a biography of Leo Castelli.

Linda Shearer is director of the Williams College Museum of Art in Williamstown, Massachusetts.

Bill Barrette is an artist and the author of *Eva Hesse Sculpture, A Catalogue Raisonné* (Timken, 1989).

Carter Ratcliff wrote *The Fate of a Gesture: Jackson Pollock and Postwar American Art* (Farrar, Straus & Giroux, 1996). He is a frequent contributor to *Art in America*.

Brendan Gill is chairman of the board of the Andy Warhol Foundation and is an honorary trustee of the Whitney Museum of American Art.

Flora Biddle is honorary chairman of the Whitney Museum of American Art.

Thomas Armstrong is director emeritus of the Whitney Museum of American Art.

Calvin Tomkins recently wrote a biography of Marcel Duchamp (Henry Holt, 1997). His essays appear frequently in *The New Yorker*.

Mary Miss is an artist who lives in New York City.

Agnes Gund is president of The Museum of Modern Art.

William Rubin was, until recently, director emeritus of the department of painting and sculpture at The Museum of Modern Art.

Kirk Varnedoe is director of painting and sculpture at The Museum of Modern Art.

Mel Bochner is an artist who lives in New York City.

Gabriella De Ferrari is a writer of fiction.

ACKNOWLEDGMENTS

Because this book was completed in four months, it required unusual dedication from everyone involved. I especially thank the authors, most of whom postponed previous commitments in order to meet our deadline. Several people, particularly Jennifer Russell, offered crucial advice regarding the selection of writers and the history of the collection. Mel Bochner and Dorothea Rockburne generously shared their personal knowledge of the Ganzes with me. Since the introduction is largely based on unpublished material (primarily the private papers of Victor and Sally, and conversations with and written responses from their children, which are not available for public consultation), I have not supplied reference notes. Some documents pertaining to the Ganzes are preserved in the Alfred H. Barr, Jr., Papers at The Museum of Modern Art (microfilm copies in the Archives of American Art) and the archives of the Whitney Museum of American Art. Victor's statement on collecting was published in *Arts Review* 1987. Dodie Kazanjian has generously allowed us to excerpt interviews she conducted with Sally on March 9, 1992.

As project editor, Anna Hammond proved unflappable and a strong partner in editing the manuscripts. At Smallwood & Stewart, John Smallwood shepherded the book through production with grace and efficiency. Patti Ratchford created a design that is intended to avoid the tedium of many art history books without sacrificing clarity. And Deri Reed brought a mastery of detail to organizing the production process.

My thanks to Christopher Burge, Christie's Chairman in America, for having invited me to serve as editor. Michele Haertel supervised the project with great finesse. Sheri Farber provided invaluable assistance with photography and documentary research as liaison with the team at White Brothers in London. Several specialists helped catalogue works and check the chronology.

Without the constant support and contributions of Victor and Sally's children, Kate Ganz Dorment, Nancy Ganz Wright, Tony Ganz, and Vicky Ganz DeFelice, this book would never have been produced. Their belief that the book should address the history of collecting as well as record their parents' activities has guided the project.

Michael FitzGerald

CREDITS

Photographs of works of art reproduced in this volume have been provided in most cases by Christie's Inc., and the Ganz family archives except for the following:

Pages 9, 18, 21, 22, 113, 227, and 229: photographs by Derry Moore; **page 10:** photograph by Roberta Bernstein; **page 23:** *Soft Toilet:* the Whitney Museum of American Art; 50th Anniversary gift of Mr. and Mrs. Victor W. Ganz; **page 31:** *Owl and Arrow* and *Concierge's Daughter with Doll:* ©1988 estate of Pablo Picasso/Artists Rights Society (ARS), New York; **page 32:** *Woman on a Red Couch:* ©1988 estate of Pablo Picasso/Artists Rights Society (ARS), New York; **page 33:** *Bullfight:* ©1988 estate of Pablo Picasso/Artists Rights Society (ARS), New York, photograph courtesy of E. V. Thaw & Co., New York; **page 38:** *The Bird Cage:* ©1988 estate of Pablo Picasso/Artists Rights Society (ARS), New York; **page 39:** *Woman in a Red Hat:* ©1988 estate of Pablo Picasso/Artists Rights Society (ARS), New York; **page 40:** *Seated Woman:* ©1988 estate of Pablo Picasso/Artists Rights Society (ARS), New York; **page 43:** *Women of Algiers "C":* ©1988 estate of Pablo Picasso/Artists Rights Society (ARS), New York; **page 50:** *The Studio:* ©1988 estate of Pablo Picasso/Artists Rights Society (ARS), New York; **pages 54 and 55:** *Bather with Beach Ball:* The Museum of Modern Art; partial gift from an anonymous donor and promised gift of Ronald S. Lauder, ©1988 estate of Pablo Picasso/Artists Rights Society (ARS), New York; **page 57:** *Baboon and Young:* ©1988 estate of Pablo Picasso/Artists Rights Society (ARS), New York; **page 59:** *Seated Woman:* ©1988 estate of Pablo Picasso/Artists Rights Society (ARS), New York; **page 90:** photograph by Paul Katz; **page 96:** *Gray Rectangles:* Collection of Barney Ebsworth, St. Louis; **page 99:** *Screen Piece II:* Collection of Richard Lane, New York, photograph courtesy of Leo Castelli Gallery; **page 146:** *Odalisk:* the Ludwig Museum; **page 148:** *Allegory:* the Ludwig Museum; **page 149:** *Winter Pool:* Collection of David Geffen, Los Angeles; **page 169:** *Dove of Tanna:* the Whitney Museum of American Art; gift of the family of Victor W. Ganz in his memory; **page 186:** *Untitled (Rope Piece):* the Whitney Museum of American Art; purchased with funds from Eli and Edythe L. Broad, the Mrs. Percy Uris Purchase Fund, and the Painting and Sculpture Committee; **page 188:** *Constant:* the Estate of Eva Hesse, photograph courtesy of Robert Miller Gallery; **page 191:** *Untitled (Seven Poles):* the Estate of Eva Hesse, photograph courtesy of Robert Miller Gallery; **pages 194 and 199:** Fischbach Gallery installation photographs courtesy of Robert Miller Gallery; **page 222:** South Cove, Battery Park City, photograph by Mary Miss; **page 225:** *Watchman:* The Museum of Modern Art, gift of Mrs. Victor W. Ganz in his memory; **page 231:** *Creek:* photograph courtesy of Leo Castelli Gallery; **back jacket:** photograph by Judy Tomkins

Special thanks to Derry Moore for the interior photographs of the Ganz apartment.